Symbolism

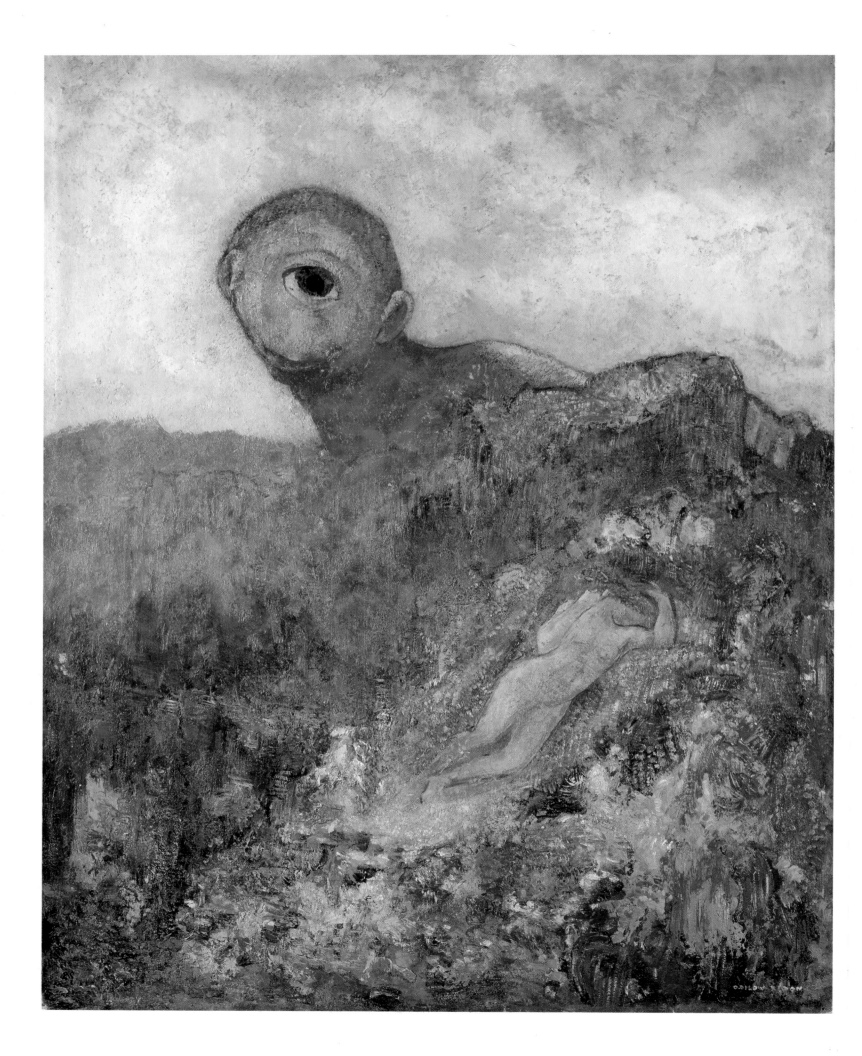

Symbolism

Michael Gibson

Conception: Gilles Néret

TASCHEN

KÖLN LISBOA LONDON NEW YORK PARIS TOKYO

ILLUSTRATION PAGE 2:
Odilon Redon
The Cyclops, c. 1898–1900
Oil on wood, 64 x 51 cm
Rijksmuseum Kröller-Müller, Otterlo

ILLUSTRATION PAGE 5:
Aubrey Beardsley
Illustration for Oscar Wilde's "Salome", 1893
Ink drawing, 22 x 15.5 cm
Fogg Art Museum, Cambridge (MA)

© 1995 Benedikt Taschen Verlag GmbH
Hohenzollernring 53, D-50672 Köln
© 1994 VG Bild-Kunst, Bonn for the works
of the following artists:
Edmond Aman-Jean, Alexandre Nicolas
Benois, Emile Bernard, Giovanni Boldini,
Carlo Carrà, Giorgio de Chirico, Paul
Delvaux, Maurice Denis, James Ensor, Max
Ernst, Wassily Kandinsky, Alfred Kubin,
Frantisek Kupka, Henri Le Sidaner, Aristide
Maillol, Edgar Maxence, Gustave Adolphe
Mossa, Alphonse Mucha, Alphonse Osbert,
Francis Picabia, Pablo Picasso, Georges
Rouault, Léon Spilliaert
© for the illustration by Henri Matisse:
1994 Succession H. Matisse/VG Bild-Kunst, Bonn
Conception and captions: Gilles Néret, Paris
English translation of captions and
biographies: Chris Miller, Oxford
Cover design: Angelika Muthesius, Cologne/
Mark Thomson, London

Printed in Germany
ISBN 3-8228-8570-3
GB

Contents

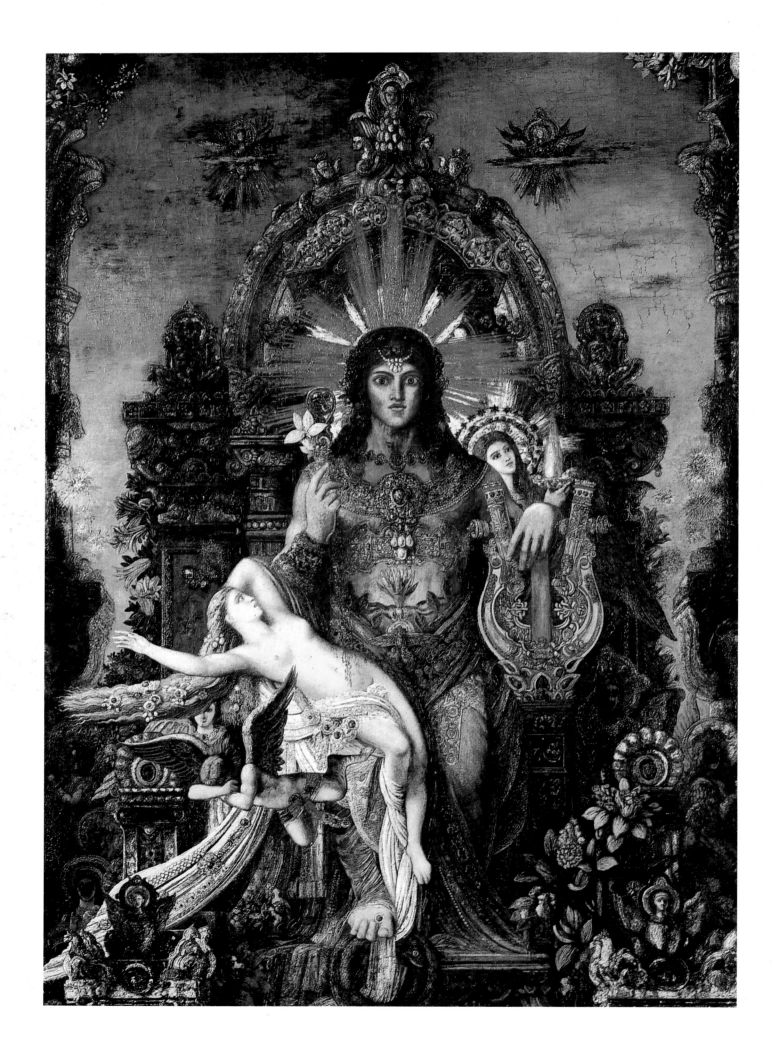

The Great Upheaval

*I presented "mentalities" to them as systems
of images, concepts of unformulated judgements,
variously ordered in the different social classes:
systems in motion and therefore objects of study for
history, but which do not always move at the same
pace in the different levels of culture, and which
order people's behaviour and conduct without their
being aware of it.* *Georges Duby*

Less an artistic movement than a state of mind, Symbolism appeared toward the middle of the 19th century. Its influence was greatest in those areas of Europe which combined two factors: advanced industrialisation and a predominantly Catholic population. We can circumscribe the Symbolist phenomenon by drawing a line linking Glasgow, Stockholm, Gdansk, Lódź, Trieste, Florence and Barcelona: the so-called "Europe of steam". Jean Moréas gave Symbolism a name and an identity on 18 September 1886. Some thirty years later, it expired amid the throes of the First World War.

By then, Modernism had triumphed and Symbolism was in disgrace; some Symbolist artists were reclassified as proto-expressionists or proto-surrealists, others, such as Khnopff, Hodler, Segantini, and von Stuck, were summarily dispatched to the attic of history.

Symbolism was swept away by the new watchwords of modernity. Some of these were movements which predated the First World War: Cubism, Fauvism, Expressionism and Futurism. Others emerged in its wake, like Dada and Surrealism. The war had cut a swathe in the ranks of science, the arts and letters, and the 1918 Spanish flu epidemic came to complete this grim harvest. Survivors of the trenches, such as the Germans Otto Dix and George Grosz, were scarred for life.

The war had divided Europe not just politically but culturally. On the one side stood the triumphant allies, on the other, the losers – Germany and the remains of the Austrian Empire. The vast expanse of Russia drifted away under the influence of other historical currents again. True, the French Dadaists and Surrealists maintained some international connections, but the great network of scholars and artists that had covered pre-war Europe lay in ruins, to be partially restored only in the fifties.

The hitherto serene ideal of beauty had itself undergone a radical transformation. As André Breton declared in his 1924 Surrealist Manifesto: "Beauty will be convulsive – or will cease to be." The momentous convulsions of the age were to be reflected in its art. All the more reason why the modernist spirit should find the vestiges of the earlier period not merely inacceptable but incomprehensible. The Soviet Revolution brought to the fore many new or revived ideas; its insistence that people's needs be taken into account and a world be created to provide for them was so radical that people might truly think that the planet they lived on was not the one their parents had known.

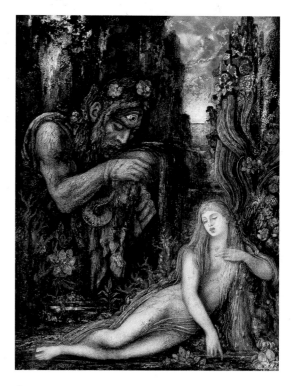

Gustave Moreau
Galatea, c. 1896
Water-colour and gouache, 45 x 34 cm
Thyssen-Bornemisza Collection, Lugano

This late work illustrates the unrequited love of the cyclops Polyphemus for the nereid Galatea. She was in love with the shepherd Acis, son of Pan and a river nymph. The jealous Polyphemus crushed his rival to death with a boulder.

Gustave Moreau
Jupiter and Semele (detail), 1894–1896
Oil on canvas, 213 x 118 cm
Musée Gustave Moreau, Paris

Semele, Jupiter's human lover, wished to see the god's face. Jupiter granted her request, but she died overwhelmed by the dazzling vision. This complex and ornate work is typical of one aspect of Symbolism.

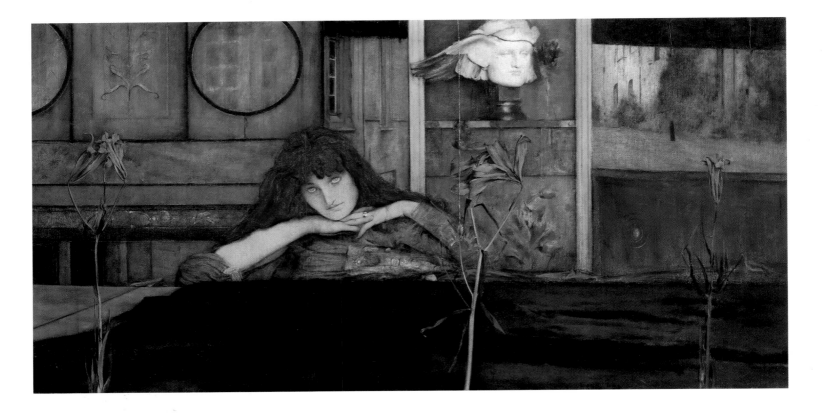

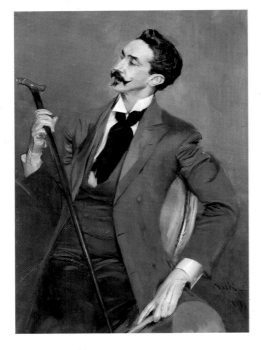

Giovanni Boldini
Le Comte Robert de Montesquiou, 1897
Oil on canvas, 200 x 100 cm
Musée d'Orsay, Paris

TOP:
Fernand Khnopff
I Lock my Door upon Myself, 1891
Oil on canvas, 72 x 140 cm
Neue Pinakothek, Munich

PAGE 9:
Edmond Aman-Jean
Young Girl with Peacock, 1895
Oil on canvas, 105 x 104 cm
Musée des Arts Décoratifs, Paris

Under these circumstances, it was predictable that the theorists of art should be perplexed by the products of the previous decades. The prevailing mood of alienation and cynicism was hardly conducive to an appreciation of Symbolism's narrative and often sentimental art. There were, of course, artists and poets who could not easily forget the idiom in which they had been brought up. Guillaume Apollinaire loved the Symbolist poets and painters; André Breton, the founder of Surrealism, remained a devotee of Gustave Moreau; and the deeply ironical Marcel Duchamp spoke affectionately of the works of Arnold Böcklin. But modernism was implacable; it found little to say in favour of Symbolism, which it tended to dismiss as an aberration.

There was a precedent for this view, which had already been held by the 19th century realist painters; the view extended even to an artist of anarchist leanings such as Camille Pissarro. This was not simply an artistic perspective. It was largely determined by the struggle between the militantly secular ideals of the Third Republic and an increasingly defensive French Catholic Church.

For realism was, in 19th century France, the idiom of republican and anticlerical artists, the banner of a social consciousness attuned to the "real issues of the day". Those who painted imaginary subjects were condemned as reactionaries or tolerated as innocent dreamers blind to the issues of the day. This state of things was in marked contrast to English attitudes. There, realism was the idiom of the pious and right-minded who sought, like John Ruskin, to render homage to the Creator by imitating Creation as closely as possible.

The reason for this difference is clear. England is a Protestant country, and the two most significant epithets in relation to Symbolism are those which appear in the second sentence of this book. Symbolism was a product of Catholic and of industrial Europe. Since these are unusual categories for a work of art history, let us consider them in depth.

Let us begin by observing that elements of a feudal mentality sur-

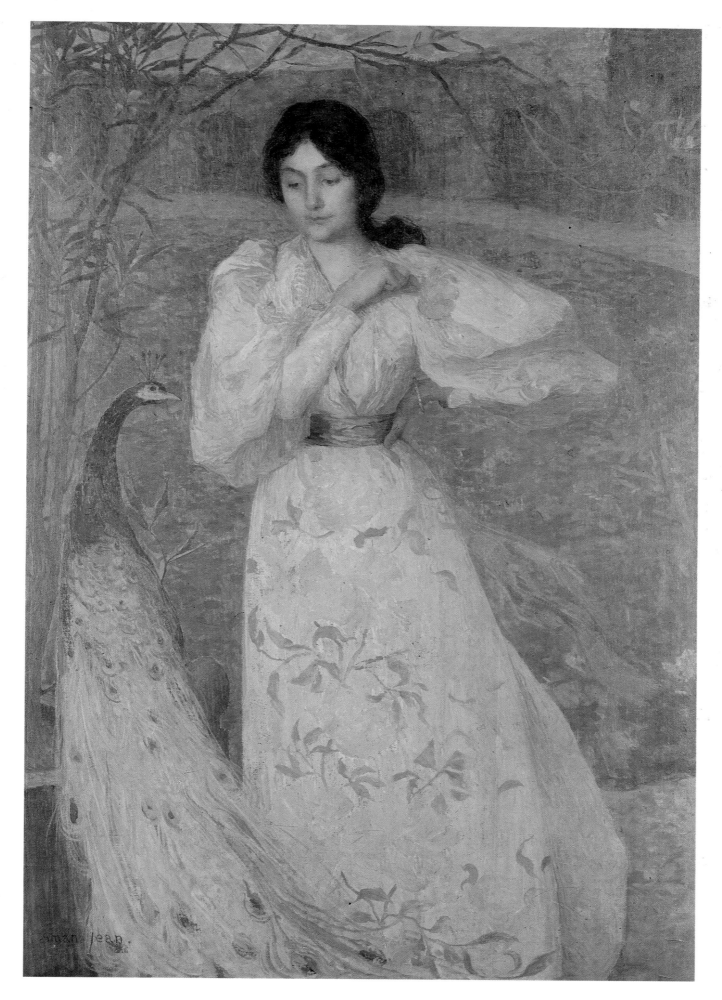

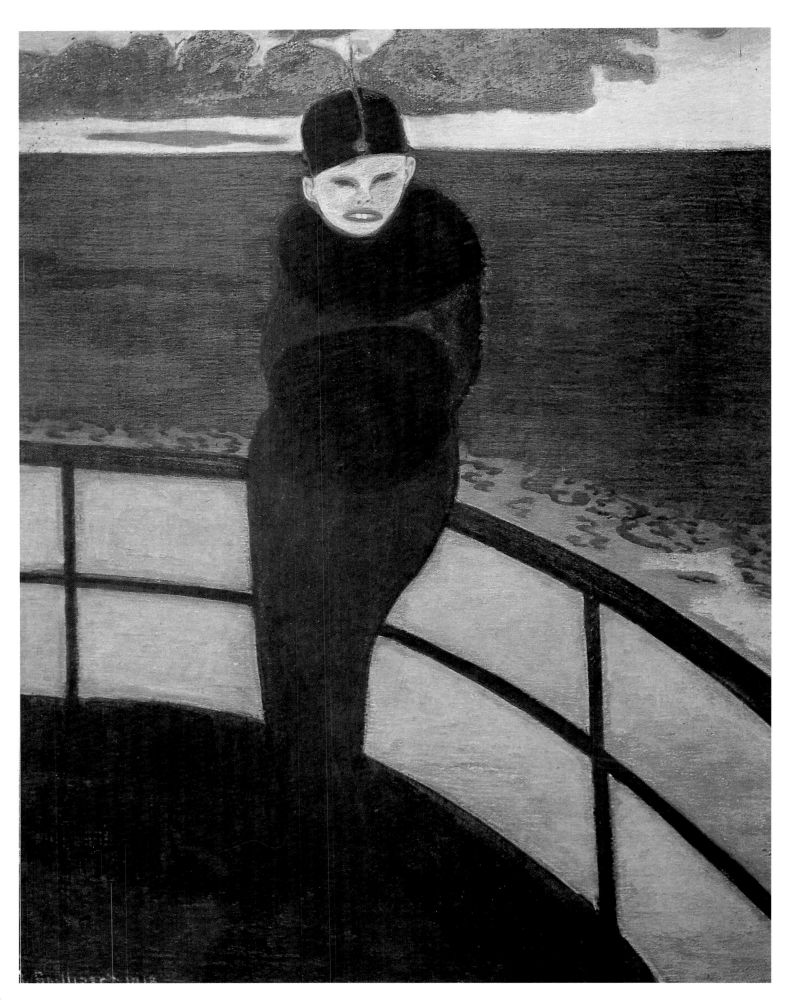

Fernand Hodler
Day I, 1899–1900
Oil on canvas, 160 x 340 cm
Kunstmuseum Bern, Bern

Only its freedom of style, sinuous line and mannered symmetry of gesture differentiate this allegorical canvas from the academic.

Charles Maurin
Maternity, 1893
Oil on canvas, 80 x 100 cm
Musée Crozatier, Le Puy

The originality of this painting lies in the way the artist has set these "mother and child" groups into the landscape as though they were memories or visions.

PAGE 10:
Léon Spilliaert
The Crossing, 1913
Pastel and crayons, 90 x 70 cm
Private collection

The simplified division of space, a characteristic of Symbolist art, is here combined with the strong colours of the first decade of the 20th century. Disquieting nocturnal visions are a feature of the first period of Spilliaert's painting. The strange daylight vision of this pastel creates a similar impression through its garish colours and abrupt expressiveness.

vived in Europe until the end of the 19th century. Shaken but not overthrown by Enlightenment scepticism, the feudal world view had survived in rural areas. Georges Duby even suggests that the behaviour of the French peasantry had become increasingly formalised over the course of the 19th century as they made the medieval courtly style their model. Thus idealised, the dying tradition gained a new intensity, going out in a blaze of glory. But here we must adjust our metaphor. The fire went out because its fuel was scattered.

The newly industrialised society had a tremendous appetite for manpower. It attracted vast numbers of men and women to the cities, into

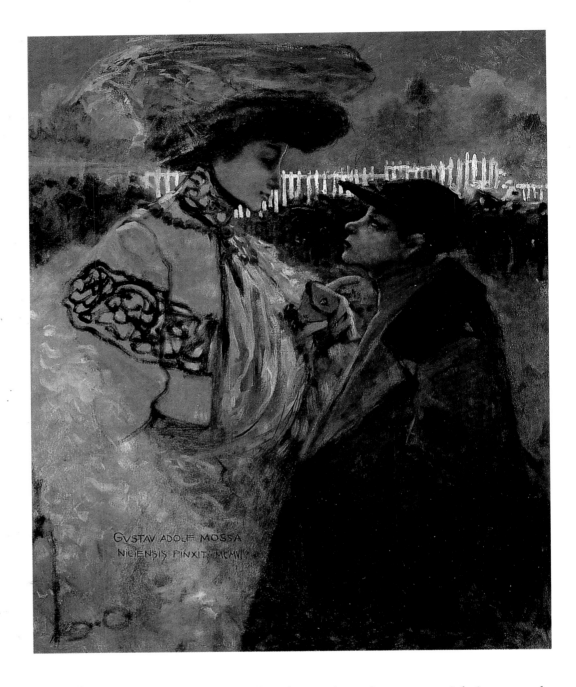

Gustave Adolphe Mossa
Woman of Fashion and Jockey, 1906
Oil on canvas, 75 x 60.5 cm
Private collection

A late Symbolist who drew on the conventional repertoire of Symbolism, Mossa produced a few powerful paintings like this one, which transposes the Symbolist theme of the fascinating and dominant woman to an everyday context. Here the jockey is small because he is a jockey and the woman is elegantly dressed for the races. But a strange and tense atmosphere prevails.

whose newly established railheads goods and raw materials incessantly flowed. The statistics are eloquent: during the period which concerns us, only one in seven persons born in the countryside remained there. One in seven emigrated to the New World or the colonies; five moved to the cities. In the half-century between 1850 and 1900, sixty million people left Europe. Still more were drawn to the cities and suburbs. The village reality had structured their private and social identity; in the city, there was no equivalent experience to give meaning and value to lives. Catholic societies seem to have felt these changes more profoundly, perhaps because Symbolism formed a greater and more integral part of their outlook. Perhaps, too, the Reformation, whose demands were those of the pragmatic, new financial and merchant classes, had better prepared Protestant minds for this event. At all events, the momentous social transformations of the industrial revolution brought a conflict between traditional, symbolic representations of the world and a new reality based on utterly different values.

The changes brought about by industrialisation were generally not

Alphonse Osbert
The Muse at Sunrise, 1918
Oil on wood, 38 x 46 cm
Private collection

well received in Catholic countries. The issue was not merely the desperate poverty that resulted; this was the same everywhere. More than 50,000 children passed through the homes Doctor Barnardo established for the waifs of London. No, in Catholic countries, the emblematic representation of the world was shaken to the core, and with it everything which had, till then, served to distinguish good and evil. "The concept of the demonic," observed Walter Benjamin, "appears when modernity enters into conjunction with Catholicism."

One metaphor for this collision of new and old is the slow, irresistible movement of continental drift. Consider how the Indian peninsula has, over the millenia, imperceptibly shouldered into the huge Asian landmass. The consequent pressure resulted in the vast, chaotic folds of the Himalayas, taken here to represent a century of perplexity and transition. On the one hand, we have the immovable mass of Asia, that is, the order of representations that tends

Arnold Böcklin
The Plague, 1898
Tempera on wood, 149 x 105 cm
Kunstmuseum Basel, Basle

The artist and his family twice had to flee cholera epidemics. In this unfinished work, there is nothing archaic about Böcklin's vision of "the plague". Today, the image might be taken to refer to a contemporary reality such as AIDS.

BOTTOM:
Henry de Groux
The Great Upheaval, c. 1893
Oil on canvas, 76 x 98 cm
Private collection, Paris

Men and women, some on foot, some on horseback, leave a place of devastation. In the foreground lies a broken cross. The enclosure in which it stood has also been levelled. We find here a naive but eloquent expression of the collapse of representations of the traditional world in a society undergoing rapid change.

PAGE 15 TOP:
James Ensor
The Expulsion of the Fallen Angels, 1889
Oil on canvas, 108 x 132 cm
Musée des Beaux-Arts, Antwerp

This astounding and chaotic work suggests how difficult it is to define Symbolism precisely. At once expressionist and abstract, it represents a wild tumult, a spiritual struggle that goes beyond the biblical account on which Ensor drew.

PAGE 15 BOTTOM:
Xavier Mellery
Immortality, undated
Water-colour on board, 80 x 58 cm
Musées Royaux des Beaux-Arts de Belgique, Brussels

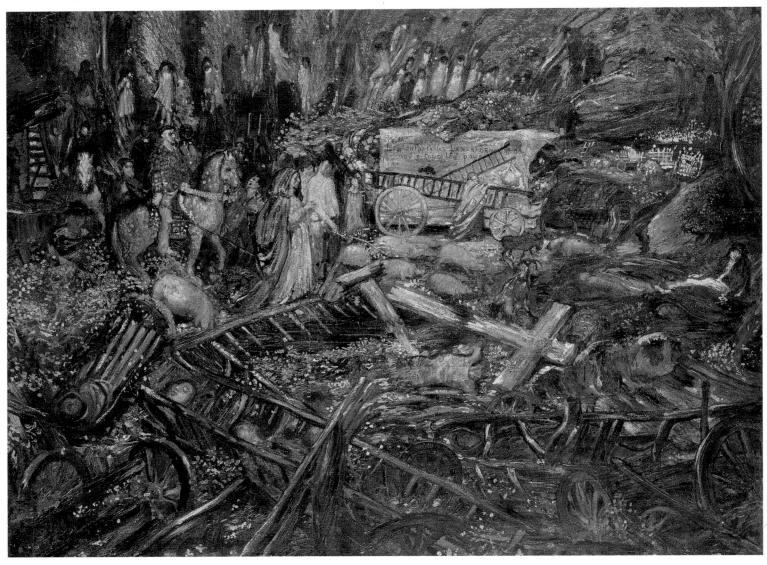

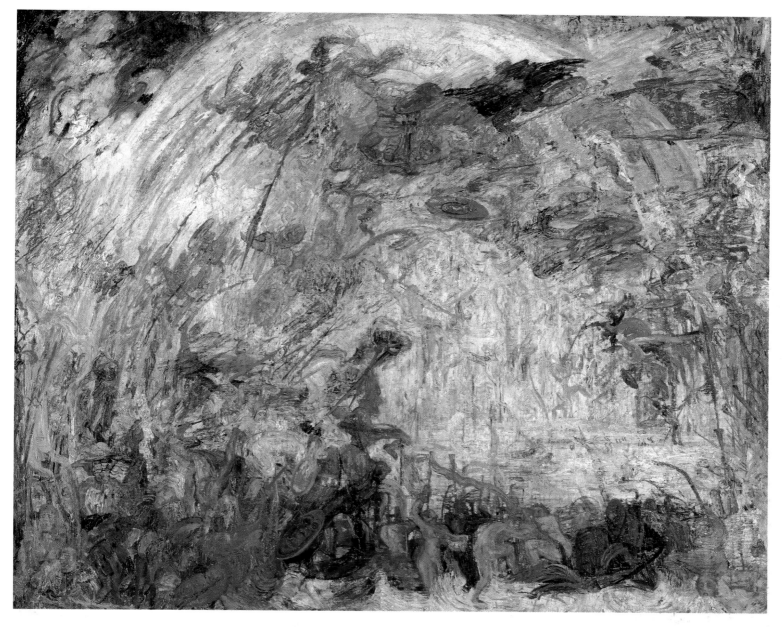

to change slowly if at all (in this case, the Catholic heritage of Europe). On the other hand, we have a continent adrift, that is, the changes in lifestyle set in train by the unprecedented development of industry in the 19th century. Theories alone, after all, have never overthrown a society. Philosophers have always criticised traditional views, yet this has never prevented the survival of a deeply traditional society in rural areas. Indeed, nothing might have changed if men and women in great numbers had not been torn away from their native environment and precipitated into radically different circumstances. It was this dizzying collision between symbolic representations and everyday lifestyle which ultimately threw up Himalayan ridges where once there had been rolling plains. This collision is the subject of a painting, *The Great Upheaval (Le Grand Chambardement;* p. 14) by the Belgian Symbolist artist Henry de Groux. It depicts men and women, some on horseback, others on foot, leaving a place of devastation. In the foreground lies a large broken cross. The enclosure in which it stood has been laid waste like the area around it, and the inhabitants are impelled to move on. A closer look belies one's first impression; this picture does not represent the kind of exodus made familiar by the last two European

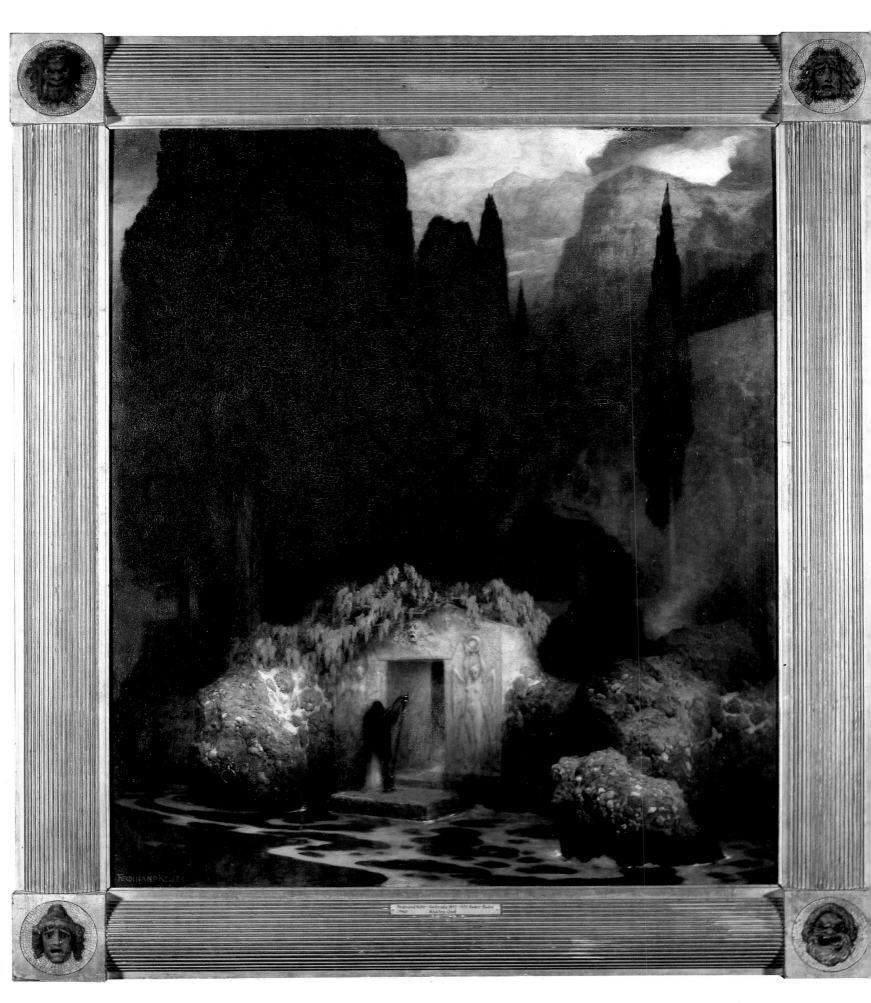

cataclysms, but a purely spiritual "upheaval". An entire society takes leave of a familiar and beloved land and sets off into exile, into the unknown.

This melancholy constatation is central to the Symbolist outlook. At the end of the 19th century, while science and positivism triumphantly announced a brave new world founded on reason and technology, some people were primarily aware of the loss of an indefinable quality which they had found in the former cultural system, in the values and meanings signified by what we might call its "emblematic order".

It is thus no accident that a broken crucifix lies at the heart of Henry de Groux's painting. In all its ambiguity, the cross is the central symbol of a representation of the world that acknowledges more than one plane of reality. In the Christian world view, there is the created world of nature, and an increate, divine order which stands above it. (Or, to take a more secular perspective, the real might be contrasted with what Guillaume Apollinaire, in a coinage that met with unexpected success, termed the "sur-real".) The positivist, on the other hand, acknowledges only one level of reality: nature. In his perspective, the "other" world is merely an illusion. To which some were inclined to retort: "You tell us that the other world is illusory. Perhaps it is. But it is there that we choose to live." It is with these people that our book is primarily concerned.

This sort of response might be prompted by a religious frame of mind. Or it might be motivated by a taste, perverse or otherwise, for

Arnold Böcklin
The Sacred Wood, 1882
Varnished tempera on wood, 105 x 150 cm
Kunstmuseum Basel, Basle

Böcklin's strong personality found in antiquity a vast repertory of allegorical and symbolic subjects.

Ferdinand Keller
Böcklin's Tomb, 1901–1902
Oil on canvas, 117 x 99 cm
Staatliche Kunsthalle, Karlsruhe

Keller was a history painter who developed an enthusiasm for Böcklin late in his career. This homage, painted after Böcklin's death, is redolent of the heady perfume of Symbolism.

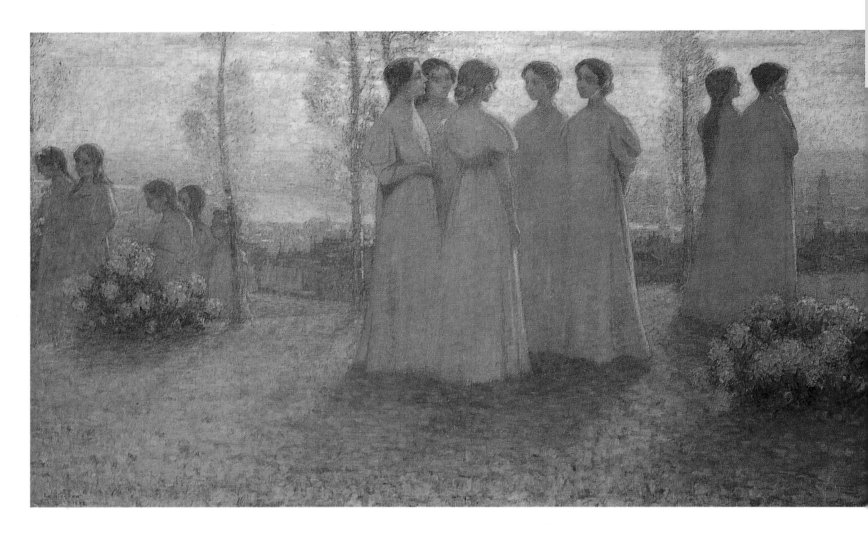

Henri Le Sidaner
Sunday, 1898
Oil on canvas, 113 x 192 cm
Musée de la Chartreuse, Douai

PAGE 19 TOP:
Lucien Lévy-Dhurmer
Portrait of Georges Rodenbach, c. 1895
Pastel on grey-blue paper, 36 x 55 cm
Musée d'Orsay, Paris

solipsistic self-indulgence. The "other world" might be the world of the Divine; it might equally be a world of artistic delectation, that parallel world in which the fictitious des Esseintes, hero of J.-K. Huysmans' *Against Nature*, and his contemporary, the very real King Ludwig II of Bavaria, sought to take refuge.

In either case, we recognise a degree of neurosis or madness. But that is not the whole point. The question that we must ask is this: were the depressions of des Esseintes and the eccentricities of Ludwig of Bavaria the result of some specifically cultural malaise? To understand this question, we must sketch in some background. Twentieth century anthropology presents a culture as a web of values and meanings which allows men and women to decide where they stand and how to find their way in the world. It is therefore no coincidence that those who most deplored the loss of meaning and value were most receptive to Symbolism.

"It is all too clear," wrote the Symbolist poet Gustave Kahn, "that these people move only in search of resources, and the source of dreams is running dry." While the logic of science, industry and commerce might be capable of satisfying the practical needs of society and the individual will to power, Gustave Kahn's metaphor suggests a thirst that can be quenched only at the source of dreams. The metaphor of dream perhaps offers too many hostages to the critical spirit of the time, which was all too inclined to identify dreams with the unreal. Nevertheless, even those for whom the positivist world view was a source of dissatisfaction and anguish tended to be overwhelmed by the compelling force of its oppressive, virile power.

It looks, then, as if we do indeed possess some sort of cultural key to the melancholy not merely of an imaginary personality like des Esseintes, but of the works of so many minor but significant Symbolist poets: Georges Rodenbach, Henri de Régnier, Camille Mauclair, Charles Guérin, Marie Krysinska, Jean Lorrain, Grégoire Le Roy and Pierre Louÿs. The industrial world might be described as a compound of fire and steel, and the Symbolist poets, impotent sons of a domineering age, sought refuge in air and water:

"The water of the old canals is cretinous and mental
So dismal between the dead towns…
Water so lifeless, that it seems fatal.
Why so naked and so barren already? And what is
the matter with it, that, entirely given over to its
somnolence, to its embittered dreams, it has thus
become no more than a treacherous mirror of frost
in which the moon itself finds it painful to live?"

Georges Rodenbach's verse is eloquent of the mood of depression and decline that characterises the Symbolist state of mind. Symbolist poets were inclined to evoke the moon rather than the sun, autumn rather than spring, a canal rather than a mountain stream, rain rather than blue skies. They complained of sorrow and *ennui*, of disillusionment with love, of impotence, weariness and solitude, and they lamented their birth into a dying world.

Louis Welden Hawkins
Mask, Symbolist portrait in the form of a fan, 1905
Gouache on board
Private collection

These leitmotifs are given caustic expression in the poetry of Jules Laforgue. In his work too, the moon, evening and autumn are predominant, but they are found there in the company of a ferocious wit:

"Everything comes from a single categorical imperative,
but what a long arm it has, and how remote its womb!
Love, love which dreams, asceticizes, and fornicates;
Why don't we love one another for our own sakes in our own little corner?

Infinity, where did you spring from? Why are our proud senses
mad for something beyond the keyboards bestowed,
do they believe in mirrors more fortunate than the Word,
and kill themselves? Infinity, show us your papers!"

"Infinity, show us your papers!" The tone is one of truculent defiance, and it is characteristic of those who discover the relativity of a culture which they had innocently believed to be the vehicle of absolute truth. Symbolism was imbued with a powerful nostalgia for a world of meaning which had disintegrated in the space of a few brief decades. This is the reason for the melancholy and anxiety expressed whenever an artist looks beyond the surface of things. For if a whole series of Symbolist artists strike one as sickly and emollient – one might cite Edmond Aman-Jean, Henri Le Sidaner, Lucien Lévy-Dhurmer, Charles Maurin, Edgar Maxence and Alphonse Osbert – it is because they chose to ignore reality; they preferred to offer a comforting illusion in perpetuating what had already ceased to exist.

To what, then, does the "symbol" at the heart of Symbolism stand opposed? By now, our answer is clear: to the limited "reality" of the age,

Alexandre Séon
Orpheus Laments, 1896
Oil on canvas, 73 x 116cm
Musée d'Orsay, Paris

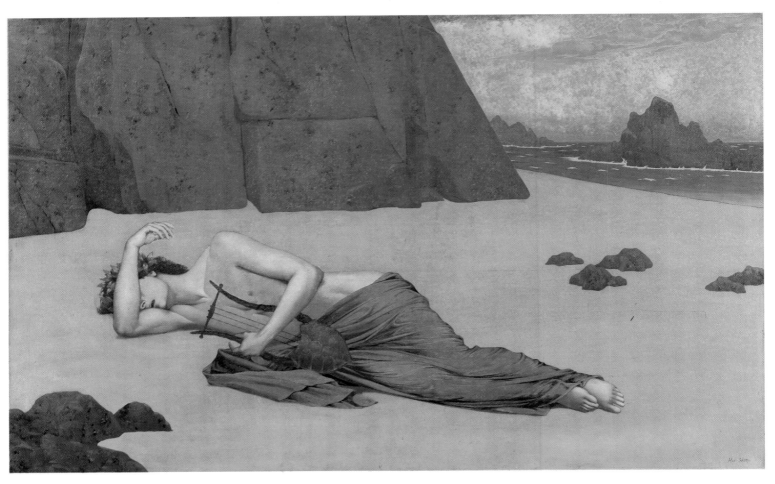

Louis Welden Hawkins
The Haloes, 1894
Oil on canvas, 61 x 50 cm
Private collection, Paris

These plump, appetising young saints have more
in common with pin-ups than with stained-glass
windows. The original frame attempted to avert
suspicion with the inscription: "They are singing
the canticles of the angels with lips still sullied
with earth."

to the given, to the profane. A symbol, by its very nature, refers to an
absent reality. In mathematics it signifies an unknown quantity; in reli-
gion, poetry or art, it lends substance to an unknown quality – a value
that remains out of reach. In a religious context, this quality is unknown
(or unknowable) because it belongs to a different order of reality – a
supernatural order – and can therefore be signified only by a sacred ob-
ject. The sacred, in this view, is merely a semantic category, and should
not be confused with the divine; as the Chinese sage puts it, one must not
confuse the moon with the finger that points to it. But even the irreligious
must acknowledge that there are things to which we cannot directly refer.
We need symbols to communicate these things. This is true of the emble-
matic categories of culture which have not yet attained the threshold of
language, but which draw their substance from a vast network of implicit
values which structure the hierarchy of the world for each individual
consciousness, signifying the position it occupies within this hierarchy.
It is also true of the future, which is constituted as much by man's hopes,
fears, and waking dreams, as by the unavoidable material conditions im-
posed by history. So much human energy is expended in reaching beyond

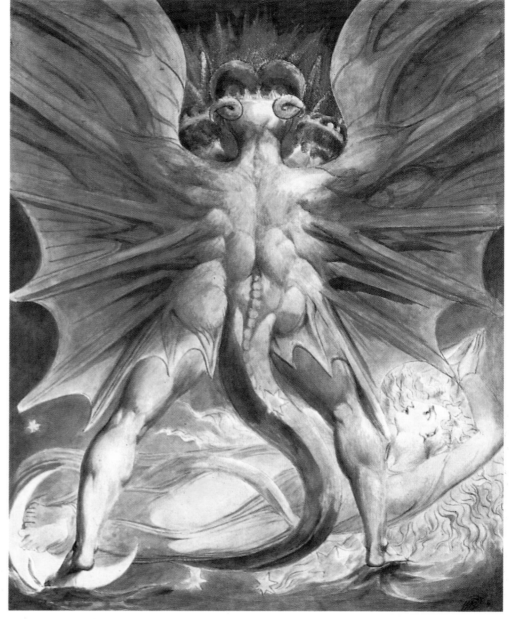

the narrow field of the given, as Laforgue ironically remarks: "Why are our proud senses/ mad for something beyond the keyboards bestowed,/ do they believe in mirrors more fortunate than the Word,/ and kill themselves? Infinity, show us your papers!"

This is the core of the conflict between the two world views: on the one hand, a given and immutable world, favourable to trade and industry but indifferent to the values which lend substance and savour to life; on the other a world dialectically related to a transcendent model (religious, visionary or poetical) that spurs the individual to action by proposing a creative transformation of the given. Western civilisation in the 19th century underwent a surgical operation which severed these two components of our relation to the world. From that point on, it seemed, reality could no longer lend its weight to the dreamer, nor dreams bestow wings upon reality. The two were at war.

It is thus apparent that Symbolist art does not merely touch upon long-standing illusions which society was finally learning to overcome. Nor is it simply the naive expression of some first, tentative

forays into the realms of the unconscious, a world soon to be charted so thoroughly. It goes much further than that, pointing to the constantly shifting state of culture and to what the eminent Hellenist E. R. Dodds termed an "endogenous neurosis". This explains why a significant part of Symbolist art reflects a new uneasiness in the relations between men and women. For culture does not only confirm the individual's personal identity, it also provides the foundation of his or her sexual identity. Though this identity has a physiological foundation, it is also, inevitably, a cultural construction. A breach or dislocation in the body of culture will inevitably affect the mode of interaction between men and women. Here the relevance of Georges Duby's analysis of the Middle Ages is clear: "Fissures appear at the points of articulation; they grow gradually wider and eventually split the body apart, but they almost always turn out to exercise their corrosive effect only insidiously. In spite of the illusion fostered by the apparent tumult of merely superficial agitation, it is always in the very long term that their reverberations bring about collapses, and these are never more than partial since indestructible vestiges always subsist."

It is thus the nature of Symbolist art to attempt to record a process

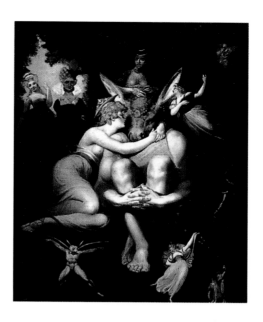

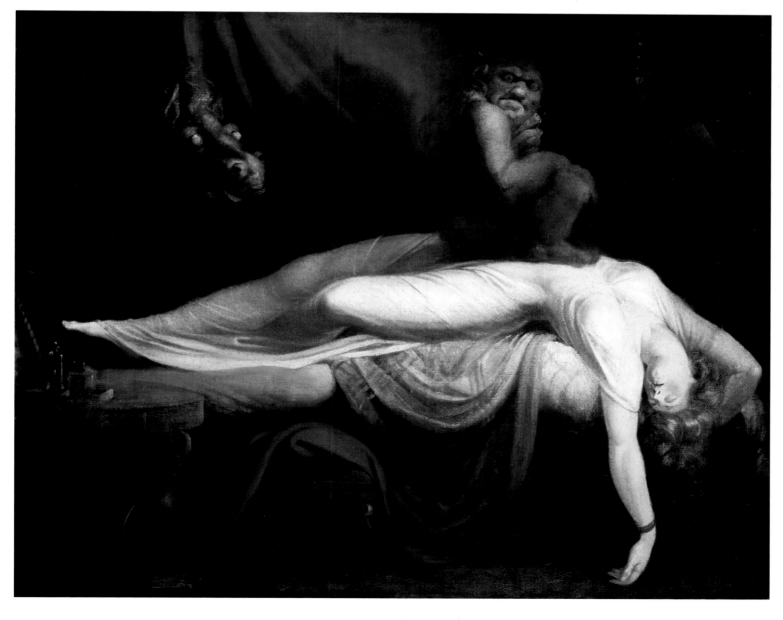

which had till then been massive, involuntary and very largely unconscious – though the collective will and the decrees of those in power had always had some power over it. The role of symbols as the traditional cement of the community had been tested during catastrophes. But by forcibly removing unprecedented numbers of men and women from the countryside and transforming them into the atomistic individuals of the newly created proletariat, the Industrial Revolution not only made adjustment more difficult; it modified the order of priorities. "Grub first," as Bertolt Brecht and Kurt Weil's *Threepenny Opera* puts it, "Morals later!" For the new city-dwellers, solidarity in obtaining the necessities of life replaced the former community of meaning.

The upper class had greater leisure to ponder the loss of meaning implied by the new order of things. Involvement in militant activity might do duty for a sense of community among the impoverished; for the rich, all sense of community was lacking. Symbolism is thus the negative imprint of a bygone age rich in symbols and the expression of yearning and grief at the loss of an increasingly idealised past. Those who had the means to do so sought solace from the brutal pursuits of the world by sipping at the soothing philtre of the arts. But even they were confronted with anxiety and nightmares from which none could then hope to be exempt.

He had sought, for the delectation of his mind and the delight of his eyes, a few suggestive works to carry him into an unknown world, to unveil the traces of new conjectures, to unsettle his nervous system with scholarly hysterias, complicated nightmares, indolent and agonizing visions.　　　J.-K. Huysmans, *Against Nature*

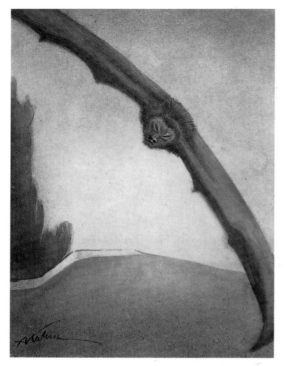

Alfred Kubin
Cemetery Wall, c. 1902
Pen and Indian ink wash on paper, 24.8 x 18.2 cm
Oberösterreichisches Landesmuseum, Linz

The Austrian graphic artist Alfred Kubin, whose earliest works date from the first years of the 20th century, took as his subject the most powerful irrational terrors. This bat may seem alarming, but it is one of his more benign creations.

PAGE 25:
Franz von Stuck
Sin, 1893
Oil on canvas, 95 x 59.7 cm
Neue Pinakothek, Munich

This painting, with its fine academic technique, is an excellent, conventional personification of the evil woman, one of the central themes of Symbolism.

Symbolist art thus strove to represent something other than self-evident physical reality. It was romantic up to a point; it was often allegorical; it was dream-like or fantastic when it wished, and it occasionally reached into those remote areas delineated by Freud in his exploration of the unconscious. Its antecedents may be sought among figures such as Fuseli, Goya or William Blake. But the roots of Symbolism are also to be sought in the fertile soil of Romanticism – the Romanticism of Novalis, E.T.A. Hoffman and Jean Paul rather than Alfred de Musset or Victor Hugo. The solipsistic stance so central to Symbolist art is to some extent prefigured in Romanticism. The movements are nevertheless distinct. Rooted in the Protestant mentality of Germany, Romanticism implied a fervent, mystical bond with Nature seen as the created word of God.

Symbolism, on the other hand, born of the Catholic mentality of France, Belgium, Austria and parts of Germany, no longer showed the same veneration for nature. "Nature, as he [des Esseintes] used to say, had had her day; the disgraceful uniformity of her landscapes and skies had finally worn out the patient appreciation of the refined. In the last analysis, how platitudinous she is, like a specialist confined to a particular domain; how petty-minded, like a shopkeeper stocking one article to the exclusion of any other; what a monotonous storehouse of meadows and trees, what a banal purveyor of seas and mountains! Besides, there is not a single one of her supposedly subtle and grandiose inventions that it is beyond the means of human genius to create; no

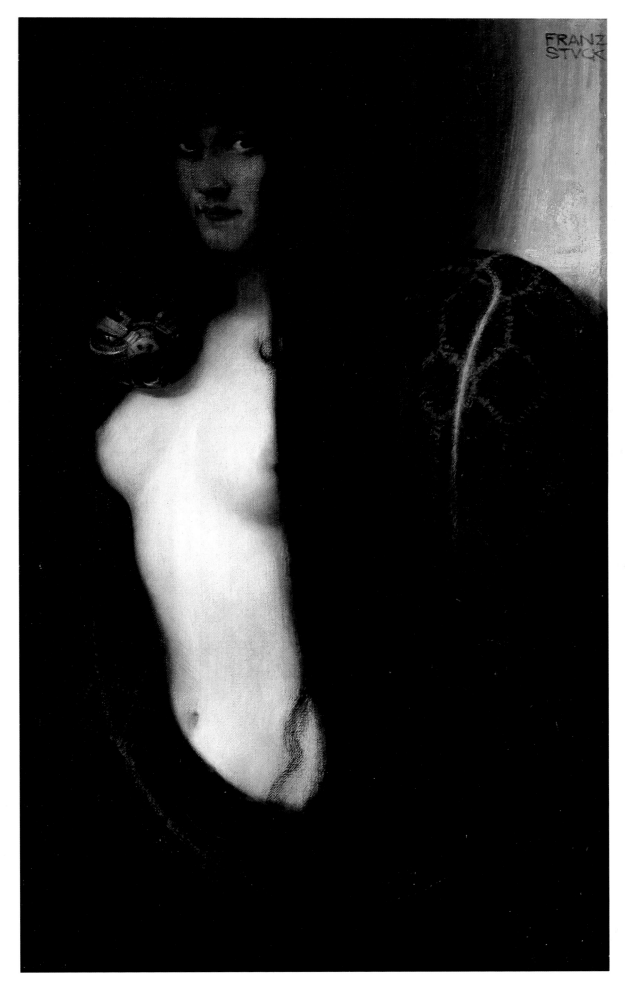

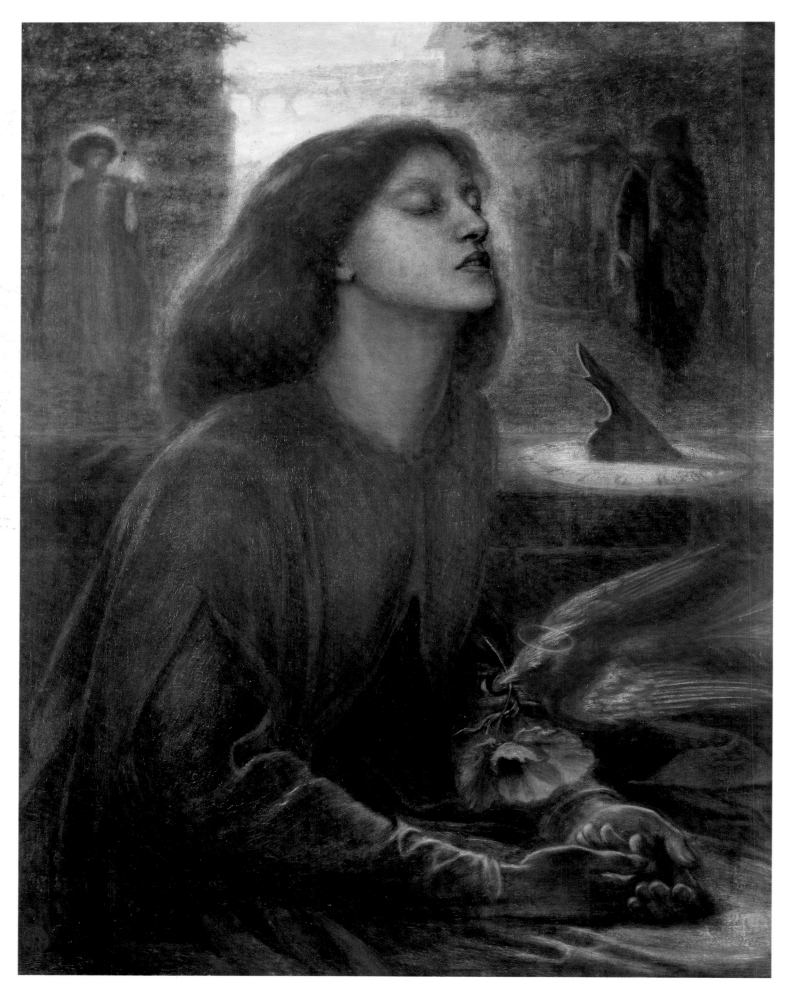

Fontainebleau forest, no moonlight that cannot be reproduced by a decor bathed in electric lighting; no waterfall that hydraulic engineering cannot imitate to perfection; no rock that papier-mâché cannot counterfeit; no flower that fine taffeta and delicately coloured paper cannot match! No doubt about it, this sempiternal chatterbox has by now wearied the indulgent admiration of all true artists, and the time has surely come for artifice to take her place whenever possible."

These words were given to his idiosyncratic brainchild by Joris-Karl Huysmans in 1893, almost exactly a century ago. In *Against Nature*, the caustic art critic and brilliant novelist enshrined some of the more striking features of Symbolist art. No longer was nature to be studied in the attempt to decipher its divine message. Instead, the artist sought subjects uncanny enough to emancipate imagination from the familiar world and give a voice to neurosis, a form to anxiety, a face, unsettling as it might be, to the profoundest dreams. And not the dreams of an individual, but of the community as a whole, the dreams of a culture whose structure was riddled with subterranean fissures. The whispering collapses distantly audible throughout the edifice offered a discreet foretaste of the world's end. "Decadence" was the great issue of the Symbolist age, "decadence" the term that des Esseintes chose to characterize it.

Decadence meant the rejection of "progress" as a misunderstanding of the true nature of things. Everyone else was climbing onto the bandwagon of progress; the decadent chose to stay behind. Turning in on himself, he rejected the exoteric culture of science and sought consolation in esoteric pursuits. It was the combination of this attitude with the dictates of fashion that made the dandy the Symbolist figure *par excellence*: the "prince of an imaginary realm" in Disraeli's words. And it was the need for a purely imaginary superiority that lay behind the somewhat hysterical arrogance of that supreme dandy, Count Robert de Montesquiou (p. 8). Montesquiou was the model for both the comical figure of des Esseintes and the tragic Baron de Charlus in Proust's *Remembrance of Things Past*.

We are thus faced with an insoluble paradox. For in "normal" times – in periods of lower social tension – far from being the secret garden of a few privileged souls, the underlying Symbolism of culture, which these lonely figures were so eager to preserve, constituted the common ground on which the cohesion of society as a whole was built.

Art, from the very outset, had been laden with symbols. Only quite recently, as a result of a notorious misunderstanding of the Renaissance ideal of "imitation of nature", had it been assumed that it was the artist's business scrupulously to reproduce what he saw. Yet, if art is to hold our interest it must refer to something over and beyond itself and its manifest subject. At its best, even Impressionism captures a part of daily reality as elusive as the metaphysical: the fleeting moment of immediate experience. Impressionism is thus a kind of borderline case, contriving to be compatible with an age which, under the sway of Positivism, rejected as unreal that which could not be touched and measured.

The high-strung idealism of so much Symbolist art led to its rejection in later years. The First World War was a devastating *exposé* of contemporary illusions, and in works such as Céline's *Journey to the End of the Night* a despairing conclusion was drawn. Almost at the same time came Freud's revelation of the hidden roots that sustained a certain kind of idealism: sublimation. Similarly, the critical apparatus elaborated by Marx and widely accepted by historians and thinkers has allowed us to

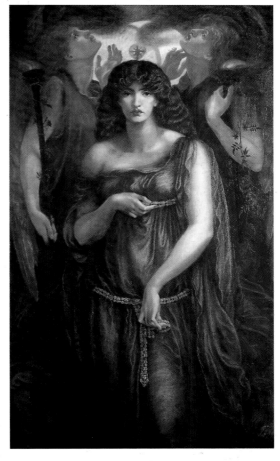

Dante Gabriel Rossetti
Astarte Syriaca, 1877
Oil on canvas, 183 x 107 cm
City Art Gallery, Manchester

The model for this painting was Jane Burden, who lived with Rossetti after the death of Elizabeth Siddal and the break-up of her own marriage with William Morris. As in other canvases to the glory of Jane, Rossetti stylises her features, investing them with a powerful sensuality.

PAGE 26:
Dante Gabriel Rossetti
Beata Beatrix, 1863
Oil on canvas, 86 x 66 cm
Tate Gallery, London

Rossetti's first name was Dante. His mistress, model, and eventual wife, Elizabeth Siddal, was thus necessarily his Beatrice. She committed suicide with an overdose of laudanum in 1862. This painting is a last and touching homage painted the year after her death. Its shows Elizabeth/Beatrice at the moment of ecstatic death. A flame-red bird, the Holy Spirit, places a poppy in her hands; laudanum is, of course, a derivative of opium, which is extracted from poppies.

comprehend how ideology uses mythopoeic representations to consecrate the existing hierarchy of power.

It is easy enough to see why the naive complacency of much Symbolist art laid it open to criticism. But time has passed, ideas have changed, and we are now in a position to take a fresh view. The anthropologists of this century have shown how the symbolic foundation of culture is indispensable to the well-being of individuals and to the survival of society. It alone can signify values worth serving and provide each member of society with a clear perception of his or her individual and sexual identity. Such things are not within the purview of reason, but arise out of a pre-

Fernand Khnopff
Art, or *The Sphinx*, or *The Caresses*, 1896
Oil on canvas, 50 x 150 cm
Musées Royaux des Beaux-Arts, Brussels

In this enigmatic picture, Khnopff offers a metaphor of the strange relation between the solitary artist and his imagination. But this is not a timeless metaphor; it is the uneasy imagination of the Symbolist period. The young man caressed by the sphinx is the artist. The two faces are cheek-to-cheek: the artist rests his cheek against his ambiguous double, his solitary inspiration. This blend of spiritual solitude and anxious pleasure is the universe of Symbolist art.

Francisco Goya
The Colossus, 1802–1812
Oil on canvas, 116 x 105 cm
Museo del Prado, Madrid

This powerful metaphor of the panic caused by events of superhuman scale suggests how Goya can be seen as the precursor of Symbolist anti-naturalism. Goya's extreme vitality is, however, in contrast with the generally depressive tone of *fin de siècle* art.

verbal, symbolic order which reason cannot afford to ignore. Nor has Symbolism ceased to exist. It remains active today in the work of poets and dramatists; an attentive ear will discover vestiges of it even in the essentially modern plays of Samuel Beckett. It is also spectacularly present in the cinema, in the baroque splendours of Fellini and Pasolini.

More unexpected are the traces of Symbolism in Marcel Duchamp's *The Large Glass* (p.214), which seems at first glance to be everything that Symbolism is not. Formally as dry as a blueprint, it expresses an ironic, not to say cynical view of sexual relations. But in both construction and outlook, it presents affinities with the great Symbolist *machines* of Gustave Moreau, the founding father of French Symbolism.

Indeed, irony was never incompatible with Symbolism. Academic and sentimental works predominate, but French Symbolist poetry numbers amongst its exponents not merely Jules Laforgue, whom we have cited, but Alfred Jarry. Jarry's dandyism and whimsicality make him very much a Symbolist; in his *œuvre*, we encounter a transition to the modernism of Duchamp.

It was in fact among Symbolist artists that a notion of the absolute autonomy of art first appeared. The assertion had a particular resonance in a society which by and large expected art to be "edifying". Modernism took up this doctrine and required that art, like mathematics, be recognized as a separate realm, unrelated to the context in which it appeared. In several respects, then, a real continuity can be seen to exist between the art of that age and our own. If we fail to perceive this, it may be because we believe that Modernism marked a radical and definitive break with the past. But this is yet another myth: the founding myth of Modernism itself.

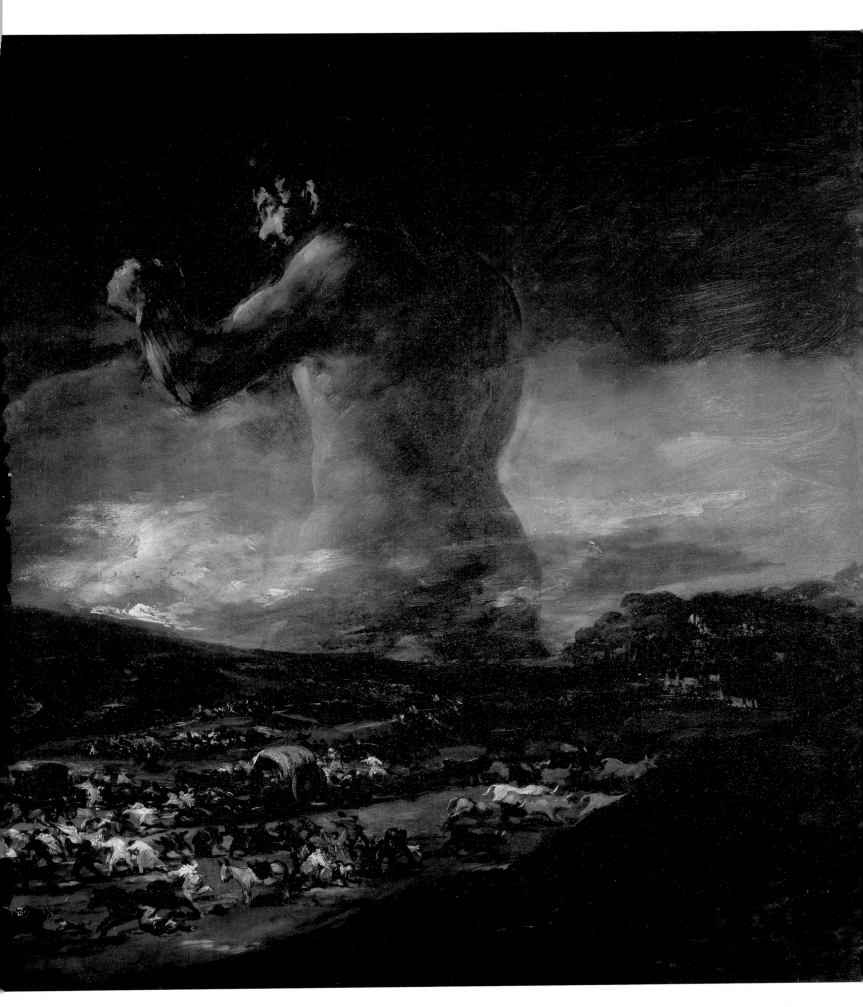

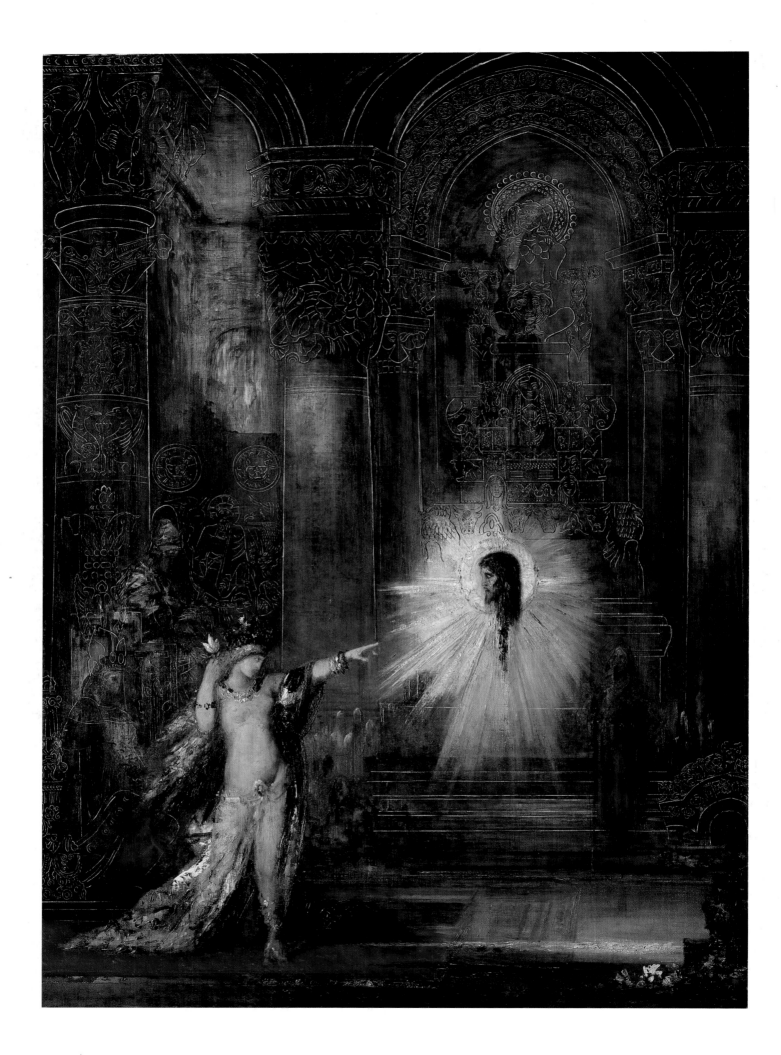

France

Gustave Moreau
Study for *Salome*, c. 1875
Black ink on yellow paper, 26.7 x 14.4 cm
Musée Gustave Moreau, Paris

Symbolism acquired its name in France. The term was suggested by Jean Moréas (*né* Ionnis Papadiamantopoulos), in the literary supplement of *Le Figaro* of 18 September 1886. Moréas' subject was the so-called "decadent" poets; in his view, "Symbolist" was a more appropriate description. "Symbolic poetry," he continued, "attempts to clothe the Idea in a perceptible form which, though not itself the poem's goal, serves to express the Idea to which it remains subordinate…."

The poem is thus an attempt to render perceptible a reality which would otherwise remain ineffable. Such is the function of the symbol: to express what is absent, or, in the case of Symbolism, what is "transcendental" or "otherworldly".

The transcendental was originally a category of religious thought: the God of the Jews and the Christians is transcendental. But transcendence is not necessarily or exclusively religious. There is much in reality which matters to us and yet remains for the most part out of reach, as though in another world. This is true of the past as of the future, and it also applies to that area of culture which serves as a repository of profound and enduring values.

In order to speak of these things, we place our speech under the sign of the aesthetic, signifying that the reality of which we speak is not the practical reality of everyday. This sign might be a rhythm of speech, the recourse to music or to a particular register of colours, or a more or less emphatically hieratic or "unreal" form of representation.

Jean Moréas' article dealt with poetry and not with the fine arts. But, despite the author's own reservations (he deplores the critic's "incurable obsession with labelling things"), artists recognized their own aspirations in Moréas' words and adopted the Symbolist label. He thus gave a name to something which had, till then, been no more than an ill-defined mood or state of mind. For Symbolism was not born in 1886 and an art applying the principles articulated by Moréas, and to that extent Symbolist, had already appeared in France twenty years before. I refer to the work of Gustave Moreau.

But before considering Moreau's work, let us give some thought to the meaning of the word "Symbolist" when applied to artists of that period. A painter may be termed a Symbolist for formal reasons, because of the content of his works, or for both these reasons at once.

Pierre Puvis de Chavannes (1824–1898), for instance, might be be considered the official painter of the Third Republic. He produced a

Gustave Moreau
The Apparition, c. 1874–1876
Oil on canvas, 142 x 103 cm
Musée Gustave Moreau, Paris

That solitary original, Gustave Moreau, developed a style of sumptuous preciosity. The abundant, precious detail, the "necessary luxury", were, in his view, an essential aspect of art. His subject matter was almost entirely confined to ancient mythology, historical legend (Alexander the Great) and the Bible (Samson and Delilah, Moses, Salome). Salome, who had forced King Herod to bring her the head of John the Baptist "in a charger", sees that head appear before her as she again dances before the King.

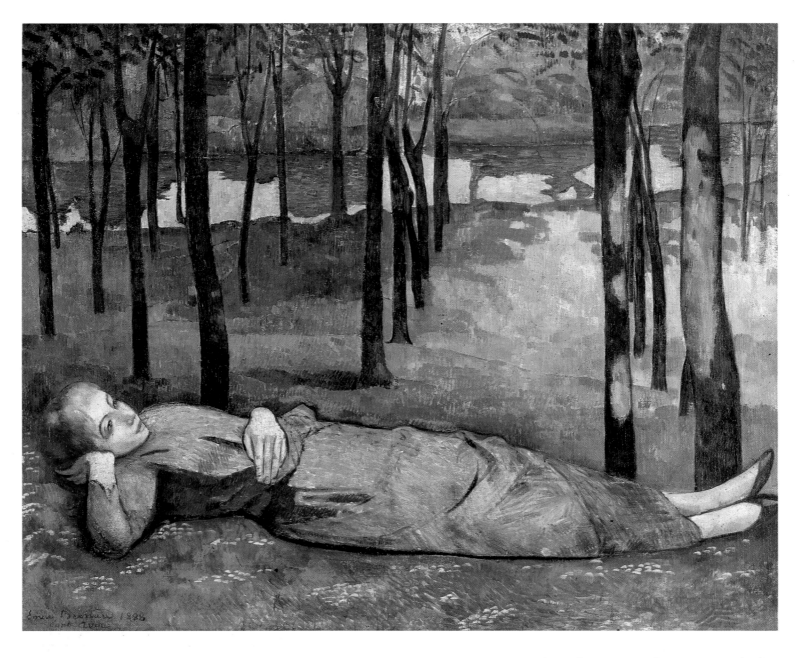

Emile Bernard
Madeleine au Bois d'Amour, 1888
Oil on canvas, 138 x 163 cm
Musée d'Orsay, Paris

Emile Bernard was only twenty when he made this portrait of his sister Madeleine resting during a walk in the Bois d'Amour, near Pont-Aven.

large number of allegorical subjects, but there is nothing particularly Symbolist about that. Innumerable academic painters treated subjects such as "Progress guiding industry" or "The arts bestowing their blessings on mankind".

Today, Puvis de Chavannes' paintings strike one as insipid in colour and subject matter – to say nothing of the simpering expressions he confers on certain of his characters. Yet we cannot deny him a degree of originality in his formal and simplified organization of space and in the way he handles large planes of colour in works such as *The Poor Fisherman* (p. 55). If we describe him as Symbolist, it is largely because a naturalistic or illusionistic representation of the world is not his primary concern.

His influence is perceptible in the work and theories of various artists. Its first theoretical formulation was given by Maurice Denis, when, in the late 1880s, he defined a painting as "a flat surface covered with colours assembled in a certain order". He had taken the idea from his friend Paul Sérusier, who had it from Paul Gauguin; he, in his turn, owed it (as we shall see) to the young Emile Bernard. Sym-

bolism, thus defined, opens the way to abstraction, as Sérusier's painting *The Talisman* (p. 43) first showed. Indeed, the major pioneers of abstraction, Kandinsky, Malevich, Kupka and Mondrian all began their careers as Symbolist painters.

Criticism and art history have, on occasion, bestowed a high status on the precursors of a movement later deemed significant. This is a notion that should be handled with the utmost care; it suggests that art progresses in the same way as science, one discovery becoming possible thanks to an earlier one, whose sole importance was its pioneering role. Unlike science, art does not "progress". It adapts to changing social relationships and modes of production and registers transformations in everyday life and in the representation of the world. As the circumstances of life and the way it is perceived change, so old forms come to seem irrelevant and new forms are needed. An artist does not make a "discovery" in the sense that scientists do. But he does discover a "means". Thanks to this "means", he can avoid repeating the familiar forms derived from an obsolete conception of the world; he can once more touch upon the heart of the matter.

Thus Emile Bernard understood the expressive power of colour treated as a unified plane (with greater intensity than in Puvis de Chavannes). But Bernard communicated his intuition to Paul Gauguin, and it was Gauguin who took it to its logical conclusion and to its highest pitch of intensity. Symbolism thus tends to include all those artists who were not primarily concerned with a so-called "realistic"

Paul Gauguin
The Lost Virginity, 1891
Oil on canvas, 90 x 130 cm
The Chrysler Museum, Norfolk (VA)

Gauguin, twenty years older than Emile Bernard when they met in Pont-Aven in 1888, painted this sardonic variant of the contemplative work that his young colleague had painted that same year. The Fox, "an Indian symbol of perseverance", echoes the black cat in Manet's *Olympia*. In Brittany, the fox is a symbol of sexual power and renewal. And the plucked flower in her hand is another transparent symbol; Symbolist is clearly the proper classification.

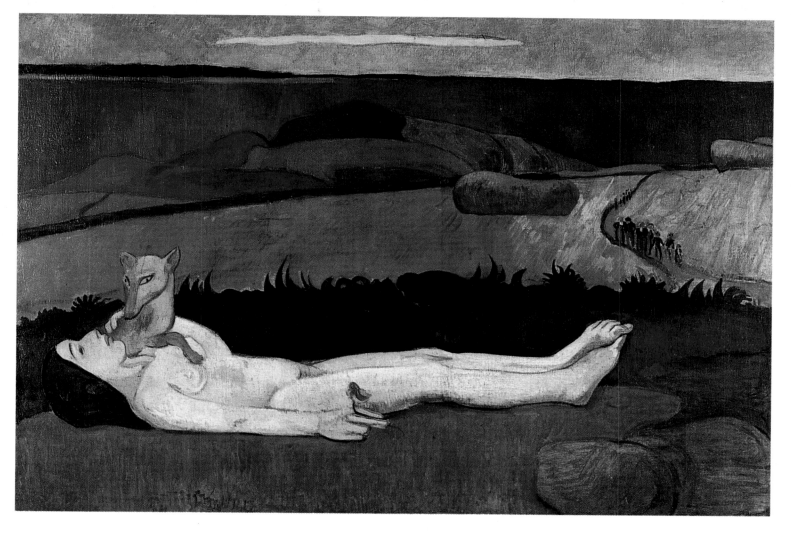

representation of the world. It also includes artists such as the Belgians Jean Delville and Léon Frédéric, the occult idealism of whose subject matter clearly designates them as Symbolist despite their overtly academic style. But the most convincing Symbolists are those who, like Gustave Moreau, may be classified as such for both the form and content of their work.

Moreau's manner was initially academic, but underwent a slow transformation to encompass surprising audacities of impasto and colour. This may not prevent us from thinking it mannered and precious. Odilon Redon aptly defined it as "the art of a bachelor". Yet it is worth noting that, during the few years late in his life when he taught at the

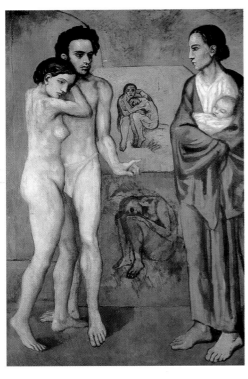

Pablo Picasso
Life, 1903
Oil on canvas, 196.5 x 123.2cm
Cleveland Museum of Art, Cleveland (OH)

Emile Bernard
Spanish Musicians, 1897
Oil on canvas, 181 x 119cm
Béatrice Altarriba Recchi Collection, Paris

Emile Bernard seems to have been doomed to inspire colleagues who made more radical and vigorous use of his ideas. Picasso clearly knew this group of Spanish musicians which precedes his "Blue Period" and has so much in common with later works of his: the gaunt characters, the pathos and the dominant blue. But Picasso's genius is evident in the classical rigour with which he treats the subject.

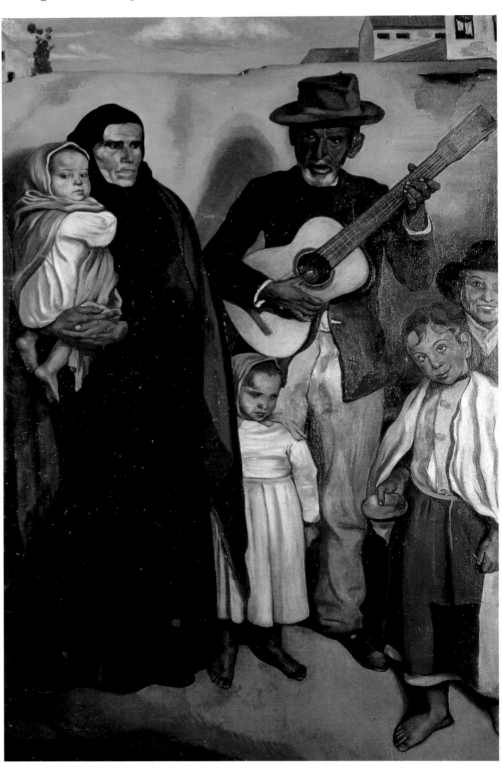

Paris École des Beaux-Arts, Moreau's pupils included Georges Rouault, Henri Matisse and Albert Marquet. His work is narrative; he was occasionally driven to deny, in tones of disabused weariness, that he was a "literary" artist. But biblical or mythological subjects do not, in themselves, make a painting Symbolist. Moreau fits into this category because he chose subjects which gave expression to the fantasies – one might almost say psychodrama – of sexual roles and identity that characterise his age. He did this by depicting figures like Salomé, but also by the surprising and almost invariable androgyny of his male subjects.

Symbolism thus touched upon the fantasies of the age as it did upon the realm of dreams, though the latter was by no means its exclusive

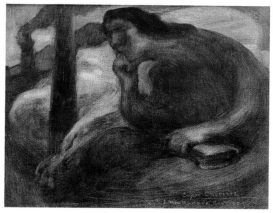

Eugène Carrière
Meditation, c. 1900
Oil on canvas, 33 x 41 cm
Musée des Beaux-Arts, Clermont-Ferrand

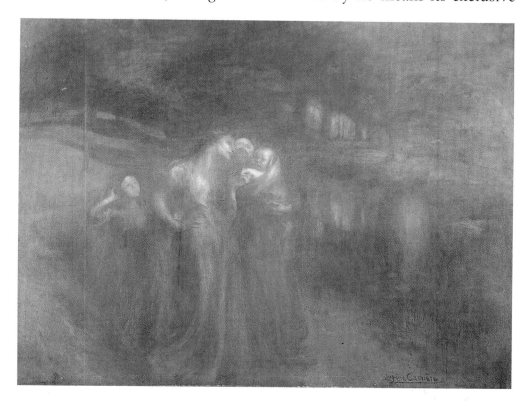

preserve, dreams having been a favourite subject of the Romantics. But the Symbolist dream had lost the confident *élan* of Romanticism; it had become more enigmatic, more perverse.

The most striking characteristic of Symbolist artists is their withdrawal into the realm of the imagination. It is the solitude of the dreamer, of one who, marooned on a desert island, tells stories to himself. It is the solipsistic solitude of one who is sure of nothing outside himself. Certain artists, like Fernand Khnopff, made a virtue of their solipsism. Others, like Redon, sought a technique capable of rendering the elusive, enigmatic qualities of experience.

It follows that our subject can be divided into a number of more or less overlapping circles. A significant part of Symbolist art is tinged with a religiosity of a Catholic, syncretic or esoteric kind. Symbolism also produced a certain mystique of art for art's sake, in the spirit of James McNeill Whistler or Stéphane Mallarmé. Though these trends are, in theory, easy to distinguish, they tended in practice to mingle; the artists' needs were not so various as their styles, and their works frequently hung side by side in the salons. Finally, certain artists were Symbolists only for a certain period, while others remained so throughout their lives.

Eugène Carrière
The Young Mothers, c. 1906
Oil on canvas, 279 x 357 cm.
Musée du Petit Palais, Paris

Carrière found a formula to which he stuck throughout his life; painting in oils, using a sort of brown wash, he confined himself to a few subjects. He was most famous for his motherhood scenes.

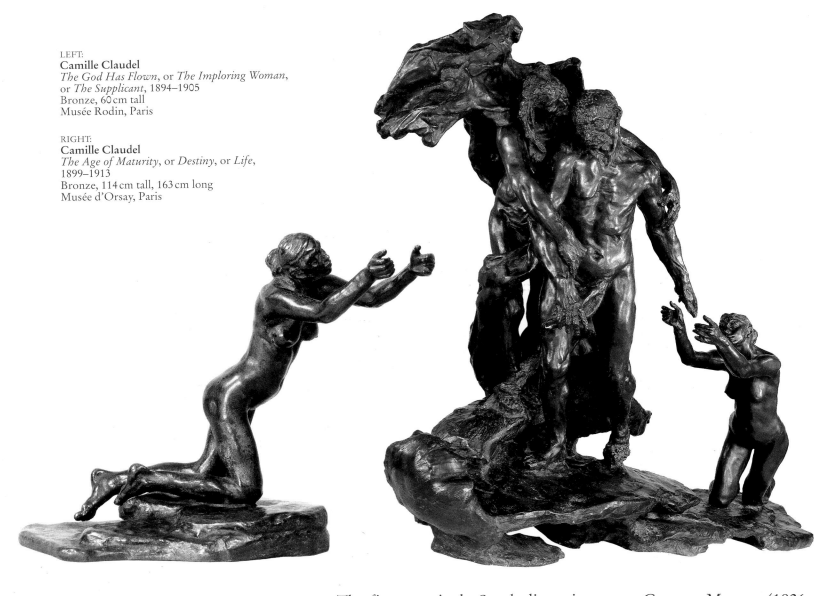

Of the two works of Camille Claudel illustrated here, the first is full of pathos, the second (which, in a procedure Claudel shared with Rodin, incorporates the first) becomes an expressive allegory. Student, mistress and rival of Rodin, Claudel spent the last thirty years of her life under confinement, suffering from a persecution mania. Her work is highly autobiographical, as Paul Claudel observes: "Imploring, humiliated, naked and on her knees! Everything is at an end (...). And do you know what is torn from her, at this selfsame moment, under your very eyes: her soul! Everything at once, soul, genius, sanity, beauty, life, her very name."

A compendium of Rodin's career, the *Gates* were originally intended for the Gare d'Orsay, but gained a life of their own. They finally became an end in themselves, integrating a variety of themes including the famous *Thinker*, who dominates the lintel of the door in reduced format.

The first genuinely Symbolist painter was Gustave Moreau (1826–1898). The son of an architect employed by the City of Paris and himself a precociously talented draughtsman, Moreau enrolled at the Beaux-Arts at the age of twenty. He admired Delacroix and, in particular, Théodore Chassériau, remaining under the latter's influence for some ten years. At the age of thirty he travelled to Italy, revelling in the art of the Quattrocento and in Byzantine mosaics. On his return to Paris, he exhibited at the Salon, where he won considerable success in 1864 with his *Oedipus and the Sphinx*, a painting of high academic finish. Five years later he gave up exhibiting for good. From then on he lived and worked at his town house at 14 rue de la Rochefoucauld, which has since become his museum. Its holdings include the majority of his abundant production (850 paintings, 350 water-colours and 5,000 drawings).

Moreau was a solitary artist who chose a most unusual path. Though he was a contemporary of Manet and the Impressionists, his brushstroke and use of colour have nothing in common with them. This is a different world, peopled with figures from the Bible and classical mythology. Emile Zola, proselytising in favour of naturalism, dismissed Moreau's work as "a mere reaction against the modern world," specifying the ideological issues at stake when he added "the danger to science is slight". Manet (whom Zola rightly defended) may seem the greater

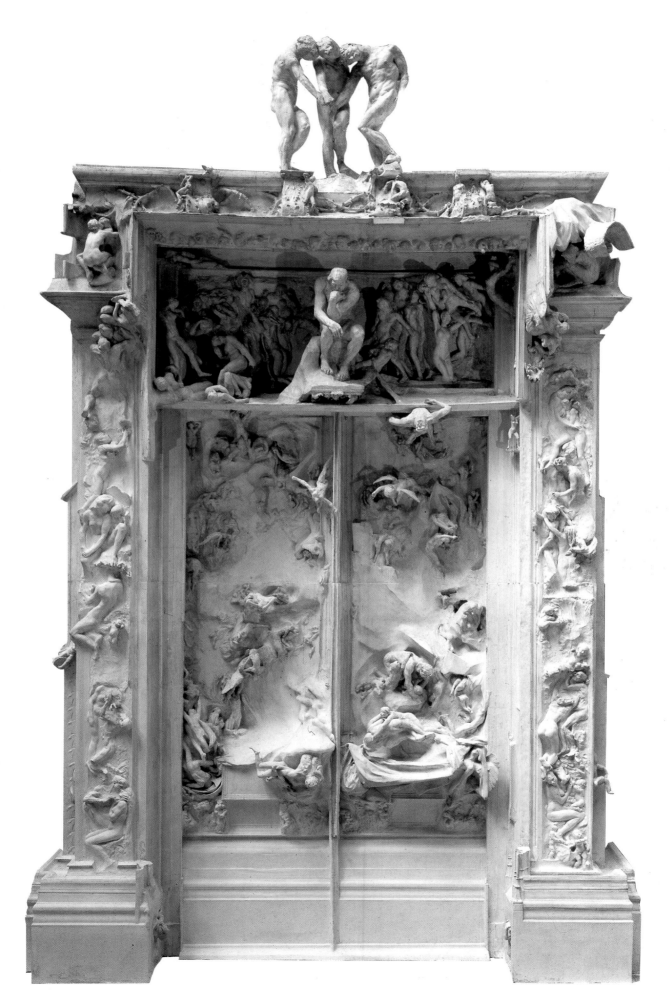

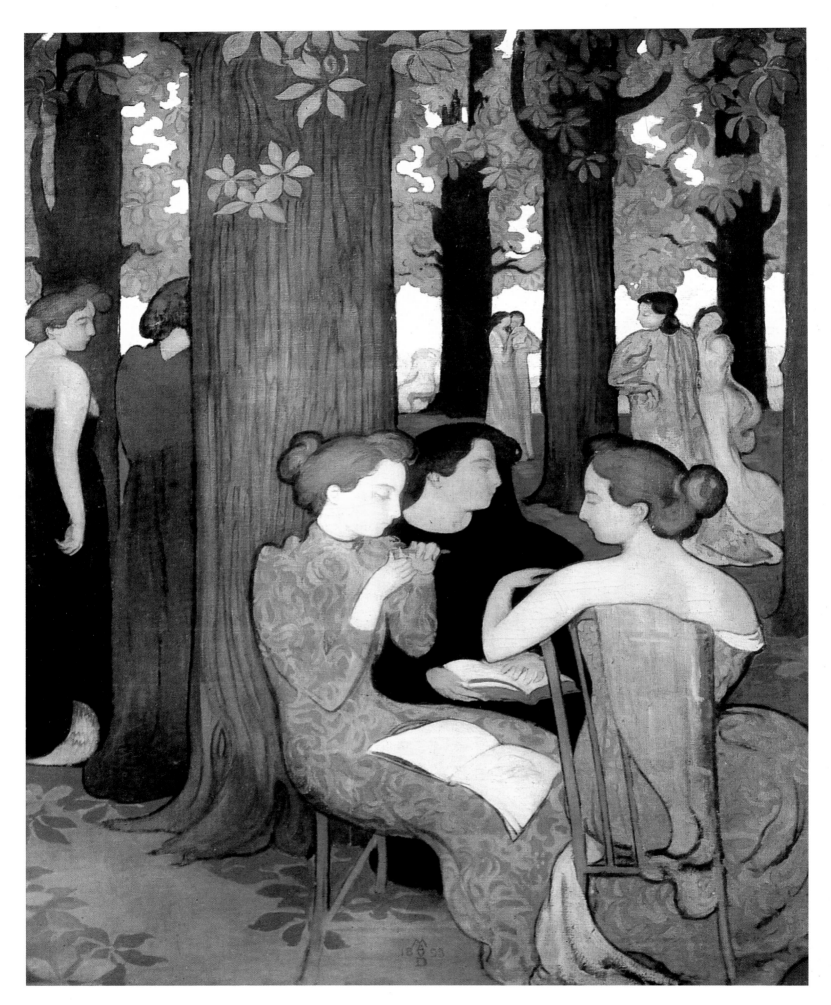

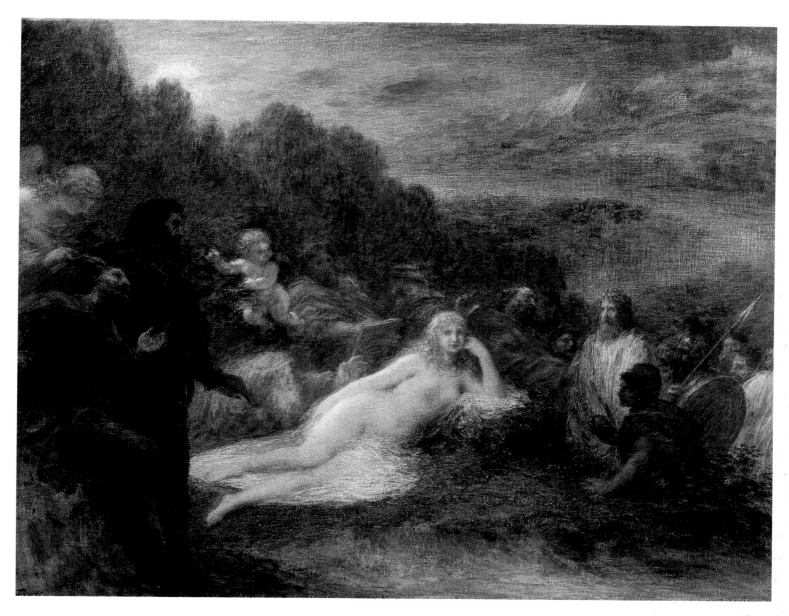

artist on purely aesthetic grounds, but Moreau's work is nonetheless significant as an exposition of the cultural fantasies of his time.

Huysmans was aware of this; he wrote at length of the "Salomé" who appears in a number of Moreau's works. The castrating woman is so widely encountered in the art of this period that one cannot help but dwell on its significance. It is treated in ironic form by Félicien Rops, in academic and conventional form by Franz von Stuck; it gained pathos in the paintings of Edvard Munch and terror in the work of Alfred Kubin. These are but a few of the artists who treated this subject: why does it recur so insistently?

It goes without saying that the late 19th century was a singularly puritanical age. Now it seems that puritanism tends to appear spontaneously, untheorised and unsystematic, at times of great cultural mutation. Every revolution, political, religious or industrial, is followed by a phase of puritanical public discourse and legislation. This can best be understood if we allow that relations between the sexes are profoundly influenced by the unspoken rules of a symbolic social order. When the old rules and cultural forms are rejected or ignored, individuals lose their bearings. Thus a young man, confronted with a woman whom he desires, asks himself how he must behave if she is to acknowledge him

Henri Fantin-Latour
Helen, 1892
Oil on canvas, 78 x 105 cm
Petit Palais, Paris

Fantin-Latour, the meticulous portraitist and painter of still lifes in the great tradition of Chardin, led a clandestine Symbolist life, painting Wagnerian or mythological subjects.

PAGE 38:
Maurice Denis
The Muses in the Sacred Wood, 1893
Oil on canvas, 168 x 135 cm
Musée National d'Art Moderne –
Centre Georges Pompidou, Paris

Denis' gracious and slightly vapid work offers an interesting and innovative use of space and surface. The painting is taken, in his own words, as "a flat surface covered with colours assembled in a certain order".

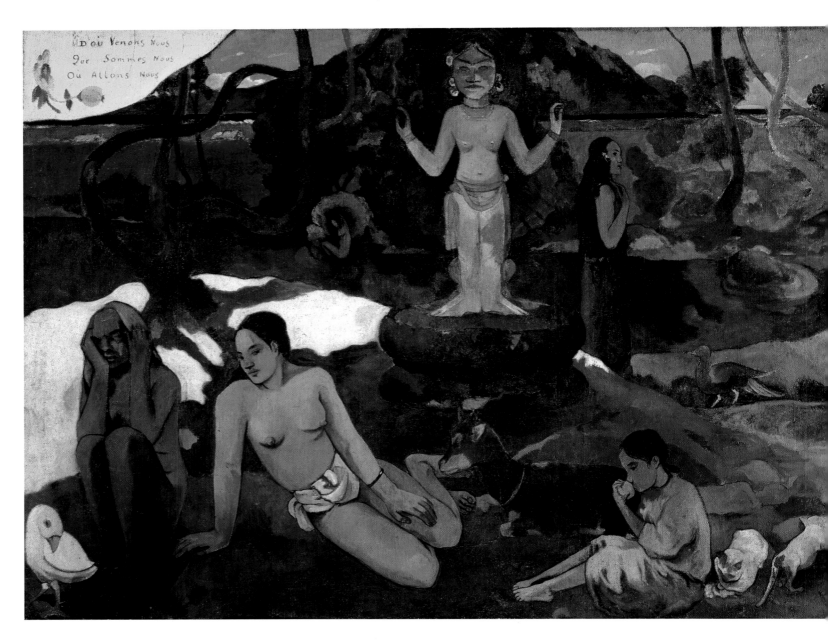

as a man. And if no answer is forthcoming, he may experience the woman's powers of attraction as a threat.

Symbolist art gives forthright expression to this sentiment. In other works, going to the other extreme, it idealizes woman to the point of absurdity, making her an almost immaterial being. The Symbolist problematic of relations between the sexes is central to Marcel Duchamp's two major works *The Bride Stripped Bare by her Bachelors, Even* and *Given...* (pp. 214–215). And it is the issue of Woman that the Futurists sought, in their way, to avoid by proclaiming in their manifesto their "scorn of woman"; their arrogance betrays their insecurity.

In terms of subject matter, this is one of the most characteristic aspects of Symbolism. For Renoir and Maillol spent these very decades depicting, without embarrassment or anguish, the seductive carnality of women. And though there are Symbolist overtones in the work of Gauguin (1848–1903), there is a splendid sensuality to some of the Tahitian women he painted. But Gauguin it was who sailed to the antipodes in search of a life lived "according to nature" – and uncomplicated by the disorders of the symbolic structure so obvious to him in Europe. His

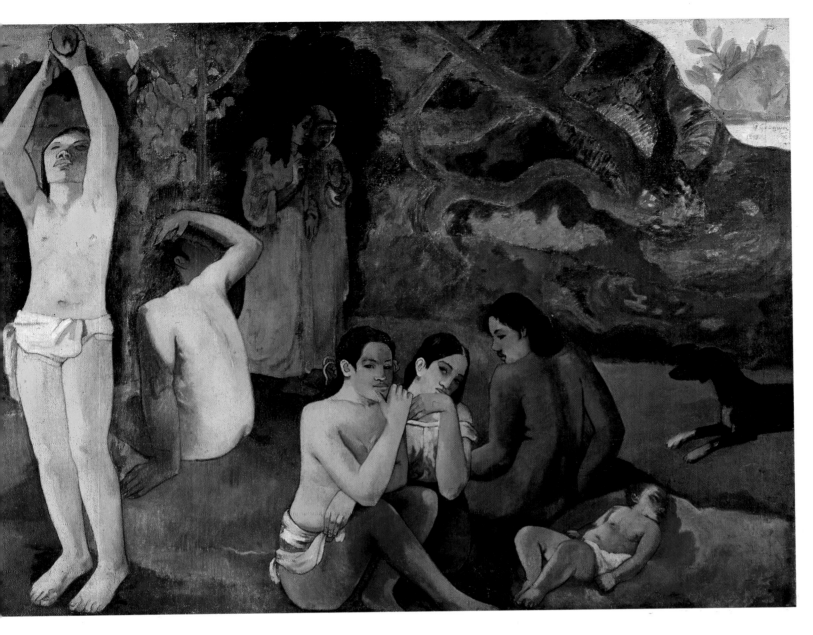

life poignantly expresses the fallacy of dialectics of "nature" and "culture", the "spontaneous" and the "artificial". Even today, these notions fundamentally distort our perception of the manner in which the self is constructed through culture.

Gauguin sought a society in which relations between the sexes were harmonious – harmonious, we should perhaps add "as the relation between mother and child"; a society, at all events, in which such relations were governed by the implicit code that regulates the behaviour of a people still possessed of a tradition. We have seen that, in the European society of his day, this code had been disrupted by the impact of the industrial revolution. This helps to explain why the collective dream of European society was invaded by *femmes fatales*, and was a factor in Gauguin's departure for the Pacific.

Gauguin was only episodically a Symbolist painter. Some of his canvases are more Symbolist than others, and his most ambitious work, his artistic testament *Where Do We Come From? What Are We? Where Are We Going?* (pp. 40–41) draws its formal inspiration from the great murals of Puvis de Chavannes. His painting is not allegorical, as Puvis de Chavannes' compositions were, nor is it programmatic; Gauguin of-

Paul Gauguin
Where Do We Come From? What Are We? Where Are We Going?, 1897
Oil on canvas, 139.1 x 374.6 cm
Museum of Fine Arts, Boston (MA)

The formal inspiration for this, one of Gauguin's major works, is Puvis de Chavannes' larger compositions – from which it is nevertheless very different. The title of the work is inscribed in the top left-hand corner, but is not illustrated by the characters portrayed, unless by a certain melancholy which transpires from their positions.

Paul Gauguin
The Spirit Is Watching, c. 1897
Signed monotype, 63.7 x 50.5 cm
Private collection

Paul Sérusier
Portrait of Paul Ranson Wearing Nabic Costume, 1890
Oil on canvas, 60 x 45 cm
Private collection

There is a sly humour in this portrait of the Nabi painter Paul Ranson wearing liturgical vestments and holding a bishop's crosier. Sérusier was 26 when he painted Ranson, who was his elder by three years.

BOTTOM:
Paul Ranson
"Nabic" Landscape, 1890
Oil on canvas, 88 x 114 cm
Private collection

This work, with its "Thousand and One Nights" atmosphere is clearly an entertainment in which the painter has tried out the vivid colours that the Nabis then favoured.

PAGE 43:
Paul Sérusier
The Talisman, 1888
Oil on wood, 27 x 22 cm
Musée d'Orsay, Paris

Painted on the lid of a cigar box during an outdoor painting expedition with Gauguin in the Bois d'Amour near Pont-Aven, this little landscape was, for Sérusier's friends, a revelation of what their art should become. They named it "The Talisman"; it borders on abstraction.

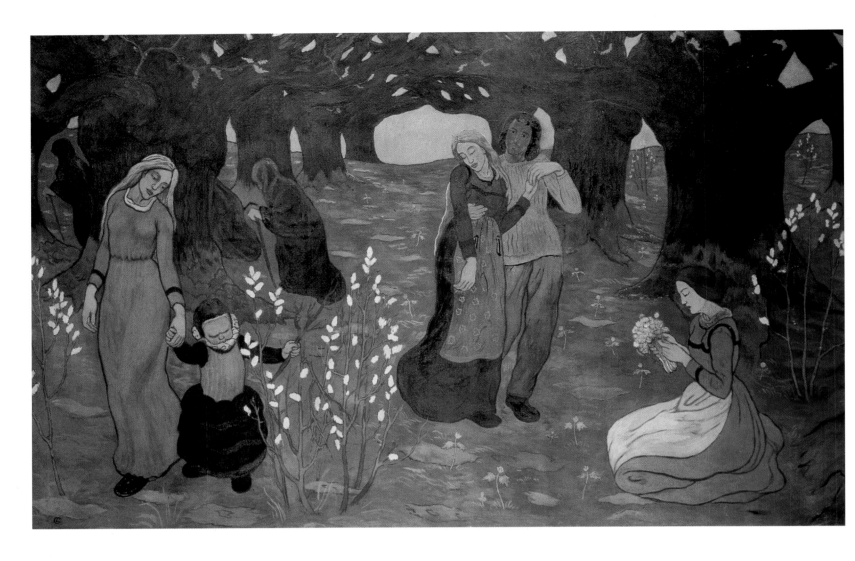

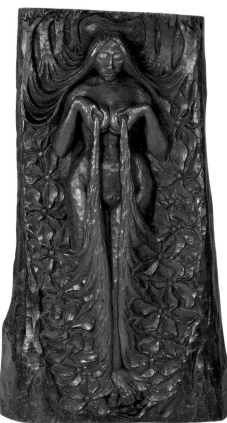

fered different interpretations to different people. But it is imbued with a mood of sensual melancholy. The veiled, allusive Symbolism that results has considerable resonance.

Gauguin set himself apart from the more conventional aspects of Symbolism, but the style he created has no truck with naturalism; it emphasised the emotional value of colour in ways to which no reproduction can do justice. Moreover, his ideas about colour were of considerable interest to the next generation of painters.

The site of this influence was Pont-Aven, in Brittany, where a small colony of painters had settled. The year was 1888. Emile Bernard (1868–1941), a precociously gifted painter born into modest circumstances, came to spend the summer there. He was twenty years old and a fervent Catholic, a point not without relevance in the ideological context of the time. Gauguin was forty. In Paris, Bernard had already met Toulouse-Lautrec, Signac and van Gogh. And he had worked out a theory of painting, which he explained to Gauguin. It called for a more autonomous use of colour, which was to be applied in flat areas separated by a black line as in stained-glass windows.

During the summer of 1888 Paul Sérusier (1864–1927) also arrived in Pont-Aven. He was twenty-four. His father, director of the Houbigant perfumery, had marked him down for a commercial career. Sérusier refused; enrolling at the Académie Julian, he found himself in the company of Maurice Denis, Paul Ranson and Pierre Bonnard. At Pont-

Aven, Gauguin took him in hand. Together they went out to paint. Gauguin's advice to Sérusier was noted down by Maurice Denis (1870–1943): "How do you see that tree?" Gauguin asked as they stood in a wood called the Bois d'Amour, "Is it really green? Then put it down in green – the most beautiful green in your palette – and that shadow is rather blue? Don't be afraid to paint it as blue as possible."

Sérusier painted the Bois d'Amour on the back of a cigar box. Returning to Paris, he unwrapped it under the eyes of his friends. "Thus, in paradoxical, unforgettable form," Maurice Denis noted, "we were presented for the first time with the fertile concept of 'a flat surface covered with colours assembled in a certain order'. Thus did we learn that every work of art is a transposition, a caricature, the passionate equivalent of a sensation received." Realizing the significance of Sérusier's little painting, they dubbed it *The Talisman* (p. 43).

In the filiation thus formed, we see how an artistic tendency comes into being, scatters and merges again like quick-silver. Puvis de Chavannes had been the first to use colour in unified planes; young Emile Bernard had arrived at this practice by his own devices; Gauguin seized on the intuition and carried it to its highest point of intensity, while Sérusier finally passed it on to his friends, forming with them the group known as Nabis. We can thus perceive the first steps of an approach which, by an entirely "phylogenetic" logic was to lead to Fauvism and the art of Matisse. Matisse acknowledged that his painting *Luxury I*

Charles Filiger
Pouldu Landscape, c. 1890
Gouache on paper, 26 x 38.5 cm
Musée des Beaux-Arts, Quimper

PAGE 44 TOP:
Georges Lacombe
The Ages of Life, c. 1894
Egg tempera on canvas, 151 x 240 cm
Petit Palais, Geneva

PAGE 44 BOTTOM:
Georges Lacombe
Isis, c. 1895
Relief, polychrome wood, 111 x 60 cm
Musée d'Orsay, Paris

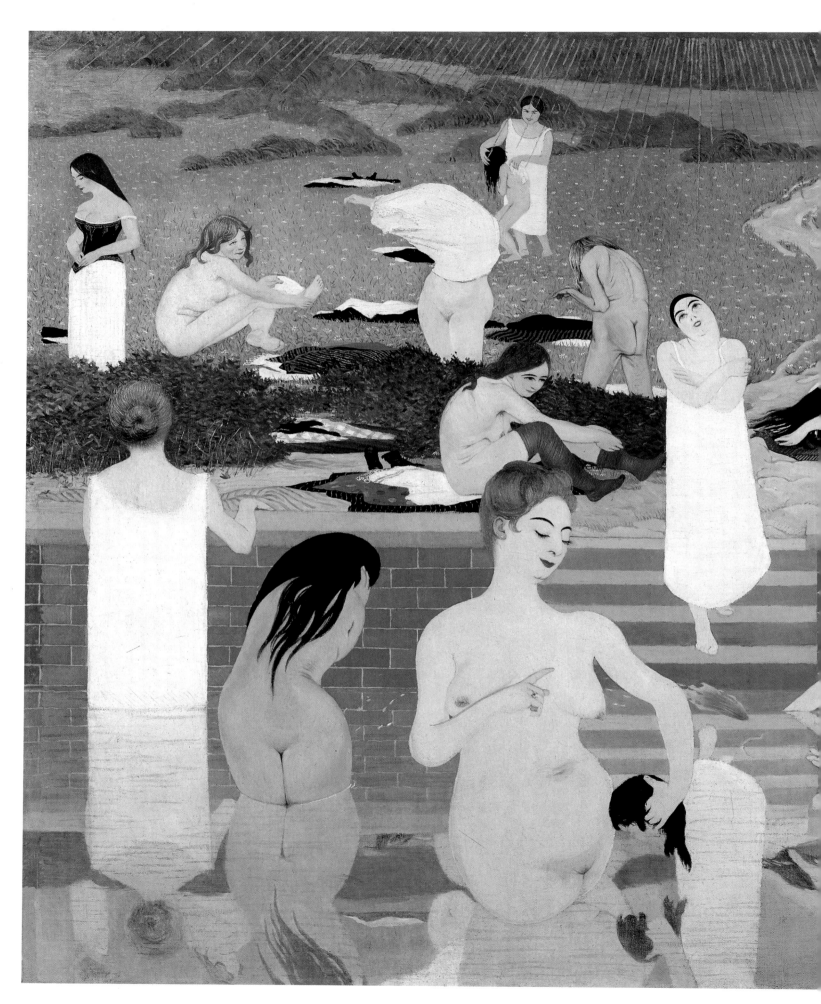

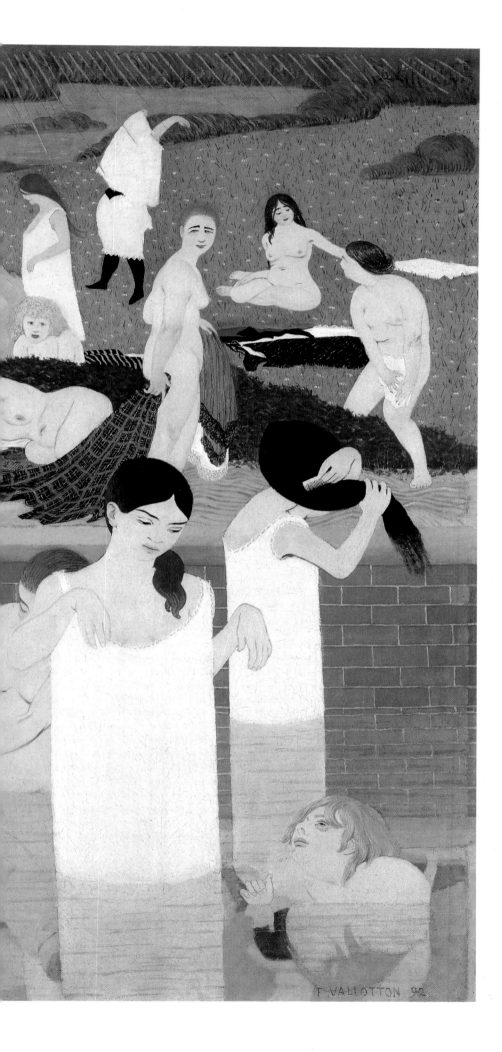

Aristide Maillol
The Wave, 1898
Oil on canvas, 95 x 89 cm
Musée du Petit Palais, Paris

LEFT:
Félix Vallotton
Bathing on a Summer Evening, 1892
Oil on canvas, 97 x 131 cm.
Kunsthaus Zürich, Zurich

Paul Gauguin
Ondine, 1889
Oil on canvas, 92 x 72 cm
Museum of Art, Cleveland (OH)

Symbolist woman, once in the water, ceases to be
"Wagnerian" and becomes lively and full of
spirit, identifying with nature and the waves. The
wave refers back to Hokusai and to the vogue
for things Japanese, whose influence is felt in all
three works.

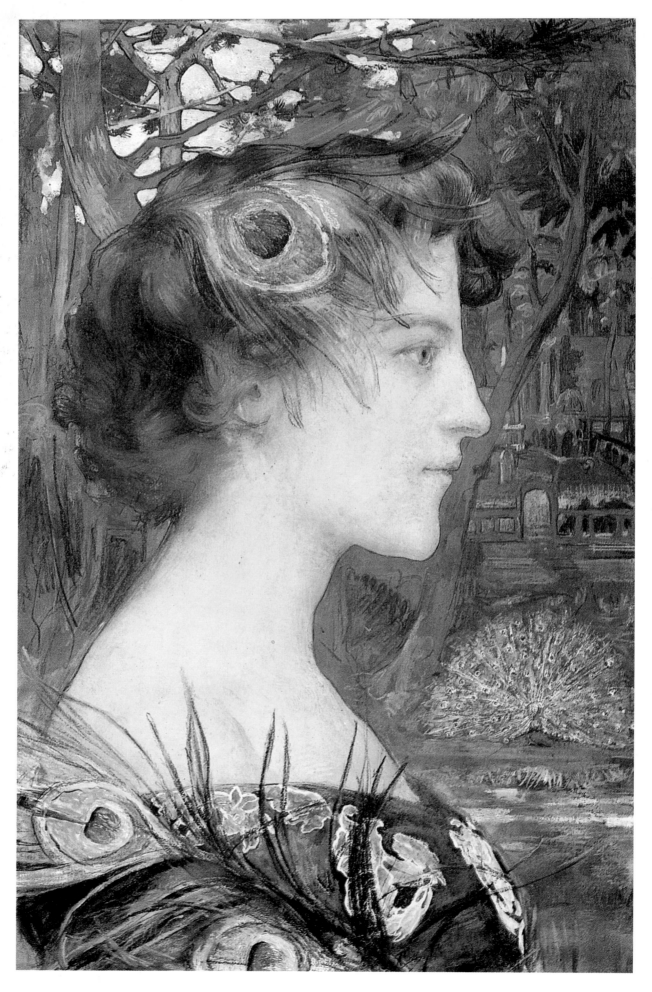

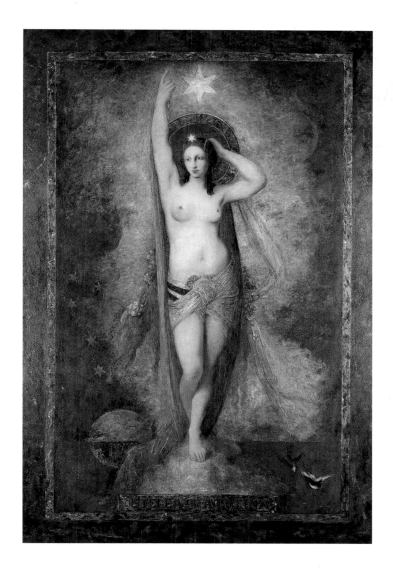 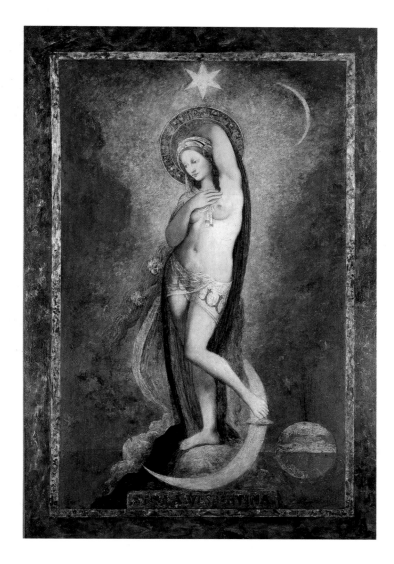

(p. 56) was in direct line of descent from Puvis de Chavannes' *Young Girls at the Seaside* (p. 57).

Nabi is the Hebrew word for prophet. The group designated themselves prophets with a hint of irony; the term at first referred to a group of friends who met once a month, first in a café in the passage Brady, then, after Paul Ranson married, in his town house at, 22 Boulevard du Montparnasse, which they dubbed "the Temple".

Paul Ranson (1862–1909) came of wealthy stock; his father was the Mayor of Limoges in 1861. A portrait by Paul Sérusier shows Ranson as a "Nabi", wearing a chasuble and clutching a bishop's crook while reading from an illuminated manuscript; around his head is a red halo (p. 42). Ranson drew tapestry cartoons for his wife to embroider. Matisse appreciated his sinuous line and is said to have been influenced by it.

Maurice Denis decided at only fourteen years of age that he wanted to be a "Christian painter". His mild-toned paintings with their flat areas of colour and sinuous line show formal similarities with those of Ranson. In 1918, Denis and Georges Desvallières (1861–1950), founded the Ateliers de l'Art Sacré.

Pierre Bonnard and Edouard Vuillard also chose to treat the canvas as a flat surface. But at the same time they favoured a novel form of tension between the two-dimensional arrangement they created and the spectator's inclination to interpret the picture as a three-dimensional

Georges Rouault
Stella Matutina, 1895
Oil on canvas, both 274 x 182 cm
Musée de l'Avallonais, Avallon

Incredible as it may seem, Rouault, one of the rare exponents of French Expressionism, was Gustave Moreau's favourite pupil, and was heavily influenced by Moreau in his earliest compositions.

PAGE 48:
Edgar Maxence
Profile with Peacock, c. 1896
Pastel, gouache, and silver paper, 46 x 30 cm
Private collection

Gustave Moreau
The Sphinx, 1886
Water-colour, 31.5 x 17.7 cm
Private collection

The legend of the Sphinx who devours those
who cannot answer her riddle was painted sev-
eral times by Moreau. This version, less aca-
demic than the 1864 one, shows the many vic-
tims festooning the rock from whose summit
the monster innocently gazes at the horizon.

PAGE 51:
Gustave Moreau
The Travelling Poet, undated
Oil on canvas, 180 x 146 cm
Musée Gustave Moreau, Paris

The poet and his winged horse have alighted
for a rest during their voyage. The poet's face
has an androgynous quality typical of
Moreau's work.

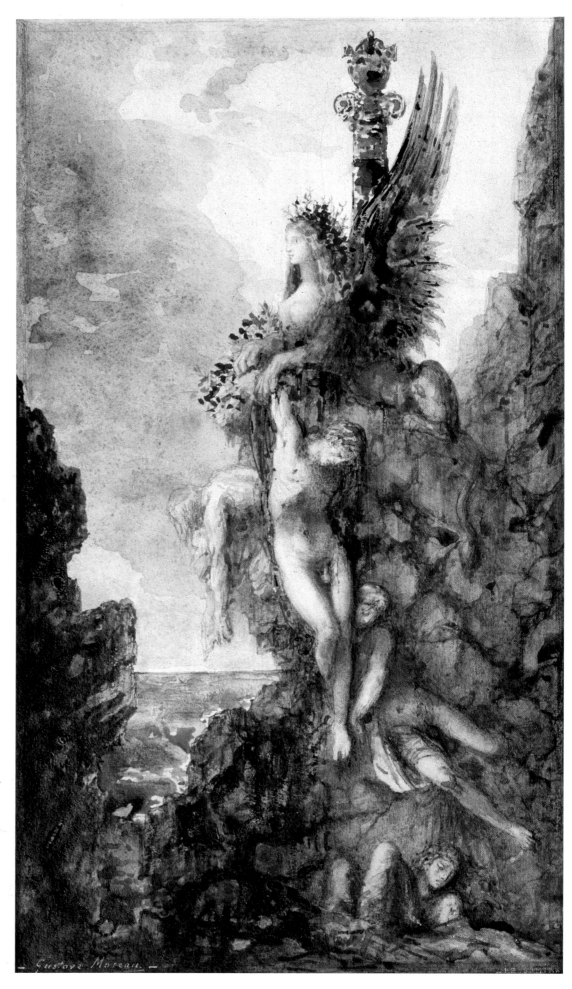

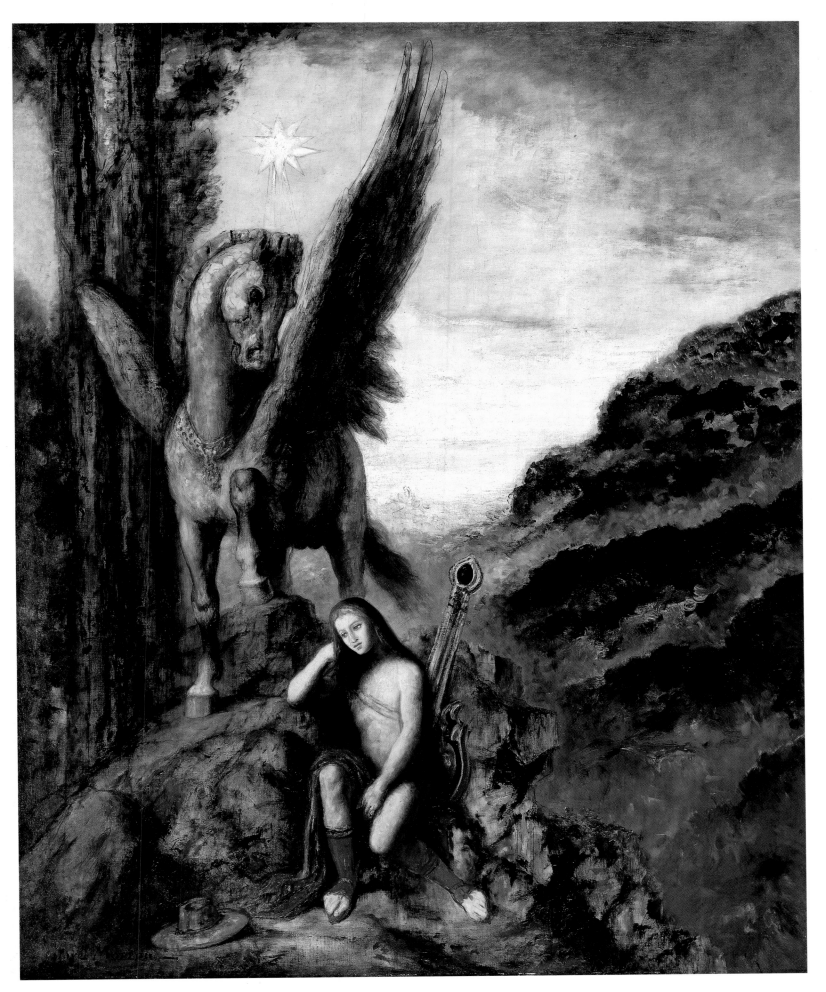

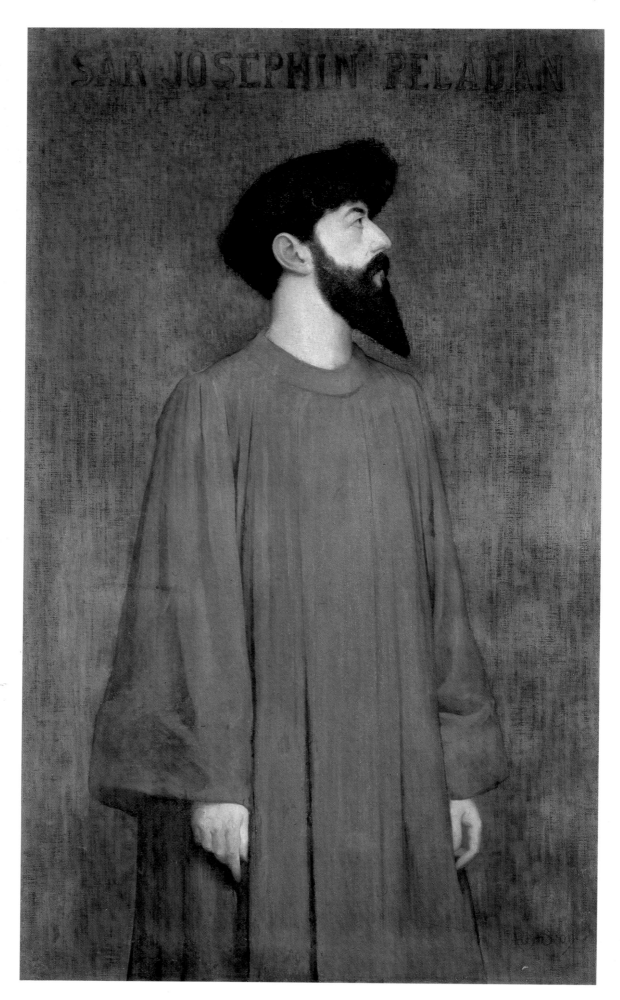

space. Both artists avoided the ornamental quality from which Denis' paintings sometimes suffer, but it was Bonnard who made perhaps the most original use of the revelation afforded by *The Talisman*, creating an illusion of depth exclusively through the interplay of colours. This is why a Bonnard always seems two-dimensionsal at first glance. To the viewer's delight, space unfolds only gradually, as though another world were unfolding before his eyes. But his lyrical, intimate work lies outside the scope of Symbolism proper, as does that of Vuillard.

Emile Bernard meanwhile felt that he had been cheated of his undeniable originality. He painted a few more paintings in the manner he had devised, including a group of *Spanish Musicians* (1897, p. 34). Did the young Picasso see this painting? The dominant blue tone and the attitudes of the figures strongly suggest that he did, a presumption that gains in strength when we compare it to Picasso's painting *Life* (1903, p. 34).

Bernard then sailed for the Middle East where he remained for ten years, painting in a more traditional idiom. Long afterwards, he grumbled to Renoir: "I was twenty years old, he (Gauguin) was forty. It was easy for him to pass for the creator of something he had merely stolen." He was unaware that his had been the spark that had set off a great conflagration, and that he could not have kept it to himself if he had wanted to.

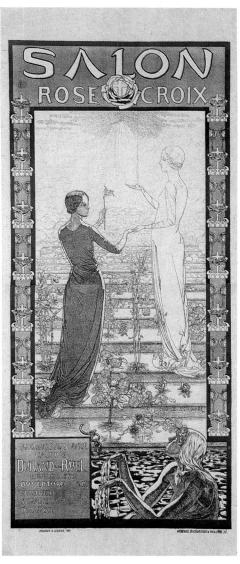

Alexandre Séon
Portrait of Péladan, 1891
Oil on canvas, 132.5 x 80 cm
Musée des Beaux-Arts, Lyon

The novelist Joséphin Péladan, one of the founders of the Rose+Croix Salon, adopted the title Sâr (Magus) and the first name Mérodak. Séon's portrait, authorised as an "iconic honour" despite the fact that the Rose+Croix forbade portraiture, lends its subject a vaguely Babylonian air in conformity with Péladan's own pretensions.

Carlos Schwabe
Poster of the first Rose+Croix Salon, 1892
Lithograph, 199 x 80 cm
Private collection

Alphonse Osbert
Evening in Antiquity, 1908
Oil on canvas, 150.5 x 135.5 cm
Musée du Petit Palais, Paris

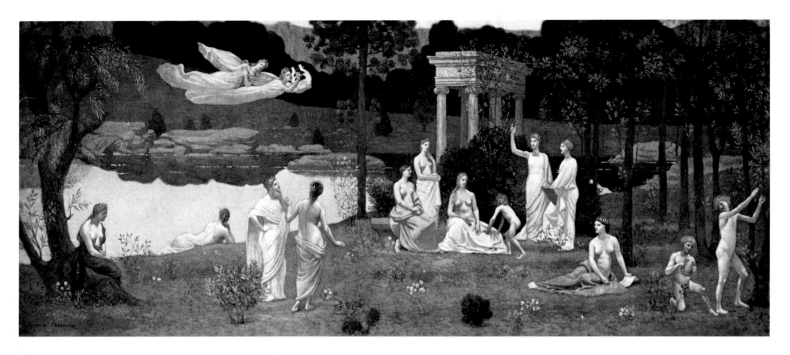

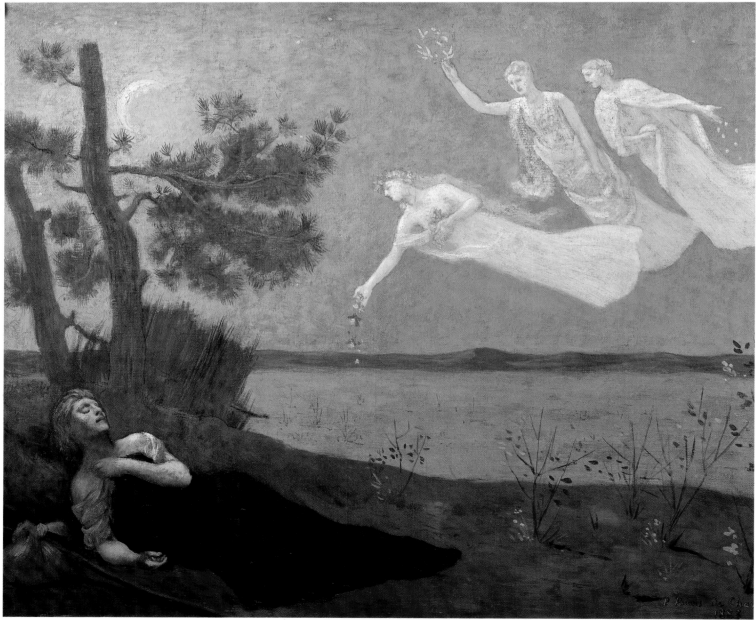

The Pont-Aven filiation was a singular phenomenon affecting several generations of painters. The new understanding of colour out of which it arose was not in itself Symbolist, but under its influence artists rejected the realistic or naturalistic style favoured by those who naively believed in "science and progress".

By contrast, the Rose+Croix Salon, founded in 1892 by the novelist and publicist Joséphin Péladan (1859–1918), was intended to provide Symbolist art with an ideological underpinning. It lasted only six years, and its chief merit was to bring together works from all over Europe.

PAGE 54 TOP:
Puvis de Chavannes
The Sacred Wood Dear to the Arts and the Muses, c. 1884–1889
Oil on canvas, 93 x 231 cm
The Art Institute of Chicago, Chicago (IL)

PAGE 54 BOTTOM:
Puvis de Chavannes
The Dream, 1883
Oil on canvas, 82 x 102 cm
Musée du Louvre, Paris

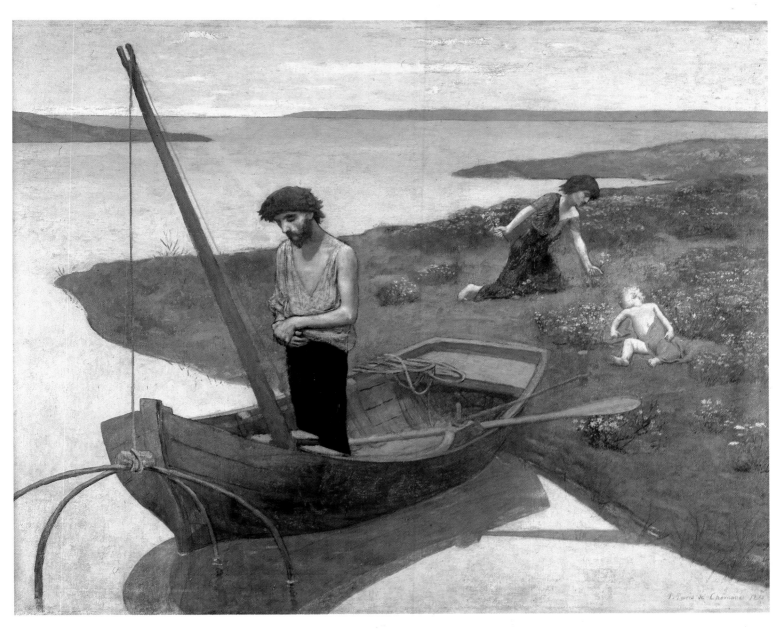

In Huysmans' novel *Là-Bas (Down There)*, one of his characters speaks of Péladan as the "magus of trash" and the "Wobbly Man from the South" (Péladan was born in Lyon). "These people are, for the most part, old, failed columnists, journalists or petty youths seeking to exploit the taste of a public worn out by Positivism!... In addition to the dupes and simpletons, these little sects harbour some frightful charlatans and windbags. – Péladan, among others..." Théo van Rysselberghe, writing in 1892 to Octave Maus, shared Huysmans' view: "Nothing is quite as sickening as the self-promotion of Péladan and his abom-

Puvis de Chavannes
The Poor Fisherman, 1881
Oil on canvas, 155.5 x 192.5 cm
Musée d'Orsay, Paris

The simplification of forms and the use of flat areas of colour are typical of Puvis de Chavannes and constitute his principal merit.

inable long-haired accomplices… and it is sad to see worthwhile people believing in the sincerity and honest intentions of this crooked character."

The son of a publisher of religious and literary periodicals, Péladan was an eccentric and exhibitionistic Catholic who claimed to have discovered Christ's tomb in Jerusalem (in the Mosque of Omar). He acquired a measure of celebrity through his 1884 novel *Le Vice suprême* (*The Supreme Vice*), for which Félicien Rops drew the frontispiece and Barbey d'Aurevilly contributed a highly laudatory preface.

Péladan revived for his own purposes the defunct secret society of the Rosicrucians ("Rose+Croix"), which had brought together various occult movements in the early 17th century. Its twin goals had been world faith and a universal religion; the English theosopher Robert Fludd (1574–1637) was a representative member. The mission of Péladan's Rose+Croix Salon (Salon de la Rose+Croix) was to "honour and serve the ideal."

In 1891, Péladan, the poet Saint-Pol Roux and Count Antoine de la Rochefoucauld promulgated "The Commandments of the Aesthetic Rose+Croix". They proscribed history, patriotic and military painting, "all representation of contemporary life," portrait painting, rural

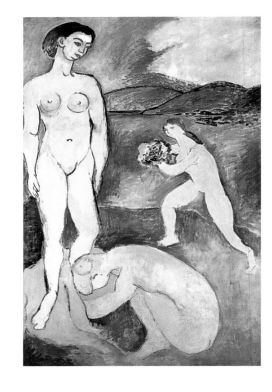

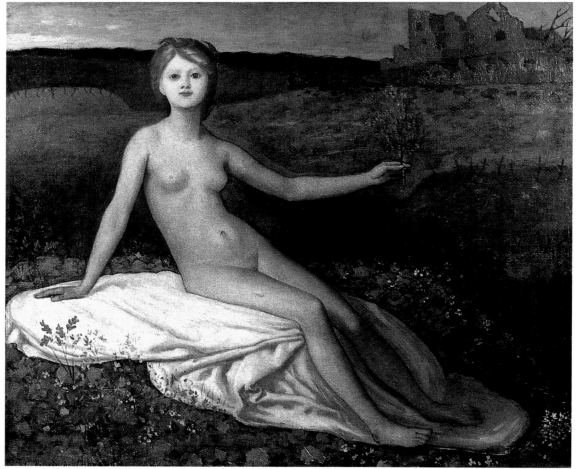

scenes, seascapes, orientalism, "all animals either domestic or connected with sport… flowers, *bodegones*, fruit, accessories and other exercises that painters are habitually insolent enought to exhibit." On the positive side, "in order to favour mystic ecstasy and the Catholic ideal, the order welcomes any work based on legend, myth, allegory, or

TOP:
Henri Matisse
Luxury I, 1907
Oil on canvas, 210 x 138 cm
Musée National d'Art Moderne –
Centre Georges Pompidou, Paris

Puvis de Chavannes
Hope, 1872
Oil on canvas, 70.7 x 82 cm
Musée d'Orsay, Paris

This gentle young woman presenting an oak sprig expresses the hope of a French renaissance after France's defeat by the Prussians in 1871. Behind her lie cemeteries and ruined houses. At the time, the critics were severe: they would have preferred a rather more muscular and vengeful incarnation of "Hope".

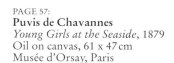

PAGE 57:
Puvis de Chavannes
Young Girls at the Seaside, 1879
Oil on canvas, 61 x 47 cm
Musée d'Orsay, Paris

Matisse felt that Puvis de Chavannes had given a new impulse to mural painting by confining it to a decorative function of rigorous clarity. Thus the three feminine nudes of Matisse's *Luxury I* were conceived under the influence of Puvis' *Young Girls at the Seaside*, which Matisse admired at the Salon de la Société Nationale of 1895. In both cases, the question arises: should we interpret these three figures as a single body presented in three different poses and three harmonising colours? Or should we interpret them as three different states: passive, active, and contemplative?

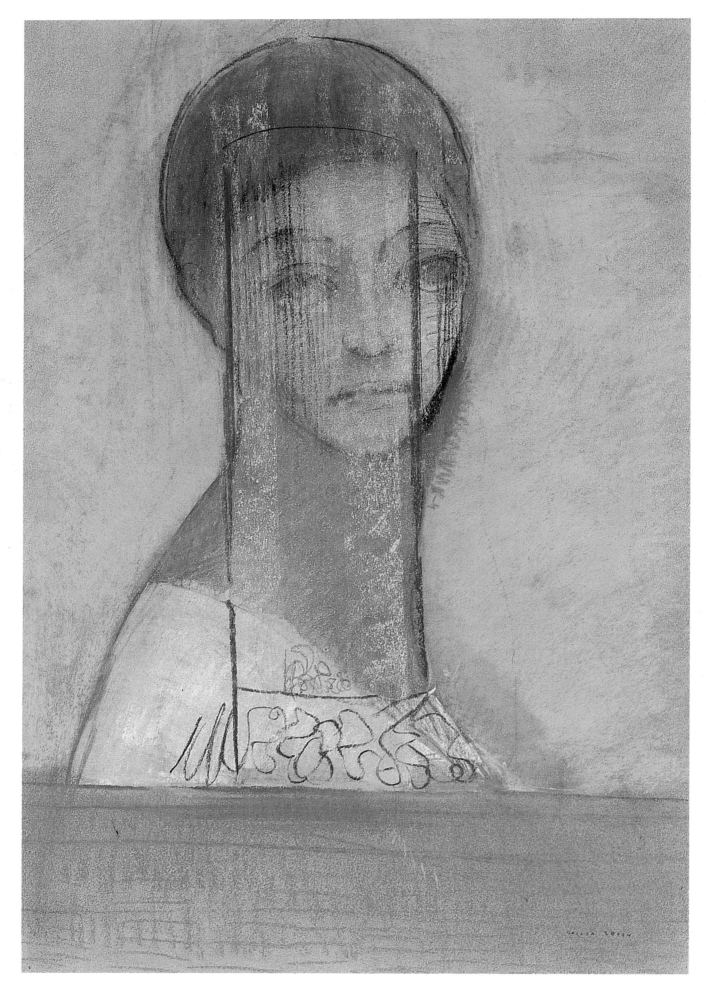

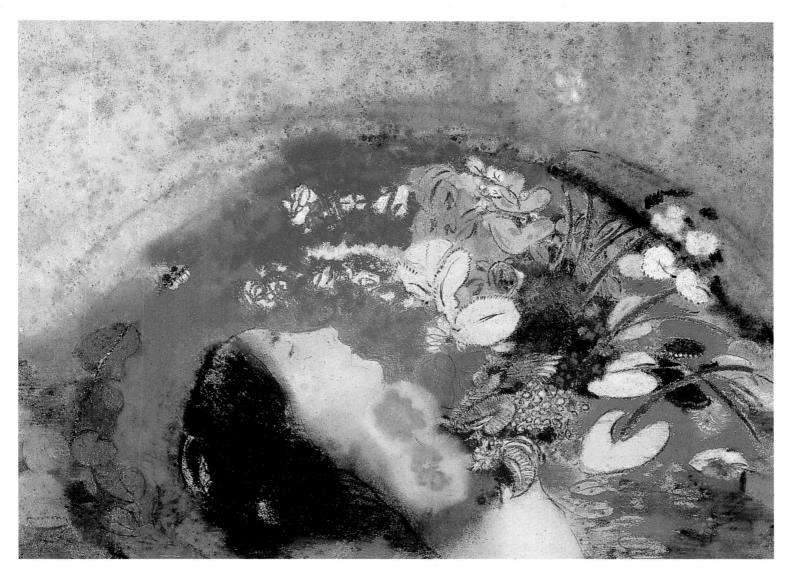

dream…" The salon attracted artists from France, Belgium, the Netherlands, Switzerland and Germany; participants included Ferdinand Hodler, Carlos Schwabe, Jan Toorop, Fernand Khnopff, Jean Delville, Georges Minne and Xavier Mellery. The work of some of the Nabis and Pont-Aven artists (Emile Bernard, Félix Vallotton, Charles Filiger) was also exhibited.

Péladan, obeying the peculiar logic of his public persona, in due course adopted the title of "Sâr" and replaced his given name, Joséphin, by the more resonantly Babylonian first name "Mérodak". And it was in the guise of an oriental magus that he was portrayed by Alexandre Séon in 1891 (p. 52). Though the portrait genre was proscribed by the Rose+Croix, this exception was reclassified as an *honneur iconique* and thus became acceptable.

Standing outside trends and movements, Odilon Redon (1840–1916), a native of Bordeaux, produced a rich and enigmatic *corpus*: "Like music," he declared, "my drawings transport us to the ambiguous world of the indeterminate." In contrast with Goya's monsters and Kubin's nightmare visions, his work is imbued with a melancholy passivity. While origins of this disposition must be sought in the artist's experience, the overall effect is entirely consistent with the moods of Symbolism that we have defined: nocturnal, autumnal, and lunar rather than solar. During the early part of Redon's career, the nocturnal did

Odilon Redon
Ophelia, c. 1900–1905
Pastel, 50.5 x 67.3 cm
Wildenstein & Co. Collection, New York

Odilon Redon
Veiled Woman, c. 1895–1899
Pastel, 47.5 x 32 cm
Rijksmuseum Kröller-Müller, Otterlo

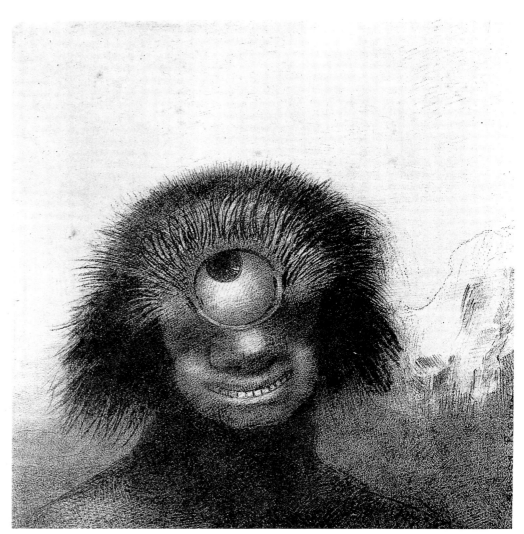

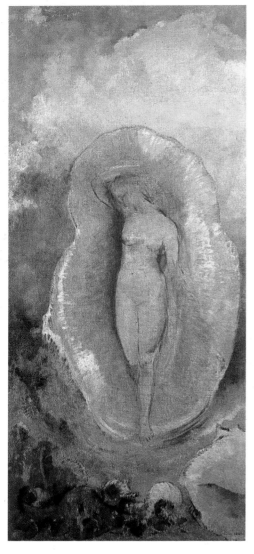

indeed predominate. Only later did he admit the light of day. His mature production began around 1875 when Redon entered the shadowy world of charcoal and the lithographer's stone. This period yielded sequences such as *In Dream* (1879), and *Origins* (1883, p. 60). Redon made it clear that they had been inspired by his dreams, and they inspire in the spectator a conviction like that of dreams.

It was only in the 1890s that he begin to use the luminous, musical tones of pastel and oils. These became the dominant media of the last fifteen years of his life. Redon's art was always commanded by his dreams, but the thematic content of his work over his last twenty years is more densely mythical, brimming with newfound hope and light which rose quite unexpectedly out of the depths of the artist's personality. This is particularly apparent in the various canvases depicting the chariot of Apollo, the god of the sun (p. 61).

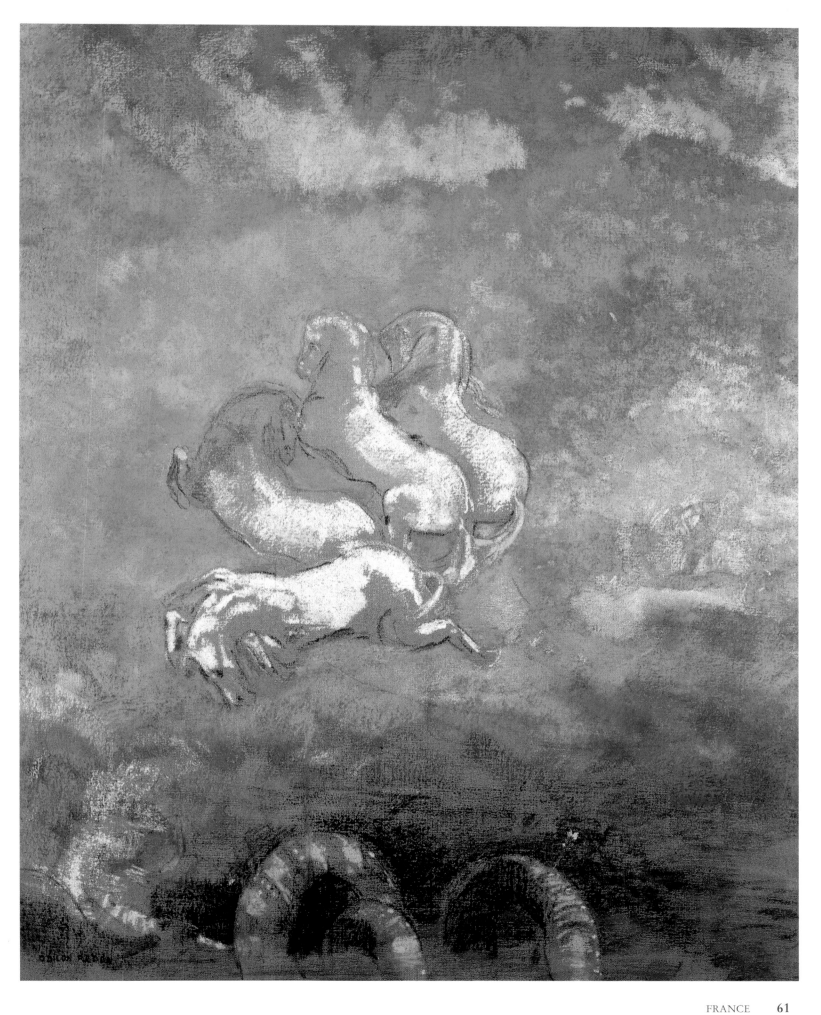

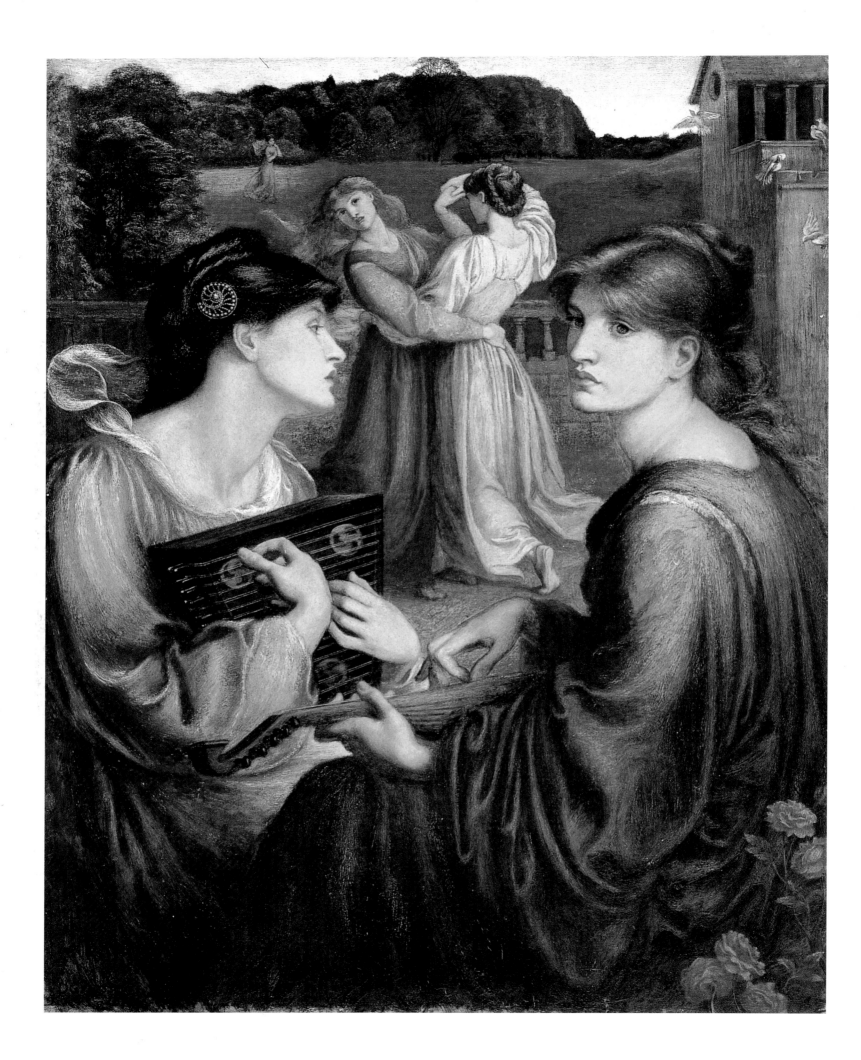

Great Britain and the United States

An art with obvious affinities to Symbolism had appeared in England in the 1850s – ten years before the Symbolist phase of Gustave Moreau and thirty years before Moréas' manifesto. The ideological context was, of course, very different. In France, the secular and scientistic overtones of realism found their ideological justification in hostility to the Catholic Church. In England, as we have seen, the influential theoretician John Ruskin (1819–1900) regarded the imitation of nature as a pious tribute to the Creator. As a painter, Ruskin used a cyanometer to measure the intensity of the sky's blue; the greater the precision with which an artist depicted nature, the more perfect the tribute paid to God.

Ruskin concerns us here because he took up the cudgels on behalf of the Pre-Raphaelites, a group of young artists which included John Everett Millais and Dante Gabriel Rossetti. Both displayed highly precocious talents: Millais was ten when he entered Sass's School (which prepared pupils for the Royal Academy), and was admitted to the Academy at eleven. Rossetti was admitted to Sass's at thirteen, and entered the Academy four years later. The two young men met in 1848 (aged 19 and 20 respectively) through William Holman Hunt, whose *Eve of Saint Agnes*, based on the poem by Keats, was much admired by Rossetti.

The three shared an antipathy to the tradition of chiaroscuro and "tobacco juice" hues favoured by the Academy since the days of its first president, Sir Joshua Reynolds (whom the three young men dubbed "Sir Sloshua"). They announced that, in the interests of naturalism and of truth, they would use only bright colours and unified lighting, turning for inspiration to Italian painters of the centuries before Raphael, in particular to Orcagna and Benozzo Gozzoli. The three of them therefore established the Pre-Raphaelite Brotherhood, which eventually came to include four further members. As a token of membership, they pledged to sign their paintings P.R.B. but kept the significance of the acronym to themselves. Enquiries elicited various suggestions such as "Please Ring Bell"; Rossetti's version, as Timothy Hilton notes in his book on the Pre-Raphaelites (London/New York 1970), was "Penis Rather Better".

Nothing in their early style connects them with Symbolism. The critics were predictably hostile to their innovations, mounting a vigorous attack. In 1851, at the height of this onslaught, one of the new members appealed to Ruskin, who wrote a letter to the *Times* on their

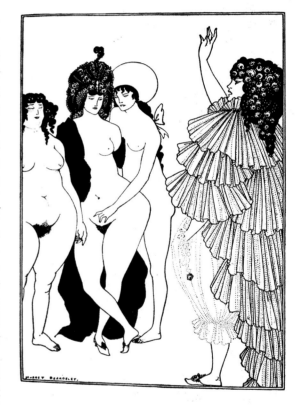

Aubrey Beardsley
Lysistrata Haranguing the Women of Athens, 1896
Ink drawing, 22.5 x 17 cm
Private collection

Dante Gabriel Rossetti
The Bower Meadow, 1872
Oil on canvas, 85 x 67 cm
City Art Gallery, Manchester

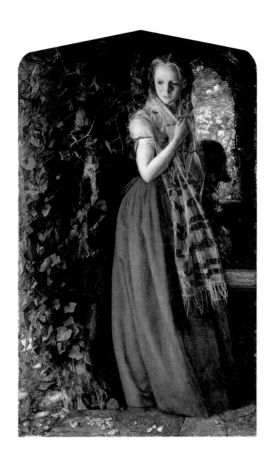

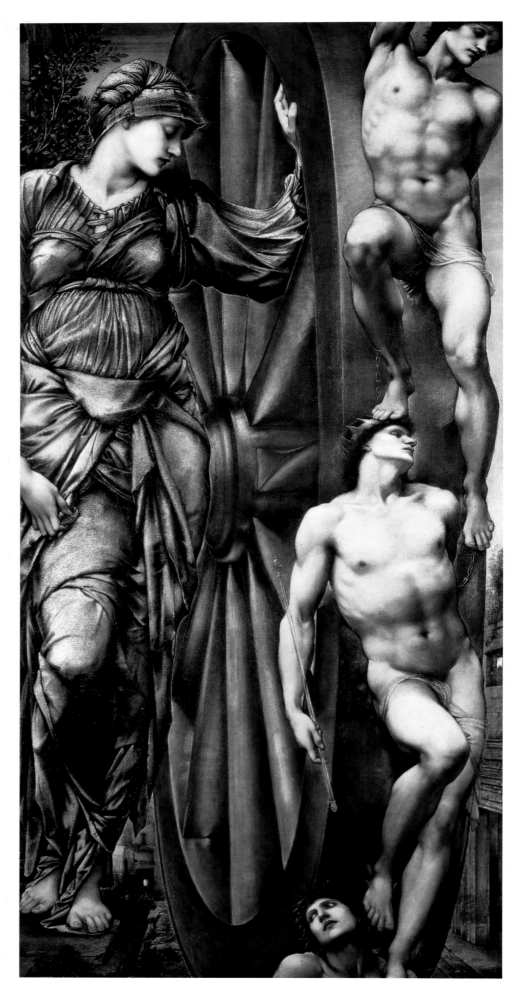

LEFT:
Arthur Hughes
April Love, 1855–1856
Oil on Canvas, 89 x 50 cm
Tate Gallery, London

RIGHT:
Edward Burne-Jones
The Wheel of Fortune, 1883
Oil on canvas, 200 x 100 cm
Musée d'Orsay, Paris

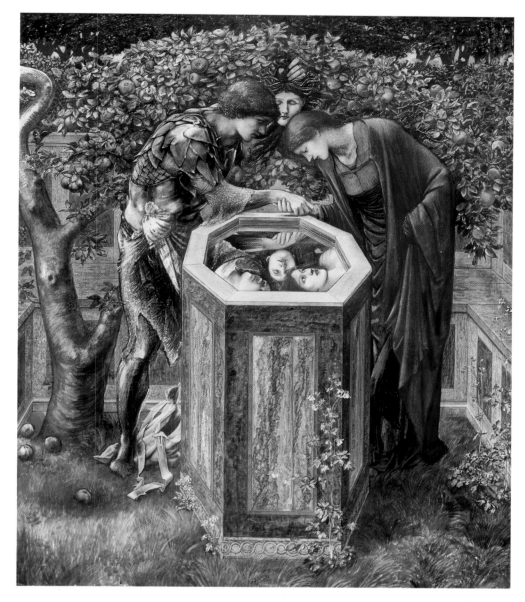

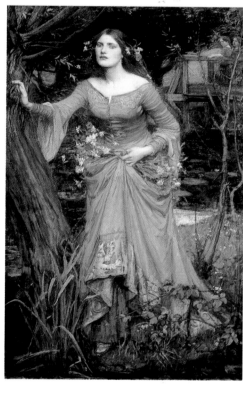

behalf. "I have no acquaintance with any of these artists and only a very imperfect sympathy with them," he stated. But he went on to commend Charles Allston Collins' painting *Convent Thoughts*: "I happen to have a special acquaintance with the water plant *Alisma Plantago* and never saw it so thoroughly or so well drawn."

Inapposite as Ruskin's defence seems, it had the desired effect, and the young Pre-Raphaelites wrote to him to express their gratitude. On the day on which he received their letter, Ruskin and his young wife paid an unexpected visit to Millais. Ruskin was ten years older than Millais and began to hope that, under his guidance, the younger artist would become the Turner of his day. The upshot was unexpected: during a holiday together in Scotland Millais painted Ruskin's portrait and Effie Ruskin fell in love with Millais. Two years later she left Ruskin, her marriage was annulled, and she married Millais.

Of course, realism was not the sole criterion in English art of this period. The public was greatly enamoured of the country's medieval heritage, which had survived better than that of France. It also favoured fairy tales and stories of witchcraft and magic derived from Celtic legends. Germany was the principal foreign influence. Albert,

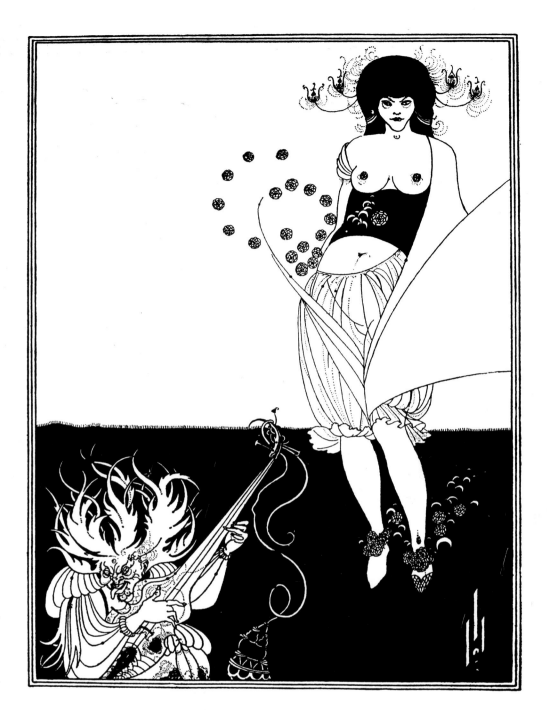

Silhouette of Aubrey Beardsley

Aubrey Beardsley
Self-portrait, 1892
Ink drawing, 25 x 9 cm
British Museum, London

RIGHT:
Aubrey Beardsley
Salome's Dance, 1893
Ink drawing, 22.5 x 17 cm
Fogg Art Museum, Cambridge (MA)

PAGE 67:
Aubrey Beardsley
Herodias (illustration for Oscar
Wilde's *Salome*), 1893
Ink drawing, 21 x 21.5 cm
Los Angeles County Museum of Art,
Los Angeles (CA)

the Prince Consort (1819–1861), was German, and through him the public became acquainted with the German Nazarene movement, which sought to combine exact observation of nature with a form of romantic archaism.

The precocious Millais (1829–1896) did his best work before he was thirty. At the age of twenty-three he painted his famous *Ophelia* (p.74) drifting downstream with her scattered nosegay; four years later, in 1856, he painted *Autumn Leaves* (p.72), an affecting symbolic work in which four young girls are seen burning leaves under a beautiful evening sky. The work is a melancholy *momento mori*, a very English and very 19th century equivalent to Herrick's celebrated imperative "Gather ye rosebuds while ye may".

That same year he completed *The Blind Girl* (p.74), in which, with ostentatious virtuosity, he depicted the blind girl surrounded by the beauties of a nature that she cannot see. The following year came a

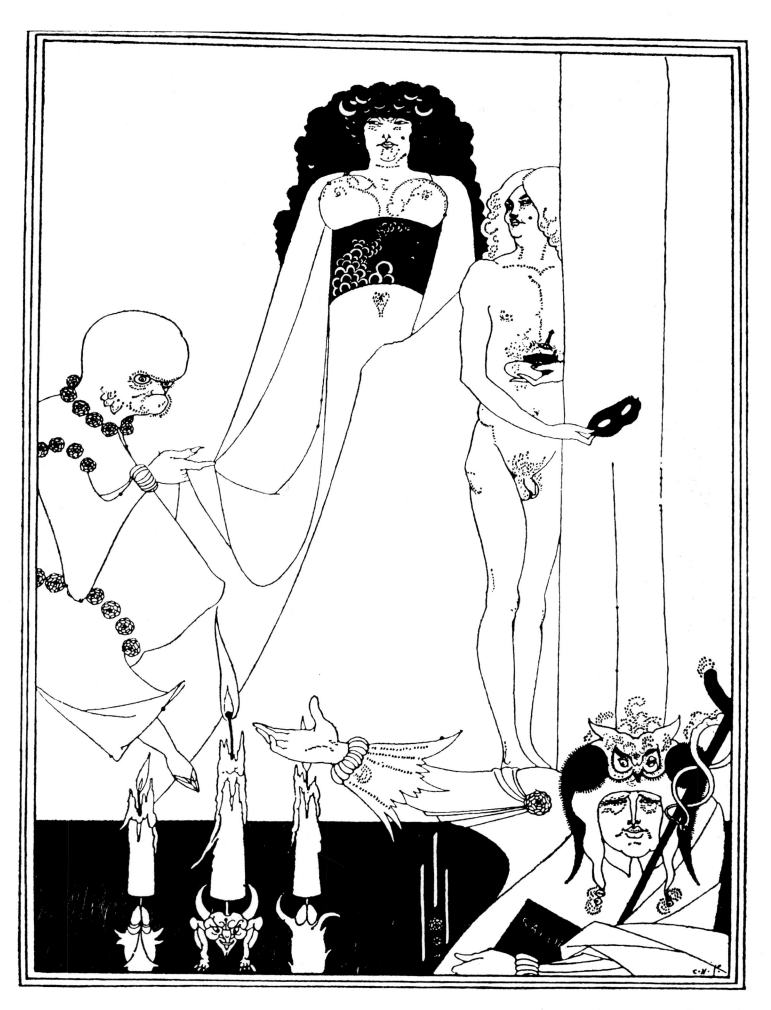

somewhat enigmatic work in Arthurian vein, *Sir Isumbras at the Ford* (p. 73). A grey-haired knight on horseback fords the river; he carries a barefoot girl and boy across the ford with him. The painting became so famous that Sir John Tenniel parodied it in the figure of the White Knight in Lewis Caroll's *Through the Looking Glass* (p. 73). Millais, at the age of twenty-eight, now drops out of our story. Henceforth he devoted himself to portraits and history painting, which earned him fame, wealth and ultimately a knighthood.

Things went otherwise with his friend Rossetti (1828–1882). The son of an Italian political refugee, he was not only a painter but a poet; he wrote *The Blessed Damozel*, set by Claude Debussy as the cantata *La Demoiselle Elue*. His strongest works have intimate connections with his own life and the women in it.

In 1850, a young member of the Brotherhood accompanied his mother to her milliner. Elizabeth Siddal, the salesgirl, dazzled him. He made friends with her and she soon became the favourite model of the

young artists. Two years later, Rossetti and Elizabeth were living together. In 1855 they were married. There was no happy ending to the story; Rossetti was unfaithful and Elizabeth committed suicide in 1862 by taking an overdose of laudanum.

Rossetti was shattered. At the age of thirty-four, he suddenly aged and grew fat. He left the house where Elizabeth had died and moved to Chelsea where he surrounded himself with an exotic menagerie: "owls, rabbits, doormice, wombats, woodchucks, wallabies, a raccoon, parrots, peacocks, lizards, salamanders, a laughing jackass and a Brahmin bull," in Timothy Hilton's inventory.

A year later, Rossetti painted *Beata Beatrix* (p. 26) as a last tribute to Elizabeth. The work represents the Beatrice of Rossetti's namesake, Dante, with whom he strongly identified. Beatrice bears the features of Elizabeth Siddal and is shown in a state of ecstatic receptivity at the instant of death. A flame-red bird, the Holy Ghost, swoops down to place a poppy in her hands (the flower is doubtless a symbol of oblivion,

Walter Crane
The Horses of Neptune, 1892
Oil on canvas, 86 x 215 cm
Neue Pinakothek, Munich

A striking metaphor of the power of the waves by one of the great English illustrators of his time.

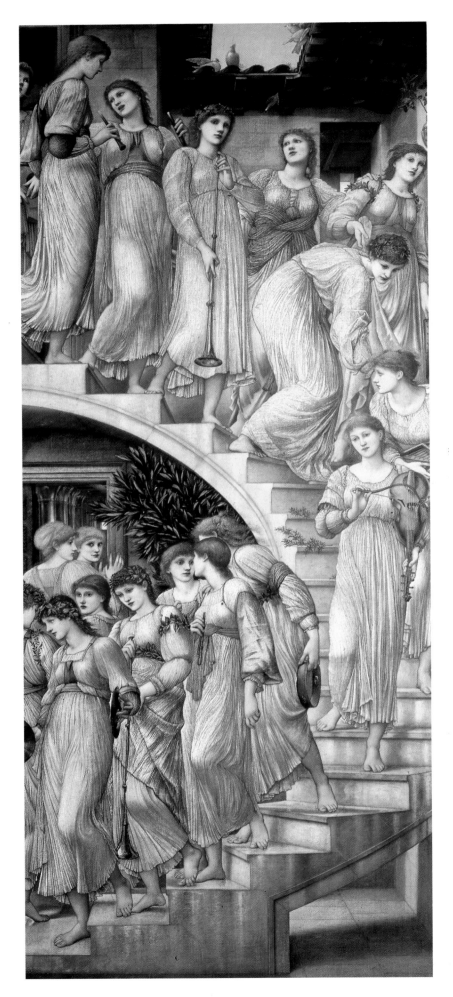

Photograph of Jane Morris, 1865

Edward Burne-Jones
The Gold Stairs, c. 1880
Oil on canvas, 270 x 117 cm
Tate Gallery, London

Rossetti and Burne-Jones met Jane Burden at the
theatre in Oxford in 1857. She married William
Morris, and after the break-up of that marriage,
lived with Rossetti.

PAGE 71:
William Morris
Queen Guenevere, 1858
Oil on canvas, 71.8 and 50.2 cm
Tate Gallery, London

A portrait of Jane. The dissatisfied artist wrote
on the canvas: "I can't paint you, but I love you."

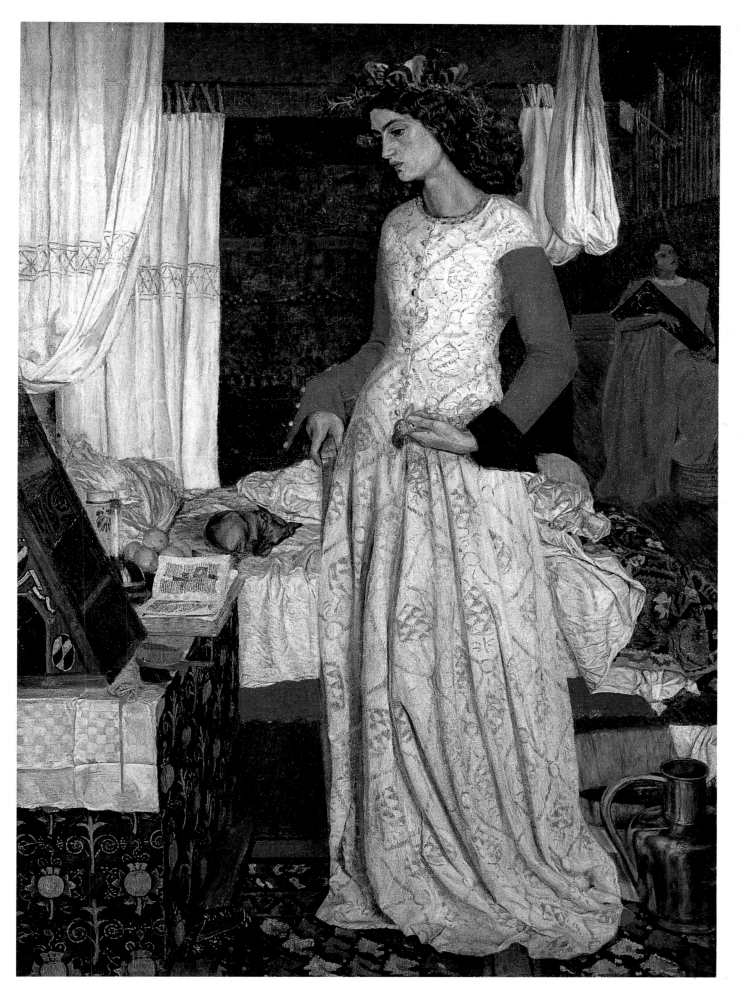

GREAT BRITAIN AND THE UNITED STATES

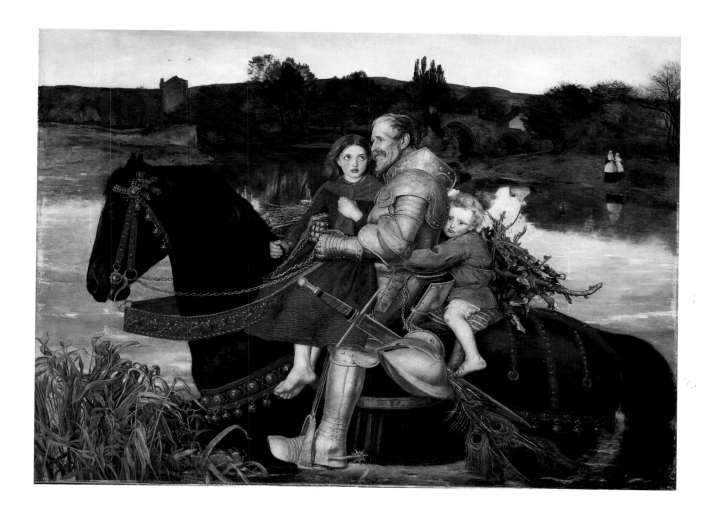

but one should also note that laudanum is derived from opium). It is thought that the two figures in the background represent Eros (in red) and Dante (by analogy, Rossetti himself) in darker clothes.

Another woman was soon to enter the artist's life. Five years before Elizabeth's death, Rossetti and Burne-Jones had been much taken by the sculptural beauty of Jane Burden (cf. photograph p.70). They had met her at the theatre in Oxford during the summer of 1857. The purpose of their visit was to fresco the Oxford Union Debating Hall, but they were so ignorant of fresco technique that the works began to fade six months after completion. Jane was immediately recruited as a model and soon after married another member of the Brotherhood, William Morris (1834–1896), who established an influential interior-decorating firm producing wallpaper, curtains, tapestries and furniture.

Some time after Elizabeth's death, Jane Burden left Morris and went to live with Rossetti. She was the model for such paintings as *Venus Verticordia* (1864–1868, p.77), *La Ghirlandaia* (1873) and the impressive *Astarte Syriaca* (1877, p.27). In each of these paintings, Rossetti foregrounds Jane's highly characteristic features, endowing them with a fetishized sensuality of undoubted fascination. In 1872, ten years after Elizabeth's death, Rossetti himself took an overdose of laudanum, but survived.

Rossetti was the most "Symbolist" of the Pre-Raphaelites; the others were, for the most part, painstaking realists. The distinction had little resonance in England. In France, when Gauguin painted *The Vision after the Sermon*, his old friend Pissarro aspersed Gauguin's sincerity. England escaped this ideological storm.

John Everett Millais
Sir Isumbras at the Ford, 1857
Oil on canvas, 124 x 170 cm
Merseyside County Art Gallery, Liverpool

The Victorian public was so struck by this work that Sir John Tenniel, the famous illustrator, could count on recognition when he parodied it in his drawing of the White Knight for *Through the Looking Glass*.

PAGE 72:
John Everett Millais
Autumn Leaves, 1856
Oil on canvas, 104 x 74 cm
City Art Gallery, Manchester

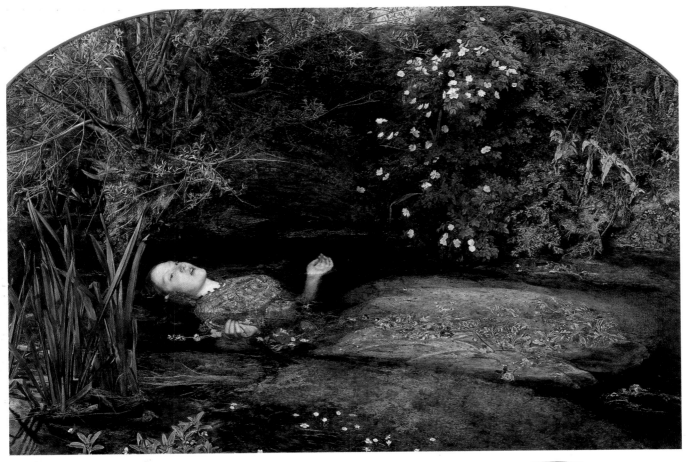

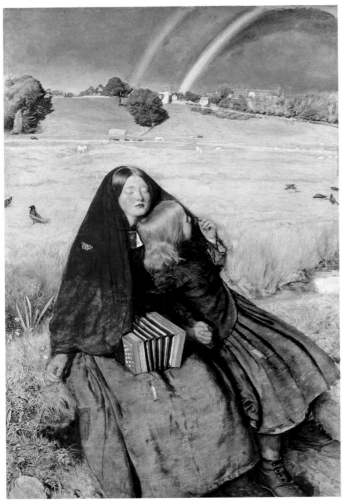

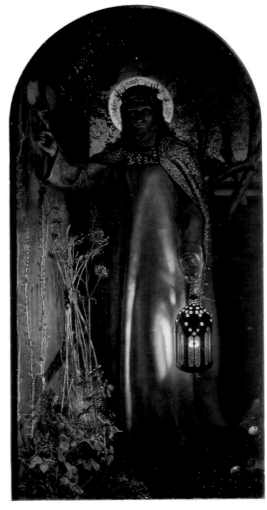

Another member of the Brotherhood, William Holman Hunt (1827–1910), carried his obsession with realism to the point of sailing to the Holy Land, in the hope that his religious paintings would acquire greater authenticity (the French painter James Tissot did something similar at a later date). For his painting *The Scapegoat*, Hunt tethered a billy-goat in the desert near the Dead Sea. Appropriately enough, the animal died.

Hunt's most celebrated work is probably *The Light of the World* (p. 74). A preoccupied Christ, wearing a threefold crown of light, gold and thorns, holds a lantern in his hand; benighted, he knocks at a door. As the tall weeds growing on the threshold evince, the door has long been closed. It is, of course, the door of the soul. Lithographic reproductions of the work were once to be found in Christian schools the world over. The edifying message of the painting conformed to public expectations of the time. Oscar Wilde's observation that "All art is quite useless" should probably be understood as a provocation directed towards those who believed that all art must be socially and morally useful rather than his last word on the subject.

Rossetti did not possess the technical mastery of Millais. Millais' realism, notably in his *Ophelia* (p. 74), is as obsessive as Hunt's; Rossetti was less concerned with detail than either Hunt or Millais. He turned to his own advantage the difficulty he experienced with perspective, creating paintings whose lack of depth suggests a timeless world distinct from that of everyday life. His painting is more allusive than that of the other Pre-Raphaelites – perhaps in compensation – and as a result his work is both more evocative and more moving.

Edward Burne-Jones (1833–1898) was reading theology at Oxford when, with William Morris, he discovered Rossetti's work. When Rossetti delivered a lecture at the Working Man's College, Burne-Jones approached him, soon becoming a disciple, though Rossetti was only five years his senior. Burne-Jones' women are derived from the Renaissance figures he had had occasion to study in the course of several journeys to Italy. Mild, pale and ethereal, they appear in paintings dealing with Greek mythology and Celtic legends. Burne-Jones' paintings, like Rossetti's, lack real depth, and this, along with their narrative or allegorical content, lends his work a Symbolist quality.

Burne-Jones in turn attracted the veneration of Aubrey Beardsley (1872–1898), probably the most remarkable English illustrator of the industrial age. He too was a precocious talent: at the age of fifteen he had illustrated his favourite books (*Madame Bovary*, *Manon Lescaut*). By the time of his death at the age of twenty-six (he died of of tuberculosis, in Menton, where he had gone in search of a favourable climate), he had made a lasting impact on the art of illustration. It was a field in which a number of outstanding artists were then working, including Walter Crane, co-founder with William Morris of the Arts and Crafts Exhibition Society.

It was through Burne-Jones that, in 1891, Beardsley, then aged eighteen, met Oscar Wilde. Wilde was writing his *Salome* in French (Arthur Douglas subsequently translated it into English), and asked Beardsley to illustrate it.

Beardsley's drawings are admirably suited to the technical possibilities of industrial reproduction. Ambitious and supremely gifted, the young artist developed a perverse and playfully theatrical style partly inspired by Greek vase painting. The venomous elegance of his draw-

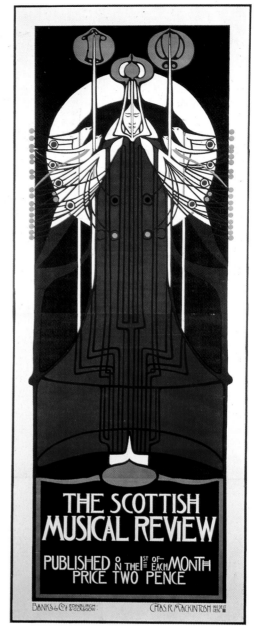

Charles Rennie Mackintosh and **Herbert MacNair**
Poster for The Scottish Musical Review, 1896

John Everett Millais
Ophelia, 1852
Oil on canvas, 76 x 112 cm
Tate Gallery, London

John Everett Millais
The Blind Girl, 1856
Oil on canvas, 82.6 x 61.6 cm
City Art Gallery, Birmingham

William Holman Hunt
The Light of the World, 1853
Oil on canvas, 122 x 61 cm
Keble College, Oxford

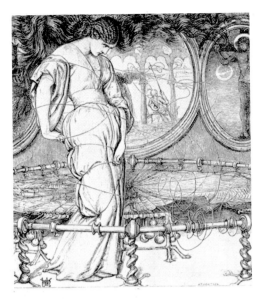

William Holman Hunt
The Lady of Shalott, illustration for *Poems* by
Alfred Lord Tennyson, 1859
Wood engraving

BOTTOM:
Robert Burns
Natura naturans, 1895
Illustration published in *The Evergreen*

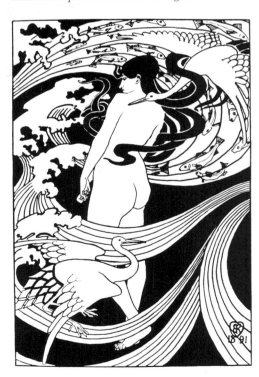

RIGHT:
John White Alexander
Isabel and the Pot of Basil, 1897
Oil on canvas, 192 x 91 cm
Museum of Fine Arts, Boston (MA)

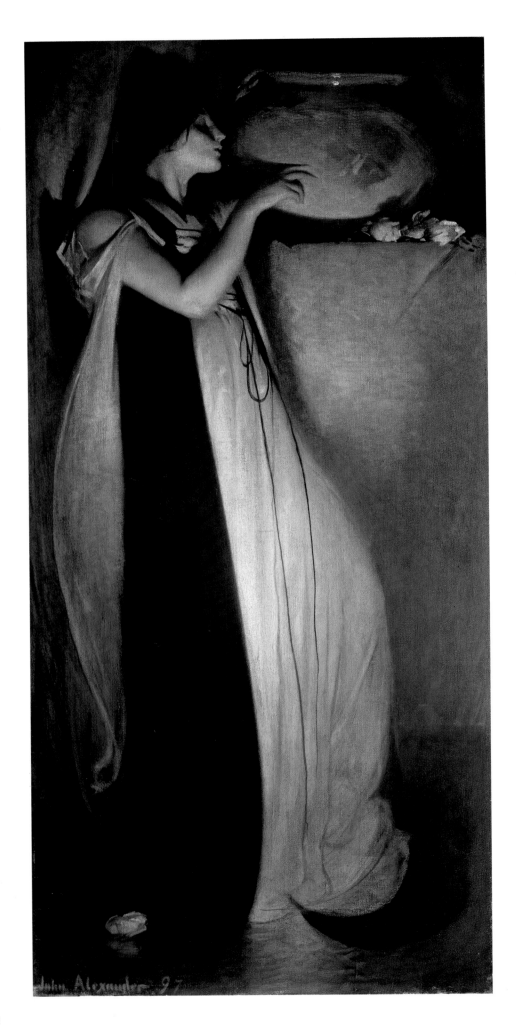

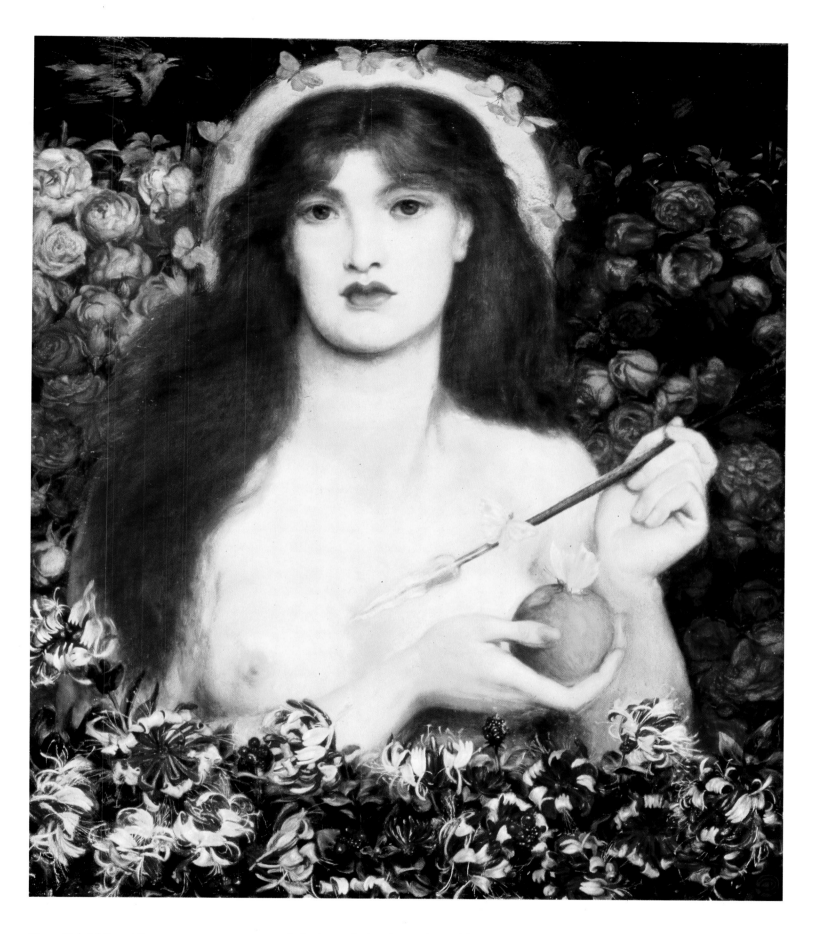

Dante Gabriel Rossetti
Venus Verticordia, 1864–1868
Oil on canvas, 98 x 70 cm
Russel-Cotes Art Gallery and Museum,
Bournemouth

As in *Astarte Syriaca* (p.27), the model is Jane
Burden, her features here almost fetichised. Is
this goddess alive or dead? The alarming flesh-
tones and wilting roses suggest a doubt. The

arrow, the butterflies which replace the expected
flies, and the apple are overt symbols of Eros and
Thanatos. Not for nothing are the Pre-Rapha-
elites cited as the precursors of Symbolism.

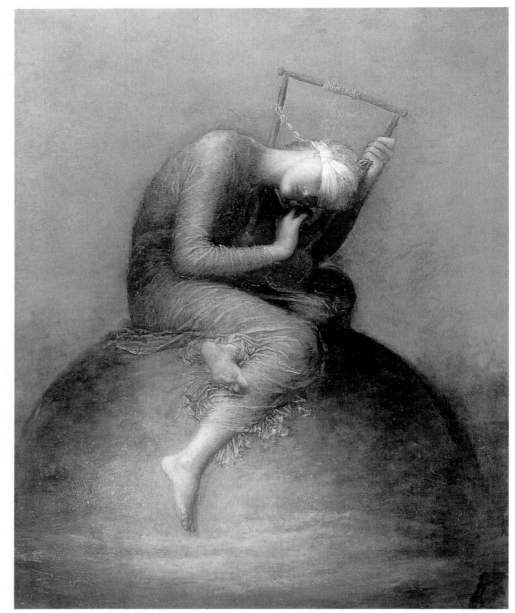

George Frederick Watts
The Sower of Systems, 1902
Oil on canvas, 66 x 53 cm.
The Watts Gallery, Compton, Surrey

George Frederick Watts
Hope, 1886
Oil on canvas, 141 x 110 cm
Tate Gallery, London

PAGE 79:
George Frederick Watts
The Minotaur, 1877–1886
Oil on canvas, 117 x 93 cm
Tate Gallery, London

Watts, with a moralising idealism typical of his period, defined his ambitions thus: "I paint ideas, not things… My intention is less to paint pictures that are pleasing to the eye than to suggest great thoughts which will speak to the imagination and the heart and which will arouse all that is noblest and best in man."

ings has an ornamental rhythm akin to the abstract decorations of Islamic palaces. For *Salome* (pp. 66–67), Beardsley ironically appropriated the decadent theme of the evil, emasculating woman. His characters are often grotesque – notably in drawings he later described as "naughty", representing, for example, grimacing "Gobbi" afflicted with monumentally tumescent phalluses. As a homosexual, Beardsley did not experience the anguish awoken in artists like Munch by the problematic state of relations between the sexes. Wilde described Beardsley's muse as having "moods of terrible laughter".

Other British artists of this period were active in other circles. George Frederick Watts, for instance, favoured a more "continental" manner – his "soft focus" is reminiscent of Lévy-Dhurmer or of the more Symbolist works of Fantin-Latour. "I paint ideas, not things," he declared. "My intention is less to paint works that are pleasing to the eye than to suggest great thoughts which will speak to the imagination and the heart and will arouse all that is noblest and best in man." To which one may retort, with Odilon Redon: "There is a literary idea wherever plastic invention is lacking." From today's perspective, Redon's dictum is the

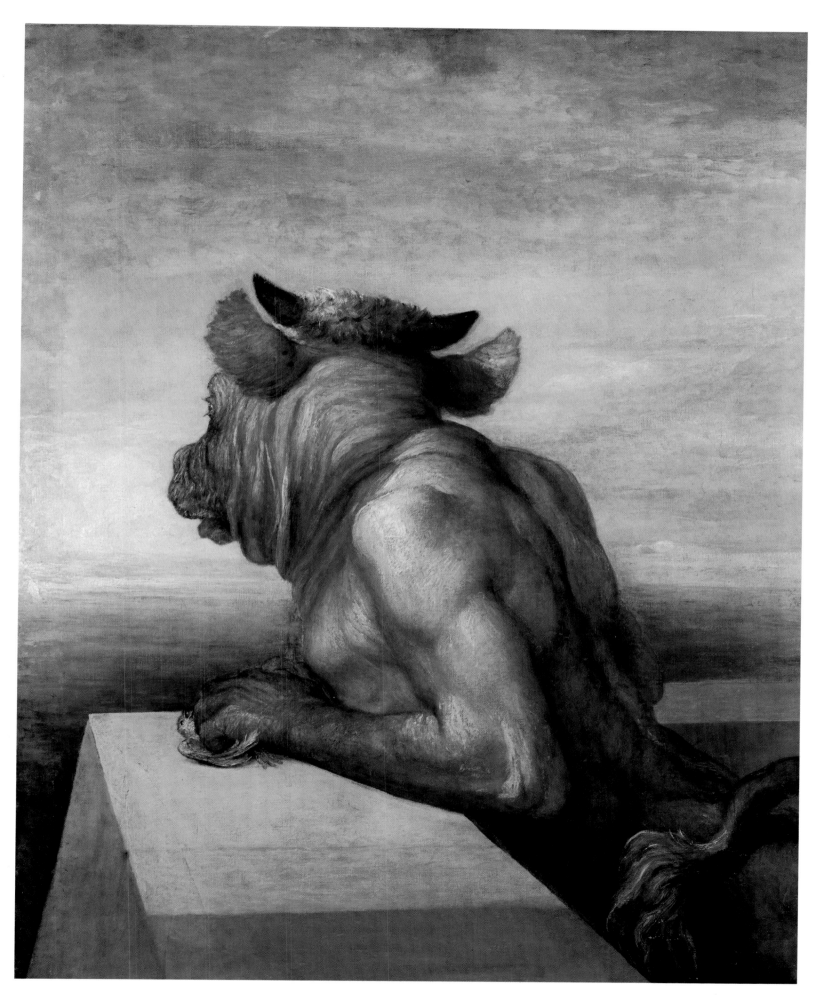

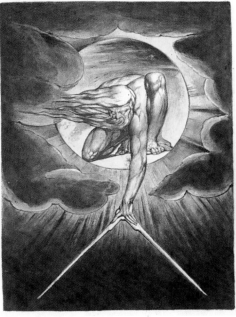

William Blake
The Ancient of Days, frontispiece for
Europe, a Prophecy, 1794
Colour engraving, pen, water-colour,
30.4 x 23.6cm
Fitzwilliam Museum, Cambridge

One understands little about Blake until one
knows that, when he was seven, he saw (not
"thought he saw") God looking at him through
the window in the form of a huge face with a
white beard, and that later in his life he saw
angels sitting in the branches of trees. He is not
merely a precursor of Symbolism, but, in both
his thought and his art, one of the most remark-
able geniuses of English Romanticism.

RIGHT:
Charles Rennie Mackintosh
Harvest Moon, 1892
Graphite and water-colour, 35.2 x 27.6cm
Glasgow School of Art, Glasgow

aptest criterion for evaluating works of the Symbolist period. Redon,
Ensor or Munch are distinguished by the power of their plastic inven-
tion. Not all Symbolist painters attained such power.

As the spokesman of innovative aesthetic theory, Oscar Wilde (1854–
1900) deserves our further attention. He personified the figure of the
dandy *à la* Robert de Montesquiou though with greater wit and more
manifest humanity. His comedies, laced with delightful paradoxes,
deride the prejudices and snobbism of the Victorian society he knew so
well. His essays present his conception of art in a certain whimsical
disorder. As a public figure he was the embodiment of the *fin de siècle*
aesthete. It is thought that Bunthorne, in Gilbert and Sullivan's *Patience*
(1881), was originally conceived as a caricature of Rossetti, but the Brit-
ish public assumed it was a portrait of Wilde, who had already made
himself famous at the age of twenty-seven by his inspired posturing.
Bunthorne is a highly affected fellow who readily acknowledges in pri-
vate that he has no use for the aesthetic oddities he publicly pretends to
enjoy. The satire was amusing and reassured a public disconcerted by

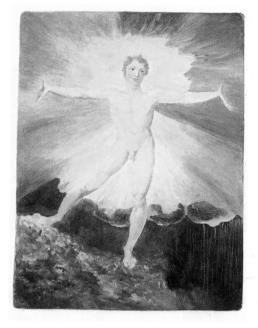

William Blake
Happy Day – The Dance of Albion, 1794–1796
Colour engraving, pen and water-colours for
Europe, a Prophecy, 30.4 x 23.6 cm
Fitzwilliam Museum, Cambridge

Elihu Vedder
The Cup of Death, 1885
Oil on canvas, 112.7 x 52.7 cm
Virginia Museum of Fine Arts, Richmond (VA)

Vedder painted landscapes and allegories, but
owed his reputation above all to his illustrations
for the *Rubáiyát* of Omar Khayyám, including
this "cup of death": "When the Angel of the dar-
ker drink…[shall offer you] his Cup, invite your
Soul Forth to your Lips to squaff – you shall not
shrink."

Albert Pinkham Ryder
Siegfried and the Rhine Maidens, 1888–1891
Oil on canvas, 50 x 52 cm
National Gallery, Washington (DC)

A self-taught painter, Ryder chose subjects inspired by the operas of Wagner or the *Tales* of Edgar Allan Poe for his dark, expressive paintings.

the aesthetic preferences of Wilde or of artists like Rossetti and Whistler. The aphorism cited above comes early in Wilde's novel *The Picture of Dorian Gray*. It is the last of a series that deserves to be quoted in full:

"All art is at once surface and symbol.
Those who go beneath the surface do so at their peril.
Those who read the symbol do so at their peril.
It is the spectator, and not life, that art really mirrors.
(…) All art is quite useless."

Some of these aphorisms are rather modern in tone, though the portentous notion of a hidden "peril" has dated badly. Wilde gives concise expression to some essential truths about art: art is indeed both surface and symbol, both delectation and communication, an intimate fusion of what is represented and of the means by which it is represented. It is at once an "aesthetic arrangement", in Whistler's famous phrase, and an evocation of an aspect of experience which cannot be signified by any other means.

Thomas Cole (1801–1848) may be described as a precursor of Symbolist art in the same sense as Goya, Fuseli or Blake. British by birth, he made his career in the United States, to where his parents emigrated when he was eighteen. His allegorical work, an outgrowth of the Romantic spirit, possesses irresistible charm. The sequence of paintings entitled *The Voyage of Life* (p. 83) is reminiscent of allegories of human life in the English tradition of edifying literature, of which *Pilgrim's Progress* is perhaps the most perfect example. By contrast, *The Titan's Goblet*, which dominates a vast landscape, is born of the same imagin-

Thomas Cole
The Voyage of Life, Youth, 1842
Oil on canvas, 134.3 x 194.9 cm
National Gallery, Washington (DC)

The work of Cole, essentially Romantic, is some-
times allegorical. His *The Voyage of Life* is remi-
niscent of allegories of human life in the English
tradition of edifying literature, of which *Pil-
grim's Progress* is perhaps the most perfect
example.

ative vein as Goya's *Panic*. Partly because Cole died relatively young,
at 47, the more imaginative part of his œuvre had little influence on the
next generation of artists, though he did contribute to the founding of
the Hudson River School of landscape painting.

His *The Voyage of Life* and *The Course of Empire* have a clearly
didactic purpose, yet Cole's treatment possesses a colouristic charm
enhanced by his vision of wide-open spaces. This poetic reverie de-
lighted his public, which also found comfort in the idea that it was being
instructed and elevated.

Though there had always been a taste for imaginative painting in
Protestant America, the country was not receptive to the Symbolist
aesthetic. Decadence had emerged in Europe in opposition to the scien-
tific world view and the religion of progress; it had little appeal in the
New World, where these were founding tenets. Like the Romans con-
fronted with the art of the Greeks, the popular classes in America, with
their pragmatic outlook and fundamentalist religion, were suspicious of
any notion that artists had access to a "superior reality". The populist
and mercantile mentality, so pervasive in the United States, inclined to
see in a taste for the arts a foolish affectation.

The poet W. H. Auden went so far as to suggest that, when Oscar
Wilde was sentenced to jail in 1895 for homosexuality, it reinforced the
assumption, already well entrenched in the United States, that art and
poetry were pastimes attractive only to women and effeminates. Wilde
had enjoyed tremendous success with the media during a lecture tour
in the United States when he was only twenty-seven. On that occasion
he had displayed great virtuosity in provocation, and the public he had

successfully shocked felt thoroughly vindicated by his condemnation fourteen years later.

The dominant trend in America was a form of realism whose romantic overtones were particularly prominent in the representation of nature. Symbolist works were relatively rare, but occasionally appeared in the production of artists practising other genres. Most of those today classified as Symbolists received their artistic training in Europe. This was the case with John White Alexander (1866–1915), and Elihu Vedder (1836–1923). Vedder came to fame through his illustrations for the *Rubáiyát* of Omar Khayyám. He was taught the rudiments of his art by a genre painter, T.H. Matteson, and went to Europe for the first time in 1856. He never considered studying in England: it was Paris and above all Florence that attracted him. In 1867 he settled in Rome, though he frequently returned to the United States. He also painted landscapes in a romantic vein, but we are concerned here with his fantastical or allegorical works such as *The Cup of Death* (p. 81).

A self-taught painter, Albert Pinkham Ryder (1847–1917) also came to Europe, traversing the Atlantic four times between 1877 and 1896. In the 1880s he began to treat sombre, expressive subjects drawn from the operas of Wagner (*Siegfried* and *The Flying Dutchman*, pp. 82, 85) and the short stories of Edgar Allan Poe. His *Death on a Pale Horse* is an expressive conjunction of the imaginary and the real; the apocalyptic figure of Death is shown galloping around an ordinary racecourse.

Arthur Bowen Davies (1862–1928) played a historic role in American art: as President of the Society of Independent Artists, he contributed to the organisation of the famous Armory Show, which brought the American public into contact with modern art. Critics of the day considered him a Romantic artist, but the label is somewhat uninformative. A work like *The Unicorns* (1906) stands at the crossroads between Romanticism, Symbolism, and even Surrealism.

James McNeill Whistler (1834–1903) went to Europe when his father, an engineer, was put in charge of the construction of a railway between Moscow and Saint Petersburg. He studied at the Beaux-Arts in Paris, where his classmates included Fantin-Latour and Alphonse Legros. Together they created the Society of Three (Société des Trois), an amiable fiction which allowed Whistler, who settled in London, to maintain his contacts with artistic and literary circles in Paris; his friend Stéphane Mallarmé translated his famous *Ten O'Clock Lecture* into French. Whistler was no Symbolist in his subject matter, though he had in common with the Symbolists a resolve to dissociate art from the utilitarian. This, of course, he shared with Wilde. In 1885, six years before Wilde published the views quoted above, Whistler declared: "Art is a goddess of dainty thought – reticent of habit, abjuring all obtrusiveness, purposing in no way to better others. She is, withal, selfishly occupied with her own perfection only – having no desire to teach." (*Ten O'Clock Lecture*).

An original and independent spirit, Whistler inclined to practice

James McNeill Whistler
Old Battersea Bridge, 1865
Oil on canvas, 66 x 50cm
Tate Gallery, London

"the gentle art of making enemies." When, in 1877, Ruskin wrote that Whistler had, with his *Nocturne in Gold and Black: The Falling Rocket*, "flung a pot of paint in the public's face", Whistler sued him for libel. Arguing that his work was "an artistic arrangement", Whistler won his case, but the farthing's damages without costs to which Ruskin was condemned suggests where the court's true sympathies lay.

Having long sought inspiration and technical mastery in Europe, American art was to take a new and very different path, in which the symbolic, pervaded by the religious heritage of Europe, would play only a secondary role. The story of that development is outside our scope.

Albert Pinkham Ryder
The Flying Dutchman, c. 1887
Oil on canvas, 36.1 x 43.8 cm
National Museum of American Art, Washington (DC)

The painting is badly cracked. In the foreground is a vessel with torn sail, battered by the waves; its passengers watch as the fateful vessel passes before the pale light of the setting sun.

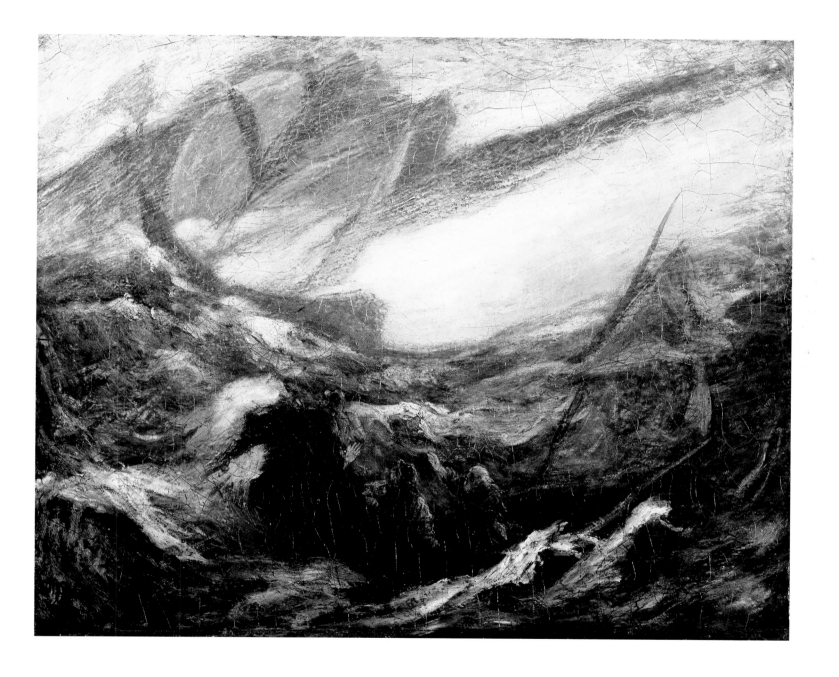

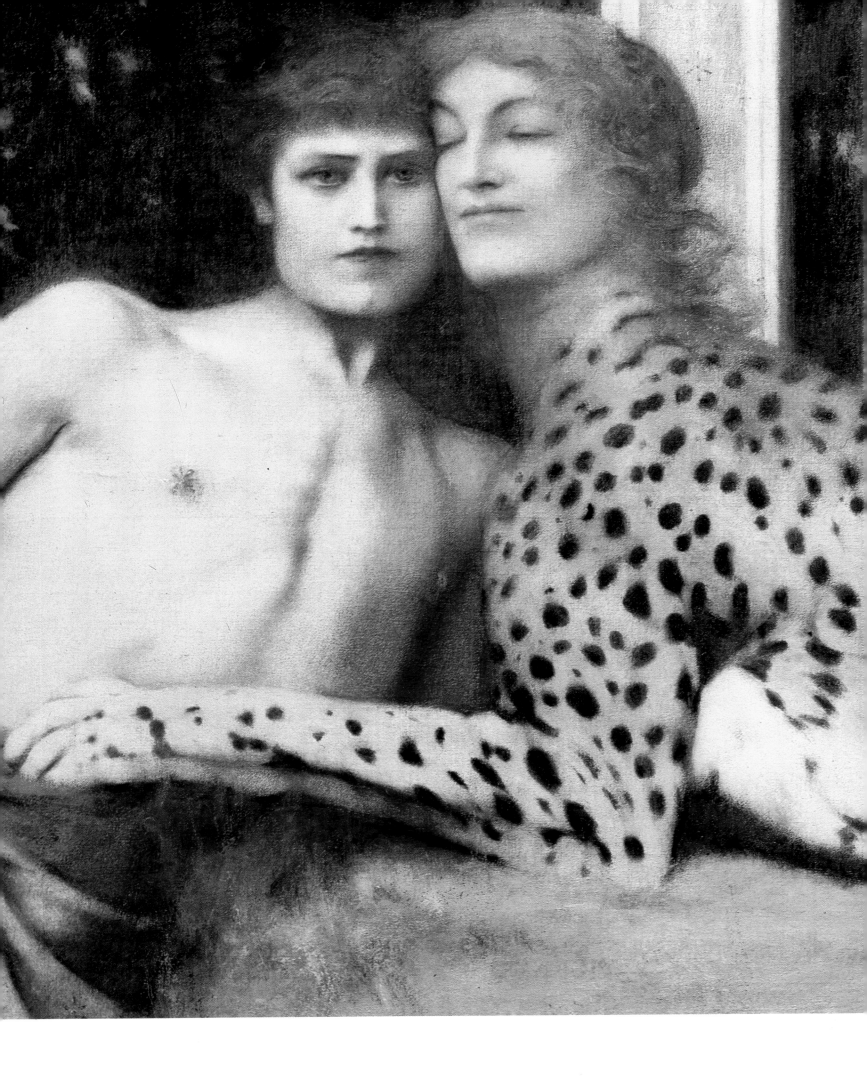

Belgium and the Netherlands

PAGE 86:
Fernand Khnopff
Art, or *The Sphinx*, or *The Caresses* (detail), 1896
Oil on canvas, 50 x 150 cm
Musées Royaux des Beaux-Arts, Brussels
(For the whole work, see p. 28.)

Fernand Khnopff
Sleeping Medusa, 1896
Pastel on paper, 72 x 29 cm
Private collection, Paris

Belgium became an independent state in 1830, and during the half-century that concerns us here was a crossroads of commerce and culture. The French language spoken in one part of the country favoured ties with France, but Belgium was also receptive to the influence of Germany and Britain. Between 1860 and 1914, the country enjoyed unprecedented industrial and economic development, significantly aided by King Leopold II's creation of a state in the Congo basin (it was founded in 1878 and remained his private property until 1908). This influx of wealth helps to explain the sudden development of the arts in Belgium.

Culturally and socially, the country had not followed the same path as France, its closest neighbour. Historical circumstance, notably the fifteen year period after Waterloo when it was part of the predominantly Calvinist and Dutch-speaking Netherlands, had enhanced the importance of Catholicism among all social classes. These economic and socio-cultural factors clearly affected the development of Belgian art of the period and in particular the solitary and exalted mood characteristic of Belgian Symbolism. Another factor was a wealthy and hospitable bourgeoisie, which took an active interest in literature and music. All this created an environment favourable to Symbolist art.

Antoine Wiertz (1806–1865) was an artist of uneven quality who nevertheless contrived, with the financial assistance of the Belgian government, to build himself a studio in the shape of a Greek temple; it now houses his Museum. Wiertz embodies the transition from Romanticism to Symbolism. *The Beautiful Rosine* (1847, p. 113) is academic in technique but of a conception unusual for its time; the subject of death and the maiden had, of course, often been treated by German artists of the 16th century. It depicts a buxom nude gazing placidly at a skeleton whose skull is labelled with the work's title. The "Beautiful Rosine" is not the woman we thought she was. Wiertz's work affords amusing insights into contemporary attitudes. The devil attending *The Novel Reader* (1853, p. 112) speeds her on the way to perdition with nothing more nefarious than the novels of Alexandre Dumas.

Somewhat surprisingly, the same subject was also dealt with by the witty and cynical Félicien Rops (1833–1898) in an 1878–1880 water-colour entitled *The Librarian*, though no author is singled out for election by the devil. Rops was an astonishing virtuoso graphic artist who exploited some of the commonplaces of the Symbolist repertoire

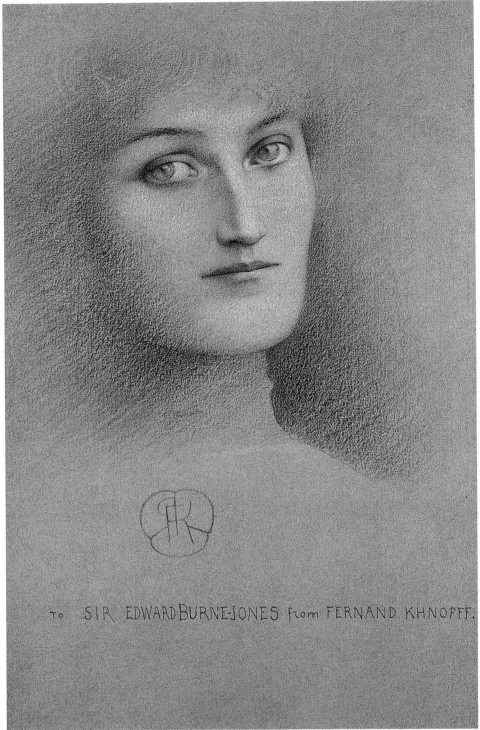

Fernand Khnopff (with Joséphin Péladan),
Istar, 1888
Red chalk on paper, 16.5 x 7 cm
Private collection

RIGHT:
Fernand Khnopff
Study of a Woman, 1896
Pencil with white highlights on paper, 23 x 15 cm
Private collection, Turin

with detachment and theatrical flair. He began his career in quite a different vein, producing caricatures and humorous drawings for the satirical weekly *Uylenspiegel*, which he founded in 1856. Thereafter, like a great *cinéaste*, he sensed the drift of the clichés of his times and played upon them in masterly fashion. One constant in his work is thus Woman, Death and the Devil, a theme that he handles with exuberantly provocative irony. On occasion the theme was imposed, as in his illustrations for books such as Barbey d'Aurevilly's *Les Diaboliques*. More often it derives from his own imagination, as in *Death at the Ball* (1865–1875, p. 99), which he began at about the time Gustave Moreau was painting his *Oedipus and the Sphinx*. Rops here shows

Fernand Khnopff
The Secret, 1902
Pastel, 49.5cm diameter
Groningemuseum, Bruges

Photograph of Marguerite Khnopff, the model
for *The Secret*, taken by Fernand Khnopff, c. 1902

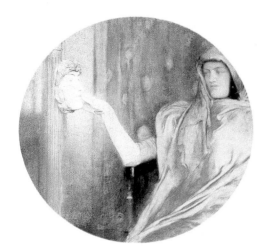

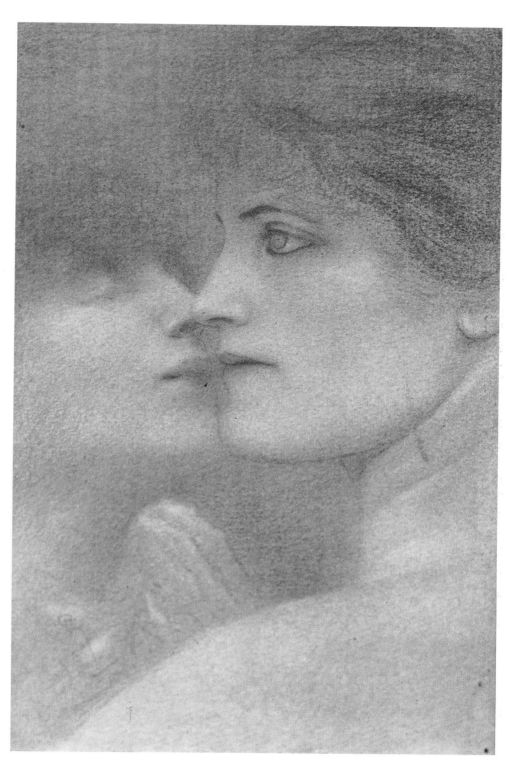

Fernand Khnopff
Study of Women, c. 1887
Red chalk on paper, 12.5 x 8.5cm
Private collection, New York

greater formal inventiveness than Moreau, seven years his senior; he might be said to anticipate Expressionism. His *The Temptation of Saint Anthony* and *Pornokrates* (both 1878, pp. 100–101) are similarly original conceptions.

Discussing *Pornokrates* in a letter to Rops, the Brussels lawyer and novelist Edmond Picard, who owned the work, spoke of "the feminine being (*l'être féminin*) who dominates our age and is so amazingly different from her ancestors…" The phrase is conventional, but the very recurrence of clichés is what makes them significant. Rops also pandered to public demand by exploiting the clichés of his day, and it is a pleasure to watch his keen wit at work. Full of derision, his work also

All these women – like the panther-woman of *The Caresses* – share a characteristic of Khnopff's art: a heavy and rather masculine jaw. This is one aspect of a tendency in Symbolist art to blur the differences between the sexes and create a universal androgyny.

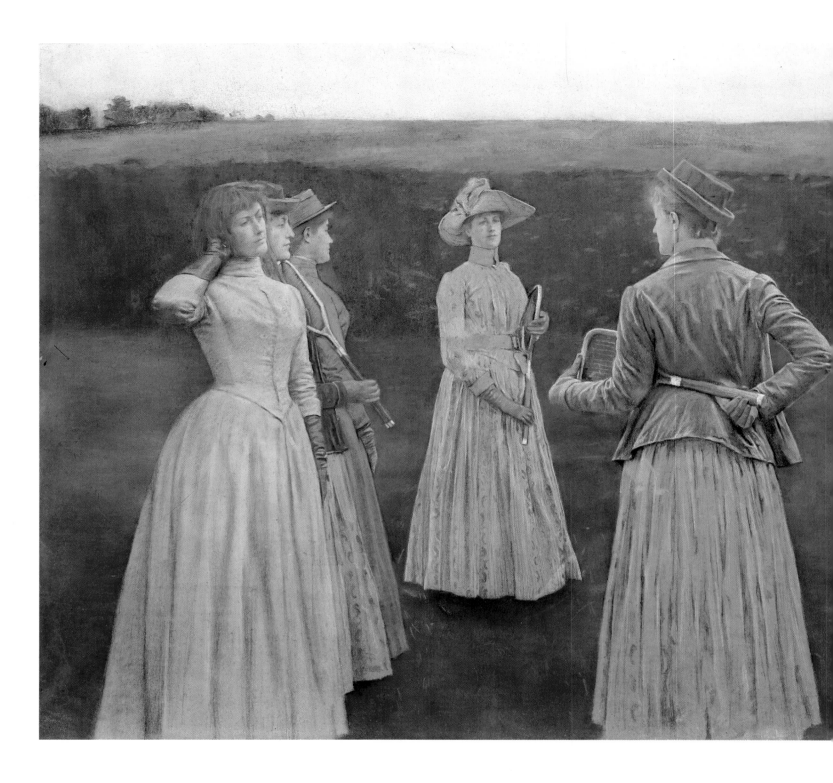

Fernand Khnopff
Memories, 1889
Pastel, 127 x 200 cm
Musées Royaux des Beaux-Arts, Brussels

bears the imprint of that immense facility which, by his own admission, prevented him from reaching the heights in his chosen art form.

The father of Fernand Khnopff (1858–1921) was an Austrian aristocrat who chose to reside in Belgium and was appointed Deputy Prosecutor of Bruges. As a result, Knopff spent the first seven years of his life in that sublime but stagnant city; it appears in transfigured form in a number of his works. Khnopff carefully moulded his public persona, becoming a prize specimen of the dandy. He was not without wit and simultaneously pursued the profession of society portraitist. Around 1900, like des Esseintes, he drew up plans for a villa of geometrical lines and had it built for himself. Unfortunately, it has not survived. His motto, "on n'a que soi" ("one has only oneself"), made a principle of

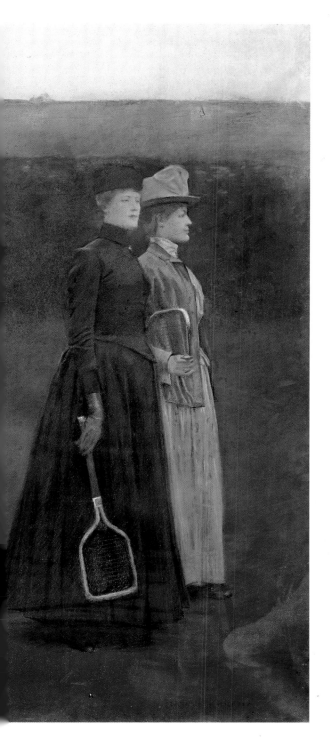

his overt narcissism. Khnopff showed his work at the Rose+Croix Salon at the invitation of Sâr Péladan but his greatest triumph came when he exhibited at the Vienna Secession in 1898. Reacting to one such exhibition, the critic Félix Fénéon singled him out for criticism: "M. Fernand Khnopff and a good number of his fellow exhibitors cannot be made to grasp the fact that a painting should first and foremost seduce by its rhythms, that a painter shows excessive humility in choosing subjects rich in literary meaning, that three pears on a table cloth by Paul Cézanne are moving and sometimes mystical, and that, when they paint it, the Wagnerian Valhalla is no more interesting than the House of Representatives." The parallel with Odilon Redon's self-imposed strictures is clear.

Photographs of Marguerite Knopff, c. 1888

These photos, which formed the basis for *Memories*, were taken by Khnopff himself with a technically sophisticated camera containing a lens by Steinhel of Munich. Khnopff was in love with his sister and attached great importance to the fabrics (often embellished with gold) in which he dressed her for photo sessions in which he himself determined her poses.

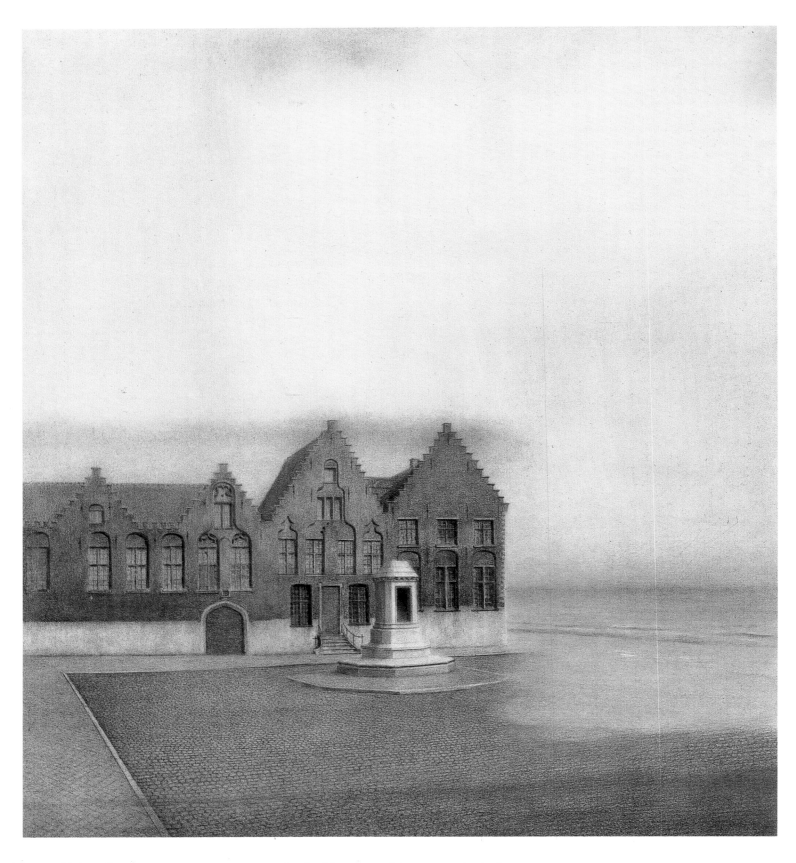

Fernand Khnopff
The Abandoned Town, 1904
Charcoal drawing, black pencil and pastel on
paper backed with canvas, 76 x 69 cm
Musées Royaux des Beaux-Arts, Brussels

We are set before a scenic square in Bruges; no
sign of life is apparent. Even the statue has been
removed from the pedestal. Under a pale brown
sky, the rising waters of the sea seep relentlessly
across the square, covering the cobblestones with
their serene invasion. The spectator thus
becomes the sole witness of the "end of the
world". Bruges stands for the decadence of a
modern society which, at the height of its eco-
nomic power, was destined for military and cul-
tural disaster.

PAGE 93:
William Degouve de Nuncques
The Shuttered House or *The Pink House*, 1892
Oil on canvas, 63 x 43 cm
Rijksmuseum Kröller-Müller, Otterlo

An important painting which was to influence
Magritte.

William Degouve de Nuncques
The Angels of Night, 1894
Oil on canvas, 48 x 60 cm
Rijksmuseum Kröller-Müller, Otterlo

The works of Degouve de Nuncques are often a poetic evocation of childhood daydreams. This is as true of *The Pink House* (p. 93) as of this nocturnal vision in which angels kiss in a ghostly, supernatural park.

Though Khnopff indulged in the academic clichés of the age, in certain works he transcended them and showed real formal invention. One such work is *Memories* (p. 90–91), a large pastel dating from 1889. Khnopff's superlative technique is central to the ambiguous charm of this painting. The model for all seven figure was Marguerite Khnopff, the artist's sister. Photographs often served Khnopff as studies for his paintings; *Memories* shows almost photographic precision of technique. Anticipating certain of today's mixed-media trends, Khnopff also retouched his own photos.

It has been said that he was in love with his sister; she perhaps became a second self within the hermetic bubble of his narcissism. This identification might also account for the androgynous ambiguity of a number of the women he painted; these are generally endowed with too large a chin to seem entirely feminine. Such is the case with the painting known variously as *Art*, or *The Sphinx*, or *The Caresses* (1896, p. 28 and 86).

The two faces revealed by the artist's meticulously academic technique, the panther with a woman's head and the youth leaning on his winged stick, his gaze lost in the distance, are typical of the way the artist handles features and expressions. One is initially struck by the

portentous tone of the work, but it is the rapt absorption of the two faces placed cheek-to-cheek that continues to haunt the eye.

The title of *I Lock my Door upon Myself* (1891, p. 8) is a quotation from a poem by Christina Rossetti, Dante Gabriel's sister; the painting expresses an indulgent pleasure in solitude, visible in the dreamy self-absorption of the woman and the labyrinthine setting over which presides a bust of Hypnos, the god of sleep. The composition, with its arrangement of horizontal and diagonal lines carefully centered around the pale gaze of the young woman, is a perfect embodiment of the claustrophobic mood typical of much Symbolist work.

Another painting by Khnopff anticipates the kind of world's end fantasy that the cinema so readily exploits. In *The Abandoned Town* (1904,

Jean Delville
Satan's Treasures, 1895
Oil on canvas, 258 x 268 cm
Musées Royaux des Beaux-Arts, Brussels

Delville believed in a divine fluid, reincarnation, dangerous telepathic forces, invultuation and ecstasy. These convictions guided his hand in - *Satan's Treasures*, in which luxurious bodies lie sleeping among the seaweed and coral as Satan, with a dancer's agility, bestrides and takes possession of them.

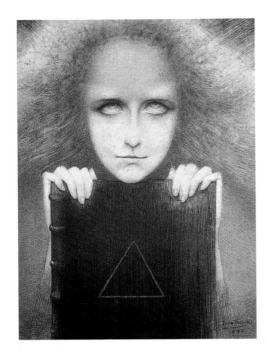

Jean Delville
Portrait of Madame Stuart Merrill, 1892
Pencil, 38.1 x 27.9 cm
Private collection, USA

p.92), the effect is the more telling because the scene is silent and contemplative. We are set before a scenic square in Bruges; no sign of life is apparent. Even the statue has been removed from the pedestal. Under a pale brown sky, the rising waters of the sea seep relentlessly across the square, covering the cobblestones with their serene invasion. The spectator thus becomes the sole witness of the "end of the world". Bruges here assumes symbolic status. The city that had died to trade at the end of the 16th century under the joint effect of a hostile political power and the silting up of the River Zwyn now stands for the decadence of a mod-

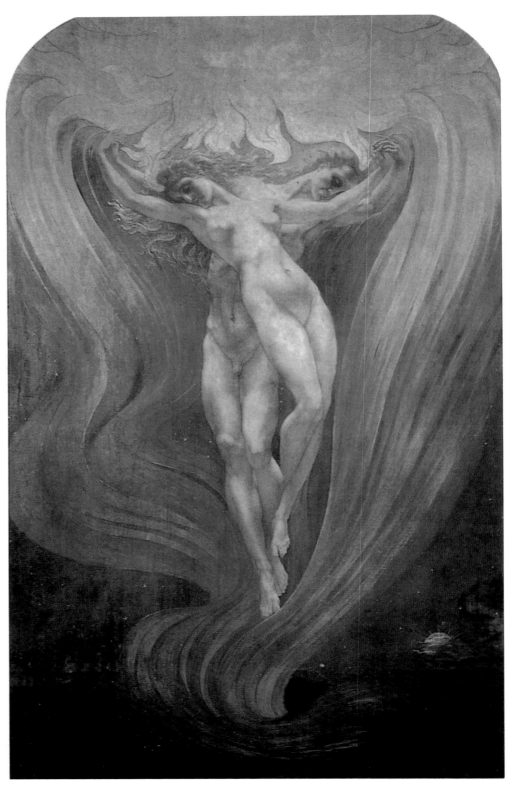

Jean Delville
The Love of Souls, 1900
Egg tempera on canvas, 238 x 150 cm
Musée d'Ixelles, Brussels

Delville illustrates the fusion of man and woman who thus return to the primordial androgyny described by Aristophanes in the humorous fable recorded in Plato's *Symposium*. No humour here, but idealism in plenty.

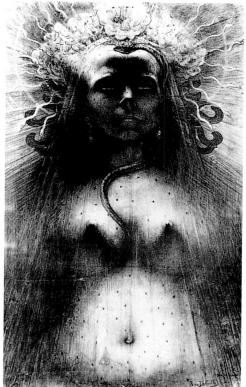

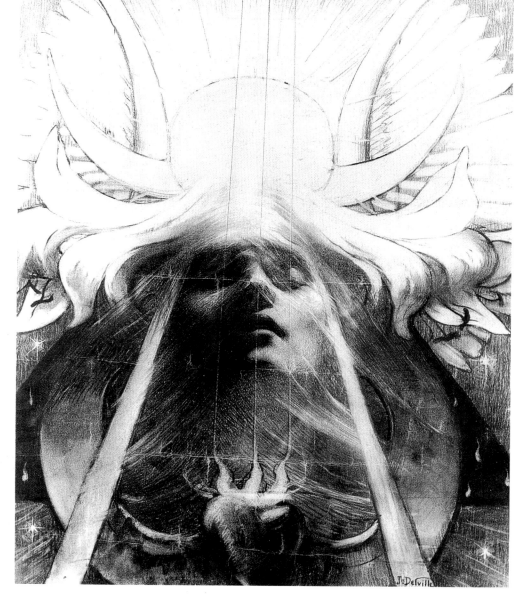

ern society which, at the height of its economic power, was indeed destined for military and cultural disaster.

James Ensor (1860–1949) is too potent and fertile an artist to fit the categories available to theory. He clearly belongs among the Symbolists, but rather after the fashion of the poet Jules Laforgue. Both Ensor and Laforgue use their powers of derision to unmask and disintegrate the threadbare, skeletal shibboleths revered by their more solemn and blinkered colleagues.

Born in Ostend, the son of an English father and a Belgian mother, James Ensor received a hostile reception not only from the critics but also from his own supposedly avant-garde colleagues. He escaped expulsion from the Salon des XX in 1889 by a single vote – his own. It was around 1900, when he was past forty, that Ensor finally won the recognition until then denied him. He was awarded the title of Baron, but his belated success had an unexpected consequence: Ensor's inspiration ran dry and the man survived the artist.

By a strange coincidence, Ensor had the same childhood experience as Leonardo da Vinci: a large black bird flew in through the window

LEFT:
Jean Delville
The Idol of Perversity, 1891
Chalk on paper, 98 x 56 cm
Private collection, Milan

RIGHT:
Jean Delville
Parsifal, 1890
Charcoal drawing, 70 x 56 cm
Private collection

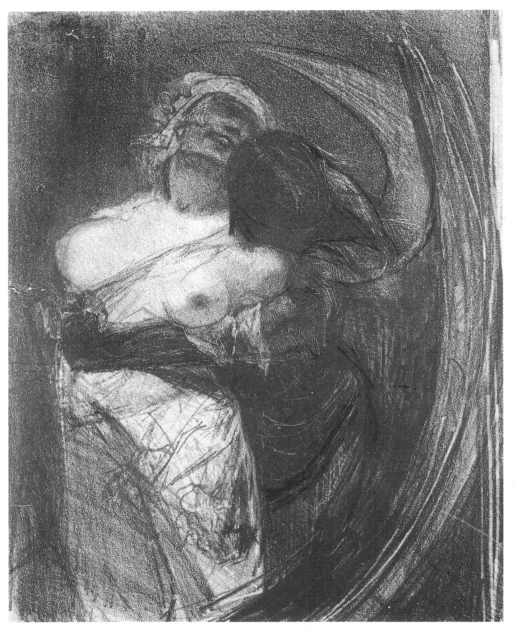

Félicien Rops
The Cold Devils, c. 1860
Lithograph, 17.2 x 13.7 cm
Cabinet des Estampes, Bibliothèque Royale
Albert Ier, Brussels

Félicien Rops
The Sacrifice, a plate from *Les Sataniques*, 1882
Soft ground, 24 x 16.5 cm
Musée Félicien Rops, Namur

PAGE 99:
Félicien Rops
Death at the Ball, c. 1865–1875
Oil on canvas, 151 x 85 cm
Rijksmuseum Kröller-Müller, Otterlo

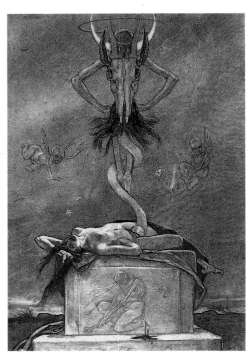

and settled on the crib of the terrified child. Ensor's shopkeeping parents sold toys, articles for the beach, souvenirs and carnival masks. It is these masks, along with sardonic and insolent skeletons, that provide the dominant theme of Ensor's work. The ferocious sarcasm of his paintings, drawings and prints is, however, balanced by the pathos of his tragic representations of a Christ who figures as the artist's *alter ego*.

This identification, also to be found in the work of Paul Gauguin and Henry de Groux, may appear excessive if not indeed blasphemous. It is no doubt meant to assert the artist's singularity. But it also touches upon a rather less obvious psychological process. It is something of a commonplace to note that the ego is not fully formed at birth. It takes shape throughout childhood, moulded by the sometimes painful conflict between the anarchy of the drives on the one hand and the sometimes intolerable demands of the cultural ideal on the other. An ego that struggles to conform to accepted norms and is thus led, as artists often are, to take some other, less familiar route, may be tempted to regard itself as both hero and victim. This is why Christ's final triumph, the

PAGES 100–101:
Félicien Rops
The Temptation of Saint Anthony, 1878
Crayon, 73.8 x 54.3 cm
Cabinet des Estampes, Bibliothèque Royale
Albert Ier, Brussels

The story of Saint Anthony the Hermit, as Hieronymus Bosch, Flaubert and Rops had all noted well before Freud, is one of repressed material erupting to the surface. Rops' work, showing a naked woman replacing Christ on the Cross, was a considerable provocation in the pious atmosphere of the Belgium of the day. Freud cited this work as a metaphor for "the typical case of repression".

Félicien Rops
Pornokrates, 1878
Water-colour, pastel and gouache, 69 x 45 cm
Ministère de la Culture et des Affaires Sociales de la Communauté Française de Belgique, held by the Musée Félicien Rops, Namur

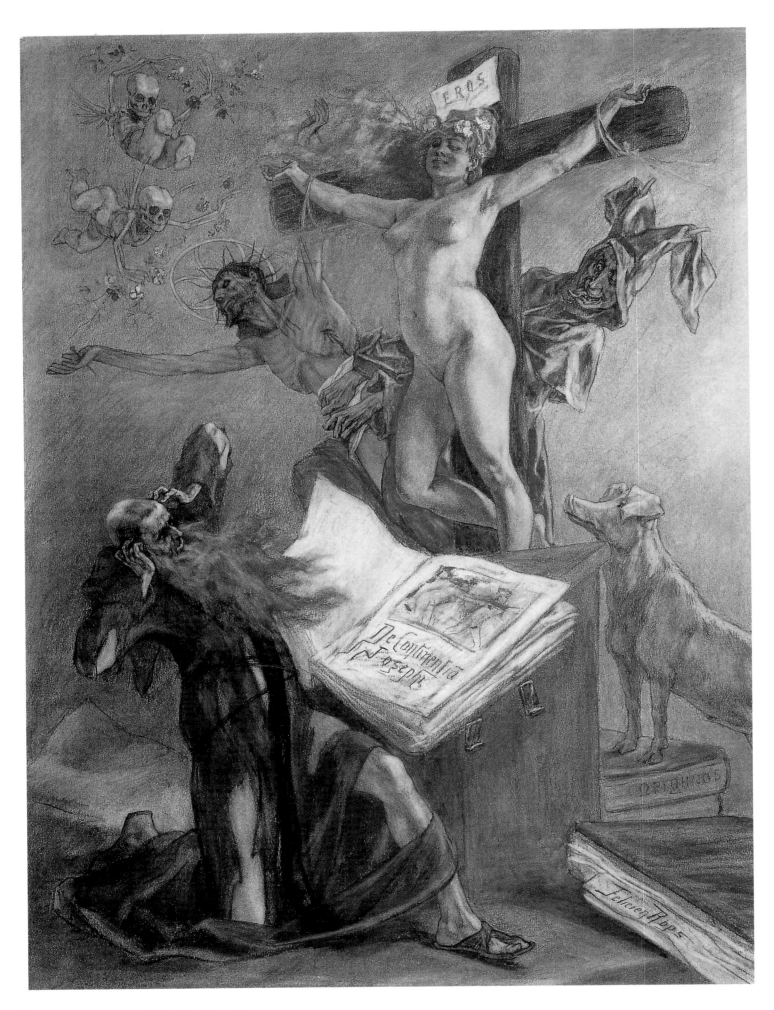

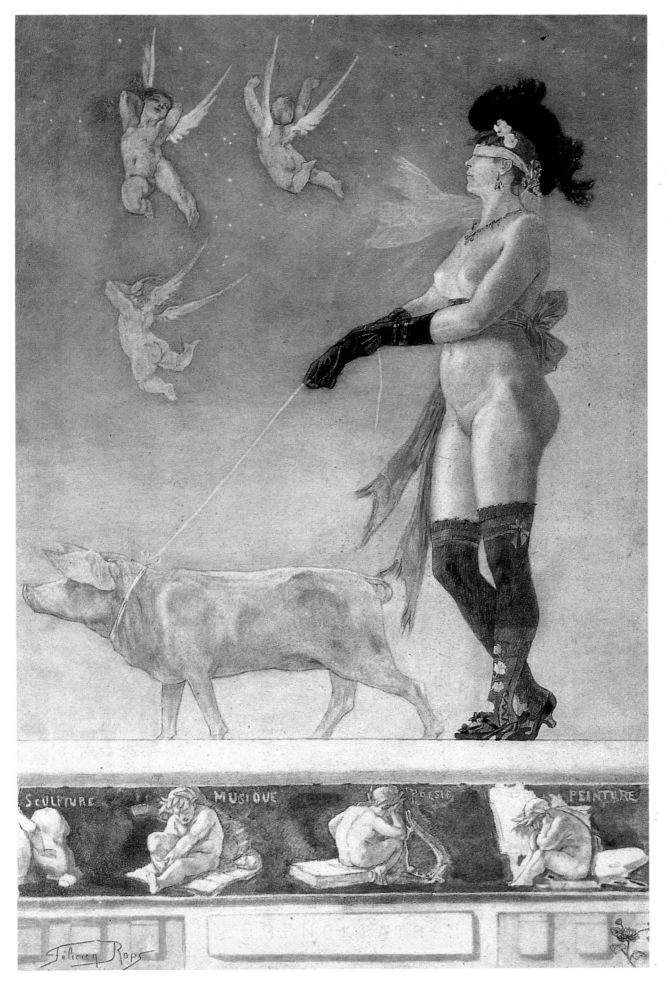

James Ensor
Christ's Entry into Brussels, 1888–1889
Oil on canvas, 258 x 431 cm
Musée des Beaux-Arts, Antwerp

This huge canvas is one of Ensor's masterpieces.
The artist identifies with Christ, who is here
given a rowdy triumph utterly at odds with all
that he represents.

PAGE 103 TOP:
James Ensor
The Dying Christ, 1886
Charcoal and conté on paper backed with
canvas, 61 x 76 cm
Musées Royaux des Beaux-Arts, Brussels

In this powerful and original vision, the dying
Christ is tormented by triumphant demons.

triumph of the "stone rejected by the builders and which is become the
corner stone," stands as the model of a victory accomplished by sacri-
fice and voluntary suffering.

In Ensor's paintings, Christ's persecutors wear the features of the
critics who attacked his work – names saved from oblivion only by
the artist's resentment. But even the ultimate triumph of the painter-
as-Christ, Ensor's colossal *Christ's Entry into Brussels* (pp. 102–103),
is a hollow one. His diminutive, mild-featured Christ seems frail and
isolated, overborne by a tide of brutal masks and rampant vulgarity.
This may, in part, explain Ensor's reaction to his eventual success. He
had sought the kind of sensitive acknowledgement that his work com-
mands today, and received in its stead formal honours and unthinking
accolades.

Ensor's startling palette and formal invention combine with his irony

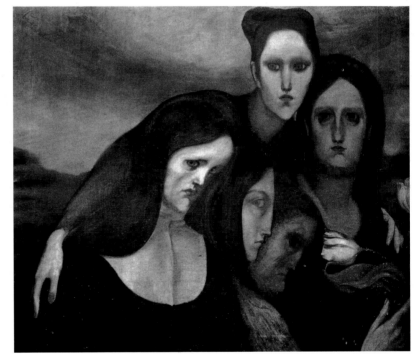

to remove him from the scope of contemporary stereotypes. No reproduction can do his colours justice, and the reader leafing through this book should bear in mind that Ensor's work needs more than most to be encountered face to face.

The work of Xavier Mellery (1845–1921) divides into two categories: a delicate, domestic world of some charm, and mural art of predictable allegorical content. Fernand Khnopff chose Mellery as his teacher, and *The Abandoned Town* (p. 92) might be considered a dreamlike transposition of the silent, shadowy scenes that feature in the best of Mellery's work.

The aspirations and imaginative powers of Henry de Groux (1867–1930) were clearly greater than his technical ability. He was a notably difficult character, a fact he despairingly acknowledged in his diary: "It is my destiny to compromise everything." His art nevertheless elicited

Emile Fabry
The Gestures, 1895
Oil on canvas, 93 x 100 cm
Private collection, Brussels

These depressive faces and strangely swollen heads evoke the theatrical world of Maurice Maeterlinck; in the words of Félicien Rops, Maeterlinck's works were suited to "women of the North, with brackish hair, hydrocephalic foreheads and other-worldly eyes, part angel and part seal".

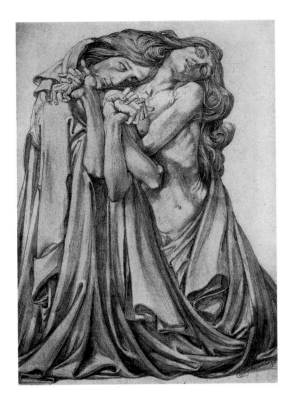

a favourable reaction from Guillaume Apollinaire and an enthusiastic one from Léon Bloy. The latter hailed him as a prophet after seeing the *Mocking of Christ* (1887), which de Groux had painted at the age of twenty-one. The painting is comparable in its overblown rhetoric to the films of Abel Gance: a convulsive mass of human bodies engulfs the figure of Christ – whose appearance is modelled on that of the artist himself. The prophetic nature of his *Great Upheaval* (p. 14) has already been discussed; it does indeed convey in naive form, the sense of "world's end" that is more articulately set forth in the work of Friedrich Nietzsche.

Both Emile Fabry (1865–1966) and Jean Delville (1867–1953) proclaimed themselves "idealist" painters and strove to elevate the public through their art. Their work is consequently guided by edifying principles rather than by formal invention. In this respect, they are representative of much Symbolist art. Both displayed their work at the Rose+Croix Salon and were at one point influenced by Péladan.

Fabry lived to be over a hundred; he left a corpus of highly mannered works, all depressive faces and strangely swollen heads. These evoke the theatrical world of Maurice Maeterlinck; in the words of Félicien Rops, Maeterlinck's works were suited to "women of the North, with brackish hair, hydrocephalic foreheads and other-worldly eyes, part angel

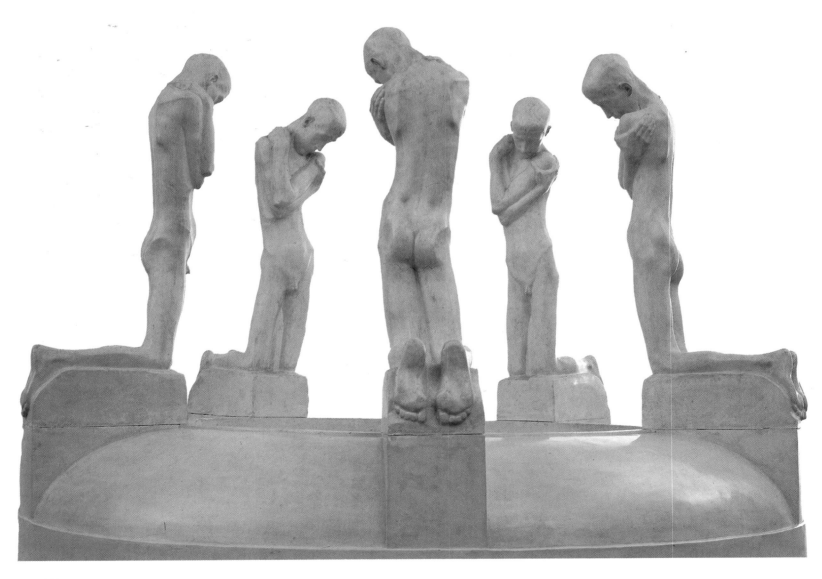

TOP:
Xavier Mellery
The Hours, or *Eternity and Death*, undated
Oil on canvas, 144 x 80 cm
Private collection

PAGE 104 TOP:
George Minne
The Outcast, 1898
Lithograph, 26.8 x 18.2 cm
Bibliothèque Royale Albert Ier, Brussels

PAGE 104 BOTTOM:
George Minne
The Fountain of the Kneeling Youths, c. 1898
Plaster, 168 cm high, 240 cm long
Museum voor Schone Kunsten, Ghent

and part seal". The monstrous creatures of his painting *The Gestures* (p. 103) fit this description perfectly. Fabry himself described the period before 1900 as "the period of my nightmare", acknowledging the influences of Wagner, Maeterlinck, and Edgar Allan Poe.

Delville was a devotee of the occult who published a book entitled *Dialogue among Ourselves. Cabbalistic, Occult and Idealist Arguments (Dialogue entre nous. Argumentation kabbalistique, occultiste, idéal-*

Henry de Groux
The Death of Siegfried, 1899
Oil on canvas, 151 x 120.5 cm
Private collection

iste, 1895). In it, he developed various notions held by occultists: he believed in a divine fluid, reincarnation, dangerous telepathic forces, invultuation and ecstasy. These convictions guided his hand in works such as *The Angel of Splendor*, a rather over-deliberate vision of ecstasy, or *Satan's Treasures* (p. 95), in which luxurious bodies lie sleeping among the seaweed and coral as Satan, with a dancer's agility, bestrides and takes possession of them.

The work of Georges Minne (1866–1941) exemplifies the anaemia and prostration of his age. It dwells insistently upon subjects such as mourning and impotence: a mother weeps over her dead child, adolescents are stilled amid the briars, men and women are racked and contorted by guilt. It was not by chance that the artist came to this sort of subject. Infant mortality was high at the time, but the mother with her dead child may also reflect the lack of spiritual perspectives experienced during the last decades of the century. Minne's form, radiating the intense and suffering religiosity of his country, is characterized by often painfully affected references to postures and attitudes in the work of the Flemish primitives. Copies of his *Fountain of the Kneeling Youths*

Constant Montald
The Nest, 1893
Oil on canvas, 55 x 46 cm
Musées Royaux des Beaux-Arts, Brussels

Xavier Mellery
Autumn, 1893
Water-colour and chalk, 90.5 x 57 cm
Musées Royaux des Beaux-Arts, Brussels

PAGE 107:
Georges de Feure
The Voice of Evil, 1895
Oil on wood, 65 x 59 cm
Private collection

The title rather than the work testifies to the puritanism of the period, which saw evil as largely sexual in kind. The woman represented is clearly attracted by lesbian love: the voice of evil.

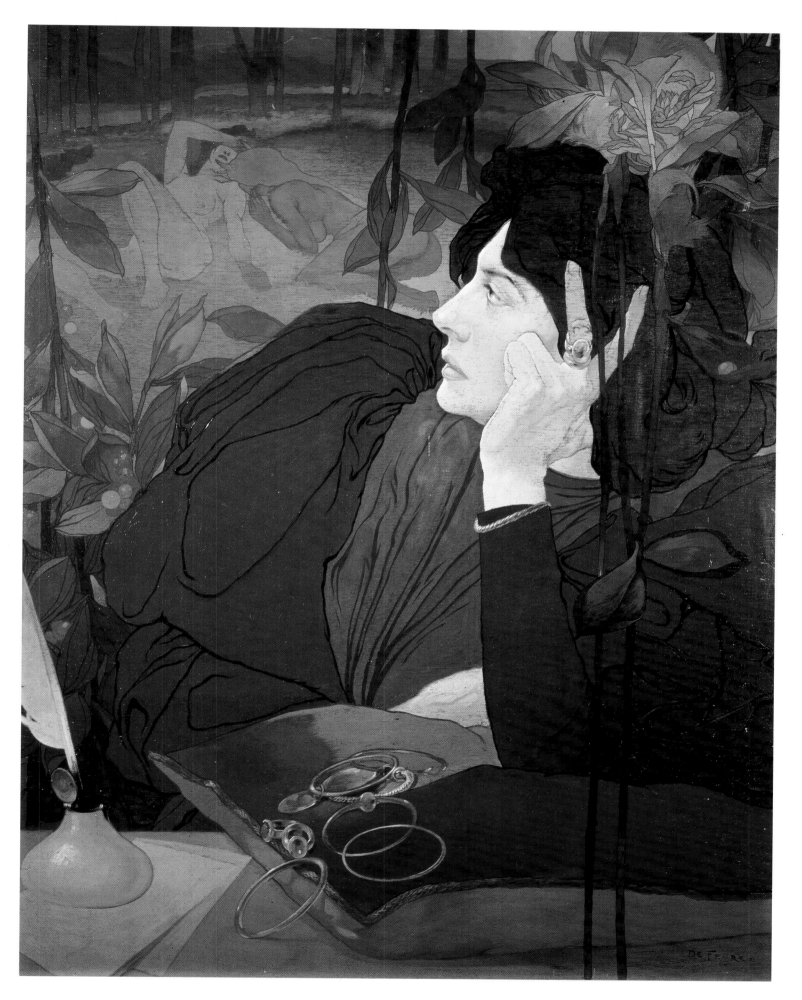

(1898, p. 104) are now to be seen in Brussels, Ghent, Vienna and Essen. It is probably the best work of his Symbolist period; elsewhere, the contorted gestures, the hysterically knotted hands, convey the *idea* of pathos rather than pathos itself. Minne stands on one of the outer limits of Symbolist sensibility.

The intimate, dreamy works of William Degouve de Nuncques (1867–1935) show signs of the influence of both Mellery and Khnopff.

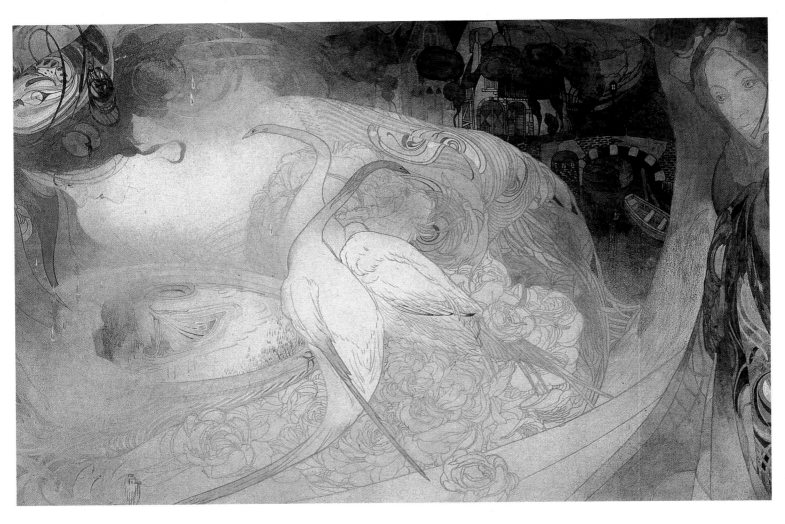

Georges de Feure
Swan Lake, c. 1897
Water-colour, 32.1 x 51.5 cm
Private collection

A delicately ornamental work, mingling woman, boats and birds in a luminous tracery that is difficult to decipher.

The Degouve de Nuncques were an old French family who settled in Belgium during the Franco-Prussian war of 1870. Degouve de Nuncques' father was a giant of a man who cultivated his eccentricity; in the words of the painter's friend, Henry de Groux, he "detests anything that represents authority, loves animals even more than mankind, and walks about with a loaded shotgun to shoot at neighbors bent on harming his cats."

He encouraged his son to daydream, thus favouring the development of a talent which owed more to imagination than to technical facility. Degouve de Nuncques' work is sometimes awkward, but a painting like *The Pink House* (p. 93) is singularly evocative of the feeling of homecoming elicited by a warmly lit house under a starry sky. Many of his works may be considered poetic evocations of childish daydreams, *The Pink House* among them. (It prompted Magritte to paint one of his most successful works.) There is a childish innocence to these nocturnal visions in which a black swan sails silently past ivy-covered tree trunks, or angels kiss in the squares at night

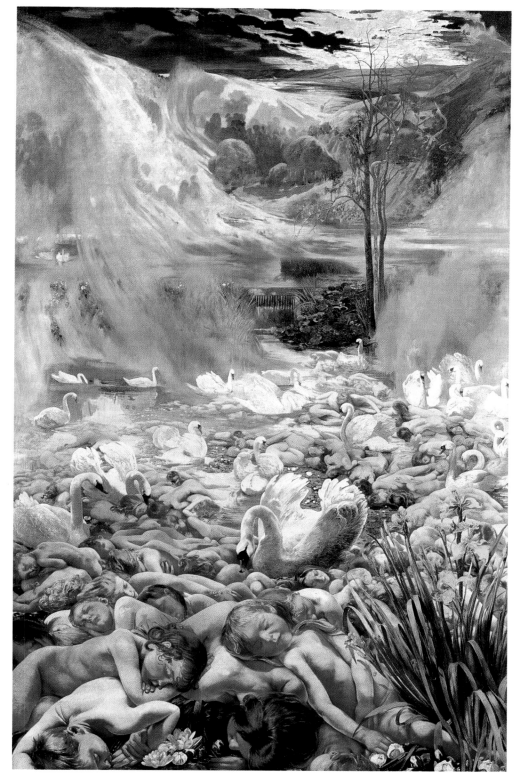

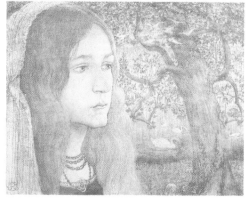

LEFT:
Léon Frédéric
The Lake, the Sleeping Water, 1897–1898
Right-hand panel of the tryptch *The Stream*,
oil on canvas, 205 x 127 cm
Musées Royaux des Beaux-Arts, Brussels

Frédéric, an idealist painter torn between Symbolism and academic realism and between lofty concepts and social commitment, produced remarkable works of symbolic depth.

(*The Angels of Night*, p. 94) while chestnut trees lift their white candle-sticks in the moonlight.

Born, like Ensor, in Ostend, Léon Spilliaert (1881–1946) was the son of a wealthy perfumer. He was the last of the Belgian Symbolists. For many years he was afflicted with acute anxiety; his insomnia drove him to wander nightlong through deserted streets and along empty beaches. He haunted the street where Ensor lived, to the point where the latter remarked that he could never take a stroll on his own because Spilliaert was always at his door.

Richard Nicolaus Roland Holst
Anangke (Necessity), 1892
Lithograph on paper, 35.5 x 32.6 cm
Museum Boymans-van Beuningen, Rotterdam

Richard Nicolaus Roland Holst
Helga's Entry, 1893
Lithograph, 30.1 x 35.6 cm
Museum Boymans-van Beuningen, Rotterdam

Suffering from insomnia, this late Symbolist prowled by night through the streets and along the deserted beaches that he depicts. By the age of 23, he was creating expressive and simplified forms of great authority; his singular use of visual rhythms and voids on occasion communicates a sense of anxiety worthy of Alfred Hitchcock. One such painting is *Vertigo* in which a female figure descends a nightmare staircase of ever larger steps. Other works stress a sense of solitude enhanced by endless empty beaches and the silent sea. The horizontality of the Belgian coast is made to seem as immutable as fate. But humanity is present in the form of the truculent, metaphorical eroticism inhabiting this desolation, as in *The Posts* and *The Forbidden Fruit*.

Spilliaert's work achieved its characteristic form while he was still quite young. By the age of 23, he was creating expressive and simplified forms of great authority; his singular use of visual rhythms and voids on occasion communicates a sense of anxiety worthy of Alfred Hitchcock. One such painting is *Vertigo, Magic Staircase* (1908, p. 110) in which a female figure descends a nightmare staircase of ever larger steps. Other works stress a sense of solitude enhanced by endless empty beaches and the silent sea. The horizontality of the Belgian coast is made to seem as immutable as fate.

Spilliaert's mood shifted with the passing years. His marriage, the birth of his daughter, and his move to Brussels during the twenties gave his work a new orientation. As early as 1904 he had turned against his Symbolist works and was tempted to destroy them. Fortunately they survive, original in themselves and, like Munch, a significant point of transition between Art Nouveau and Expressionism.

Like Belgium, the Holland of the last decades of the 1800s was a prosperous country and a point of intersection for both commerce and

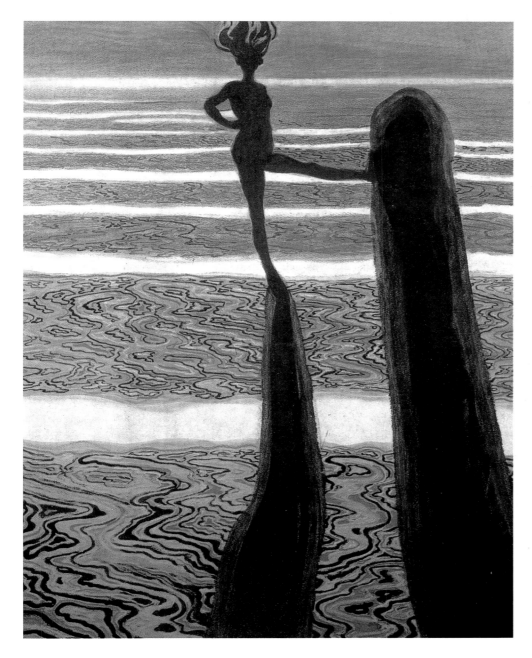

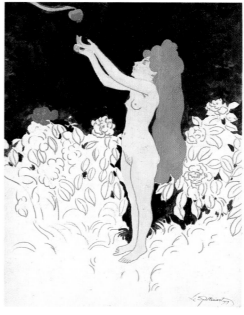

culture. Unlike Belgium, Holland was and remains a Protestant country. This seems to have been the decisive factor that made Belgium rich in Symbolist art and Holland comparatively poor.

The form of realist art favoured in the Netherlands and exemplified at the turn of the century by the School of the Hague was the product of an implicit theology, a philosophy of life and of art which lies outside the present subject. Van Gogh, now probably the most famous painter of this period, was initially a practitioner (albeit a very independent one) of the style then prevailing in Holland; to find a new and different approach, he had to go to France. Should one conclude that the pragmatic outlook of a Protestant society had lost touch with the symbolic register active in Catholic countries – as of course throughout Asia, Africa and South America? A century of anthropological studies has clearly identified the symbolic structure of human societies and of our representations of the world. This structure is far from arbitrary; it obeys a logic similar to the logic of dreams. And scientific positivism, the dominant ideology of the turn of the century, could not

LEFT:
Léon Spilliaert
The Posts, 1910
Indian ink wash and crayon, 65 x 50 cm
Private collection

RIGHT:
Léon Spilliaert
The Forbidden Fruit, 1919
Indian ink wash and watercolour, 40 x 29 cm
Private collection

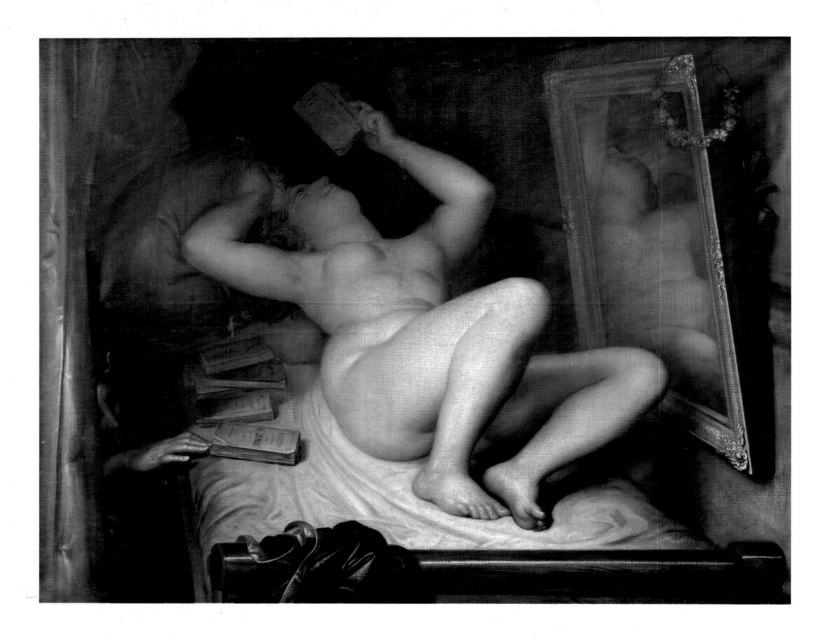

Antoine Wiertz
The Novel Reader, 1853
Oil on canvas, 125 x 155 cm
Musée Wiertz, Brussels

A precursor of Belgian Symbolism, Wiertz also
painted moralising works of the kind that ap-
pealed to his contemporaries, investing them,
however, with a sensuality which runs counter to
his supposed intentions. The works here sup-
plied by the attentive devil to this ecstatic nude
reader are those of Alexandre Dumas, which will
surely bring her to perdition.

Antoine Wiertz
The Beautiful Rosine, 1847
Oil on canvas, 140 x 110 cm
Musée Wiertz, Brussels

Contrary to one's expectations, the title of the
work, *The Beautiful Rosine*, is not the name
of the nubile nude model but of the skeleton,
whose skull bears a label to this effect.

perceive the function or logic of this register. This is what incited a
"public weary of Positivism" (as Huysmans put it), to turn to "char-
latans" and "windbags". It also led certain artists to put their art at the
service of the Ideal – a fallacy similar to that of placing one's art at the
service of the People.

The two significant Symbolist figures of the Netherlands are Jan
Toorop (1858–1928) and Johan Thorn Prikker (1868–1932). Toorop
discovered Symbolism while staying in Belgium; Thorn Prikker was
in turn influenced by Toorop and by his admiration for Maurice
Denis.

Toorop is a painter of striking formal eccentricity. A partial explana-
tion lies in his origin and childhood: he was half-Javanese and spent his
childhood in Java. The figures encountered in his paintings are those of
the Javanese shadow theater, with their long, thin arms. From our own
perspective, the work of both Toorop and Thorn Prikker appears schem-

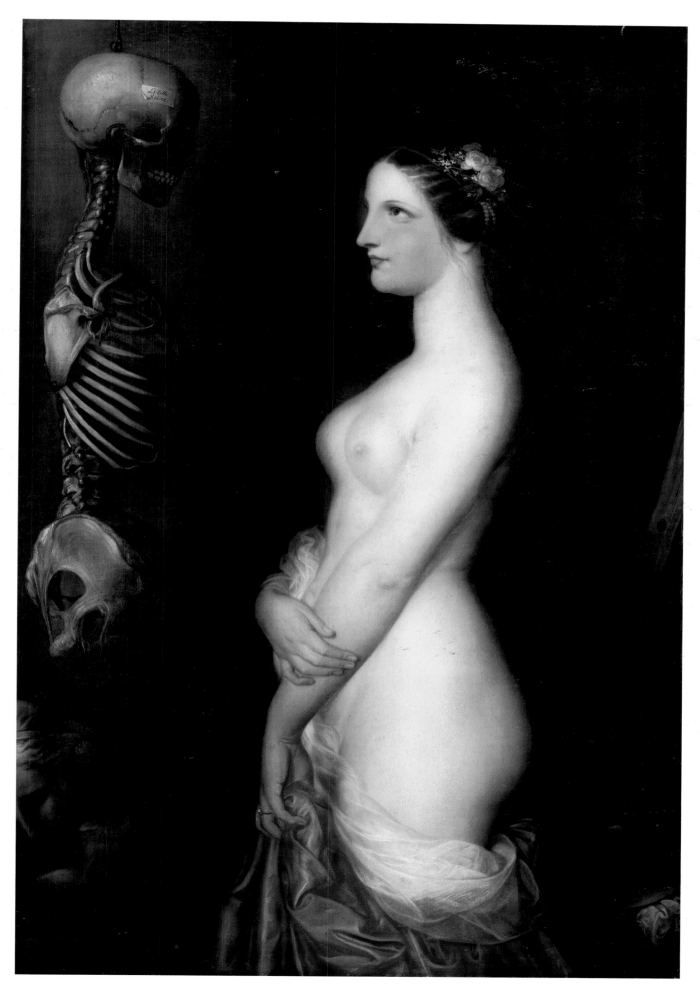

PAGE 115, TOP LEFT:
Jan Toorop
Turning in on Oneself, 1893
Water-colour, 16.6 x 10cm
Museum Boymans-van Beunigen, Rotterdam

Jan Toorop
The Young Generation, 1892
Oil on canvas, 96.5 x 110cm
Museum Boymans-van Beunigen, Rotterdam

The child in the highchair is the daughter of the artist. She turns her back on the past (her mother, who carries withered flowers) and lifts her arms towards the luminous and mysterious world. Modernity is signified by the telegraph post and the rail.

atic and overliteral. Toorop himself offers a perfectly banal commentary on his painting *The Three Fiancées* (1893, p.115): "The central fiancée evokes an inward, superior and beautiful desire… an ideal suffering… The fiancée on the left symbolizes spiritual suffering. She is the mystic fiancée, her eyes wide with fear…." The bride on the right has "a materialistic and profane expression…" and stands for the sensual world.

Thorn Prikker took Toorop's formalism a step further; the garland worn by *The Bride* (p. 115) echoes Christ's crown of thorns. The work is of considerable formal interest and suggests that the schematic forms favoured by both artists were stages in the process of abstraction.

It is significant that Toorop transformed his style in painting a testament of love for his infant daughter. *The Young Generation* (p. 114) shows the child seated in her high chair, turning her back on the past and lifting her arms to the luminous and mysterious world that opens before her.

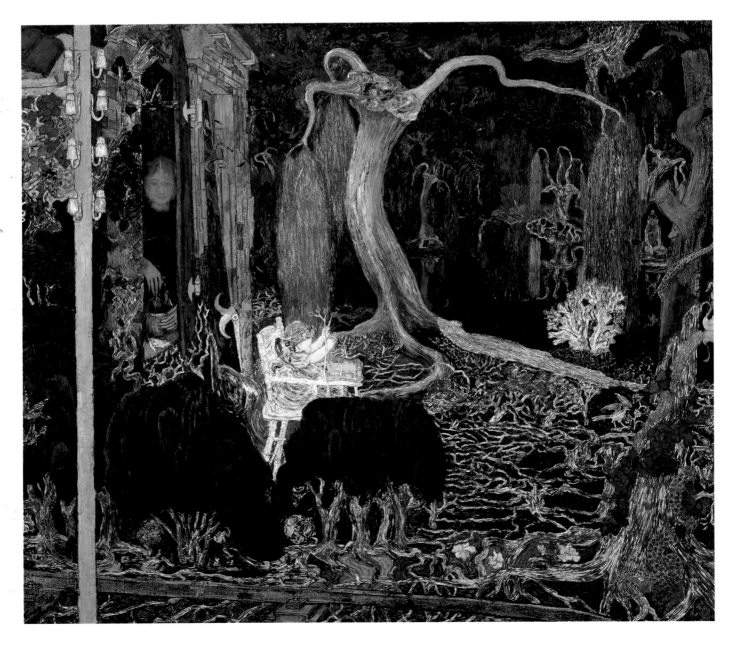

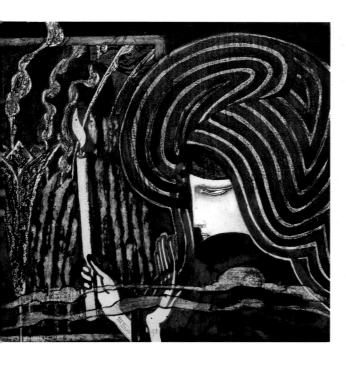

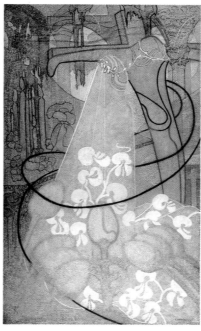

TOP RIGHT:
Johan Thorn Prikker
The Bride, 1892–1893
Oil on canvas, 146 x 88 cm
Rijksmuseum Kröller-Müller, Otterlo

The bride's flowering wreath is of the same stem as Christ's crown of thorns. The formalism of this kind of work, later adapted by Mondrian, leads directly to abstraction.

BOTTOM:
Jan Toorop
The Three Fiancées, 1893
Crayon and black and coloured chalk on paper, 78 x 98 cm
Rijksmuseum Kröller-Müller, Otterlo

The artist was half-Javanese and the figures here, with their long, thin arms, are those of Javanese shadow theatre. According to the artist, "the central fiancée evokes an inward, superior and beautiful desire… The fiancée on the left symbolizes spiritual suffering". The bride on the right stands for "the sensual world".

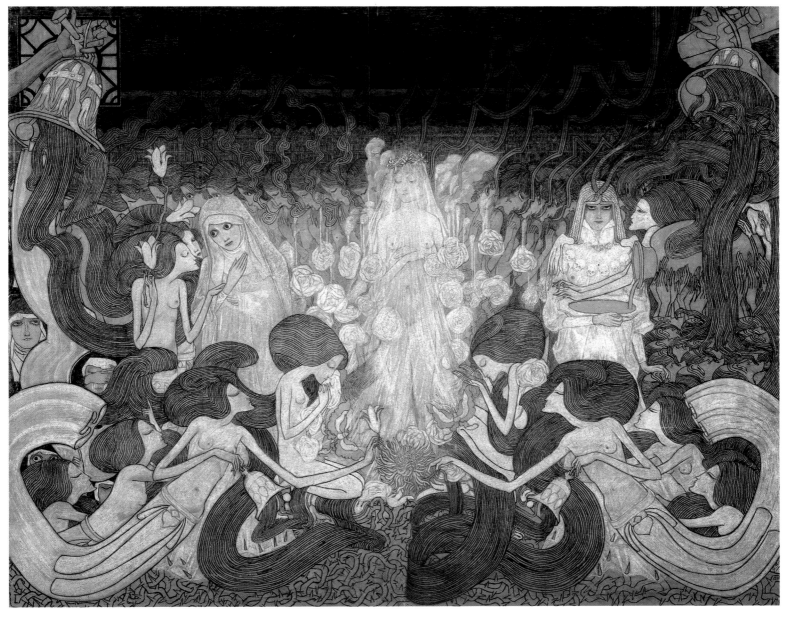

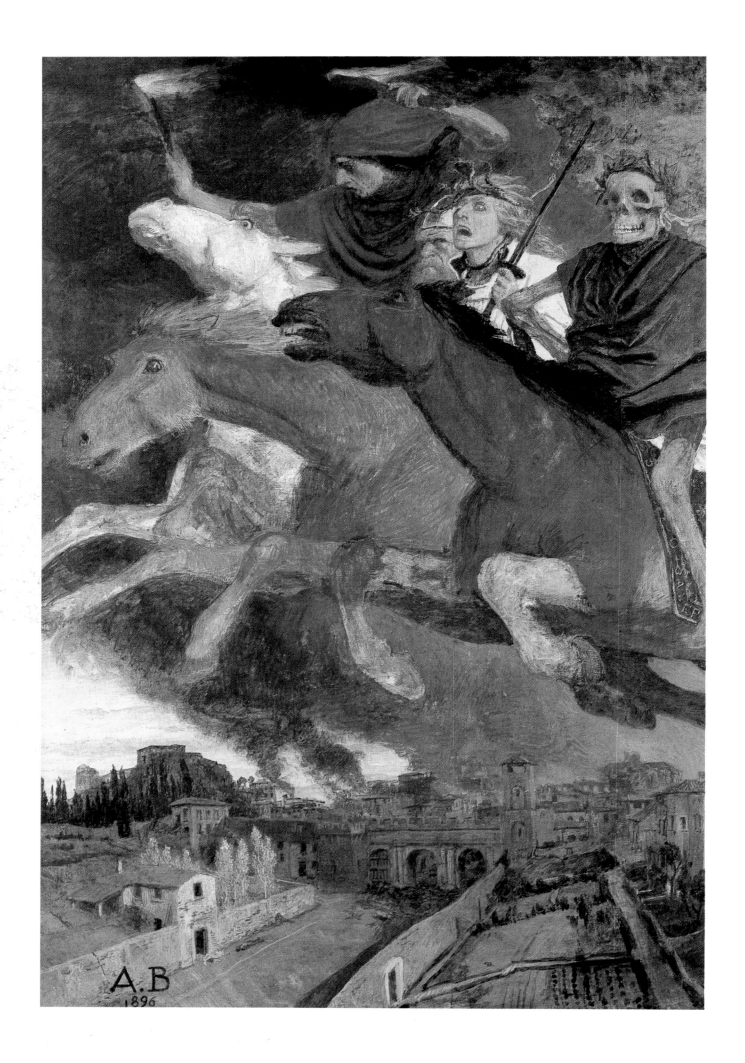

German-speaking Countries and Scandinavia

A day will come when the memory of a tremendous
event will attach itself to my name – the memory
of a crisis unprecedented in the history of the earth,
of the most profound collision of consciences,
of a decree issued against everything that had been
believed, required and hallowed until our time…
 Friedrich Nietzsche

In the German-speaking world, the "crisis unprecedented in the history of the earth" – the great social and cultural debate which Symbolist art so closely echoes – produced three giant protagonists: Richard Wagner (1813–1883), Friedrich Nietzsche (1844–1900) and King Ludwig II of Bavaria (1845–1886). Wagner and Nietzsche cast an imposing shadow over subsequent generations. Not content with transforming harmony, vocal style and the staging of opera, Wagner strove, through the hypnotic music of his tetralogy, to express a fundamental aspect of the crisis then shaking the mytho-cultural system of the West. The great operatic cycle based on the *Nibelungen* legend relates (in a form which was later to influence cinema) the mythical events leading to the twilight of the Nordic gods.

More than any other philosopher of his time, Nietzsche (who admired and defended Wagner before launching a violent polemic against him) was keenly aware of the consequences that followed from the collapse of traditional structures of thought and values. "I am, quite as much as Wagner," he declared, "a child of my time, I mean a *decadent*; the only difference is that I have been aware of this and have resisted it with all my power."

A man of delicate constitution, he was emotionally and psychologically vulnerable and subject to a variety of ills: eye-trouble, intestinal disorders and frequent migraines. He lived through this ordeal as might a tragic hero – until the ultimate collapse of his intellect. He saw it as his role in life to formulate the conditions of an existence worthy of man in a world which had survived its gods.

As we have seen, the strong sense of decadence in Europe at this time coincided with the zenith of European power. Nietzsche, with his impassioned and wilful sensibility, realized that the old ideas and philosophical categories had been irrevocably damaged by the theoretical and scientific criticism of the previous two centuries and their allies, the scientific discoveries and economic and social mutations of the day. They had therefore to be swept aside to make room for the new; this was his undertaking.[1]

Wagner is the preeminent Symbolist composer; others include Gustav Mahler (1860–1911), and Claude Debussy – who was in no sense the "Impressionist" he has often been thought. Nietzsche remains the only Symbolist philosopher, above all in the poetic and image-laden

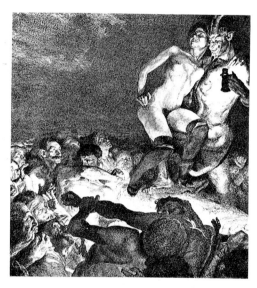

Otto Greiner
The Devil Showing Woman to the People, 1897
Lithograph, 53 x 45 cm
Gilles Néret Collection, Paris

What could be more "German" than this allegory! Here is the old puritan argument that woman is the instrument of the devil and destruction – a dominant theme in Symbolist art. It is noteworthy that the "people" here consists exclusively of men.

Arnold Böcklin
War, 1896
Oil on wood, 100 x 69 cm
Staatliche Kunstsammlungen, Dresden

This allegory of war is inspired by St John's vision of the four horsemen of the Apocalypse.

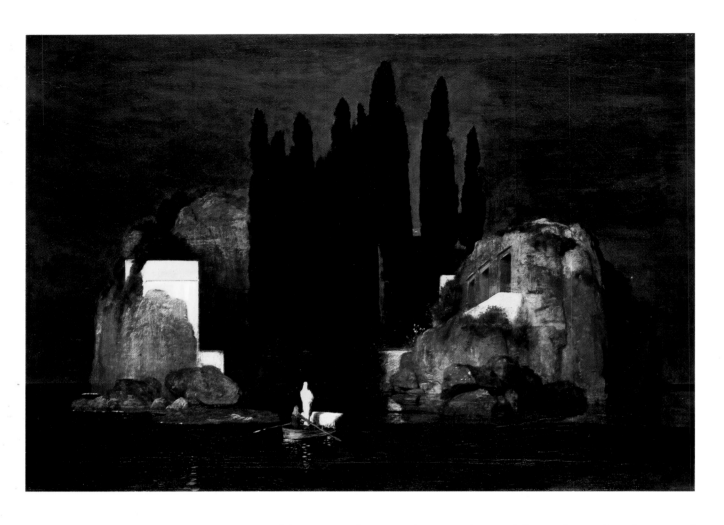

Arnold Böcklin
The Isle of the Dead, 1880
Oil on canvas, 111 x 155 cm
Kunstmuseum Basel, Basle

Painted at the request of a young widow who
wanted an "image to dream by", this powerful
vision was initially entitled "a tranquil place".

PAGE 119 TOP:
Arnold Böcklin
Venus Genitrix, 1895
Oil on canvas, 115 x 170 cm
Kunsthaus Zürich, Zurich

PAGE 119 BOTTOM:
Ludwig von Hofmann
Idyllic Landscape with Bathers, c. 1900
Oil on canvas, 65 x 96 cm
Georg Schäfer Collection, Schweinfurt

This work illustrates a practice common to
several Symbolist artists: making the frame an
integral part of the picture.

language of his *Zarathustra*; the mordant philosopher of a theory of
decay and rebirth. This makes it particularly apposite to quote his
evaluation of the spiritual climate prevailing in Germany, one which,
in many parts of the country, made Symbolism's uneasy religiosity
extremely alien. "In Germany," he writes, "among those who live
outside religion today, I find (…) a majority of men in whom the
habit of work has, from generation to generation, destroyed the relig-
ious instincts." And he goes on – he, the uncompromising atheist – to
speak with bitter irony of the naivete of the scientist of his day who
believes in his own superiority and "instinctively regards the religious
man as an inferior individual". Here, in a nutshell, is the whole issue
of Symbolism – and an explanation of why it and the problematic that
it expresses have been an object of repression throughout the the 20th
century.

As to King Ludwig of Bavaria, Wagner's patron, he embodied in
tragic form the spirit of the Symbolist age. For, like des Esseintes, he
lived withdrawn into a world of dreams. Unlike des Esseintes, he had
at his disposal the budget of a state and could satisfy his whims on an
incomparably grander scale. Royal palaces, which had in the past been
in some degree functional, became no more than a stage set on which
his delusions were enacted. No necessity of state, no symbolism of
power commanded the construction of Neuschwanstein. It was as
though the king, sensing the divorce between what he was supposed to
embody and the actual drift of the world, resolved the contradiction by
ignoring reality. And so his palaces survive, freighted with fantasy and
unreality, as perfect examples of "decadent" architecture.

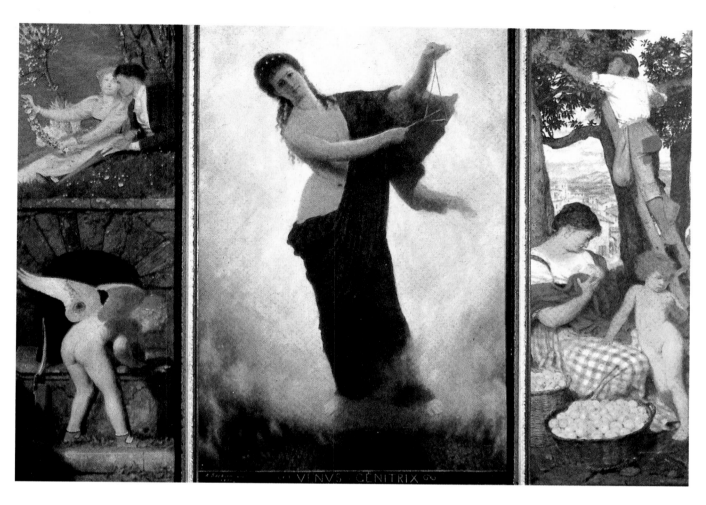

VENVS GENITRIX

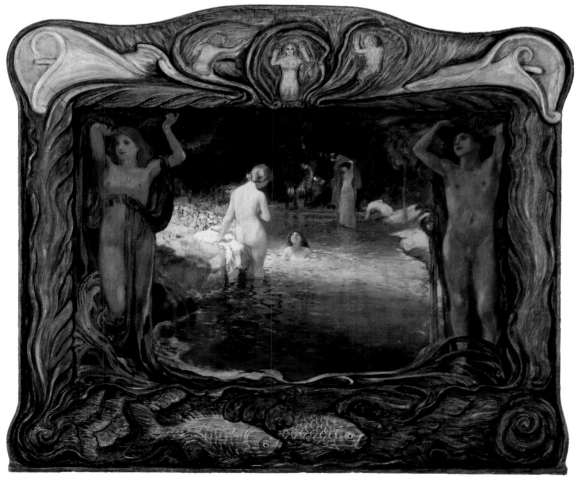

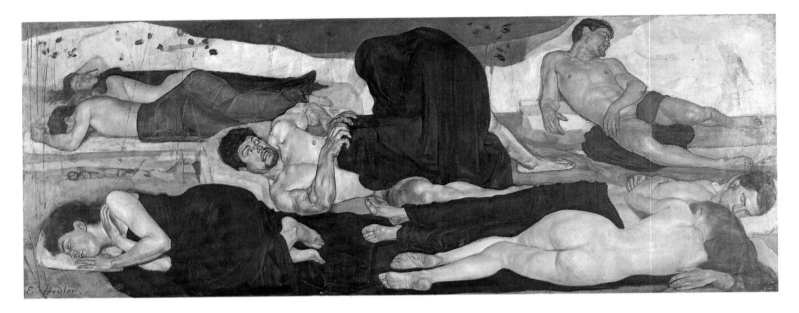

Ferdinand Hodler
Night, 1890
Oil on canvas, 116 x 239 cm
Kunstmuseum Bern, Bern

Night, with its central figure waking in terror
under the weight of a black-draped form, is one
of the most authentically Symbolist of Hodler's
works. It suggests the growing interest in dreams
and the unconscious during the decades directly
preceding Freud's first publications.

BOTTOM:
Henry van de Velde
Julius Meier-Graefe's Office, c. 1899
On the wall, Hodler's *Day* (see p.11)

PAGE 121:
Ferdinand Hodler
Communion with the Infinite, 1892
Oil on canvas, 159 x 97 cm
Kunstmuseum Basel, Basle

PAGES 122–123:

Ferdinand Hodler
Study for "Day", 1898–1899
Black crayon, water-colour on Ingres paper,
15.7 x 30.8 cm
Kunstmuseum Bern, Bern

Ferdinand Hodler
Truth II, 1903
Oil on canvas, 207 x 293 cm
Kunsthaus Zürich, Zurich

Ferdinand Hodler
Emotion, 1901–1902
Oil on canvas, 193 x 280.5 cm
Private collection, Switzerland

Ferdinand Hodler
Gazing into Infinity, 1916
Oil on canvas, 138 x 245 cm
Kunstmuseum Winterthur, Winterthur

Men and ideas moved about Germany in relative freedom. Emperor
William II had his own, absurdly narrow views on art, and sought to
impose them; yet from Bern and Vienna to Oslo and Stockholm, new
ideas in art were propagated and discussed. The Copenhagen Academy
might close down a Gauguin exhibition in 1885, the Berlin Academy an
exhibition of paintings by Munch in 1892, but change had begun. It
took institutional form in the founding of the *Sezession* in Munich
(1892), Vienna (1897) and Berlin (1899). Artists were "seceding" from
the control of the academies and from the sclerotic conventions of style
that the academies imposed.

There was thus a constant ferment of ideas, to which new currents

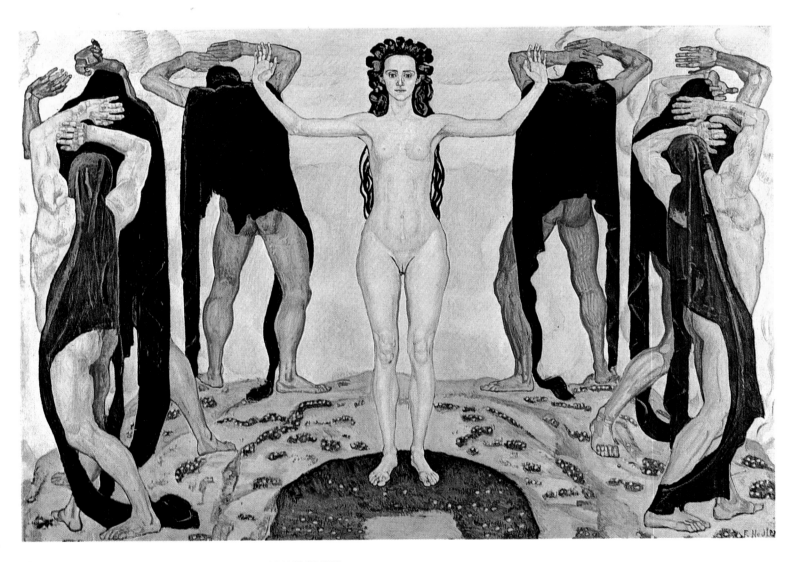

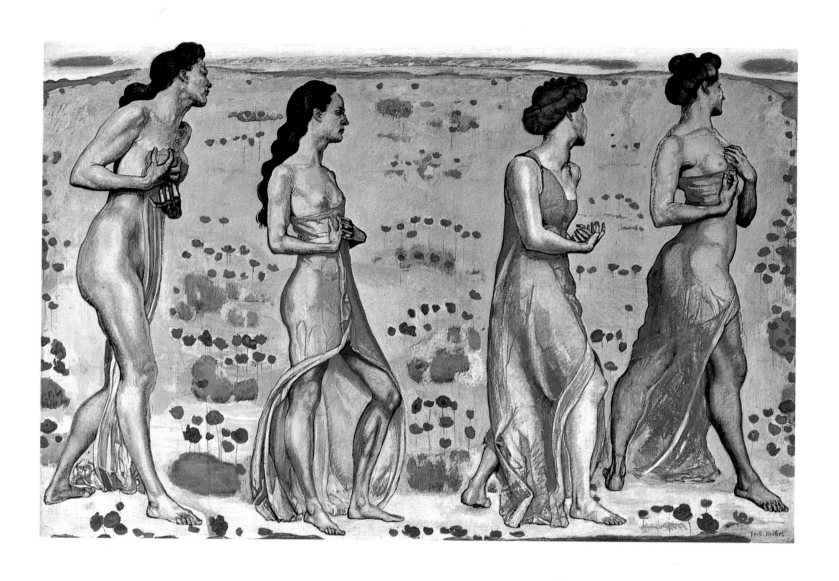

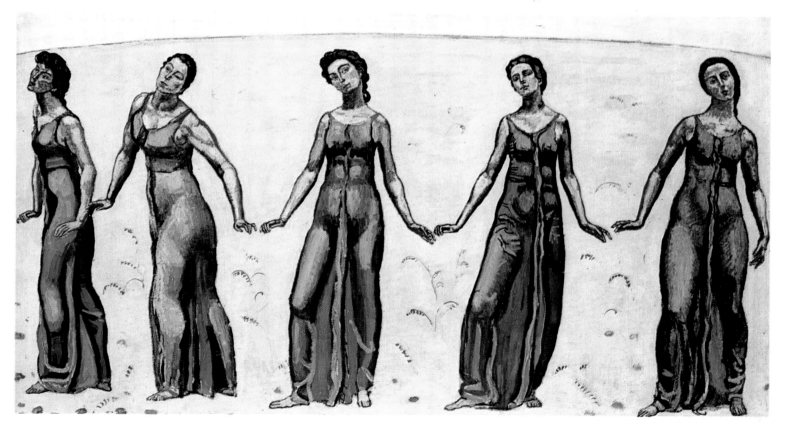

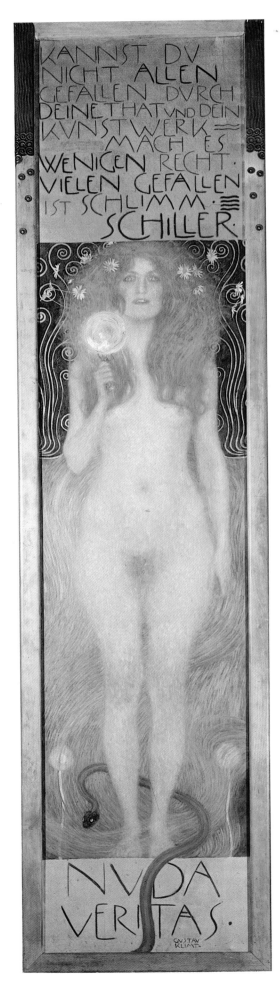

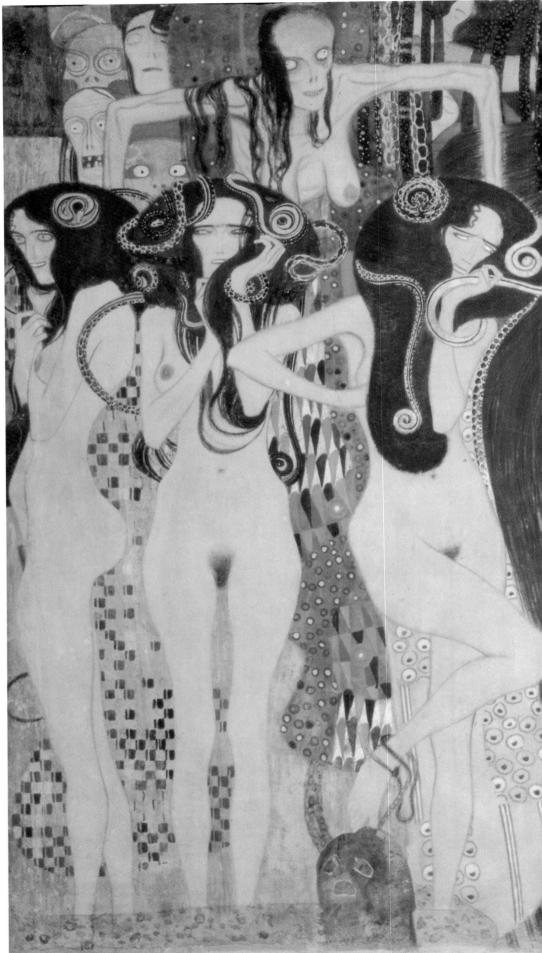

were added from throughout the German-speaking world: Switzerland, Austria and Germany. Artists influenced by Symbolism appeared in both Catholic Bavaria and Protestant Prussia. Neither the religious cleavage which bred distinct cultural attitudes in Belgium and the Netherlands, nor the struggle between Church and secular republic which made such a deep mark on France at the turn of the century, had any real equivalent in Germany.

German artists ventured beyond their frontiers. We note that Hans von Marees (1837–1887) who had trained in Berlin, and Max Klinger (1857–1920), a native of Leipzig, met the Basle-born artist Arnold Böcklin (1827–1901) in Italy. They felt drawn at first to the mythological tradition of antiquity, and this in due course lent them affinities with the Symbolists.

Böcklin, the doyen of the artists cited in this chapter, was an energetic figure devoid of the languid melancholy of "decadence". Italy's light and aura of antiquity were decisive in his early development; his paintings quickly came to be populated with mythological figures, with centaurs and naiads. Not until his fiftieth year did he begin to paint the powerfully atmospheric works associated with his name today.

Among the most famous of these is the painting known as *The Isle of the Dead* (1880, p. 118), which Böcklin himself entitled "a tranquil place". It was clearly important to him; he made five different versions of the composition. The new title was suggested by the white-draped coffin on the boat, the funerary presence of the cypresses, and the overwhelming impression of immobility and silence. The white figure vividly lit by a setting sun is contrasted with the dark, vertical forms of the trees, impervious to the slanting rays of the sun. Like a dream, the painting condenses a number of contradictory sensations and emotions.

Böcklin's choice of imagery is not coincidental. A young widow had asked him for an "image to dream by", and the funereal serenity perhaps echoes something of the artist's own emotions about death. At the age of twenty-five, during one of his stays in Rome, he had married the daughter of a pontifical guard who bore him eleven children between 1855 and 1876; five of them died in infancy, and the Böcklin family was twice (in 1855 and 1873) forced to flee cholera epidemics.

Böcklin's art reveals a robust temperament. He showed no reticence towards the new technologies then sweeping the continent. He devoted time to the invention of a flying machine, negotiating with businessmen for its manufacture. His Germanic feeling for nature was expressed, in canonic Romantic fashion, in such paintings as *The Sacred Wood* (1882, p. 17), but its most striking expression is *The Silence of the Forest* (1885) in which a bizarre unicorn, part cow, part camel, emerges from a forest, bearing an equally enigmatic woman on its back.

Ferdinand Hodler (1853–1918), the son of a modest family of the canton of Bern, lost his parents and all his siblings to tuberculosis before his fifteenth year. He painted works by turn Symbolist, patriotic and *intimiste*, which elicited the enthusiasm of Guillaume Apollinaire. Though not in the Symbolist vein, his poignant series of quasi-expressionistic canvases devoted to the death of his companion Valentine Godé-Darel deserves to be mentioned. When she gave birth to Hodler's daughter in 1913, she was already suffering from the cancer which caused her death.

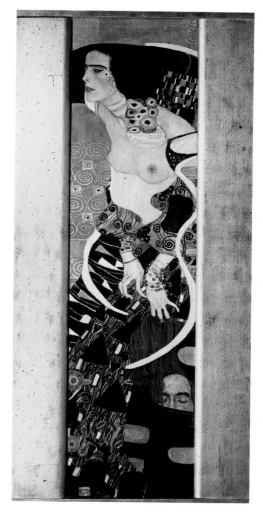

Gustav Klimt
Judith II (Salome), 1909
Oil on canvas, 178 x 46 cm
Galleria d'Arte Moderna, Venice

Gustav Klimt
Nuda Veritas, 1899
Oil on canvas, 252 x 56.2 cm
Theatersammlung der Nationalbibliothek, Vienna

Gustav Klimt
The Beethoven Frieze: The Hostile Powers (detail), 1902
Casein colour on plaster, 220 x 636 cm
Österreichische Galerie, Vienna

These provocative and aggressive nudes disconcerted the Viennese public of Klimt's time. The inclusion of pubic hair was in itself a declaration of war on the classical ideal – even if, in Klimt's words, we are in the presence of "Disease, Madness, and Death". As to Judith, or rather Salome (illustration top), Klimt has clearly painted the "hideous orgasm" of the *femme fatale* rather than the pious Jewish widow.

Anna Bahr-Mildenberg (the model for *Judith I*
as Clytemnestra in the *Electra* of Richard Strauss

Gustav Klimt
Judith I, 1901
Oil on canvas, 84 x 42 cm
Österreichische Galerie, Vienna

Klimt and Freud were not alone in their fascina-
tion with the association of death and sexuality,
of Eros and Thanatos. The subject haunted Sym-
bolist Europe, which shuddered at the spectacle
of the blood-thirsty Clytemnestra in Richard
Strauss' opera.

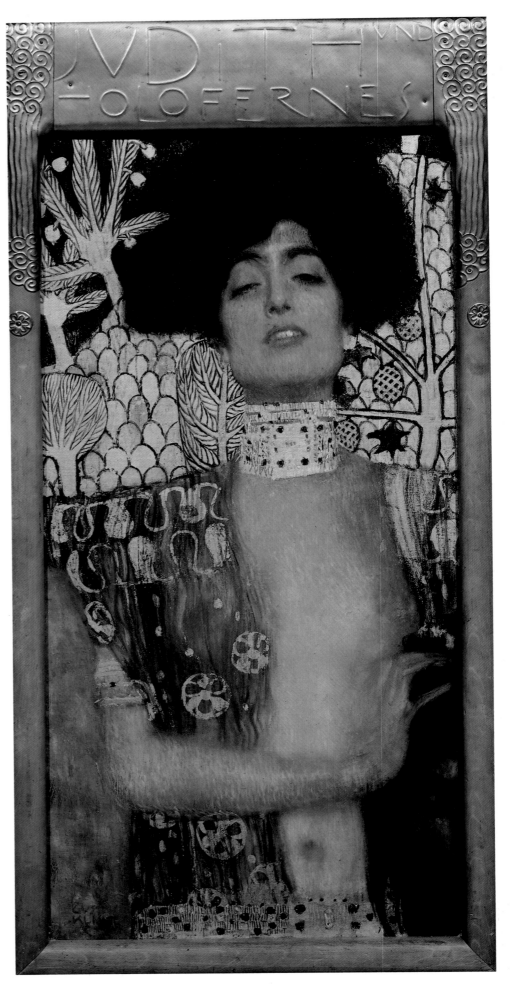

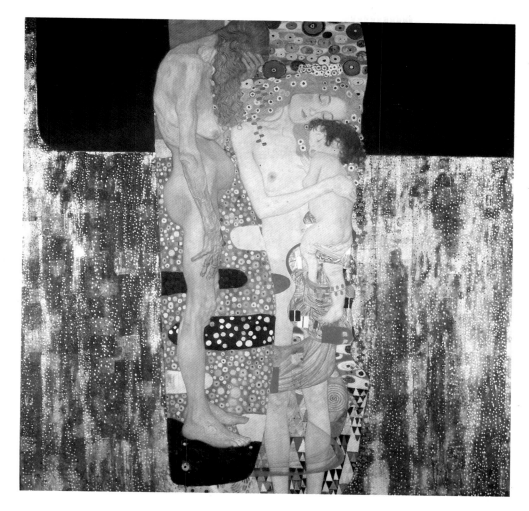

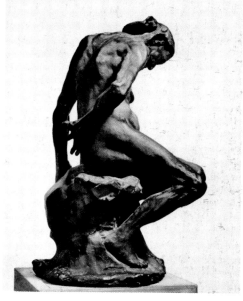

Hodler was commissioned to decorate numerous public buildings both in Germany and in Switzerland. The patriotic message of these large paintings is expressed in the unambiguous and heroic terms typical of such work.

Paintings such as *Day I* (1899–1900, p. 11) and *Night* (1890, p. 120) are characteristic of Hodler's Symbolist vein. The first of these is allegorical, and only certain formal traits, the repetitive sinuosity of line and the mannered symmetry of the gestures, remove it from the academic style. *Night*, however, with its central figure waking in terror under the weight of a black-draped form, is the more fascinating for the imprecision of the fear it records. Something similar may be said of *Autumn Evening* (1892–1893), in which the perspective view and frontality of the path seems to draw the spectator into the painting, symbolically evoking the efforts and expectations of an entire life.

Max Klinger, though twenty years younger than Böcklin, expressed his admiration by dedicating a sequence of prints to him. Klinger completed his studies in Karlsruhe, then travelled to Berlin, Munich and Brussels. He spent three years (1883–1886) in Paris and two more in Italy before returning to settle in his native Leipzig. There he enjoyed tremendous prestige; his home became the centre of the city's social and artistic life. Himself inspired by Goya, he, in his turn, exercised a beneficial influence on Otto Greiner and Alfred Kubin. Klinger's work revealed the power of art to Kubin at the time of the latter's great existential crisis; it led him to conclude that "it was worth devoting one's entire life to such creations".

Gustav Klimt
The Three Ages of Woman, 1905
Oil on canvas, 180 x 180 cm
Galleria Nazionale d'Arte Moderna, Rome

Auguste Rodin
She who was "La Belle Heaulmière", 1885
Painted plaster, 50.6 cm high, 25.8 cm long
Musée Rodin, Paris

Rodin and Klimt admired each other; Rodin visited the Beethoven exhibition in 1902 and congratulated the painter on his "sumptuous and tragic" frieze, while Klimt borrowed from Rodin's *The Gates of Hell* the figures for several compositions. Here, the old woman in *The Three Ages of Woman* is none other than *La Belle Heaulmière*.

Gustav Klimt
Hope I, 1903
Oil on canvas, 189 x 67 cm
National Gallery of Canada, Ottawa

The Symbolists were, in the last analysis, terri-
fied of woman, and their works reflect "the ambi-
guity of the sex, as punishment or end-point"
(C.E. Schorske). Here we meet the theme of the
return to the womb, the end of man's journey
reached in the maternal womb he should never
have left; the final embrace which is also a return
to the origin, the cosmos, of which woman is the
triumphant principle. This "uterine emprison-
ment" is found in *Hope I*, in the magnificent
belly that dominates everything, like a "living
receptacle in which the hopes of humanity are
walled". Klimt's full erotic repertoire is put to
work here, from the shameless body to the red
hair which suggests a hint of waywardness and
the penetrating shapes in their symbolic relation
to the prominent belly. For surely the classical
background, with its masks, death's-heads, bale-
ful forms and allegorical monsters, is also a meta-
phor of night and death? As if in response, Julius
Klinger (not to be confused with Max Klinger)
brings out the sub-text of the obsessive imagery
of Salome and other castrating women in the
Symbolist imagination. Dating from 1909, the
image is Symbolist in subject matter, but not in
treatment, being far too explicit to lend itself to
reverie. Indeed, we read today about the literal
misfortunes of an American woman who takes
just such sanguinary revenge upon her rapist hus-
band.

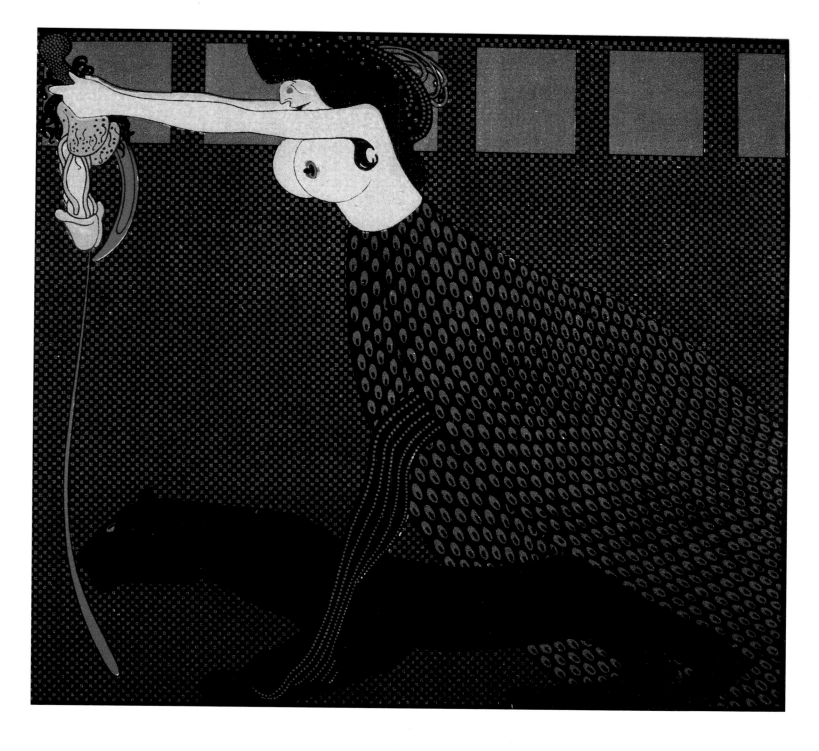

Klinger practised a broad range of artistic forms: sculpture, painting and etching. His graphic work was complex, sombre and richly imaginative; it took the form of series of etchings, of which the first began to appear in 1878. They include *Eve and the Future* (1881), *Dramas* (1881–1883), *A Life* (1881–1884), *A Love* (1879–1887) and the most famous of them all, his *Paraphrase on the Discovery of a Glove* (1881, pp. 131–133).

This sequence begins in realist manner with a man picking up a woman's glove on a roller-skating arena. It continues in imaginary vein with the tributes paid to the fetishized object. In the extraordinary penultimate print the glove is carried off by a sardonic pterodactyl flying out of the window in a crash of broken glass. The man's arms reach through the broken panes in a futile attempt to restrain the animal.

Julius Klinger
Salome, 1909
Colour zincography, 19.5 x 21 cm
Galerie Michael Pabst, Munich

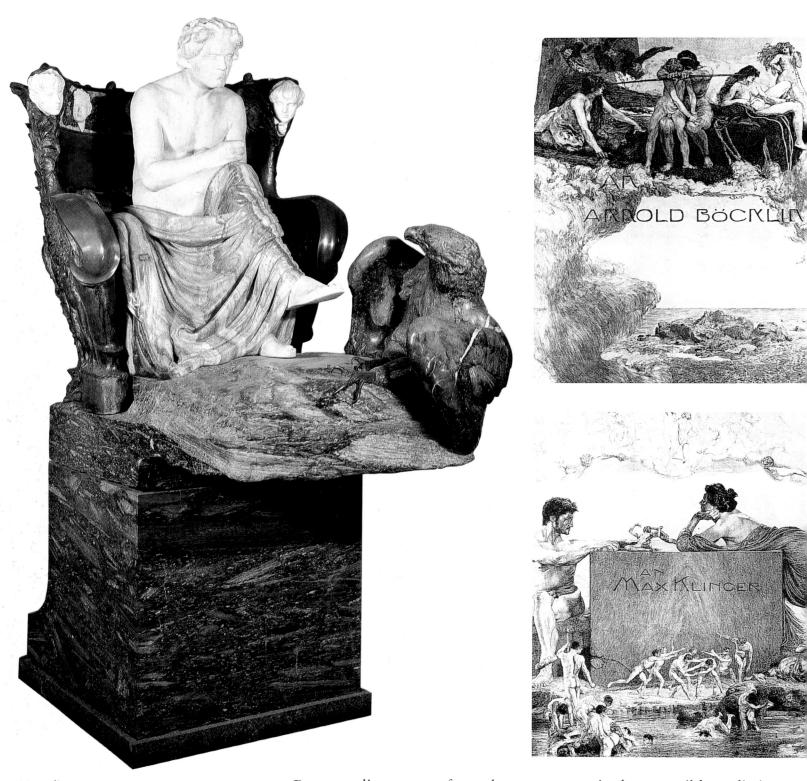

Max Klinger
The Statue of Beethoven, 1902
Various kinds of marble, 310 cm high
Museum der Bildenden Künste, Leipzig

Max Klinger and **Otto Greiner**
Two *Engraved Frontispieces*, one dedicated by
Klinger to Arnold Böcklin, the other by Greiner
to Max Klinger, c. 1880

Klinger was a fine engraver who revered Goya
and was attracted by the fantastic. His engrav-
ings are characterised by the development of an
imaginary world which is both realistic and yet
slightly out of kilter with reality, thus giving an
impression of the uncanny. Klinger influenced
Otto Greiner, a less gifted student, and, above
all, the astonishing Alfred Kubin.

But unreality appears from the outset, even in the ostensibly realistic
prints. One easily overlooks the tiny wheels of the roller-skates on the
feet of these dignified men and women; the slant of the bodies in the
second print then seems enigmatic and even surrealist (we think of the
remarkable collages of Max Ernst). The dream-like nature of the se-
quence is subtly hinted at: in the penultimate print the pterodactyl can-
not, it seems, have emerged from the unbroken frame of the window.
Were the panes then broken by the outflung arms?

"Modern" as Klinger seems in his prints, his painting and sculptures
(not least his famous monument to Beethoven, p. 130) display a grandi-
loquence at poles from the manner of his graphic work – though en-
tirely typical of the period.

Otto Greiner (1869–1916), an admirer of Klinger's (to whom he dedicated a sequence of prints), was also an able craftsman. His *Devil Showing Woman to the People* (p. 117), though highly competent in execution, is utterly devoid of the ambiguity encountered in Klinger's work; it leaves no room to the imagination and merely echoes the cruder stereotypes of the day. As much may be said of Julius Klinger's coloured zincograph of *Salome* (1907, p. 129). Salome is shown triumphantly carrying off not the severed head of St John but severed genitals. Julius

BOTTOM AND PAGES 132–133:
Max Klinger
Paraphrase on the Discovery of a Glove, 1881
Series of etchings and aquatints, Staatliche
Graphische Sammlung, Munich
1. *Place*/ 2. *Action*/ 3. *Desires*/ 4. *Salvage*/ 5.
Triumph/ 6. *Homage*/ 7. *Anguish*/ 8. *Tranquillity*/ 9. *The Seizure*/ 10. *Love*

Klinger's work nonetheless has the merit of self-mockery which, one suspects, is lacking in Greiner's print.

Franz von Stuck (1863–1928), the son of farmers from Lower Bavaria, settled in Munich and soon became the city's dominant artistic figure, the 'prince of painters'. A teacher at the Academy, he counted Kandinsky, Klee and Albers among his pupils. He himself was influenced by Böcklin, peopling his paintings with male and female fauns and centaurs. For a number of years, starting in 1892, when he contributed to the creation of the Munich Secession, he painted works of Symbolist content such as *Sin* (1893, p. 25), *The Kiss of the Sphinx* (1895, p. 136) or *The Wild Hunt* (1899, p. 137).

Sin is probably his best-known work; its notoriety today may be

This remarkable series of engravings constitutes a veritable comic-strip. Well-dressed people roller-skate in the opening frame. There follow visions of barely-veiled eroticism in which the glove, saved from the ocean and borne aloft in triumph, is finally carried off by a sardonic pterodactyl. Klinger has cunningly drawn the frames of the broken window intact; the reptile in flight is therefore purely imaginary.

Franz von Stuck
Poster for the 7th International Exhibition of the Munich Sezession, 1897

gauged from the fact that a reproduction of it hangs in the bar of the "Mexiko" station of the Berlin metro. In a procedure not unusual for von Stuck, the moralising subject – yet another *femme fatale* – is the pretext for a handsome nude. The splendid body is caught in a loop of light, while the woman's dark eyes scrutinise the viewer from a pool of shadow; she is wrapped in the coil of an enormous snake whose snarling gaze has a disagreeable intensity. The painting's "moral" is simplistic at best, but the design and unaffectedly academic execution are impressive.

Carlos Schwabe (1866–1929) was the most "international" of the artists quoted in this chapter: a Swiss citizen, born in Germany, he spent most of his life in France and regularly took part in the Rose+Croix Salon, for which he designed the first poster in 1892 (p. 53). He displays admirable craft in his water-colours, but when he touches upon religious and edifying subjects his excessive sweetness of tone is typical of the sentimental and commercial "religious art" of the period.

Throughout the period which concerns us, the power of Germany was on the rise and that of Austria was waning. Beset with irreconcilable conflicts born of the aspirations of its peoples, the Austrian Empire descended into instability. The resulting cultural climate received its definitive portrayal in Robert Musil's *Man without Qualities*. The lack of all coherent policy accompanied the collapse of political will in an atmosphere that favoured world's end expectations; Hermann Broch described it as a "Joyful Apocalypse". Once the war had finally come, this same Apocalypse, no longer joyful, was described by the formidable critic, Karl Kraus, in a collage play entitled *The Last Days of Mankind*. And they were indeed the last days of a way of life. But the period with which we are concerned is the entertainment before the storm. It

Franz von Stuck
Water and Fire, 1913
Part of the tryptych *Air, Earth, Fire*, all parts oil on canvas, 114 x 49cm
Piccadilly Gallery, London

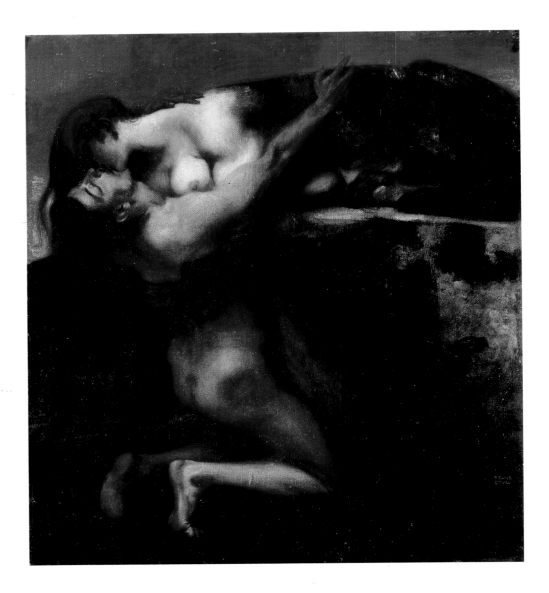

Franz von Stuck
The Kiss of the Sphinx, c. 1895
Oil on canvas, 160 x 144.8 cm
Szépmüvészeti Múzeum, Budapest

In the same spirit as *Sin* (p. 25), here is a further
metaphor of the dangerous woman. This time it
is the seductive and destructive Sphinx.

Franz von Stuck
The Wild Hunt, 1899
Oil on canvas, 97 x 67 cm
Musée d'Orsay, Paris

is, to adopt another metaphor, the sanatorium of Thomas Mann's *The Magic Mountain*; the visiting Hans Castorp is caught up in the sanatorium for seven years and freed from the enchantment only by the outbreak of war.

Gustav Klimt (1862–1918) first made himself known by the decorations he executed (with his brother and their art school companion F. Matsch), for numerous theatres and above all (on his own this time) for the Kunsthistorisches Museum in Vienna, where he completed, in a coolly photographic style, the work begun by Makart. At the age of thirty he moved into his own studio and turned to easel painting. At thirty-five he was one of the founders of the Vienna Secession; he withdrew eight years later, dismayed by the increasingly strong trend towards naturalism.

The coruscating sensuality of Klimt's work might seem in perfect accord with a society which recognized itself in those frivolous apotheoses of happiness and well-being, the operettas of Johann Strauss and Franz Léhar. Nothing could be further from the truth. Far from being acknowledged as the representative artist of his age, Klimt was the target of violent criticism; his work was sometimes displayed behind a screen to avoid corrupting the sensibilities of the young. His work is deceptive. Today we see in it the Byzantine luxuriance of form, the vivid juxtaposition of colours derived from the Austrian rococo – aspects so

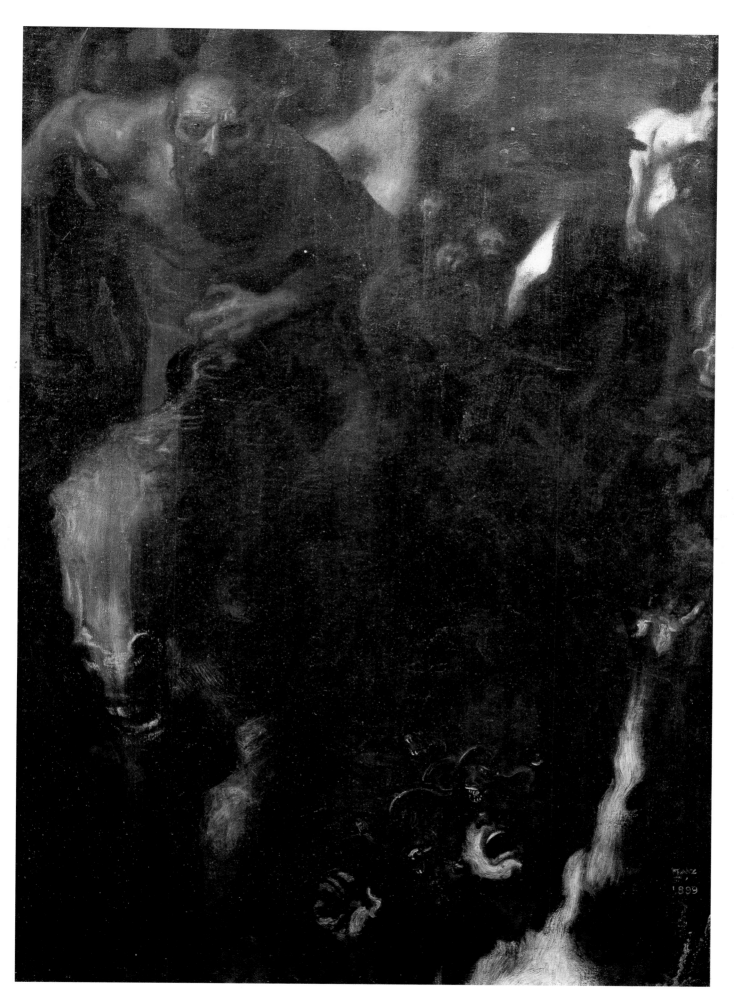

markedly different from the clinical abruptness of Egon Schiele. But we see it with expectations generated by epochs of which his own age was ignorant.

For the sumptuous surface of Klimt's work is by no means carefree. Its decorative tracery expresses a constant tension between ecstasy and terror, life and death. Even the portraits, with their timeless aspect, may be perceived as defying fate. Sleep, Hope (a pregnant woman surrounded by baleful faces) and Death are subjects no less characteristic than the Kiss. Yet life's seductions are still more potent in the vicinity of death, and Klimt's works, though they do not explicitly speak of impending doom, constitute a sort of testament in which the desires and anxieties of an age, its aspiration to happiness and to eternity, receive definitive expression. For the striking two-dimensionality with which Klimt surrounds his figures evokes the gold ground of Byzantine art, a ground that, in negating space, may be regarded as negating time – and thus creating a figure of eternity. Yet in Klimt's painting, it is not the austere foursquare figures of Byzantine art that confront us, but ecstatically intertwined bodies whose flesh seems the more real for their iconical setting of gold.

Alfred Kubin (1877–1959) makes everything more explicit. Ernst Jünger, writing in the twenties, described his own pre-war work as a

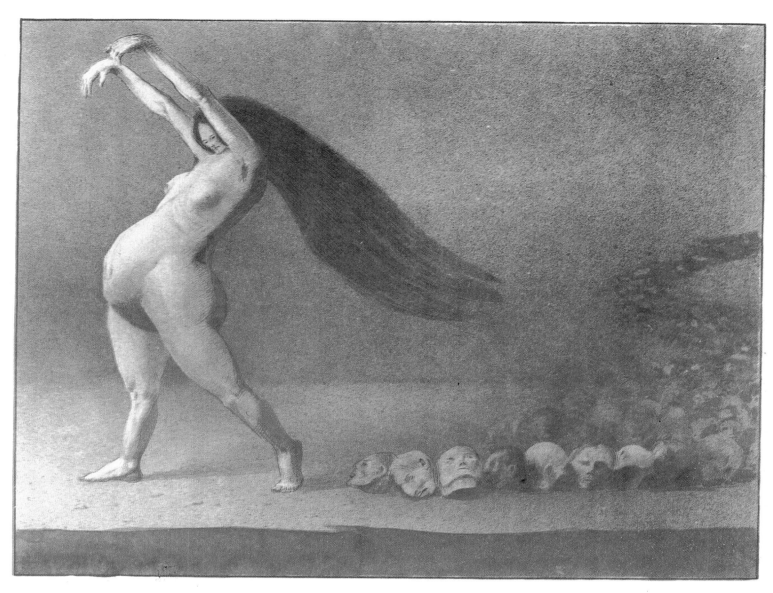

Alfred Kubin
Our Universal Mother, the Earth, 1901–1902
Pen and Indian ink wash on paper, 23.2 x 29.8cm
Private collection, Fribourg

prophecy of decline: "The atmosphere which precedes major catastrophes is like a disease which is latent in the limbs before even producing visible symptoms, and which often makes itself known by a warning given in a dream." The metaphor is exact: the artist is, on occasion, a prophet, not through access to supernatural inspiration, but because he or she is exceptionally attentive to the unspoken moods of his age, and is thus led to anticipate the inevitable.

After a painful adolescence marked by terror and depression, Kubin attempted suicide on his mother's grave. The gun was rusty and did not go off. The despair and anxiety to which that act testifies became the energies that Kubin channeled into art, and the work of Max Klinger was (we have seen) the catalytic agent in this process. Kubin also admired Goya, Munch, Ensor and Redon. Under Klinger's influence, Kubin devoted himself to drawing, producing an extraordinarily fertile and inventive body of work, especially during the first decade of this century (pp. 138–141).

A nightmarish terror pervades these works. Monsters of every kind rear up from the bowels of night or the ocean bed; demons, spiders, snakes, and worms batten upon their defenseless victims. Skeletons sneer, human monsters delight in displaying their deformities and above all, with terrifying insistence, the female principle exhibits a dispassion-

PAGE 138 TOP:
Alfred Kubin
Adoration, 1901–1902
Pen and Indian ink wash on paper, 29.8 x 27.4cm
Oberösterreichisches Landesmuseum, Linz

PAGE 138 BOTTOM:
Alfred Kubin
Woman, sequence of illustrations for *Sex and Character*, 1902
Indian ink
Private collection

PAGE 141:
Alfred Kubin
Death Leap, 1901–1902
Pen and Indian ink wash on paper,
30.2 x 22.7 cm
Private collection, Fribourg

Alfred Kubin
Lubricity, 1901–1902
Pen and Indian ink wash on paper,
15.2 x 22 cm
Private collection, Fribourg

ate and malevolent power. This is the message of *The Egg* or *Death Leap* (p. 141) and many others. In the first of these, Woman is represented in the shape of an enormous, radiant belly capped with a skeletal torso and a death-white face. The figure stands beside an open grave. In *Death Leap* a Tom Thumb dives headlong into a colossal vulva.

These are the particularly repellent variants of the *femme fatale* already encountered in the works of Gustave Moreau, and who returns as a less menacing vision in Franz von Stuck's *Sin*. Sexuality, in Kubin's view, is an arbitrary and perilous power. Whoever succumbs to it is lost.

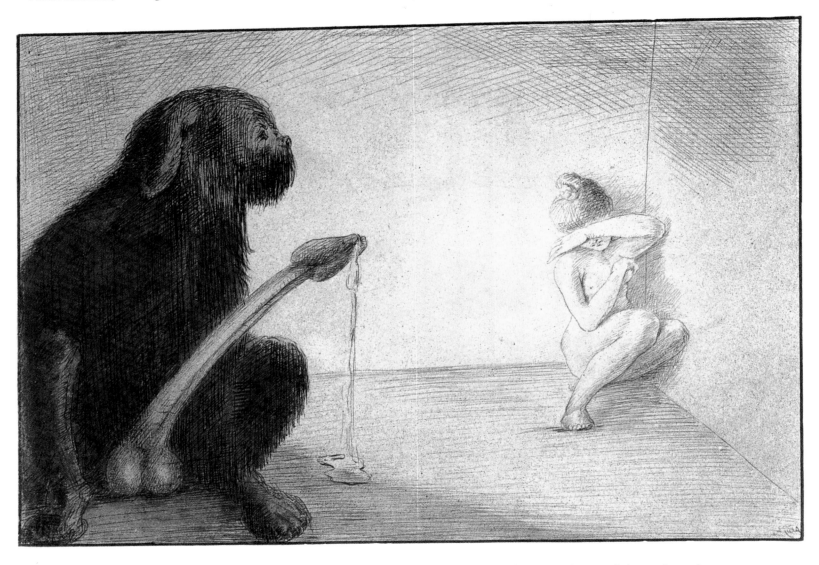

Clinically insane during his youth, then cured, at least in theory, Kubin remained a solitary individual obsessed with his impersonal, unintelligible sexual destiny. He used his dazzling command of line-drawing to illustrate his literary forebears (Dostoevsky, Poe…) and his own themes. In his metaphor, "Earth-Fertile-Mother" leaves behind her a trail of skulls (p. 139). The virgin of *Lubricity* (p. 140) places her hand before her eyes to block out the monstrous priapic ape who sits before her. And in *Death Leap* (p. 141), a Tom Thumb plunges toward his destiny: the vulva.

Yet there is no choice. Beneath the trappings of the cultural superstructure we find the fearful figure of sex as destiny. Kubin is undoubtedly giving expression to his own neurosis, but it would be of merely clinical interest did it not coincide with the "endogenous neurosis of culture" discussed in the introduction. Kubin is not the last (Bruno Schulz's work appeared in the nineteen-twenties), but surely the most fearful and agonised witness of that decomposition of the symbolic substance of his culture which is the central fact of the Symbolist age.

A similar anxiety haunts the work of Edvard Munch (1863–1944), but it is expressed with a formal inventiveness that impinges upon the emotions before we are even aware of the subject; the deeper regions of the psyche are accessible only through the potent agency of rhythm and colour.

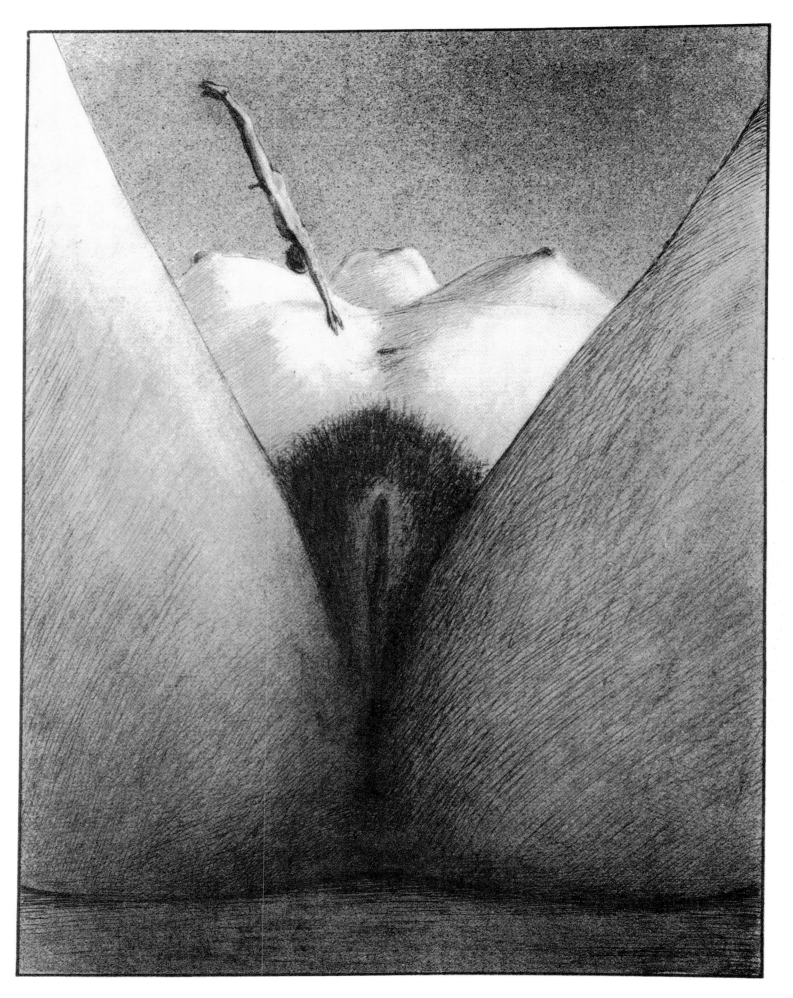

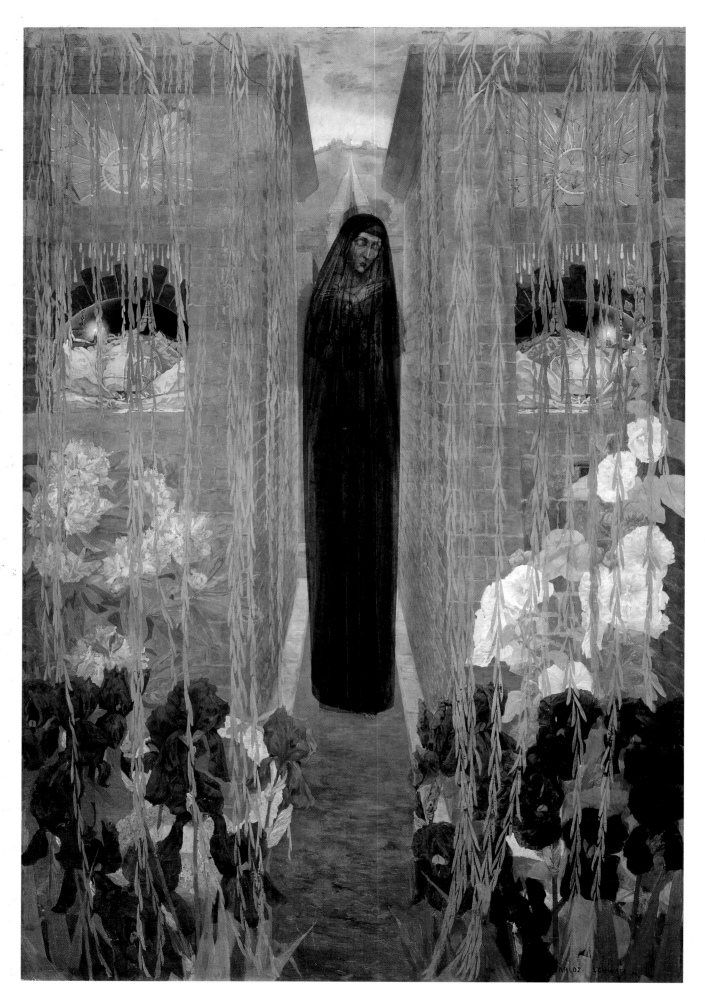

Carlos Schwabe
The Grave-Digger's Death, 1895–1900
Water-colour and gouache, 75 x 55.5 cm
Cabinet des dessins, Musée du Louvre, Paris

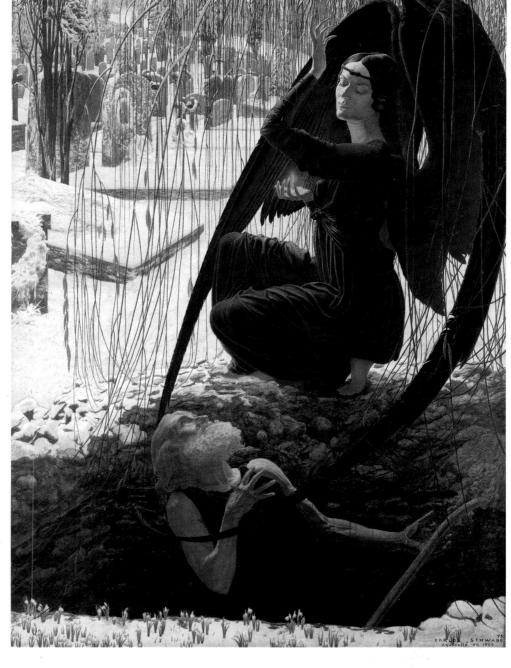

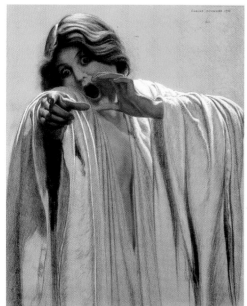

Carlos Schwabe
Study for *The Wave*, feminine figure, back right
Mixed media on board, 66.2 x 48 cm
Musée d'Art et d'Histoire, Geneva

PAGE 142:
Carlos Schwabe
Pain, 1893
Oil on canvas, 155 x 104 cm
Musée d'Art et d'Histoire, Geneva

A woman in mourning clothes walks between
the tombs in which the dead lie. The black irises
in the foreground echo the texture and colour of
her mourning garb.

Munch's name leads us to the Scandinavian countries, which remained on the fringe of the Symbolist world, not just geographically but because the austere religion of these cultures had no use for decadent fantasy. When Munch began studying art in Christiania (now Oslo), Norwegian artists practised a form of Protestant, populist realism. Munch was, however, from the very start, an innovator. True, he painted genre scenes, but in a spirit all his own. His mother died of tuberculosis when he was five. At fourteen, he watched his fifteen-year-old sister Sophie succumb to the same disease. When, at twenty-two, he had acquired the technical means to portray it, her death became an obsession to which he returned again and again: the wan face in profile against the pillow, the despairing mother at the bedside, the muted light, the tousled hair, the useless glass of water.

Norway had long been under the influence of German aesthetics.

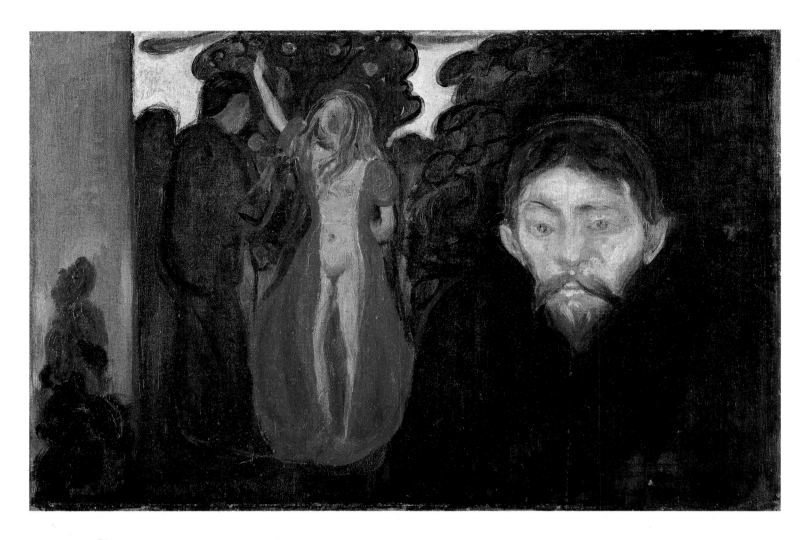

Edvard Munch
Jealousy, 1895
Oil on canvas, 67 x 100.5 cm
Rasmus Meyers Collection, Bergen

The whole of Munch's first period is dominated
by the theme of attraction-repulsion. This pic-
ture is a portrait of Stanislas Przybyszewski, the
Polish writer, whom Munch and Strindberg had
met in Berlin, probably through Przybyszew-
ski's Norwegian wife, Dagny Juel.

Edvard Munch
Madonna, 1895–1902
Colour lithograph, 60.7 x 44.5 cm
Munch-Museet, Oslo

She overtly offers her ecstatic sexuality – and yet
remains inaccessible… Around the frame which
encloses the seductress, the straggling spermato-
zoa wriggle in vain while, in the lower left-hand
corner, a pathetic homunculus or wide-eyed
foetus lifts its supplicant gaze toward the god-
dess.

Until 1870, Norwegian artists usually went to Düsseldorf to study and
pursue a career. Later they went to Paris, Berlin, Munich and Karlsruhe.
But by 1880, Paris had become the centre. And so it was that Munch,
in 1885, undertaking his first journey at twenty-two, was led to discover
French art and the Symbolist spirit. It was in these circumstances that
Munch's personal neurosis, the anxiety which women caused him (al-
though he pursued them incessantly until the great psychological crisis
of his forties), entered the ambit of cultural anxiety expressed in Sym-
bolist art.[2]

Munch was chiefly concerned with his own existential drama: "My
art," he declared, "is rooted in a single reflection: why am I not as others
are? Why was there a curse on my cradle? Why did I come into the
world without any choice?", adding: "My art gives meaning to my life."
Thus he considered his entire work as a single entity: *The Frieze of Life*.
The frieze was manifestly an expression of anxiety (for example, in *The
Scream*) but also of tender pathos: of the "dance of life". (This seems to
have been a common subject at the time; we find Gustav Mahler allud-
ing to it in reference to the dance-like movements of his symphonies.)
Munch, like Kubin, perceived sex as an ineluctable destiny, and few of
his works represent Woman (capitalised as usual) in a favourable light.
In *Puberty* a skinny young girl meditates, sitting naked on her bed
beneath the threatening form of her own shadow, while in *The Voice*
(p. 147 top) a young woman, alone in the woods, attends to some inner
whisper; these are the most sensitive representations of woman in
Munch's work.

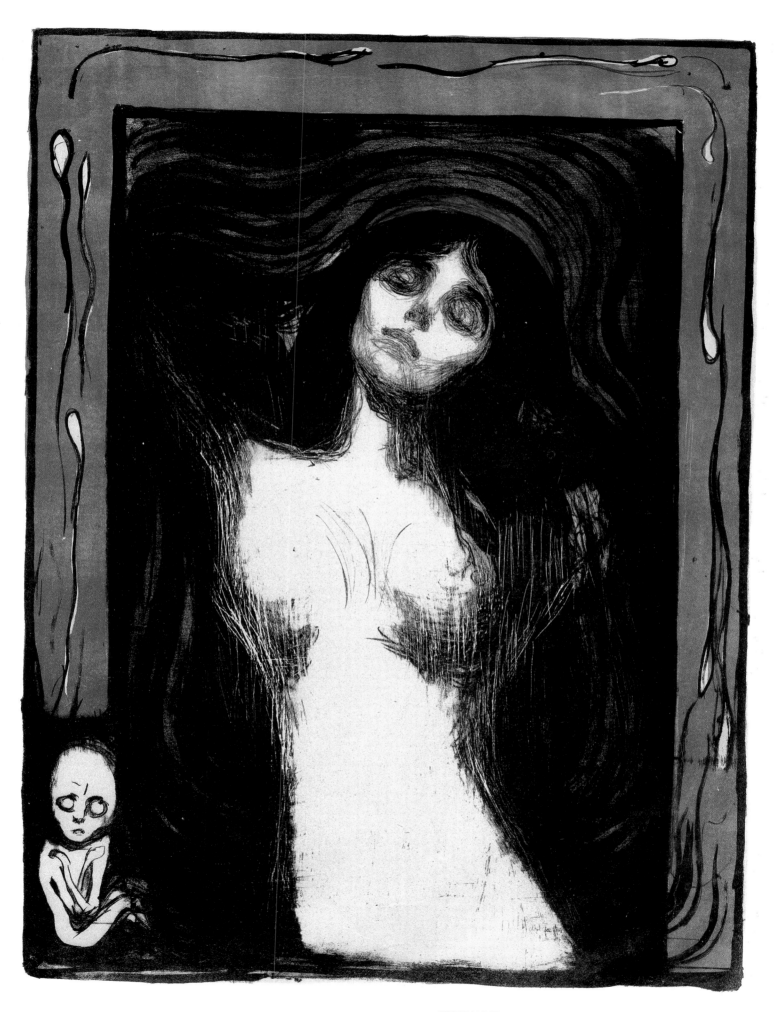

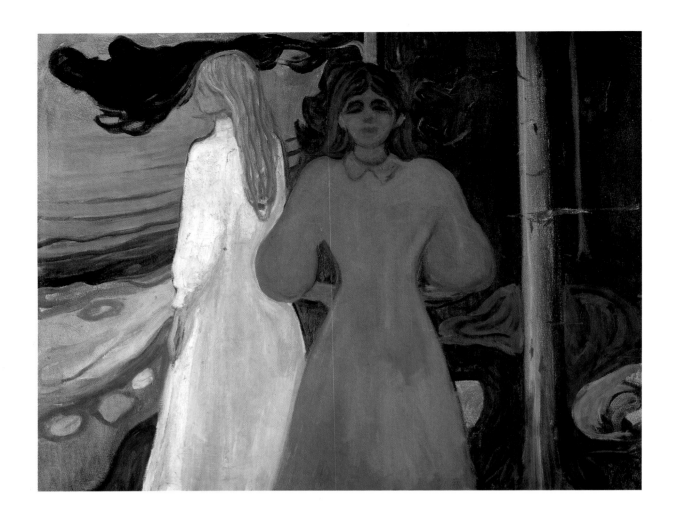

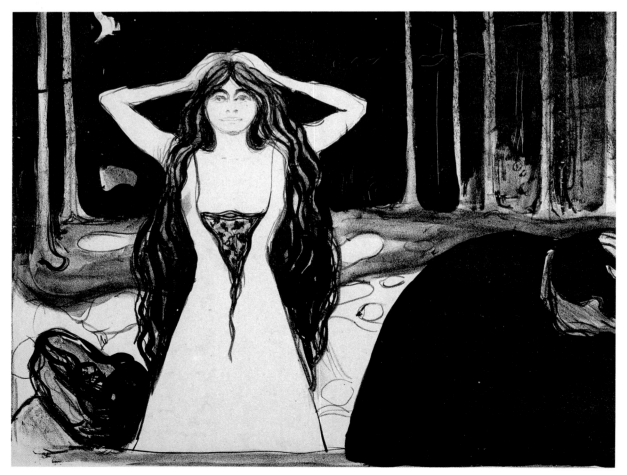

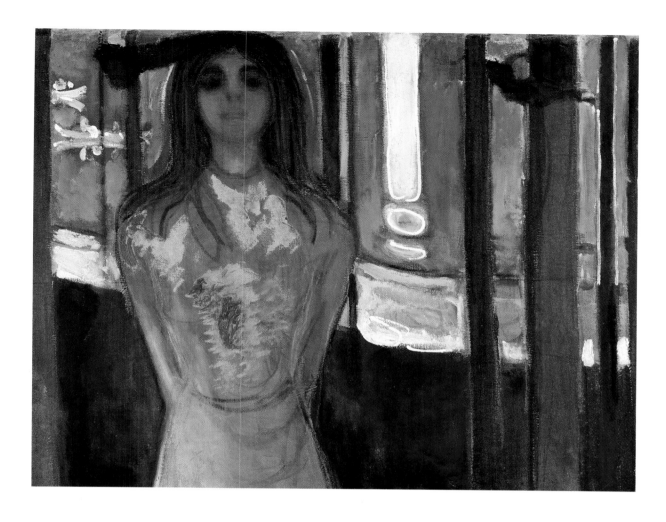

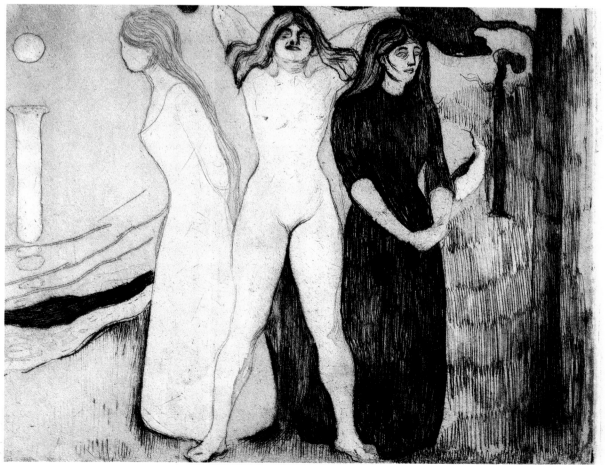

In another iconic image, the *Madonna*, of which he painted various versions between 1893 and 1902, overtly offers her ecstatic sexuality and yet remains inaccessible. Why inaccessible? A lithographic version (p. 145) suggests the answer: around the frame which encloses the seductress the straggling spermatozoa wriggle in vain while, in the lower left-hand corner, a pathetic homunculus, a wizened and ageless wide-eyed foetus, lifts its supplicant gaze toward the goddess.

Munch's lithograph verges on irony, to which he was not averse. Even so, modifying the well-known phrase, we may wish to suggest that "irony is the courtesy of despair". Munch's art represents women in the light of trauma. Seduction itself is a source of anxiety; satisfaction brings remorse (*Ashes*, p. 146 bottom), and jealousy and separation are experienced as terrifying and depressing events.

The personal aspect of Munch's work need not concern us in relation to a coherent and authoritative *œuvre* whose themes are, as we have seen, common to many other artists of the time. But it should

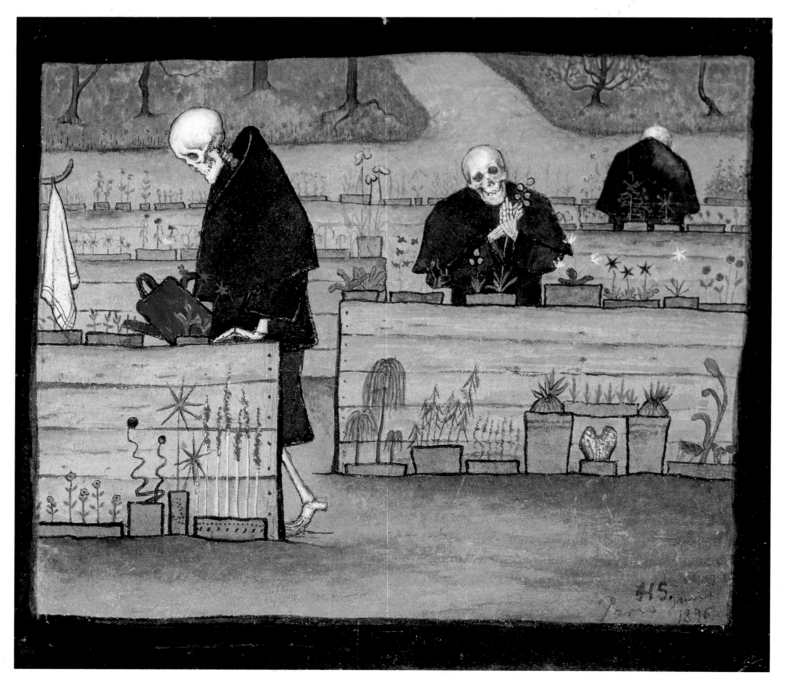

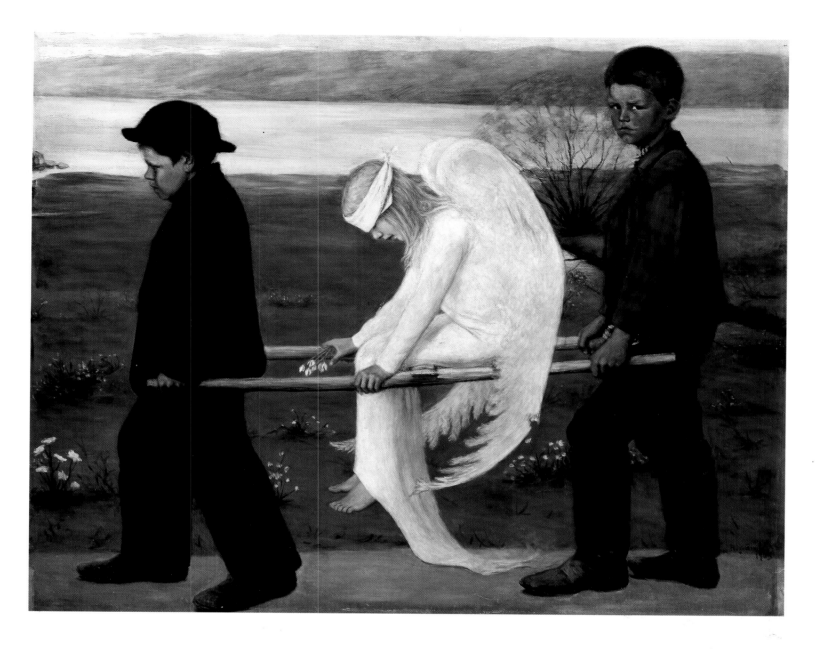

be noted that, at around forty-five, Munch suffered a profound depression and spent eight months in a sanatorium in Denmark. Thereafter he gave up the anxiety-laden subject matter so central to his work and began painting everyday subjects with the same vigorous brushwork and expressionistic colours as before. His motives may have been prophylactic. He later claimed to a friend that he had simultaneously given up women and alcohol, though here again irony is not ruled out.

Other Scandinavian artists allowed themselves to drift with the Symbolist current at least for a while. One such was Jens Ferdinand Willumsen (1863–1958), who was born the same year as Munch and died in Cannes at the age of ninety-five. He spent a good deal of time in Paris, notably in 1890, where he met Gauguin and Sérusier. That same year Theo van Gogh introduced him to the work of Odilon Redon. Willumsen was at various times a Realist, a Symbolist and an Expressionist. His *Jotunheim* (1892–1893, p.153), a mixed-media work (oil on zinc and enamel on copper), now at the J.F. Willumsens Museum in Frederikssund, illustrates the practice, common to a number of Symbolist artists, of integrating the frame into the work. Ludwig von Hofmann (1861–

Hugo Simberg
The Wounded Angel, 1903
Oil on canvas, 127 x 154 cm
Ateneumin Taidemuseo, Helsinki

Simberg made numerous poetic and sardonic images of Death, which he shows going about various activities, gardening, gnawing the trunk of a tree in an allegory of autumn, or coming to carry off a peasant's child. His *Wounded Angel*, carried on a stretcher by two helpful but simple little peasant boys, gives ironic and pathetic expression to the incompatibility between too angelic an ideal and the dull, blinkered reality with which that ideal will, inevitably, collide.

PAGE 148:
Hugo Simberg
The Garden of Death, 1896
Water-colour and gouache on paper, 16 x 17 cm
Ateneumin Taidemuseo, Helsinki

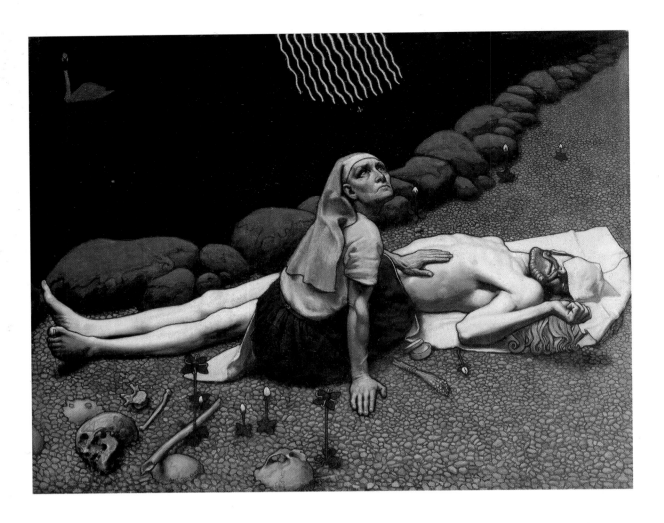

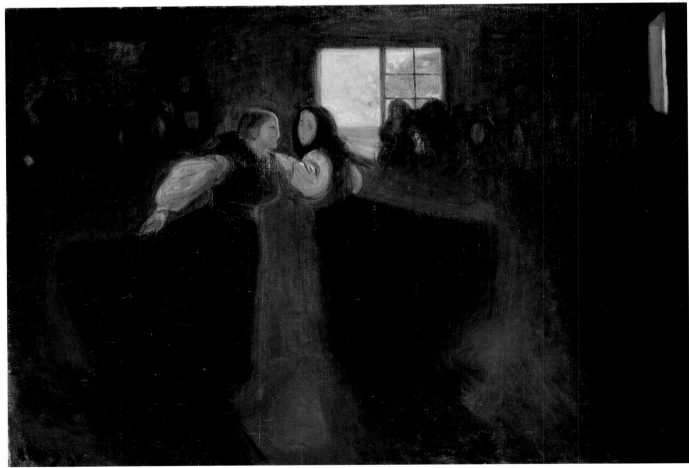

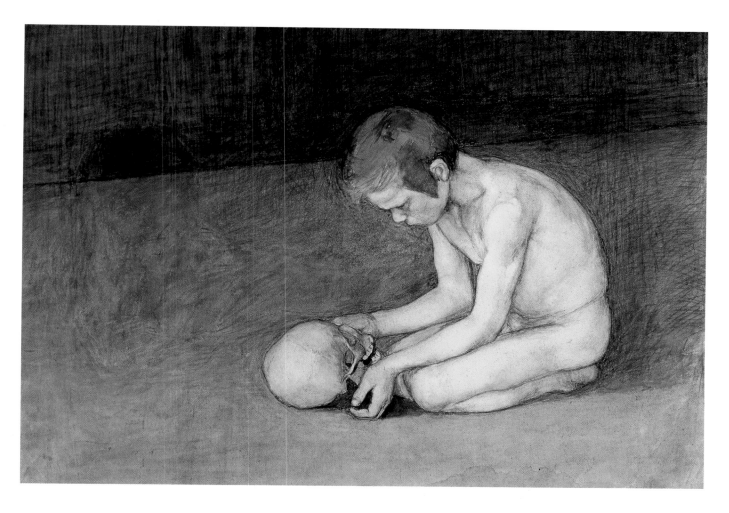

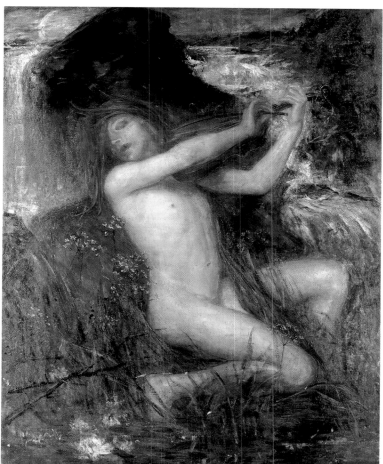

Axel Gallén Kallela
The Death of Leminkaïnen, 1897
Oil on canvas, 85 x 118 cm
Ateneumin Taidemuseo, Helsinki

Gallén Kallela devoted a part of his *œuvre* to illustrating the Kalevala, the great Nordic epic.

Halfdan Egedius
The Barndance, 1895
Oil on canvas, 69.5 x 99.5 cm
Nasjonalgalleriet, Oslo

Egedius was a precocious talent, who began his artistic studies at eight years of age. He died at twenty-two, after showing considerable promise in his paintings inspired by Nordic sagas or by scenes of peasant life, such as this *Barndance*.

Magnus Enckell
Young Boy and Skull, 1893
Water-colour and charcoal on paper, 70 x 100 cm
Ateneumin Taidemuseo, Helsinki

Ernst Josephson
Näcken or The Water Spirit, c. 1890
Oil on canvas, 144 x 114 cm
National Museum, Stockholm

Josephson was a painter of great originality, which his madness intensified or at least modified. He lived in Brittany, painting his hallucinations and communicating by spiritualism with the soul of the Swedish mystic, Swedenborg. The Näcken, a figure from Scandinavian mythology, lures humans to their death with its music.

Jens Ferdinand Willumsen
The Big Relief, 1893–1928
Marble, bronze, 440 x 646 cm
J.F. Willumsens Museum, Frederikssund

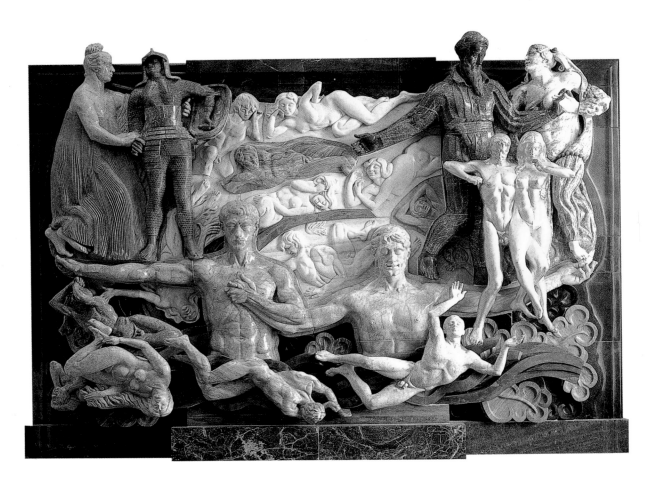

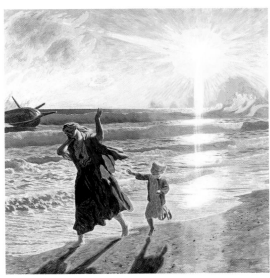

Jens Ferdinand Willumsen
After the Storm, 1902
Tempera on canvas, 155 x 150 cm
Nasjonalgalleriet, Oslo

1945) did something similar in his *Idyllic Landscape with Bathers* (c. 1900, p. 119) in which the figures to the outside of the painting seem to extend the frame into the painting itself.

Another Norwegian painter, Halfdan Egedius (1877–1899) showed an unusually precocious talent and began studying painting at the age of eight. He died at twenty-two, after having shown considerable promise in depicting scenes of peasant life and episodes from the Nordic sagas.

The Finnish painter Axel Gallén Kallela (1865–1931) gave up the Nordic realist manner in 1893, after a visit from Doctor Adolph Paul, who frequented the same Berlin cabaret as Munch (the "Zum schwarzen Ferkel" or "Black Piglet"), and began to illustrate scenes from the Kalevala, the great Nordic epic. This resulted in a number of rather stilted paintings such as *The Defence of Sampo* (1896) or *The Death of Lemminkaïnen* (1897, p. 150 top)

Two years after Dr. Paul's visit, Gallén accepted young Hugo Simberg (1873–1917) as a pupil; Simberg lived in his studio from 1895 to 1897. Simberg's admirations included Böcklin and subsequently, after a trip to Britain, Burne-Jones. He produced an engaging body of paintings peopled with trolls and strange beasts; in his most char-

Jens Ferdinand Willumsen
Jotunheim, 1892–1893
Oil on zinc and enamel on copper, 105 x 277 cm
J.F. Willumsens Museum, Frederikssund

Willumsen here follows a common tendency in Symbolist art, making the frame an integral part of the composition. The artist commented that the figures on the left are those who seek the

"link between the infinitely great and the infinitely small" and those on the right are "men without a goal".

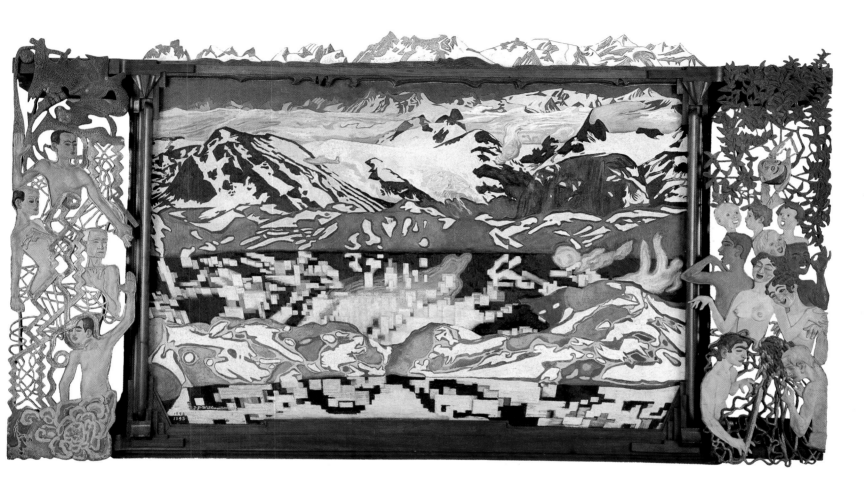

acteristic works, Death, in the form of a skeleton, is discovered gardening, gnawing a tree trunk in an allegory of autumn, or coming to carry off a peasant's child. His *The Wounded Angel* (1903, p. 149) gives ironic and pathetic expression to the incompatibility between ideal and reality.

[1] An accident of history established a regrettable connection between Nietzsche and Nazism which Nietzsche himself would certainly have rejected. The philosopher's sister, who took charge of his literary estate, was the widow of Bernhard Förster, a sort of proto-Nazi who sought to save the Aryan race by establishing a colony of German peasants in Paraguay. Nietzsche loathed him. Mrs. Förster was an unscrupulous editor of her brother's writings; she occasionally censored them, and was at pains to gain Hitler's approval. Hitler visited the Nietzsche Archives in her company. The Nazis were always eager to appropriate symbols and concepts for their own use. The term "Third Reich", for example, was borrowed from the mystic theology of Gioacchino da Fiore. In his writings it designated the reign of the Holy Ghost which was to follow that of the Father and the Son. The Nazi movement thus appropriated one of the myths of apocalyptic Christianity. Something similar occurred with Nietzsche's formulae, notably with the concept of the "superman" and the idea of "philosophising with a hammer" (*mit dem Hammer philosophieren*). The latter expression originally meant that contemporary idols should be sounded with a philosophical hammer to establish whether they were hollow.

[2] Munch's neurosis was probably heightened by that fact that twice in his lifetime a woman turned a gun on him. On the second occasion he grappled with the woman and was wounded in the left hand when the gun went off.

Jens Ferdinand Willumsen
Mountain in Sunlight, 1902
Oil on canvas, 209 x 208 cm
Thielka Galleriet, Stockholm

The Slav Countries

It is easily forgotten that Prague is further West than Vienna. The geography of our imagination is a construct sometimes independent of physical reality. Until 1918, Slovakia and the Czech Republic were part of the Austrian Empire and their artists had easy access to all that was going on in Vienna and the rest of Europe.

Frantisek Kupka (1871–1957) was born in Opocno in East Bohemia, and is best known today as one of the pioneers of abstraction. But he turned in that direction when he was already past forty and had a considerable Symbolist œuvre behind him. He was a precociously gifted draughtsman, whose first lessons were from his father. He left school at thirteen and was apprenticed to a saddler. Five years later, he took classes with the Nazarene painter Frantisek Sequens, while working as a medium to supplement his funds. Sequens taught him that art must concern itself with poetic and philosophical issues. Kupka was an avid reader who devoured Plato and Mme Blavatsky, the Vedas and Schopenhauer, Bergson and Nietzsche. Another Nazarene painter, the obscure Karl Diefenbach, revealed to Kupka the affinities between painting and music.

In 1895 he left for Paris, where he came under the influence of Forain, Ensor, Steinlen and Toulouse-Lautrec. Technically very able, Kupka produced works in a wide variety of styles, from political satire touched with populist irony to the grandiloquence or mysticism of the Symbolist idiom. Even within this idiom, his manner is extremely varied: decorative mysticism in *The Principle of Life* (p.156) and dramatic fantasy in *The Black Idol* (p.157). The latter was clearly the inspiration for Dracula's castle in Francis Ford Coppola's film. In the painting known as *Epona-Ballade* or *The Joys*, (p.159) Kupka places his dark-haired companion of the day alongside an earlier mistress who had died in 1898.

Kupka's superlative technique allowed him to work in many different styles. Certain of the works he painted on his arrival in Paris show a flawlessly naturalistic idiom, while the realism and irony of his line opened the way for a career like that of Félicien Rops. But Kupka was a man of very different character, and a combination of many factors – his penchant for the esoteric, his passion for music, and the impact of the 1909 Futurist manifestations – precipitated the breakthrough into abstraction.

Bruno Schulz
The Secular Story, 1st version, plate from
The Book of Idolatry, 1920
Glass print, 16.8 x 12.2 cm
Muzeum Narodowe, Warsaw

This engraving from the *The Book of Idolatry* uses a very rare technique involving drawing with a needle in a layer of black gelatine spread on a glass plate. The book is a series of plates devoted to the Symbolist vision of woman, who here dominates and humiliates the man.

Frantisek Kupka
Money, 1899
Oil on canvas, 81 x 81 cm
Národni Galerie, Prague

Kupka had strong anarchist connections and for several years his talent was devoted to ferocious political caricatures. This work is an oddity insofar as Kupka has treated a subject suitable for a satirical cartoon with the full panoply of the painter's art.

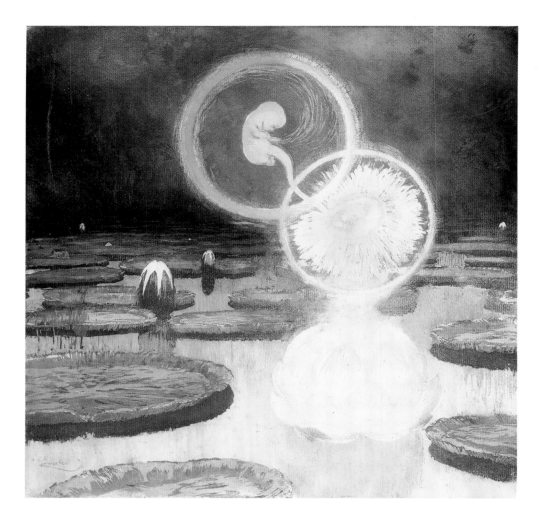

Frantisek Kupka
The Principle of Life, 1900–1903
Aquatint and colours, 34 x 34 cm
Musée National d'Art Moderne –
Centre Georges Pompidou, Paris

Kupka showed a lifelong interest in the esoteric.
Here he gives his subject a Buddhist treatment:
the lotus is a symbol of the soul. He attempts to
synthesise the spiritualist and scientific world
views by linking the foetus to the flower by an
umbilical cord.

Frantisek Kupka
The Piano Keys or *The Lake*, 1909
Oil on canvas, 79 x 42 cm
Národni Galerie, Prague

This strange work is a first step in the direction
of abstraction. Kupka makes painting analogous
to music; the piano keys at the bottom of the
painting arise and are transformed into part of
the landscape that includes boats on a lake.

The international career of Alphonse Mucha (1860–1939) illustrates the great mobility enjoyed by artists in this period. Born in Moravia, he worked in Vienna and in Munich before moving on to Paris, where he studied at the Académie Julian and ultimately won considerable success. His drawings were regularly published in various periodicals including *La Plume*, and he drew numerous posters for Sarah Bernhardt. He decorated the Bosnian pavilion at the 1900 World Fair and spent some years in the United States before returning to his own country, where he devoted himself exclusively to painting. Mucha was a virtuoso in many domains; he designed exquisitely intricate jewelry and his drawings and posters are the embodiment of Art Nouveau.

His first commission from Sarah Bernhardt was a matter of luck. He was at his printer's workshop on Christmas Eve when news came that the famous actress wanted a poster within the next few days. All the other artists having left, the printer had recourse to Mucha, who was then unknown. The printer disliked Mucha's design, unlike Bernhardt, who was delighted with it and continued to commission work from him for many years.

One of the original features of Mucha's posters was his habit of working from photographs, as many surviving examples show. His paintings have undeniable charm, but he himself was too content with life to express in his work the intense melancholy (or affectation thereof) which pervades the work of his Symbolist colleagues.

Between 1795 and 1919, Poland had no official existence, having been divided into three unequal parts under Prussian, Russian and Austrian

Frantisek Kupka
Resistance, or *The Black Idol*, 1903
From the sequence *The Voice of Silence*,
coloured aquatint on paper, 34.7 x 34.7 cm
Musée National d'Art Moderne –
Centre Georges Pompidou, Paris

An excellent example of Kupka's fantastic vein: a
colossal, menacing statue stands at the end of a
road. Francis Ford Coppola or his designer were
clearly inspired by this work in creating Dracu-
la's castle for the film of that name.

government. In the second half of the 19th century, Prussia and Russia
began to enforce a policy aimed at assimilating the population. German
and Russian became the official languages and the teaching of Polish in
schools was no longer permitted.

The Austrians governed the southern part of Poland, including Cra-
cow, the former royal capital. Their occupation was less repressive, at
least to the extent that Austria did not try to assimilate the Polish popu-
lation. This probably accounts for the fact that the Symbolist vein in
Polish art was largely centred on Cracow.

Frantisek Kupka
The Path of Silence, c. 1900
Pastel on paper, 58.1 x 65.1 cm
Národni Galerie, Prague

Poland's oppression lasted for over a hundred years, despite a num-
ber of insurrections, and inevitably left its mark on the arts. Like other
countries similarly oppressed – we might compare Ireland or French
Canada – the national language and the national faith helped define and
preserve the national identity. Above all, the lack of a true national
government meant that Polish identity had to be represented and
defended by a "government of souls", and this became the mission of
writers and artists. This responsibility is constantly invoked in the writ-
ings and paintings of the period; one cannot expect to understand the
development of Polish art without some notion of the historical situation.

True, Polish representatives sat in the Austrian parliament (and even,
at one point, in the Russian *Duma*), life was not uniformly difficult and
the wealthier classes in the Austrian part of the country were not averse
to speaking German. Hence the importance assumed by the duty of
memory, as embodied in the person of Stańczyk. He was a clown at the
royal court in the 16th century, but 19th century literature turned him

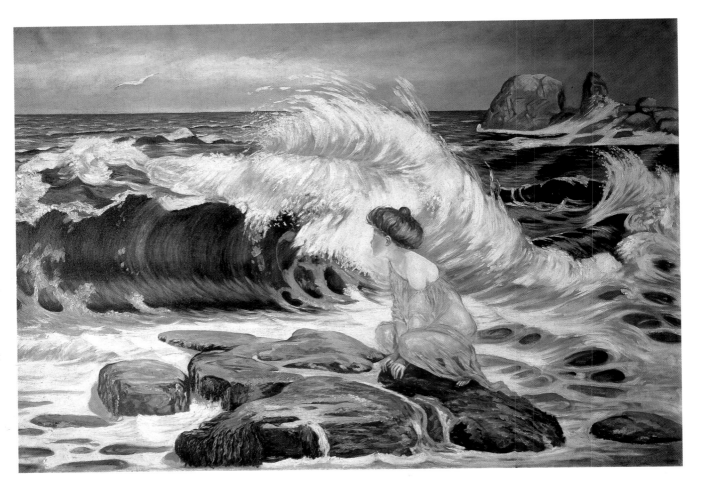

TOP:
Frantisek Kupka
The Wave, 1902
Water-colour and gouache on cardboard,
40.8 x 50.2 cm
Národni Galerie, Prague

BOTTOM:
Frantisek Kupka
The Bathers, 1906
Charcoal and watercolour on paper,
22.9 x 28.5 cm
Národni Galerie, Prague

into a personification of lucid patriotism. The almost "sacred" status of memory also explains why a number of artists and intellectuals sought to return to their "roots" among a peasantry which had, in their view, remained culturally pure. Two of the protagonists of this movement, the poet Lucjan Rydel and the painter and writer Stanislaw Wyspiański, married women of peasant families. These themes are developed in Wyspiański's play *The Wedding (Wesele)* of which Andrzej Wajda has made an excellent film.

Polish artists of the turn of the century travelled as widely as any others, finding their way to Paris, Berlin, Munich and Saint Petersburg. Wladyslaw Slewinski was in Pont-Aven with Gauguin and returned to Poland as the bearer of the good news. But the most striking and dramatic spokesman for Symbolist ideas in Poland was the writer Stanislaw Przybyszewski (1867–1927).

Przybyszewski's features are known to us from Munch's painting *Jealousy* (p. 144). He is the bearded figure of greenish complexion behind whose back two lovers meet. Munch, Strindberg and Przybyszewski all met in Berlin; the point of contact may have been Przybyszewski's wife, Dagny Juel, who was Norwegian. She was also a woman of great beauty and both Munch and Strindberg seem to have been fascinated by her. The painting no doubt reflects this situation.

Przybyszewski was a poet, theoretician of art, and occasional pianist, who cut a scandalous, not to say a devilish, figure. Borrowing from the repertory of the then fashionable Satanism, he coolly urged those who turned to him for advice to commit suicide. His complicated private life ended in tragedy for Dagny Juel.

He settled in Cracow when he was thirty (a year after Munch's por-

Frantisek Kupka
Epona-Ballade, The Joys, c. 1900
Oil on wood, 79.5 x 126 cm
Národni Galerie, Prague

Another aspect of Kupka's *œuvre*, this picture pays homage in surprising form to the two women in the artist's life: his dark-haired mistress of the time, and his former mistress who had died in 1898.

trait), and his house soon became known as "Satan's Synagogue" after the title of one of his novels. He befriended Stanislaw Wyspiański and together they founded the magazine *Zycie* (*Life*), which became the organ of "Young Poland", an artistic and literary movement. Przybyszewski was at pains to offend the Catholic sensibility of his compatriots, proclaiming a blasphemous distortion of the famous opening phrase of the Gospel of Saint John: "In the beginning was lust." This led him to a satanist theory of the creation of man and woman. It was Satan, he declared, who separated the original androgyne (a notion borrowed from the humorous myth recounted by Aristophanes in Plato's *Symposium*). The two sexes thus created have desperately sought to return to unity ever since. We must therefore thank Satan for the joys and torments of sexual desire.

Art, according to Przybyszewski, is a reflection of the absolute, and it is the artist's duty to reveal the "naked soul" (*naga dusza*) and to give utterance to the "cry" of the individual. Whatever the merit in these ideas, the tinsel in which Przybyszewski wrapped them has not worn well and has tended to discredit them.

Stanislaw Wyspiański (1869–1907) was one of the major artistic figures of Cracow. A playwright, an excellent portraitist and illustrator, he also made his mark in the decorative arts, designing the stained-glass windows of the Franciscan church in Cracow (p. 173). As so often with Polish art of this period, an apparently innocent work, like the nocturnal winter view of rose bushes wrapped in straw in Cracow's Planty gardens (p. 175), holds a coded message: the plants protected in this way symbolized the nation hibernating till spring and resurrection.

Wyspiański lived in Paris from 1890 to 1894, and was introduced to

PAGE 160:
Alphonse Mucha
The Abyss, c. 1898–1899
Pastel on canvas-backed paper, 129 x 100 cm
Musée d'Orsay, Paris

TOP:
Alphonse Mucha
Study for the cover of *Christmas and Easter Bells*, c. 1900
Pencil on tracing paper
Private collection, Paris

BOTTOM RIGHT:
Photograph of a model taken by Mucha, which he used for the magazine cover.

Alphonse Mucha
The Photographic Art, 1903
Drawing for the cover of a magazine,
Indian ink, 26 x 21 cm
Private collection, Paris

Like many other Symbolist artists from Khnopff to Klimt, Mucha made substantial use of photography. A friend of Nadar and of other major Parisian photographers of the period, he depicted the large-format bellows camera designed for portrait photography that he used in the drawing *The Photographic Art*. Ingres had already remarked that photography "is very beautiful, but you mustn't say so", and at its invention, photography terrified artists; they threw down their brushes in despair at the perfection with which photographs captured reality. In the 1850s, the many painters who used photography for their work tended to conceal and even deny the fact. Others, like Delacroix, openly admitted using it. Mucha did not suffer the typical dichotomy of the 19th century artist who used photography but was anxious about its relation to art. He loved photography for itself, was a lifelong amateur photographer and made widespread use of photos in his work. For him, the camera was a useful toy that performed the task which Baudelaire scornfully attributed to it, that of documentation, note-book, and timesaver.

Gauguin by Slewinski. His classmate at the Cracow school of Fine Arts, Józef Mehoffer (1869–1946), joined him in Paris where both studied at the Académie Colarossi (1891–1896). Mehoffer met Gauguin and Mucha there. A charming painting in Mehoffer's Symbolist manner is *The Strange Garden* (p.173 top). The naked child in the foreground, brandishing two hollyhocks, is the artist's son. Behind the child, Mehoffer's wife is shown plucking an apple from a heavily laden bough. The presence of a huge golden dragonfly hovering above the child's head invests the timeless scene with a somewhat magical significance – as though the artist were expressing a wish for never-ending happiness.

Like Wyspiański and Mehoffer, Jacek Malczewski (1858–1929) was a pupil of Jan Matejko, a supremely rhetorical painter whose entire *œuvre* was devoted to the glorification of Polish history. A similar obsession with history transpires from the poignant works that Malczew-

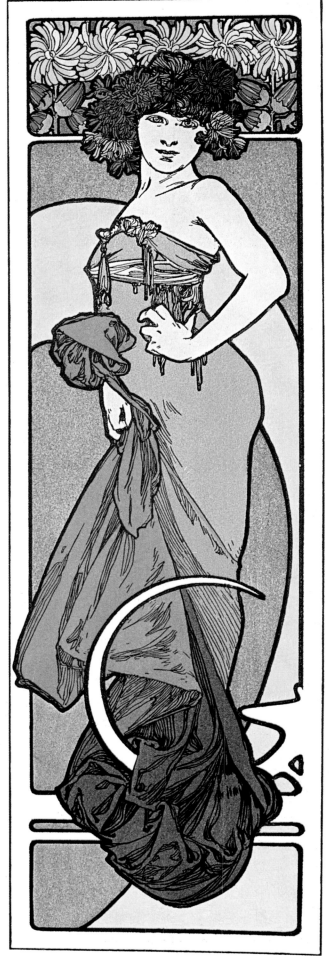

PAGE 162:
One of Mucha's favourite models posing for *The Brunette*, c. 1901

Alphonse Mucha
The Brunette, a page from *Decorative Documents,*
hand-coloured Monochrome lithograph,
46 x 33 cm
Private collection, Paris

Alphonse Mucha
Photograph of model and resulting drawing,
c. 1928

Photograph of a model for *February*, 1889

Alphonse Mucha
February, from *The Twelve Months of the Year*, 1889
Illustration for *Cocorico*

ski devoted to Poles deported to Siberia. This is the subject of *In the Dust Storm* (p. 167 top); a dust devil on a country road becomes a powerful metaphor for the way in which the memory of the fettered bodies of the deported could surge unexpectedly into the mind.

The grandiloquent rhetoric of paintings such as *Melancholia* (1890–1894, p. 169) and *Vicious Circle* (1895–1897, p. 169) returns to the obsessive question of the nation's frustrated hopes. But Malczewski did not restrict himself to this subject, and treated both mythological and Christian themes. Death itself is the subject of several of his paintings. In one of these (*Thanatos I*, p. 168), death is represented by an androgynous winged figure who draws an old man out of his manor by running the whetstone over the blade of a scythe. The old man represented is the artist's father, who had died four years before. In another (*Death*, p. 167), the angel of death lays her fingers as if in a healing gesture upon the eyelids of the man kneeling trustingly before her.

Witold Wojtkiewicz (1879–1909) introduces an entirely different tone into Polish art. An excellent caricaturist and one of the guiding spirits of Cracow's "Green Balloon" cabaret, he painted mainly childhood and circus scenes. If we attempt an overview of the themes of Polish painting in the 19th century, we perceive a progression from the downright heroism of Matejko, to the still heroic pathos of a Malczewski and thence to the ultimately pessimistic resistance of a Wyspiański.

In Wyspiański's play *The Wedding*, the figure of "the poet" drinks heavily. On the poet, by definition, responsibility for the spiritual health of the nation devolves; is he entitled to get drunk? The guests

upbraid him. The poet's answer is enigmatic: "If Chopin were alive today, he too would get drunk." For the Polish image of Chopin is not, as it is in the West, that of the valetudinarian salon genius, but that of a towering, heroic figure. Wyspiański's marriage to a peasant girl was intended as a patriotic manifesto; he found it intolerable that Polish artists of his day complained of "the burden" of national expectation being "too heavy". They, in turn, despaired of living up to such exorbitant expectations. Thus the figures depicted by Wojtkiewicz, child knights and damsels, may be considered an ironic variation on the heroic themes which had dominated the art of the preceding century. One should also mention the charm of Wojtkiewicz's use of colour. His talent was admired by Maurice Denis and André Gide before he died, prematurely, at the age of thirty.

Bruno Schulz (1892–1942) was born in the small town of Drohobycz where he taught drawing after studying architecture in Lvov and art at the Vienna School of Fine Art. A major author (best known for *The Street of Crocodiles*), he was also a fine draughtsman and engraver. The majority of his work was destroyed during World War II, but the extraordinary sequence of prints entitled *The Book of Idolatry* (1920, p. 155 and 170–171) fortunately survived. It is devoted to a single subject – the voluntary humiliation of a man before a woman.

Alphonse Mucha
The Emerald, 1900
One of the decorative panels for *Four Precious Stones*
Colour lithograph, 110 x 52 cm
Private collection

Photograph of the model for *The Emerald*, 1900

Jacek Malczewski
Self-Portrait in Armour, 1914
Oil on canvas, 54 x 65 cm
Muzeum Narodowe, Poznan

Malczewski painted many self-portraits in which he appears in different costumes. Here, in knight's armour, he evokes the past military glory of his country.

Jacek Malczewski
Death, 1911
Oil on canvas, 46 x 55 cm
Muzeum Narodowe, Poznan

The theme of a peaceful and healing death appears several times in the work of Malczewski. The young woman who incarnates Death is generally depicted gently touching the eyelids of a man who greets his fate with serenity.

PAGE 167 TOP:
Jacek Malczewski
In the Dust Storm, 1893
Oil on canvas, 78 x 150 cm
Muzeum Narodowe, Poznan

The Polish insurrections which occurred at regular intervals during the 19th century resulted in the deportation to Siberia of the defeated. This was one of Malczewski's chosen themes for a substantial period of his career. Here, the deported surge unexpectedly into the mind's eye on a country road, the violent, tormented movement of the dust devil evoking their suffering.

PAGE 167 BOTTOM LEFT:
Jacek Malczewski
Death, 1902
Oil on panel, 98 x 75 cm
Muzeum Narodowe, Warsaw

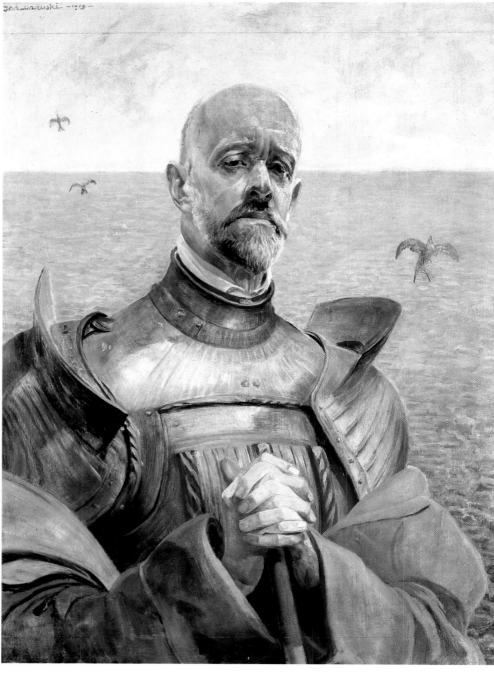

It is tempting to seek a clinical explanation for his choice of subject matter and to maintain that Schulz's work merely reflects his fetishistic inclinations. But the quality of the work transfigures this obsession and endows it with meaning, while the subject necessarily evokes the myriad representations devoted to relations between the sexes during the Symbolist age. Schulz's work began to appear after World War I, at a time when the Western European public perceived the major preoccupations of the preceding decades as clichéd and moribund. But given his treatment of this central Symbolist theme, Schulz might properly be regarded as the last great representative of the Symbolist spirit.

The passage of twentieth century history also left its mark on Stanislaw Ignacy Witkiewicz (1885–1939), whose artistic *nom de plume* was Witkacy. He fought in the Russian army during the First World War and was in Saint Petersburg when the Revolution broke out. These events determined his pessimistic view of history and the anti-aesthetic

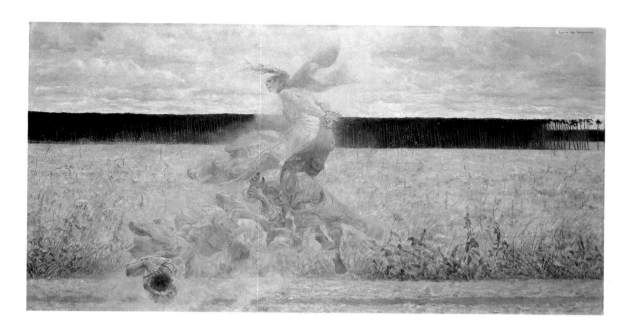

Jan Preisler
The Black Lake, 1904
Oil on canvas, 100 x 153 cm
Národni Galerie, Prague

Karel Masek
Spring, 1903
Oil on canvas, 44.5 x 66 cm
Private collection

Initially a disciple of Seurat, Osbert, and Henri
Martin, Masek developed a very personal style,
using mosaics of brilliant colour as Klimt had be-
fore him.

PAGE 168:
Jacek Malczewski
Thanatos I, 1898
Oil on canvas, 134 x 74 cm
Muzeum Narodowe, Warsaw

In front of a traditional manor, winged death sharpens its scythe. The noise attracts the old man who lives there, in whom we recognise the father of the artist, who had died several years earlier.

Jacek Malczewski
Vicious Circle, 1895–1897
Oil on canvas, 174 x 240 cm
Muzeum Narodowe, Poznan

BOTTOM:
Jacek Malczewski
Melancholia, 1890–1894
Oil on canvas, 139 x 240 cm
Muzeum Narodowe, Poznan

These two large paintings are complex allegories of the political situation of Poland divided between three imperial powers.

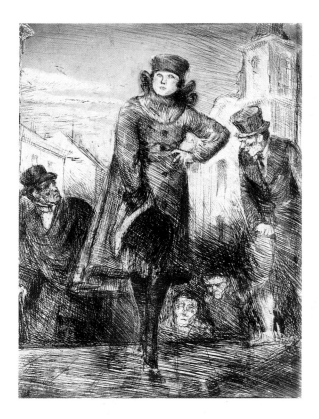

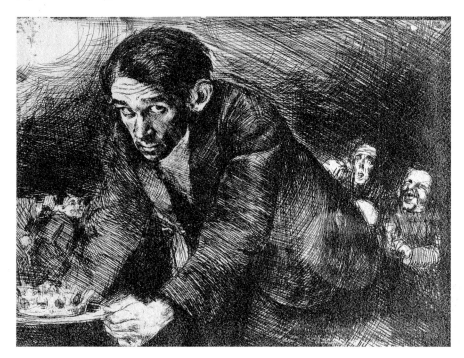

Undula Walks Off into the Night,
11.6 x 8.4 cm
Muzeum Narodowe, Warsaw

Dedication (Self-Portrait), 11 x 17.5 cm
Muzeum Narodowe, Warsaw

The Procession, 17 x 23 cm
Jagellonian Library, Cracow

The Stallions and the Eunuchs,
17.5 x 23.5 cm
Muzeum Narodowe, Warsaw

Undula the Eternal Ideal, 10.3 x 15.3 cm
Muzeum Narodowe, Warsaw

Bruno Schulz
Plates from *The Book of Idolatry*, 1920
All glass print (see p. 155 for details of the technique)

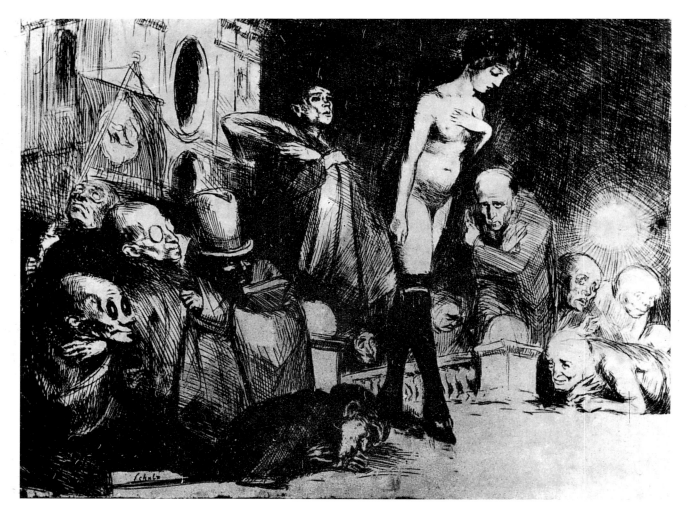

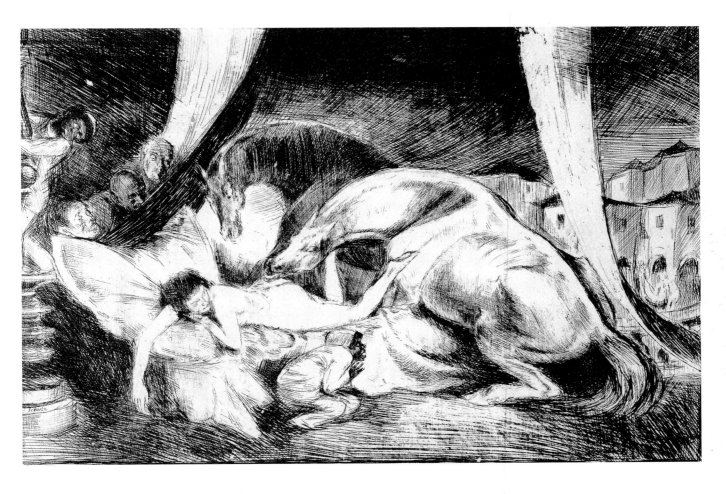

Wladyslaw Podkowinski
Ecstasy, 1894
Oil on canvas, 310 x 275cm
Muzeum Narodowe, Cracow

Podkowinksi discovered Impressionism at
twenty-three; three years later he turned toward
Symbolism. He died at twenty-nine, only a year
after painting this huge canvas which caused an up-
roar at its first exhibition. The flamboyant eroti-
cism of its transparent metaphor has nothing in
common with the theme of the evil woman
which was so common elsewhere in Europe.

Witold Pruszkowksi
Eloe, 1892
Pastel, 56.8 x 104 cm
Muzeum Narodowe, Wroclaw

PAGE 173:
Józef Mehoffer
The Strange Garden, 1903
Oil on canvas, 217 x 208cm
Muzeum Narodowe, Warsaw

Jan Matejko
Stanczyk, 1862
Oil on canvas, 88 x 120cm
Muzeum Narodowe, Warsaw

An academic painter who taught a whole genera-
tion of Polish artists (Malczewski, Wyspiański
and Mehoffer), Matejko made Stańczyk, a 16th
century court jester, a personification of lucid
patriotism.

Stanislaw Wyspiański
God the Father, 1896–1902
Stained glass, 846 x 390cm

This is the major stained-glass window of a very
homogeneous set made for the Franciscan
Church in Cracow.

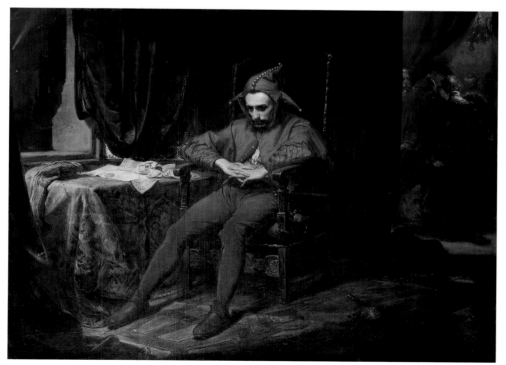

Witold Wojtkiewicz
Christ Among the Children, 1908
Oil on canvas, 67 x 70 cm
Muzeum Narodowe, Warsaw

The theme of childhood dominates the work of Wojtkiewicz. An excellent colourist, in other paintings he depicts a pathetic and derisory variant of the triumphalism of Matejko or the pathos of Malczewski.

Witold Wojtkiewicz
The Circus, 1906
Oil on canvas, 99.5 x 105.5 cm
Muzeum Narodowe, Warsaw

Stanislaw Ignacy Witkiewicz
General Confusion, 1920
Oil on canvas, 99 x 90 cm
Muzeum Narodowe, Cracow

This delirious parody of Symbolist composition makes, in provocative style, the claim that "Art is dead".

Stanislaw Wyspiański
The Planty Park by Night – Straw-men, 1899
Pastel, 69 x 107 cm
Muzeum Narodowe, Warsaw

These rosebushes, sheltered from the frost in casings of straw, are a coded image: the nation hibernates but will resurrect with the spring.

Mikhail Alexandrovich Vrubel
Head of the Demon, 1891
Illustration for M.I.Lermontov's poem "The Demon"
Water-colour and charcoal on paper, 23 x 35.6 cm
Tretiakov Gallery, Moscow

that predominates throughout his written and artistic œuvre (*General Confusion*, 1920, p. 175). He gave up painting in 1925, declaring that art was dead. Over the five years up to that date, he had executed a series of works which constitute "demonic" or senseless parodies of typically allegorical or Symbolist works. It is in this guise that he concerns us here; his paintings, like the work of Picabia, are at once a provocation and a comprehensive rejection of the art of the past.

For Russia, the first decades of the century marked a crucial phase in its troubled history. Torn since the early 19th century between a keen interest in the West, and the deep suspicion with which Western religion, scientific and political ideas were often viewed, the country was plunged into an insoluble debate and an equally insoluble institutional crisis.

The emancipation of the serfs in 1861 necessitated a fundamental restructuring of rural society, which inevitably led to yet further reforms. Land had to be distributed to the emancipated peasants. The intelligentsia took an interest in the fate of the peasantry. Its first naive impulse, in 1874, was a crusade to educate the popular classes and prepare them for the coming revolution. The repression which ensued favoured the development of terrorism, culminating in the assassination of Czar Alexander II in March 1881. The timing was unfortunate: he was on his way to the *Duma* to sign a liberalising law.

The development of the railway and the industrialisation of the country led to the rise of a new class, coinciding with the decline of the landed gentry. Anton Chekhov (1860–1904), himself the grandson of emancipated serfs, paints a humane and moving portrait of "lives coming undone" among the incomprehending gentry. (He also wrote an amusing parody of Symbolist theatre in *The Seagull*.)

The arts, in this context, were torn between the traditional, populist views of the Wanderers (*Peredwishniki*), who favoured a realistic chronicle of Russian life, and that of cosmopolitan artists and writers receptive to Western ideas. Orthodox Russia was also attracted to the Symbolist spirit, precisely to the extent that religious Symbolism remained a potent force in that country. In 1899 a number of these "cosmopolitan" artists, founded the magazine *Mir Iskustva (The World of Art)* in Moscow. They wished to keep their readers informed of significant artistic events in Munich, Berlin, Vienna and Paris. Notable among them was Sergei Diaghilev who was later to found the *Ballets Russes*, Léon Bakst, his stage and costume designer, Constantin Somov and above all the painter Mikhail Vrubel.

Despite his short and tragic life, Mikhail Alexandrovich Vrubel (1856–1910) was the most influential of the Russian painters working in the Symbolist vein. The son of Danish and Polish parents, he studied law in Saint Petersburg before enrolling in that city's School of Fine Arts at the age of twenty-four. He devoted five years of his life to restoring the frescoes of the Church of Saint Cyril in Kiev and finally settled in Moscow where he was welcomed into the circle of Savva Mamontov, a wealthy patron of the arts. At his request, Vrubel created opera sets and designed various objects manufactured at the artistic colony which Mamontov had established on his country estate.

Vrubel depicted a variety of subjects, including ballet and mythological (*Pan*, 1899) and allegorical themes. But his reputation is based on a series of paintings illustrating Lermontov's poem "The Demon" (pp. 176–179). It is the story of a quasi-supernatural being who is in love with the beau-

Mikhail Alexandrovich Vrubel
Seated Demon, 1890
Oil on canvas, 114 x 211 cm
Tretiakov Gallery, Moscow

TOP:
Mikhail Alexandrovich Vrubel
The Demon Carried Off, 1901
Sketch for the 1902 painting, water-colour,
gouache and colour on paper, 21 x 30 cm
Pushkin Museum, Moscow

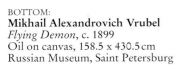

PAGE 179 TOP:
Mikhail Alexandrovich Vrubel
The Pearl, 1904
Pastel and gouache on cardboard,
55 x 43.7 cm
Tretiakov Gallery, Moscow

BOTTOM:
Mikhail Alexandrovich Vrubel
Flying Demon, c. 1899
Oil on canvas, 158.5 x 430.5 cm
Russian Museum, Saint Petersburg

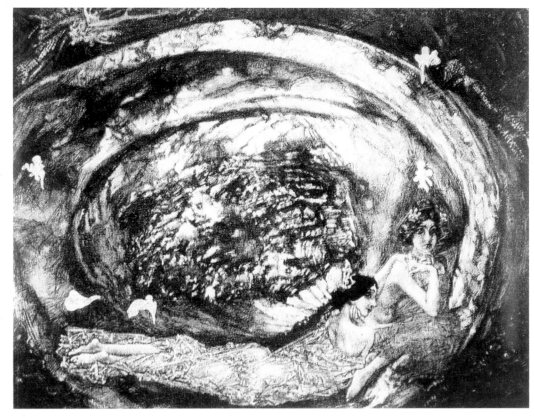

The Russian Constructivist Gabo considered Vrubel "the Russian Cézanne". Vrubel's vital influence on the generation of Malevich and Kandinksy is almost unknown in Western Europe. And yet Vrubel was the first to translate into his art the historical break with Byzantine art (whose imprint remains in the form of strange mosaics), which he transcends and manipulates. The result is a scaly impasto full of fossil flowers and fragments of slate and mineral. The textural invention and the deformation of his figures, which are often reduced to the merest allusions, were the source for a whole area of Modern Art. These works and those of the preceding pages express the essentially magic-based mysticism of the painter, and are based on Lermontov's poem "The Demon". Obsessed by the figure of the Demon, whom he depicted as a suffering, excluded angel rather than a malevolent being, Vrubel spent fifteen years painting picture after picture in which his hero, a beautiful androgynous figure marked by despair, undergoes a gradual decomposition till he becomes, in G.H. Hamilton's words, a being "half-woman, fallen to earth, his body contorted and crushed, his wings with their peacock feathers crushed beneath him, and on his face an expression of unspeakable despair". This obsessional psychosis culminated in Vrubel's madness in 1902; he went blind in 1906 and died in 1910.

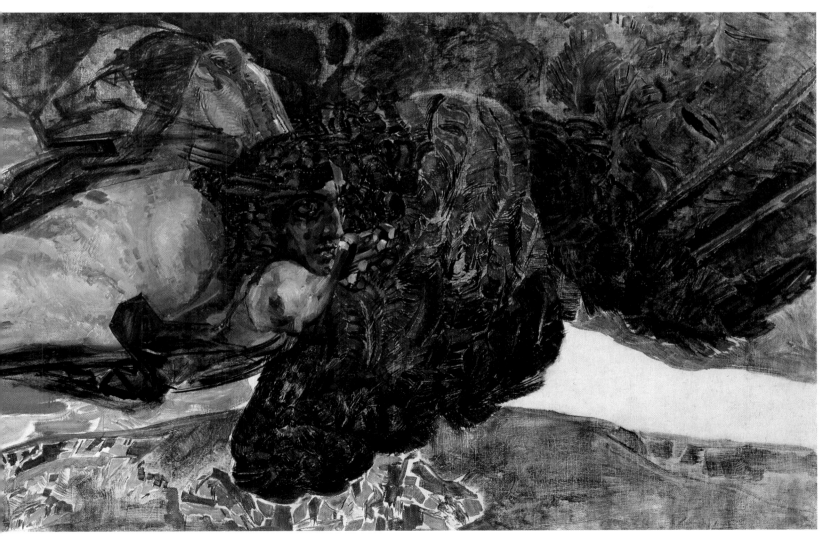

Léon Bakst
Terror Antiquus, 1908
Oil on canvas, 250 x 270 cm
Russian Museum, Saint Petersburg

tiful Tamara. He arranges for her fiancé to be assassinated by bandits, then seduces her in the convent to which she has retired. She dies and the Demon remains alone and in despair. The figure of the Demon undergoes a slow transformation in Vrubel's paintings. First depicted as a "demon of superhuman beauty" he eventually becomes, in the words of George Heard Hamilton, "a being half-woman, fallen to earth, his body contorted and crushed, his wings with their peacock feathers crushed beneath him, and on his face an expression of unspeakable despair". Vrubel himself went mad at the age of thirty-six. He lost his sight at forty and died four years later. Identifying Vrubel with his theme, the painter Vassili Denissov (1862–1920) commemorated Vrubel's death in his water-colour *The Fallen Demon, on the Death of Mikhail Vrubel* (1910, p. 185).

Victor Samirailo (1868–1939) was influenced by both Vrubel and Western artists and illustrators. *Night* (1908, p. 185), with its solitary

wanderer surrounded by snakes, is reminiscent of the disquieting, visionary world of Alfred Kubin. Léon Bakst (1866–1924) made his reputation by designing sets and costumes for Diaghilev's *Ballets Russes*, but his paintings are very much in the Symbolist vein. *Terror Antiquus* (1908, p. 180) shows the sinking of Atlantis, and with it, a world and its values cataclysmically destroyed. Konstantin Somov (1869–1939) was also active in the circle of *Mir Iskustva*. His manner is more traditional than that of other Russian artists mentioned so far, at times romantically atmospheric (as in his *Fireworks* of 1922), at others bizarrely evocative (as in *Sorcery* of 1898, p. 183). Victor Elpidiforovich Borissov-Mussatov (1870–1905) devoted his work to a nostalgic vision of the landed gentry and the great estates of the past. He influenced a number of young Russian Symbolists, notably Wassily Kandinsky (1866–1944). Kandinsky showed himself highly original in his treatment of traditional Russian themes (*Moonlit Night*, p. 188; *George and the Dragon*, p. 189) but by 1910 had turned to abstraction and was producing some of the most hauntingly "musical" paintings of Western art.

Alexandre Nicolas Benois
The Sultane Rouge, 1911
Water-coloured drawing, costume for
Stravinsky's ballet *Petrushka*.
Private collection

RIGHT:
Léon Bakst
Coppelius and Coppelia, 1903–1904
Oil on canvas, 83 x 62.5 cm
I. Brodsky Museum, Saint Petersburg

Bakst, best known as the designer of exotic décors for Diaghilev's famous *Ballets Russes*, was also a painter of the fantastic. *Terror Antiquus* evokes the disappearance of a civilisation (Atlantis) and *Coppelius and Coppelia* is an ironic fantasy based on Hoffman's famous tale.

Victor Samirailo
Witch, 1910
Water-coloured drawing on paper, 31.4 x 32 cm
Russian Museum, Saint Petersburg

PAGE 183:
Konstantin Somov
Sorcery, 1898
Gouache, pencil and bronze with white highlights, 49.5 x 34.1 cm
Russian Museum, Saint Petersburg

Ilya Repin
Sadko, 1876
Oil on canvas, 322.5 x 230 cm
Russian Museum, Saint Petersburg

With these works, one enters the nocturnal,
phantasmagoric and alarming world typical of
Russian Symbolism.

TOP:
Vassili Denissov
*The Fallen Demon, on the death of Mikhail
Vrubel*, 1910
Water-colour and pen on paper, 48 x 56.6 cm
Russian Museum, Saint Petersburg

In this last homage to Vrubel, the painter of Ler-
montov's *Demon*, Denissov identifies the artist,
who died prematurely, blind and insane, with his
supernatural subject who has fallen prey to guilt
and solitude.

Victor Samirailo
Demon, undated
Water-colour on paper, 30.8 x 22.5 cm
Russian Museum, Saint Petersburg

RIGHT:
Victor Samirailo
Night, 1908
Water-colour, white highlights on paper glued to
cardboard, 30.8 x 22.5 cm
Russian Museum, Saint Petersburg

Kosma Petrov-Vodkin
Shore, 1908
Oil on canvas, 128 x 159 cm
Russian Museum, Saint Petersburg

Valentin Alexandrovich Serov
The Rape of Europa, 1910
Tempera on canvas, 138 x 178 cm
Serov family collection

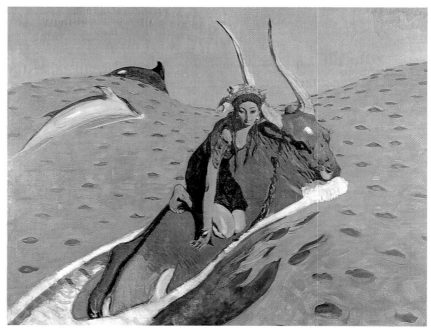

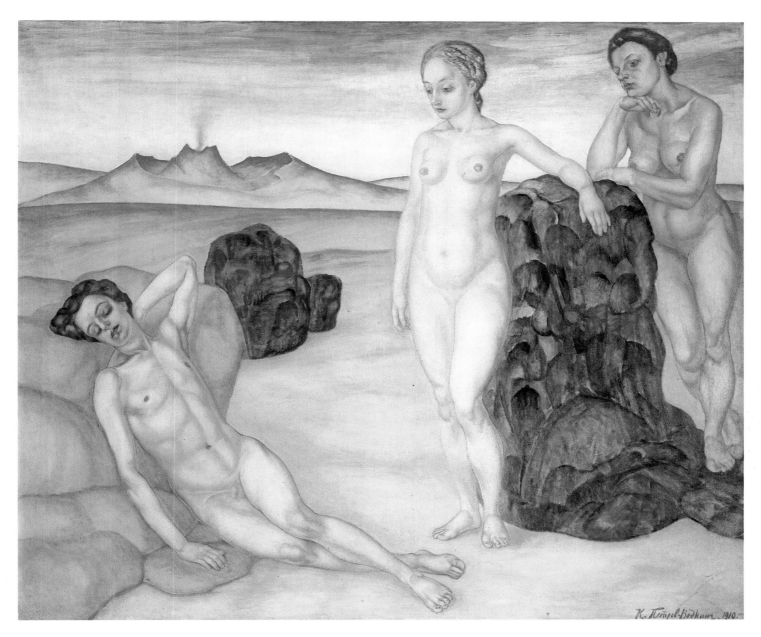

Kosma Petrov-Vodkin
Sleep, 1911
Oil on canvas, 161 x 187 cm
Russian Museum, Saint Petersburg

Valentin Alexandrovich Serov
The Rape of Europa, 1910
Painted porcelain, 24 cm high
Private collection

Mysticism and eroticism characterise the Symbolist works of Kasimir Malevich (1878–1935), whose marked tendency to polarisation between two colours or even monochromaticism foreshadows Suprematism; thus the yellow of *The Flower Gathering* (1908, p. 190) or the red of *Oak and Dryads* of the same period (p. 191). But Malevich's Symbolism also partakes of the heady atmosphere of Russia with its religious, theosophical, anthroposophic, esoteric and occult activities. *The Flower Gathering* has an esoteric philosophical import in direct line of descent from the

Wassily Kandinsky
Moonlit Night, 1907
Water-coloured wood engraving, 20.8 x 18.6 cm
Tretiakov Gallery, Moscow

Nabis, and in particular from Maurice Denis, who had visited Moscow and exhibited there. Yet in this mystical garden, the feminine triad may well be regarded as a Far Eastern version of the European "Three Graces". And in *Oak and Dryads* we may perhaps detect a synthesis of Greek tradition, the Biblical tradition of the Tree of Life and the Far Eastern "tree of illumination". The mystery of the Cosmos is presented to our eyes in the meeting of the male (the phallic tree) and female (the womb within the tree). *Epitaphios (The Shroud of Christ)* (p.190) is or-

thodox in inspiration but draws on Buddhist models despite the iconographical debt it owes to Vrubel's Kiev frescoes.

Kosma Sergueevitch Petrov-Vodkin (1878–1939) belonged to the younger generation of *Mir Iskustva*. He studied in Munich and was heavily influenced by Puvis de Chavannes, as the peaceful, classical poses of *Shore* (p.186) and *Sleep* (p.187) testify.

The singular paintings of Pavel Nicolaievich Filonov (1883–1941) place him somewhere on the outer limits of Symbolism. His obsessional style is exhibited in works which combine the attention to detail of a miniature and the uncanny aspect of nightmare, as illustrated by his *Peasant Family* (1915, p.192). Filonov's art fell into disgrace after the Revolution in the streets of Saint Petersburg/Leningrad. An exhibition in Saint Petersburg was cancelled at the last minute, a critic having claimed that Filonov, though the son of a coachman, had a mystical, *petit bourgeois* conception of the world. He died of cold and hunger in

Wassily Kandinsky
George and the Dragon, undated
Oil on cardboard, 61.4 x 91 cm
Tretiakov Gallery, Moscow

Even Kandinsky, like all the great masters of Modern Art, passed through a Symbolist phase. Yet three years later, Kandinsky abandoned the deliberately naive tone he had assumed in painting subjects from legend, and painted his first abstract water-colour, thus becoming the great pioneer of abstract art.

Kasimir Malevich
The Flower Gathering, 1908
Water-colour, gouache and pencil on
cardboard, 23.5 x 25.5 cm
Private collection

Kasimir Malevich
Epitaphios (The Shroud of Christ), 1908
Gouache on carton, 23.4 x 34.3 cm
Tretiakov Gallery, Moscow

Kasimir Malevich
Oak and Dryads, c. 1908
Water-colour and gouache on paper, 21 x 28 cm
Private collection

Kasimir Malevich
Repose. Society in Top Hats, 1908
Water-colour, gouache, Indian ink, and ceruse on
cardboard, 23.8 x 30.2 cm
Russian Museum, Saint Petersburg

The invention of Suprematism was a gradual
artistic evolution in which Malevich necessarily
passed through Impressionist, Symbolist and
Cubist phases. Under the influence of Maurice
Denis, his Symbolist works display a primitivist
approach to drawing, as well as certain leanings
towards monochromism and spiritual syncret-
ism, in which the seeds of Suprematism are evi-
dent.

LEFT:
Pavel Filonov
Peasant Family, 1915
Oil on canvas, 89 x 72 cm
Russian Museum, Saint Petersburg

Filonov was a strange, tormented and largely self-taught man, whose complex and confused philosophy and theory of art found direct and sincere expression in his painting. The obsessional character of his compositions is clear in this *Peasant Family* as it is in the other two canvases reproduced. Like Malevich some years later, he found himself at a crossroads between an increasingly formal organisation of his paintings and the abstraction which he never in fact adopted.

Pavel Filonov
A Man and a Woman, 1912–1913
Pen, brush, brown ink, Indian ink and water-colour on paper, 31 x 23.3 cm
Russian Museum, Saint Petersburg

PAGE 193:
Pavel Filonov
War with Germany (detail), 1915
Oil on canvas, 176 x 156.3 cm
Russian Museum, Saint Petersburg

the streets of Leningrad during the siege of the city in 1941. Ironically, the retrospective devoted to his work in the late 1980s was hung in the very same museum, the Museum of Saint Petersburg.

The Lithuanian artist, Mikolajus Čiurlionis (1875–1911), lived in poverty and solitude, taking a passionate interest in the writings of Nietzsche and Rudolph Steiner and in the mythology of his own country. He lived in Warsaw for six years and died at the age of 36. His work, still relatively unknown in the West, combines the decorative and the mystical. Tending toward abstraction, it draws much of its inspiration from music, as in his *Sonata* series (pp. 194–195).

Mikolajus Čiurlionis
Star Sonata. Allegro, 1908
Tempera on cardboard, 72.2 x 61.4 cm
Čiurlionis Museum, Kaunas

The work of Čiurlionis is inspired by music; it presents analogies with those of the Hopi Indians or with Australian Aborigines in the way his art is put at the service of a mystical rite and teaching.

Mikolajus Čiurlionis
Rex, 1909
Tempera on cardboard, 72.2 x 63 cm
Čiurlionis Museum, Kaunas

The Mediterranean Countries

We have still to consider Italy and Spain. It was only in the second half of the 19th century that Italy became a unified state. The crucial year was 1861, when Victor Emmanuel was crowned King of Italy. (Serfdom was abolished in Russia in the same year.) Though the nationalists ardently desired that Rome should be the capital of the new state, it remained merely the capital of the Pontifical States. And so it might have remained, had not the French defeat by the Prussian army at Sedan in 1870 and France's subsequent capitulation led to the withdrawal from the city of French troops.

In Italy as in Spain, innovative art forms developed mainly in the great industrial and commercial centres of the North, particularly in Milan and Barcelona. The style was frequently derived from the most graceful – and insipid – forms of French Symbolist art. This description summarizes the works of the Spanish artists Juan Brull-Viñolas (1863–1912) and Adria Gual-Queralt (1872–1944). Brull-Viñolas attended the Barcelona School of Fine Arts before studying in Paris, where he took up residence. In addition to his work as a painter, Gual-Queralt was a prominent stage director and taught acting. He played a significant role in the theatre and was one of the major figures of the Catalan modernist movement.

French influence also made itself felt in Italy, for example in the work of Gaetano Previati (1852–1920) who at one stage of his career produced "decadent" and "mystic" works. *Motherhood* was exhibited in Milan in 1891 and provoked a lively polemic, earning him an invitation to the Parisian Rose+Croix Salon. Previati's *Paolo and Francesca* (1901, p. 201) is very much in French Symbolist style, while the execution of his 1907 *Eroica* (p. 200) in which the pigment is applied in dynamic (divisionist) stripes, offers a foretaste of Futurism *à la* Boccioni.

Giovanni Segantini (1858–1899), who died at the age of thirty-nine, had a singularly unfortunate childhood. After his mother's death, his father abandoned him in the streets of Milan. He spent three years (from twelve to fifteen) in a reform school, and it was thanks to the director of this establishment that he was accepted by the Brera Academy, then attended by many outstanding artists. He practised first a naturalist vein, then pointillism, and turned to Symbolism when he was past thirty. It was at this point that he was suddenly taken with a passion for literature and philosophy. Withdrawing into the Grison mountains, he began to read Maeterlinck, d'Annunzio, Goethe and Nietzsche, and to study Indian philosophy.

His admiration for Nietzsche is expressed in the frontispiece he drew

Umberto Boccioni
Modern Idol, 1911
Oil on wood, 59.7 x 58.4 cm
Private collection, London

Before taking part, with Marinetti, in the composition of the famous *Manifesto of the Futurist Painters*, Boccioni happily mingled literary themes, Modern Style, and Divisionism. His style evolved rapidly, moving from a semi-abstract but fluid lyricism to the painting of "states of mind" and, later, "a new lyrical anatomy of movement".

Umberto Boccioni
Study of a Female Face, 1910
Oil on canvas, 64 x 66 cm
Private collection, Milan

Giovanni Segantini
The Punishment of the Lustful, 1891
Oil on canvas, 99 x 173 cm
Walker Art Gallery, Liverpool

Segantini's essentially lyrical art tended toward landscape, in which his luminous, almost mystical palette excelled; but his fluid stroke-painting was combined with an increasingly heavy Symbolism.

for the Italian translation of *Thus Spake Zarathustra*. Inspired by traditional representations of the Annunciation, it bears the title *The Annunciation of the New Word*. On the wall of the garden in which the scene unfolds can be read: "May the children of thy womb be beautiful for love, strong for battle, and intelligent for victory."

A painting such as *Love at the Springs of Life* (1896, p. 198) is overwhelmingly Symbolist, in the pantheism inspired by the Alpine landscape and in the winged figure sitting by the spring. A letter from the artist to a friend confirms its symbolic content: The painting "represents the joyful and carefree love of the woman and the pensive love of the man wreathed in the natural impulses of youth and of springtime. The path they follow is narrow and bordered with rhododendrons in bloom, and they are dressed in white (a pictorial representation of lilies). 'Eternal love,' say the red rhododendrons, 'eternal hope,' replies the evergreen privet. An angel, a mystical and suspicious angel, spreads its great wing over the mysterious fountain of Life. The water flows out of a bare rock, both of which are symbols of eternity." The artist's language reflects the tenor of his philosophical meditations in his mountain retreat.

Segantini corresponded at length with Giuseppe Pellizza da Volpedo (1869–1907), a painter from Northern Italy whose work was not exclusively Symbolist. Pellizza was close to Neo-Impressionism at times, and his work set up polemics which were to play an important part in

Giovanni Segantini
Love at the Springs of Life (The Fountain of Youth), 1896
Oil on canvas, 69 x 100 cm
Galleria Civica d'Arte Moderna, Milan

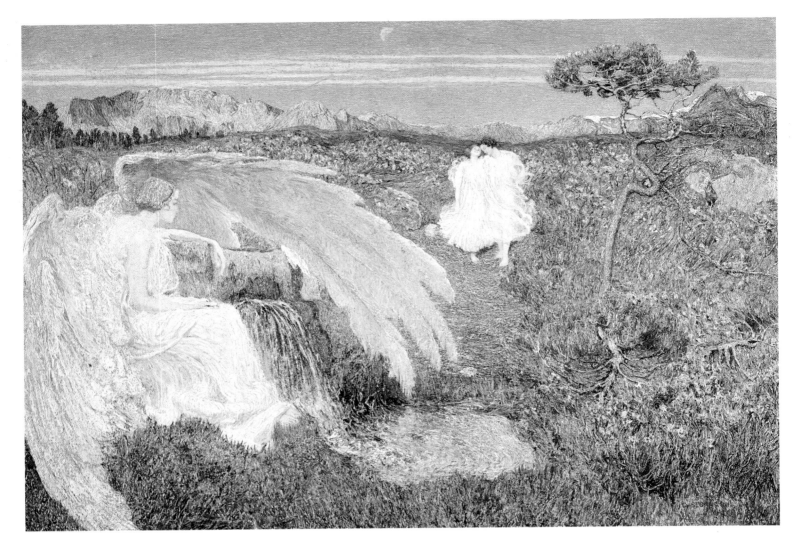

the development of the Italian art of the following decades. His *Rising Sun* (1903–1904, p. 204), with its radiating prismatic and divisionistic effects, expresses both his passion for nature and his interest in the theory of colour.

Alberto Martini (1876–1954) was above all an outstanding illustrator, as witness the splendid Indian ink drawings he executed in 1908 to illustrate the *Tales* of Edgar Allan Poe (p. 202). The terror of Poe's work is evoked by the way the black ink devours the white page like a dark cloud hiding the moon and by the energetic dramatisation of attitudes. In his youth, Martini studied the drawings of such 16th century German artists as Dürer and Cranach. He also illustrated the writings of

Carlo Carrà
The Horsemen of the Apocalypse, 1908
Oil on canvas, 36 x 94 cm
The Art Institute of Chicago, Chicago (IL)

Another Italian artist in search of "simultaneity of sensation" with the help of an expressionist technique close to Divisionism and subjects drawn from the fantastic. This eventually led him to *Pittura Metafisica*, a movement that he, Savinio and de Chirico founded in 1916.

Alberto Martini is the greatest illustrator of the Italian strand of Symbolism. His tendency toward the fantastic, macabre and grotesque is akin to Redon and Moreau, and led him to illustrate authors such as Dante, Boccaccio, Verlaine, Rimbaud and Mallarmé.

PAGES 200–201, FROM LEFT TO RIGHT:

From the sequence *The Struggle for Love*:

The End of Venus Aphrodite, 1903
Pen and Indian ink, 22.5 x 12.9 cm

The Virgins: The Woman in Love, 1904
Drawing and water-colour, 24 x 16.4 cm

Human Passions: Mockery, 1904
Pens and Indian ink wash, 16.2 x 21.6 cm

Human Passions: Engulfing, 1904
Pen and Indian ink wash, 16.2 x 21.6 cm

LA FINE DI VENERE AFRODITE

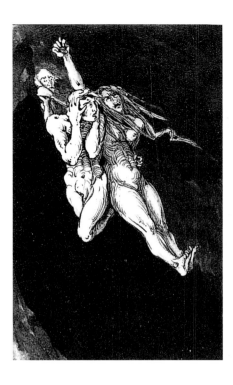

PAGE 200 BOTTOM:
Gaetano Previati
Eroica, 1907
Oil on canvas, 116 x 144 cm
Private collection

BOTTOM:
Gaetano Previati
Paolo and Francesca, 1901
Oil on canvas, 230 x 260 cm
Galleria Civica d'Arte Moderna, Ferrara

Again the Apocalypse, Dante, and *amour fou*
symbolised by the lovers forever damned
and forever locked in each others' arms.

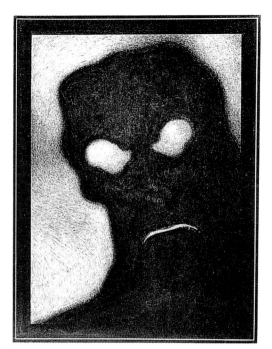

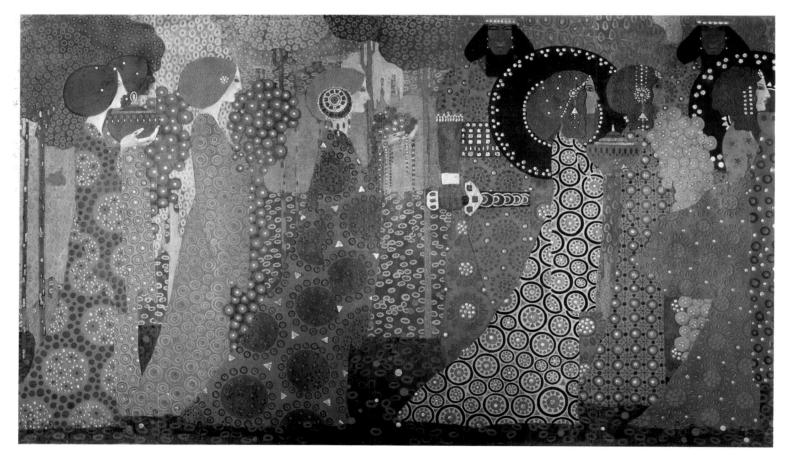

TOP:
Alberto Martini
Three illustrations for the *Tales* of Edgar Allan Poe:

Conversation of Eiros with Charmion, 1906
Pen and Indian ink, 28 x 20 cm

Silence, 1908
Pen and Indian ink, 28 x 20 cm

Hop-Frog, 1905
Pen and Indian ink, 28 x 20 cm

BOTTOM:
Vittorio Zecchin
First panel of the tryptych of "The Thousand and One Nights", 1900–1912
Oil on canvas, dimensions and whereabouts unknown

The sumptuous elegance of this canvas is clearly derivative of Gustav Klimt, who, a few years earlier, had been inspired by the rich mosaics of Venice and Ravenna.

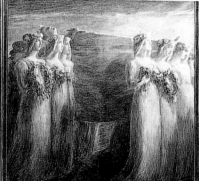

Giuseppe Pellizza da Volpedo
Broken Flower, c. 1896–1902
Oil on canvas, 79.5 x 107 cm
Musée d'Orsay, Paris

This funeral cortège, with its overt Symbolism, might be the image of Pellizza's life: he committed suicide at thirty-nine, shortly after his wife's death. A typical product of Italian Divisionism, it explores the effects of light. The figures are seen from behind to signify the departure to another world.

Dante, Boccaccio, Mallarmé, Verlaine and Rimbaud. He lived in Paris from 1928 to 1931, and the Surrealists, seeing affinities between his work and their own, made overtures to Martini but were rebuffed.

Among the secondary figures of Italian Symbolism, Vittorio Zecchin (1878–1947) was clearly indebted to Gustav Klimt, while Felice Casorati (1883–1963) practised a decorative vein of Symbolism.

Romolo Romani (1884–1916) was one of the signatories of the 1910 Futurist manifesto. Before then, his work had been somewhat Symbolist in its aspiration to evoke mood, moving towards abstraction some two years earlier than either Kandinsky or Kupka (cf. p.205). Romani gave up his art at twenty-eight as a result of mental illness, and died four years later at the age of thirty-two.

The Venetian painter Guido Cadorin (1892–1976), the youngest Italian Symbolist, descended from a family of artists which can be traced back to the 16th century. He was twenty-four when World War I broke out and his Symbolist period was consequently short. His *Carnaval* triptych (1914, p.207), painted at the age of twenty-two, juxtaposes a chicken hanging in a butcher's shop, four friends draped around a table in drunken confusion, and a young woman's stockinged legs surrounded by carnival streamers. This is not the Symbolist *femme fatale* so much as adolescent sexual revulsion.

Cadorin's *The Trench* depicts a small expanse of meadow dotted with

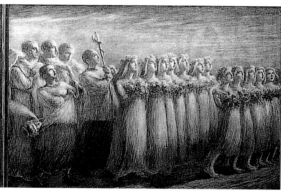

Gaetano Previati
The Funeral of the Virgin, c. 1901
Oil on canvas, 156 x 583 cm
Galleria Nazionale, Rome

Another representative of Divisionism, Previati was also notable for his sinuous and at times convoluted line, which makes him one of the rare Italian representatives of Art Nouveau. In 1910 he published a theoretical work, *The Scientific Principles of Divisionism*, which attracted the attention of the Futurists and, in particular, of Balla, who became his pupil.

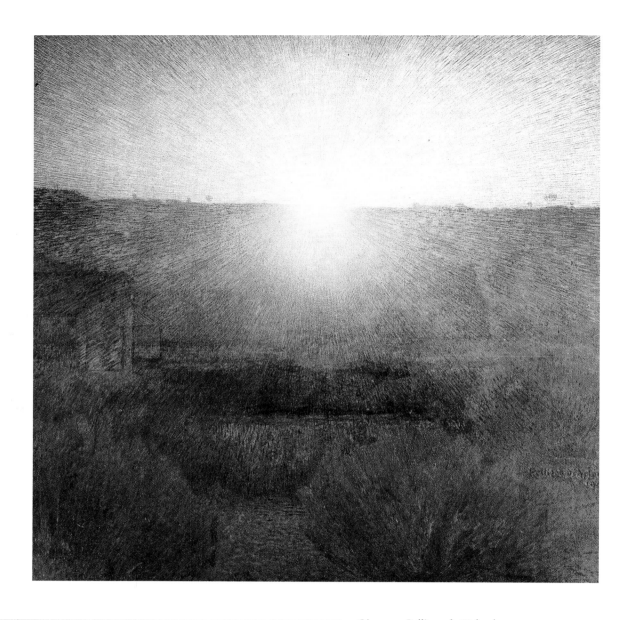

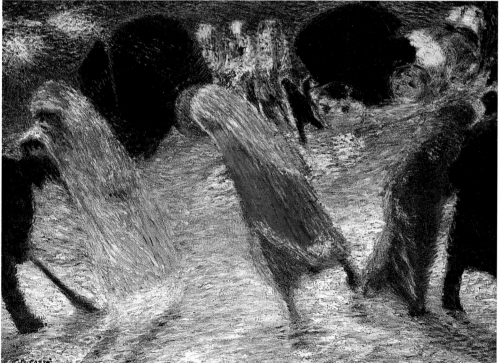

Giuseppe Pellizza da Volpedo
The Rising Sun or *The Sun*, 1903–1904
Oil on canvas, 150 x 150 cm
Galleria Nazionale d'Arte Moderna, Rome

Carlo Carrà
Leaving the Theatre, 1909
Oil on canvas, 69 x 91 cm
Private collection, London

PAGE 205:
Romolo Romani
Images, c. 1908
Pencil and tempera on backed hardboard,
185.5 x 244.5 cm
Pinacoteca, Brescia

Romolo Romani
Lust, undated
Pencil on paper, 62 x 47 cm
Musei Civici d'Arte e Storia, Brescia

Romolo Romani
The Scruple, undated (c. 1904–1906)
Pencil on paper, 63 x 48 cm
Private collection, Brescia

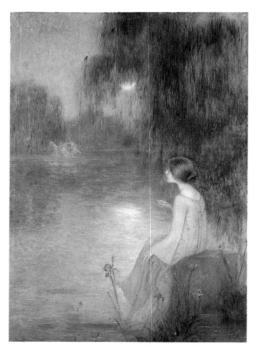

Juan Brull-Viñolas
Reverie, 1898
Oil on canvas, 200 x 141 cm
Museo de Arte Moderno, Barcelona

TOP:
Adria Gual-Queralt
Dew, 1897
Oil on canvas, 72 x 130 cm
Museo d'Arte Moderno, Barcelona

wild flowers, and the sky beyond. It is dated 1917; a moving understatement, it portrays in pastoral mode a corner of the front line where the young artist awaited the forthcoming assault.

Until the end of the 19th century, architecture seems to have been confined to an orthogonal principle stressing vertical, horizontal and parallel lines. Antoni Gaudí y Cornet (1852–1926) was undoubtedly the most original architect of his century; even today, his buildings seem strikingly exotic. His housing blocks, covered with a mosaic of multicoloured ceramic fragments, are instantly recognisable in the streets of Barcelona, standing out like brightly coloured toadstools. The Güell Park is also decorated in this style. But the huge unfinished structure of the Sagrada Familia (Holy Family) Cathedral, begun in 1883, constitutes a summation of Gaudí's fantastical craft. To be sure, rococo art had already cultivated a sense of vertigo by its use of curved and asymmetrical forms. But Gaudí, in his many-spired building (the cathedral is intended to have thirteen towers to signify Christ and the apostles), as in his crypts and chapels (notably the one built for the Colonia Güell), dispenses with the reassurance of verticality one is inclined to expect and sets his pillars at a disquieting slant. By fracturing and slanting his lines, he broke with a millenial tradition.

What are we to make of this? Did Gaudí, following his artistic intuition, express the essence of his age, the collapse or deliquescence of an emblematic cultural structure transparently disintegrating around him? If so, his Sagrada Familia might be considered the supreme religious monument of decadence.

In the context of Symbolism, it is interesting to compare the Sagrada Familia with the baroque edifice constructed in the same period by the French rural postman Ferdinand Cheval at Hauterives in the Drôme. This self-taught man devoted more than thirty years of his life to single-

handedly building a "palace" expressive of a popular philosophy of life and work. There is a sort of formal affinity between the two buildings; both are reminiscent of the castles that children build on the seashore by letting moist sand dribble through their fingers. Cheval built his castle with oddly shaped stones he picked up on his rounds; Gaudí was directly inspired by the jagged rocks of Capes Creus and Ampurdan.

Gaudí's disconcerting exuberance presents analogies with the work of his contemporary the postman, who was quite unaware of his existence. Both in their own way sought to create a complete representation of the world. With the main structure still incomplete, Gaudí began working on complex ornaments for the façade, which is decorated with carved figures. These the architect initially fashioned in plaster, having modelled them on faces encountered as he walked through the streets of Barcelona on his way to the site.

It is the very concept of "the building" which is most significant in Gaudí's case; his cathedral embodies the central dilemma of the age, the debilitating tension between decadence and the ideal that emerges from so many of the works exhibited in these pages. That tension was not

Guido Cadorin
Carnaval (Flesh, Flesh, Forever Flesh), 1914
Tempera on canvas, 100 x 100 cm
Private collection, Venice

Omnipresent in Symbolism, woman can be pure spirit, dew, reverie, or exclusively carnal, as in this work by Cadorin: "Carne, Carne, Sempre Carne".

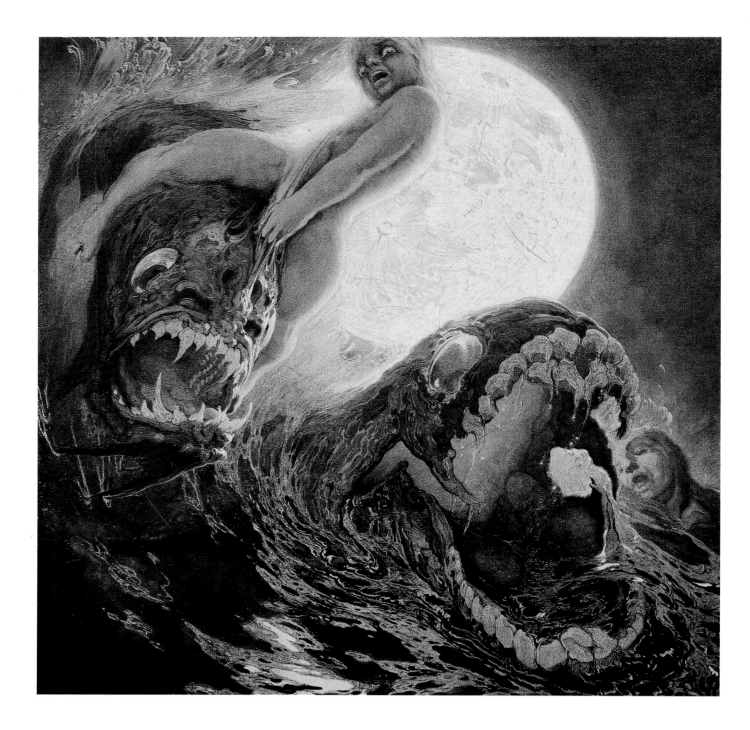

Néstor Martín Fernández de la Torre,
known as **Néstor**
Night, "Poem of the Atlantic", 1917–1918
Oil on canvas, 126 x 126 cm
Museo Néstor, Las Palmas de Gran Canaria

LEFT:
Néstor
The Satyr of the Garden of the Hesperides,
1922–1923
Water-colour and coloured pencil, 75 x 54 cm
Private collection

RIGHT:
Néstor
Adagio, 1903
Oil on canvas, 109 x 103 cm
Museo Néstor, Las Palmas de Gran Canaria

Néstor
High Tide, "Poem of the Atlantic", 1921–1922
Oil on canvas, 126 x 126 cm
Museo Néstor, Las Palmas de Gran Canaria

Salvador Dalí
Tuna Fishing, c. 1966–1967
Oil on canvas, 304 x 304 cm
Paul Ricard Foundation, Ile de Bendor

Little known outside Spain and a veritable dis-
covery, Néstor, a flamboyant Spanish Symbolist,
inspired Dalí's enthusiasm; Dalí drew on Nés-
tor's repertory of nudes and huge fishes for his
famous *Tuna Fishing*, an homage to Meissonier.

Antoni Gaudí
Sketch of the exterior of the Colonia Güell Church, c. 1898

Giacomo Balla
Form-Spirit Transformation, 1918
Oil on canvas, 51.5 x 65.5 cm
Balla Collection, Rome

exclusive to the fine arts; it is also found in poetry and music. Wagner's chromaticism might also be described as deliquescent; foregoing the orthogonal relations of tonic and dominant, it leads through the pathos and sarcasm of Mahler into Expressionism, and thence into the abstract rigour of Arnold Schoenberg's serialism, where all tonal reference is lacking.

Néstor, that prince of combined kitsch and Symbolism, is a recent rediscovery; a hero of his own time, he had almost entirely disappeared from view. We owe his re-emergence to Dalí, who confessed that his famous *Tuna Fishing* was inspired by Néstor. In it, the same huge, luxuriant fish leap and plunge, seeming to cry aloud; on their backs are the same cherubs and naked boys (pp. 208–209). In both cases, the ensemble constitutes a poetic and pictorial interpretation of the natural forces which obsessed these painters.

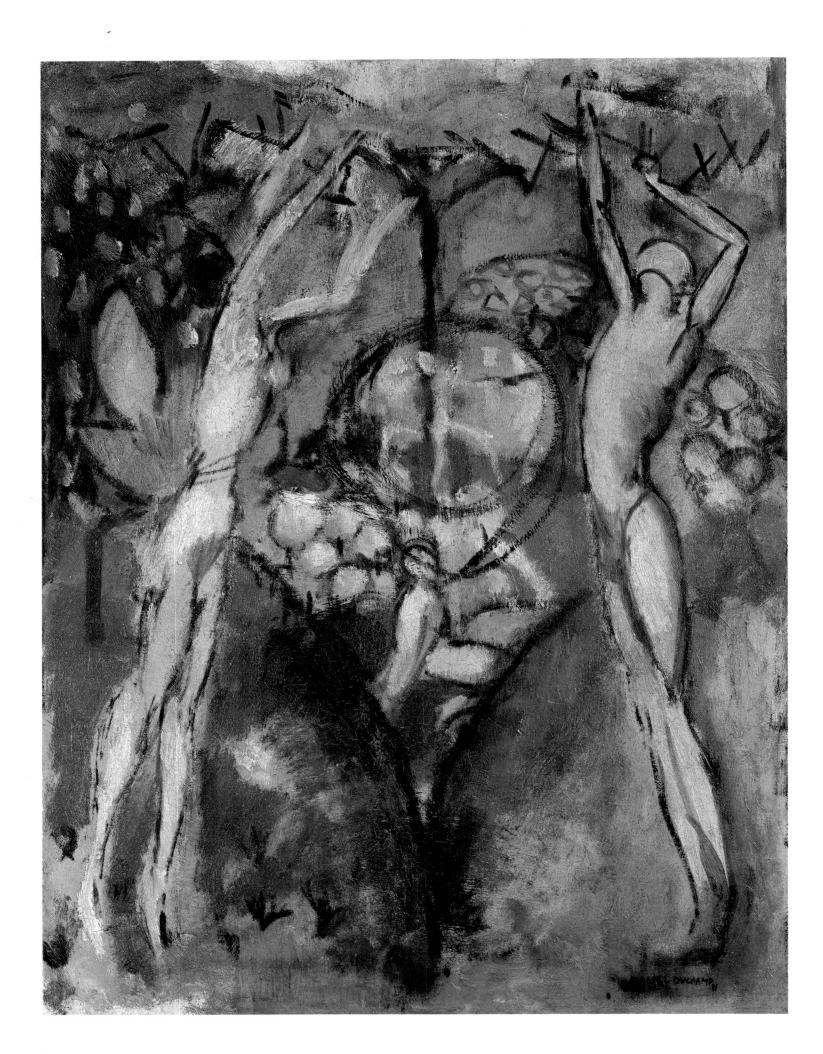

Post-Symbolism

I t is now easy to see why Symbolism was finally swept aside by the triumph of Modernism. The Great War marked such a break with the past that young people in the twenties might easily entertain the disquieting sense of living in a completely different world. A modicum of critical sense was sufficient for young people who had firsthand experience of the war to be disgusted by the propaganda of either side. And this led them to question the values that they were exhorted to defend. The First World War was experienced by the leading intellectuals of the period as the suicide of Europe. This suicide was first and foremost cultural, and it is significant that the Surrealists sought to destroy the vestiges of culture that had survived.

The first notion to be discarded was that of "decadence". It had outlived its purpose. But what was to take its place? For some, the answer was "primitivism", that putative ally of progress and modernity. Like Decadence, Primitivism was a specious concept lacking serious foundation, but it carried conviction; people felt that they understood it. In 1926, when Alexander Calder first arrived in Paris, his friends hastened to explain that it was better to be a primitive than a decadent. Calder possessed a child's love of play and a thoroughly American faith in "nature"; he consequently chose to be a primitive. In practice, this meant that he did not trouble to acquire a demanding – and perhaps stifling – technique; instead, he trusted his own impulses. These were supposed to be ground-breaking, and in many cases, so it proved.

Meanwhile, the theorization of the unconscious in terms of libidinal economy had occurred, and it seemed likely that this was an ultimate truth. The atom could not be split; there was nothing beyond or behind the libido. The primary point of reference here was Freud. But there was also Nietzsche and, further afield, the Marxist notion of ideology; further afield again was the crudely articulated Darwinian concept of the struggle for life, another of the fundamental "truths" which moralising sentimentality had shielded from sight. This was one of the conclusions drawn from the savagery of the war. It was therefore necessary to unmask the contents of the unconscious and its hidden drives. The Surrealists set about fulfilling this programme, discarding Symbolist idealisation on the way.

The great political powerhouse of the time was the 1917 Revolution and the extraordinary upheavals that it had initiated. No more talk of

Marcel Duchamp
Chocolate Grinder No 2, 1914
Oil, wire, graphite on canvas, 65 x 54 cm
Philadelphia Museum of Art, Philadelphia (PA)

The chocolate grinder is a proto-type of one element in the "absurd sexology" of *The Large Glass*, in which it represents an aspect of masculine sensuality. On this page we thus see two works of extremely contrasting forms which both deal with the relations of man and woman. The first of these (*Spring*) is lyrical, whereas the second is cynical, representing sexuality as essentially mechanistic.

Marcel Duchamp
Young Man and Girl in Spring, 1911
Oil on canvas, 65.7 x 50.2 cm
Private collection

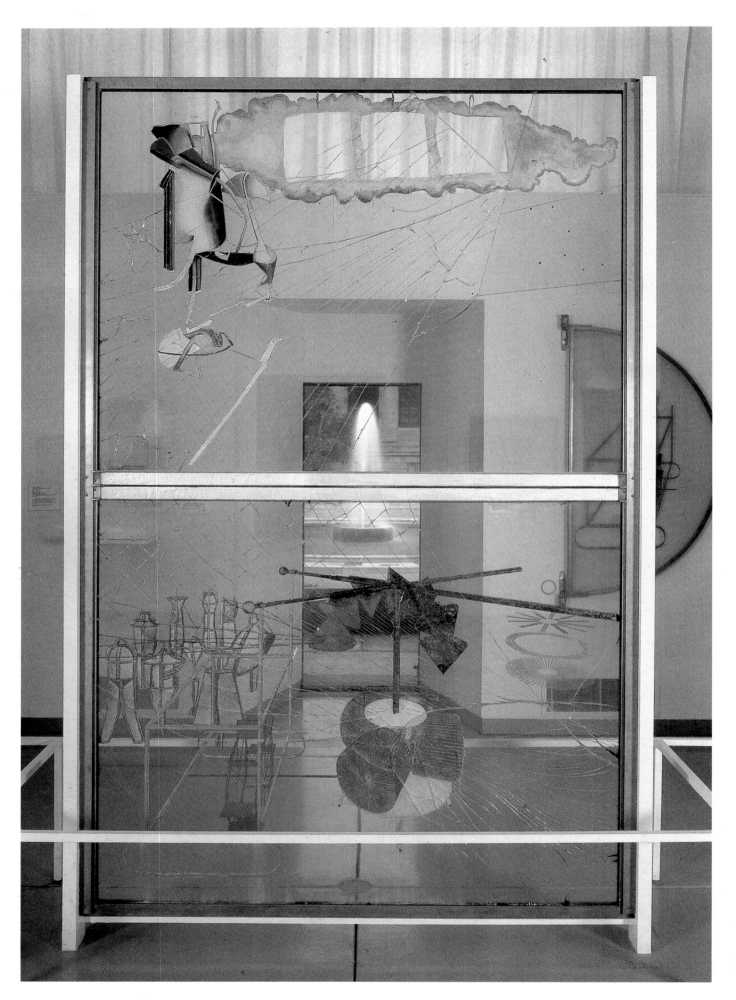

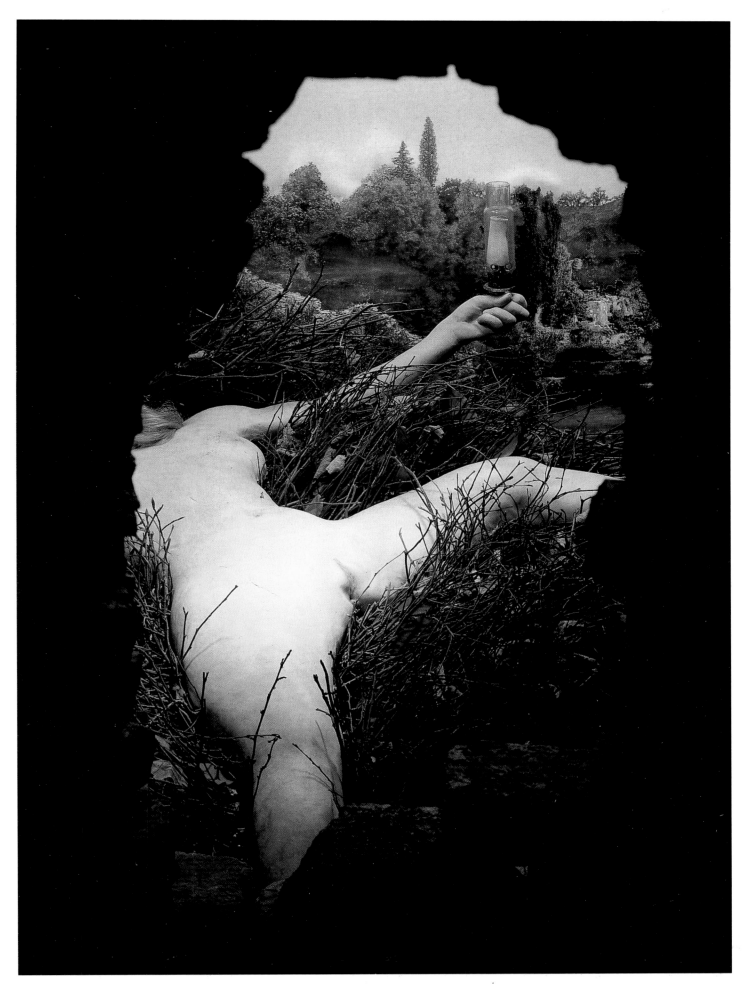

PAGE 214:
Marcel Duchamp
*The Bride Stripped Bare by her Bachelors, Even
(The Large Glass)*, 1915–1923
Various substances on glass, 272.5 x 175.8 cm
Philadelphia Museum of Art, Philadelphia (PA)

PAGE 215:
Marcel Duchamp
Given: 1. The Waterfall, 2. The Gas Lighting,
1946–1966, environment.
Internal view, velvet, wood, leather on metal
frame, twigs, plexiglass, gaslamp, 242.5 x 177.8 x
124.5 cm
Philadelphia Museum of Art, Philadelphia (PA)

Major works from the beginning and end of Du-
champ's career, *The Large Glass* and *Given* both
deal with the same theme: sex envisaged as the
riddle of the sphinx.

Etienne Jules Marey
Pole vaulting, 1890
Chronophotograph, 14 x 35 cm
Musée E.J. Marey et des Beaux-Arts, Beaune

Marcel Duchamp
Nude Descending a Staircase No 2, 1912
Oil on canvas, 146 x 89 cm
Philadelphia Museum of Art, Philadelphia (PA)

The Cubist painters suspected that this work was
a parody of Cubism and demanded that it be
removed from the Salon. Duchamp's approach
was, however, closer to that of the Futurists,
who sought to represent not several sides at once
of the same object, but an object or being in
movement in a form akin to that shown by the
photographic research of Marey or Muybridge.

PAGE 217:
Eadweard Muybridge
Human Locomotion No 133, 1887
Black and white photography, 19 x 40 cm
Private collection

Giacomo Balla
Young Girl Running on a Balcony, 1912
Oil on canvas, 125 x 125 cm
Civica Galleria d'Arte Moderna, Milan

"other worlds"; there was a *new* world to create. Art must henceforth serve a social purpose (we remember Odilon Redon's revulsion from this idea). Without troubling themselves about the nature of artistic creation, intellects argued at length over the form in which the artist should serve society. Symbolism was tainted with the image of des Esseintes, of the solitary artist indulging in sterile and private experiments. In the Soviet Union, Stalin imposed his own brutal, elementary solution to the problem.

These were some of the reasons, good and bad, that led to the rejection of all things Symbolist. Each generation makes its selection. Many artists fell into oblivion, some of them deservedly; others were recategorised. Gauguin, for instance, one day ceased to be a Symbolist and became something more acceptable: a "primitive". Had he not proclaimed himself a savage? Why take the trouble to find out what he meant by the word when it seemed so obvious that he sought the substratum of authenticity in man? But was it so obvious? It seems likely that Gauguin was referring with painful nostalgia to the only truly savage period in life, that of early childhood. Gauguin was brought up in Peru, and when he left the country at the age of seven, he experienced his departure as a tragic, irreversible exile.

Artists of more radical temper sought to bring an end to the conventional discourse of art; they hailed the death of art. In France, Marcel

Duchamp and Francis Picabia ("Where is modern art going? To the shithouse!") were of this tendency. Even before the First World War, the Futurists had attempted to break with the past. These provocative and hyperbolic procedures were necessary, particulary in Italy, if contemporary mentalities were not to stand in their way. (Spain's turn came much later, with Buñuel and Dalí.) Machines were the Futurist theme *par excellence*, but a fascination with machines and, above all, with the car can also be found in the work of Picabia and Duchamp. Picabia painted several works whose titles suggest that they are portraits, but which in fact represent an engine or mechanism (*Star Dancer on a Transatlantic Steamer* and *Paroxysm of Pain*, p. 220).

The revolutionary brilliance of Marcel Duchamp's work was widely hailed as a complete break with the past. And it was, of course, a break with facile pre-First World War aestheticism. But, *pace* modernist theory, one can also detect a real continuity with the past in certain aspects of his work. How could things be otherwise? Every rebellion bears the mark of the oppression which gave rise to it. Duchamp's *The Bride Stripped Bare by her Bachelors, Even (The Large Glass)* and his *Given* (p. 214 and p. 215). both deal with the paradigmatic Symbolist subject: Woman. But in these works she is no longer *fatale*, she is simply and utterly inaccessible. A new predicament is presented. Symbolist Woman was a source of anxiety because moral codes had been 'blurred';

PAGE 218:
Umberto Boccioni
Unique Form of Continuity in Space, 1913
Bronze, 110.5 cm high
Private collection, Milan

Umberto Boccioni
States of Mind I: Those Who Leave, 1911
Oil on canvas, 71 x 96 cm
Civico Museo d'Arte Contemporaneo, Palazzo Reale, Milan

Umberto Boccioni
States of Mind I: Those Who Stay, 1911
Oil on canvas, 70 x 95.5 cm
Civico Museo d'Arte Contemporanea, Palazzo Reale, Milan

Boccioni painted several pairs of paintings on this theme – by turn post-Symbolist and proto-Futurist. The singularity of the two canvases resides in the fact that Boccioni does not evoke mechanical movement (for example, the movement of the train in *Those Who Leave*) but the movement or sensations of the person carried off by the train. *Those Who Stay* are, by contrast, decomposed, empty, almost unreal.

DANSEUSE ETOILE SUR UN TRANSATLANTIQUE

Picabia 1913

Francis Picabia
Star Dancer on a Transatlantic Steamer, 1913
Water-colour, 75 x 55 cm
Private collection, Paris

PAGE 221:
Max Ernst
The Clothing of the Bride, 1940
Oil on canvas, 130 x 96 cm
Peggy Guggenheim Collection, Venice

This complex work presents certain analogies with the sumptuous Symbolist aesthetic of Gustave Moreau, but the strange narrative, erotic content and sexual Symbolism (the phallic bird presenting its equally phallic spear) simultaneously distance it completely from Moreau.

Francis Picabia
Paroxysm of Pain, 1915
Oil on cardboard, 80 x 80 cm
Private collection, Paris

The machine, all powerful in the 20th century, provided the model for amorous relations in Duchamp's *Large Glass*. It is also at the root of Picabia's reflections on sexuality and the cosmos as a whole during his "mechanical" period. The metaphor is the more surprising in these two essentially lyrical painters.

in Duchamp's sardonic perspective, Woman is inaccessible not because the codes are uncertain, but because they have been completely rejected.

This becomes clear in relation to the cardboard box (*la boîte verte*) into which Duchamp inserted all the torn-up bits of paper on which he had noted ideas relating to *The Large Glass*. Duchamp's procedure constituted a cynical and mechanistic presentation of the sexual act ("As if an alien had sought to imagine this kind of operation," as André Breton put it); a sexual act of which *The Large Glass*, in its austerity, offers no explicit narrative. By contrast, *Given* offers an illusionistic, three-dimensional representation of a recumbent naked woman whose legs are spread open towards the spectator. Her inaccessibility is signified by the fact that she can be seen only through two holes pierced in a barn door – which cannot be opened.

The absence of all narrative content was one of the first rules of modern art, as evinced in the works of Picasso and Matisse. But like the religious or mythological art of the past, the works of Duchamp cited

De Chirico
The Uncertainty of the Poet, 1913
Oil on canvas, 106.4 x 94.6 cm
Private collection, London

De Chirico
Love Song, 1914
Oil on canvas, 73 x 59.1 cm
The Museum of Modern Art, New York

The only artists whom De Chirico praised and claimed to have been inspired by were Arnold Böcklin and Max Klinger. These two Symbolists led him to what he described as "metaphysical painting".

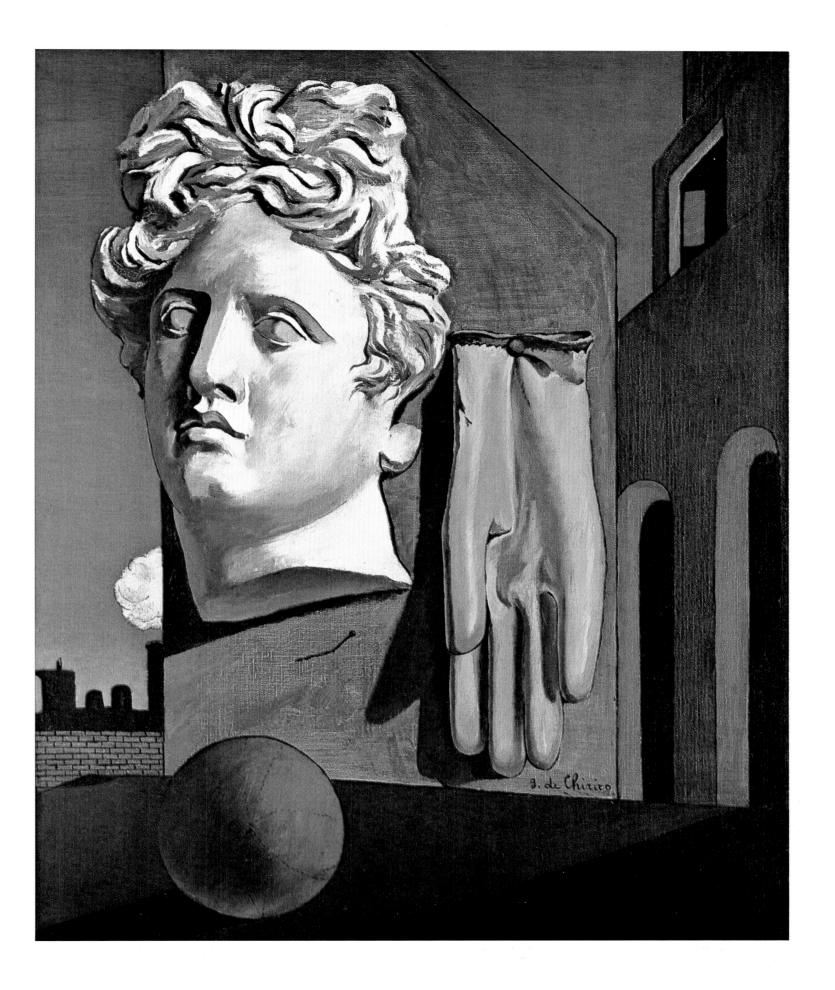

above do present the spectator with a complex narrative derived, in this case, not from myth or scripture but from the artist himself. Perhaps, then, Duchamp simply reversed the Symbolist values that had prevailed during his youth, substituting irony for the ideal.

As Picabia's first wife, Gabrielle Buffet, reports, in 1910 Duchamp and Picabia began "an extraordinary rivalry in destructive, paradoxical statements, in blasphemy and inhumanity..." Even in the first decade of this century, they were attracted by the kind of radical cynicism whose consequences the impending war would so definitively and startlingly reveal. Duchamp and Picabia exposed the cynicism beneath the fine sentiments described by Thomas Mann as concealing the "individual's immense loss of value", a loss that "the war simply brought to a head, lending it concrete form and expression".

To understand the energies of Futurism and the need felt by its artists to savage consecrated values, one must attempt to imagine the often stifling context of the time. The constant transformation of people's

Paul Delvaux
Nymphs Bathing, 1938
Oil on canvas, 130 x 150 cm
Nellens Collection, Knokke

Nothing distinguishes the work of Delvaux from that of his Symbolist predecessors but the exacerbated sexuality of his feminine nudes. The dreamlike content is not exclusive to Surrealism (Redon too was inspired by dream). One cannot help but note how misleading it is to represent epochs and movements as neatly compartmentalised.

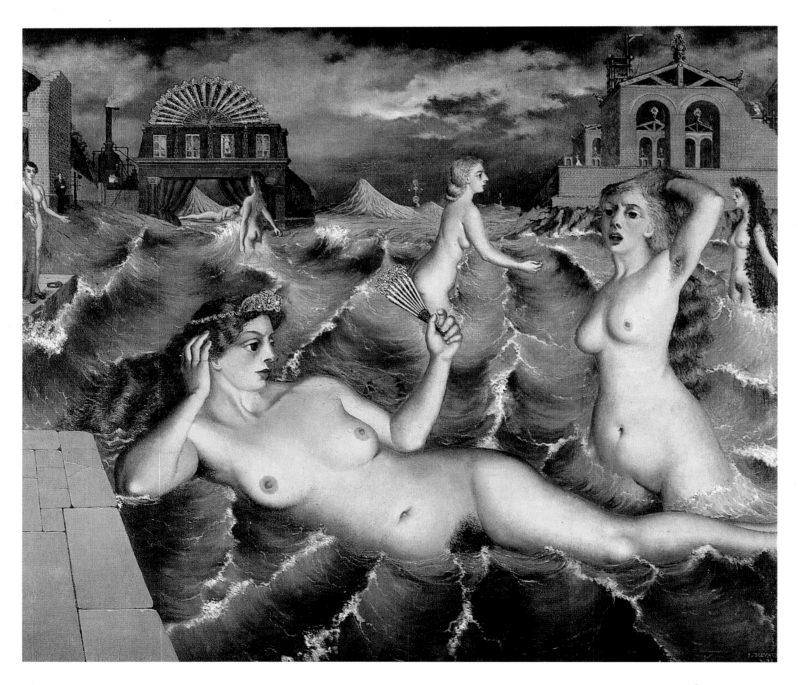

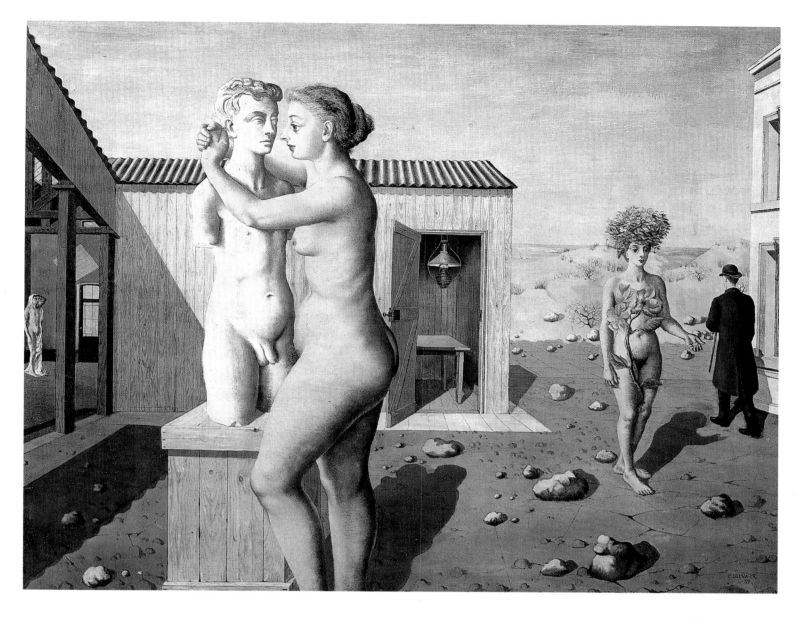

Paul Delvaux
Pygmalion, 1939
Oil on wood, 117 x 147.5
Musées Royaux des Beaux-Arts, Brussels

Only the presence of the man in the bowler hat introduces a modern and everyday note into this scene, which is otherwise reminiscent of the treatment of the same theme by the Pre-Raphaelite painter Burne-Jones. But it should be noted that Delvaux has inverted story and protagonists: Pygmalion has become a statue, and it is his creature who is alive and "in the flesh". The inversion is typically Surrealist.

way of life, ever faster means of communication, the development of the car ("An automobile driven at a hundred miles an hour is more beautiful than the Venus de Milo," proclaimed Marinetti, the theoretician of Futurism), made the obligation to venerate the past unendurable. And then the "Woman problem" that Symbolism so interminably ruminated on: what should be done about that? The Futurists chose to ignore the issue and proclaim their "scorn for Woman". In the same spirit they suggested filling up Venice's Grand Canal with concrete.

In the early part of his career Umberto Boccioni (1882–1916) painted works whose mood was not far removed from Symbolism. Two such are the semi-abstract paintings from *States of Mind I: Those Who Leave* and *Those Who Stay* (1911, pp. 218–219). The transition toward Futurism is apparent in the determination (present in Previati's *Eroica*, p. 200) to escape the static model of eternal beauty and attempt to evoke movement by means other than those used by Romantics such as Delacroix. The photographic experiments of Muybridge and Marey had captured movement in process, and Duchamp and Balla had already tried to portray it (pp. 216–217).

Surrealism, no less than Futurism, bears the unacknowledged imprint of Symbolism. This is true not only of the "proto-surrealist" work of

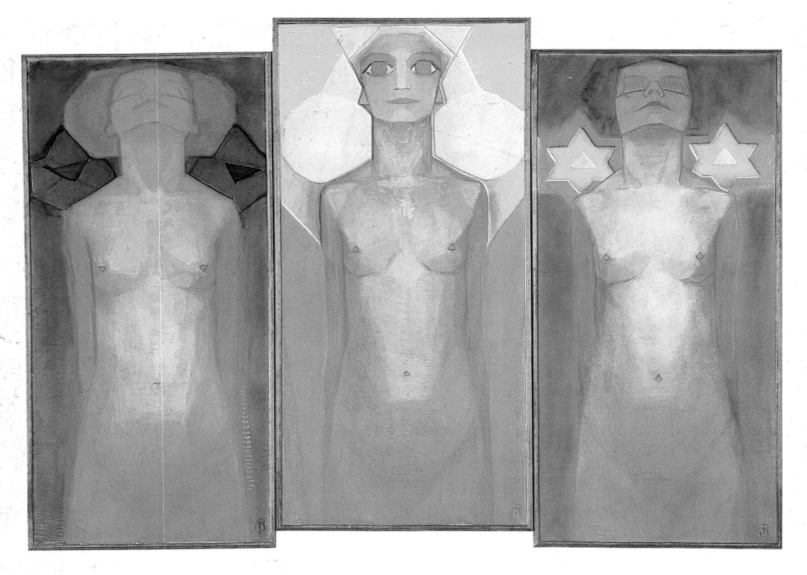

Piet Mondrian
Evolution, 1910–1911
Oil on canvas, central panel 183 x 87.5 cm,
side panels 178 x 85 cm
Haags Gemeentemuseum, The Hague

Mondrian, like Kupka, arrived at abstraction
through his esoteric research; he was a member
of the Theosophical Club of Amsterdam. This
work is in the same spirit as that of his senior Jan
Toorop. *Evolution* represents, in its three images
laden with geometric Symbolism, access to
knowledge and spiritual light.

PAGE 227:
Alekse Ljubomir Popovic, known as **Ljuba**
The Temptations, Afterwards, 1988–1989
Oil on canvas, 220 x 200 cm
Private collection, Paris

From metamorphosis to metamorphosis, from
mutation to mutation, from reincarnation to rein-
carnation, the Symbolist pursuit of dream con-
tinues to our own day… in the work of the Ser-
bian artist Ljuba, we find the same fascination
with the war between chaos and logos, demonic
self-destruction and harmonious reorganisation.

Giorgio di Chirico (pp. 222–223) but of certain works by Max Ernst;
The Clothing of the Bride (1940, p. 221) has clear affinities with Gustave
Moreau. Something similar may be said of Paul Delvaux (pp. 224–225),
who, though he never used the painterly equivalent of "automatic writ-
ing", is universally regarded as a Surrealist. Yet the Symbolist filiations
of his work are blindingly obvious. More recent artists (Ljuba, Dado),
whose works of obsessive eroticism and cruelty display an unequivo-
cally Symbolist heritage, are still classified, by force of habit or by sheer
negligence, as late Surrealists.

Finally, we should not forget that such paradigms of modernism as
Picasso, Kupka, Mondrian, Kandinsky and Malevich at one time painted
in an idiom close to Symbolism and that some of them (Mondrian and
Malevich, for example) came to abstraction by extrapolating from the
Symbolist tendency towards formal simplification. Abstraction may be
considered the most demanding and Neo-Platonic aspect of Symbolism.
In the course of the decades that have passed since the emergence of what
we term "Symbolism", new ways of perceiving and explaining the world
have emerged. The inadequacies of Symbolist theory are obvious enough;
the inadequacies of modernist theory have become increasingly appar-
ent. Underlying this opposition are divergent ways of viewing the world
and man's destiny in it. Each seeks to justify itself and demonstrate that
its hopes or despair have solid foundations. There can be no final verdict.

Biographies

The biographical and bibliographical information, the captions, and the list of illustrations are by Michael Gibson and Gilles Néret.

ALEXANDER John White
(1866–1915) American illustrator. 1877–1881 lived in Europe. Studied at Munich, Florence and Venice. Returning to New York, he came to prominence as illustrator and society portraitist at Harper Brothers. 1890–1901 lived in Paris, frequenting Whistler, Rodin, Mallarmé and Henry James. In 1901 returned to New York. 1909–1915 President of the National Academy of Design.

AMAN-JEAN Edmond
(1859–1936) The most charming French Symbolist. In 1880, he studied with Lehmann at the Beaux-Arts. He was a friend of Seurat and collaborated with Puvis de Chavannes in the transfer to tiles of *The Sacred Wood*. 1885 visited Rome. A friend of Péladan and Mallarmé. He exhibited at the Rose+Croix Salons and designed the Salon Poster in 1893. In 1925, founded the Salon des Tuileries with Rodin.

BAKST Léon (born Lev Samoile-vich Rosenberg)
(1866–1924) Russian painter and designer. Studied in St Petersburg, then enrolled with Jean-Léon Gérôme and entered the Académie Julian in Paris (1893–1896). One of the founders of the magazine *Mir Iskustva* (The World of Art). Illustrator, portraitist, and painter, he designed sets and costumes for the theatre, the opera, and above all for the ballets of Diaghilev (Stravinsky's *The Firebird*, Debussy's *Prelude to the Afternoon of a Faun*). Lived in Paris from 1912.

BALLA Giacomo
(1871–1958) Born in Turin, discovered Impressionism and Neo-Impressionism in Paris. He taught his technique, a derivative of Divisionism, to Boccioni and Severini 1901–1902. In 1910 they all signed the two manifestoes of the Futurist painters. With his "simultaneist" works, he analysed movement while continuing his research into light; the result is a form of rigorous abstraction. Initiated into spiritualism, he went beyond "metaphysical painting" in his ambition to transpose onto the canvas a "state of mind" or fleeting emotion without any external reference. He finally signed the Manifesto of Futurist Areopainting which foreshadowed the mysteriously cold, mechanical style of Konrad Klapheck.

BEARDSLEY Aubrey Vincent
(1872–1898) Precocious English illustrator and draughtsman. Beardsley at first worked in insurance (1889–1892). Burne-Jones encouraged him to give up his job for art. In 1892, commissioned to illustrate Malory's *Le Morte Darthur*. Met Oscar Wilde and illustrated *Salome*. Artistic director and illustrator of the magazine *The Yellow Book*, he was sacked on account of his private life. Erotic drawings for a specialised publisher. Having suffered from tuberculosis

Edmond AMAN-JEAN

Giacomo BALLA

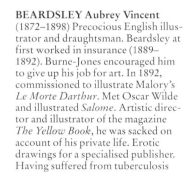

Alexandre BENOIS

Aubrey Vincent BEARDSLEY

Emile BERNARD

William BLAKE

Umberto BOCCIONI

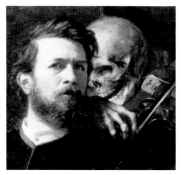

Arnold BÖCKLIN

Juan BRULL-VINOLAS

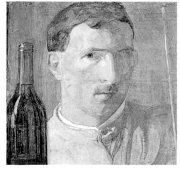

Guido CADORIN

Edward BURNE-JONES

Carlo CARRA

since childhood, he moved to Menton (France) for his health. Died there, a Catholic convert who condemned his own "naughty drawings".

BENOIS Alexandre Nikolaievich
(1870–1960) Born in St Petersburg of a family of artists with French roots; his father was a court architect in Russia. 1894, with Diaghilev one of the founders of *Mir Iskustva* (The World of Art). Benois is, like Bakst, famous for his work with Diaghilev's *Ballets Russes*; he was largely responsible for the important role painting had in the *Ballets*. Designed the costumes and sets for *Arnide's Pavilion* (1909), *Giselle* (1910) and, above all, in close collaboration with Stravinsky, *Petrushka* (1911). Later designed the sets for the most important of Ida Rubinstein's dance-spectacles and was involved in the Ballets de Monte Carlo.

BERNARD Emile
(1868–1941) Born in Lille. In 1886, expelled from Cormon's studio in Paris for indiscipline. Friend of Toulouse-Lautrec and van Gogh. 1886–1888 at Pont-Aven. 1887 first efforts at Cloisonnism. Friendship with Gauguin. 1890 religious crisis. Attracted to medieval art. In 1891, he quarreled with Gauguin. 1893–1903 travels in Italy, Egypt, Spain. One of the most important Pont-Aven painters, initially a "primitive", he eventually imitated the Venetian masters. He influenced Picasso's "Blue Period".

BLAKE William
(1757–1827) English painter, engraver and poet, born in London. From age seven, he habitually saw a white-bearded God peering in through his window, or angels perching in trees. An admirer of Dürer, Michelangelo and Raphael and a friend of Fuseli, Blake was extremely eccentric. Walked the streets in a Phrygian bonnet. His work, still obscure, suggests a new version of Christianity, whose radicalism lies in its visual Symbolism. A precursor of the Pre-Raphaelites and Symbolism.

BOCCIONI Umberto
(1882–1916) Italian painter and sculptor. 1898 moved to Rome, met Gino Severini on arrival and Giacomo Balla in 1902, Balla having just returned from Paris and contact with Seurat. 1905–1908 he travelled in Russia, France and Italy. Met Mari-

netti in Milan and in 1910 signed the Futurist Manifesto. In 1913, he published *Paintings and Sculptures*. Died in an accident at the Front in 1916. A tragic death that occurred early in Boccioni's career as a sculptor, when it seemed likely that he would demonstrate in sculpture even greater and more masterly innovation than he had shown in his paintings.

BÖCKLIN Arnold
(1827–1901) Swiss. He studied drawing in Basle. 1841–1847 he attended the Düsseldorf Academy. 1848 trip to Paris with the Swiss painter Rudolf Koller. Jacob Burckhardt advised him to go to Italy; he moved to Rome 1852, staying five years. Spent his life moving between towns in Germany, Italy and Switzerland. Six years before his death, he settled in his Florentine villa. Heir to Friedrich's Romanticism, the precursor of many modern tendencies, Böcklin populated his work with allegories, legends, and imaginary figures to extraordinary and obsessive effect. Little understood, especially in France, but de Chirico and certain of the painters of Die Brücke openly proclaimed his influence on them.

BOLDINI Giovanni
(1842–1931) Society portraitist of Italian origin. He moved to Paris in 1871 where he painted the eminent. Linked to the Macchiaioli group, a friend of Whistler, Sargent and Degas (who amiably referred to his "monstruous talent") he borrowed from them certain techniques, which he used with incredible virtuosity. But, preferring substance and physical pose to "states of mind", he remained above all a privileged witness of the *Belle Epoque*.

BRULL-VINOLAS Juan
(1863–1912) Spanish painter, student of Simon Gomez at Barcelona and of Raphael Collin in Paris. 1887–1889 he exhibited at the *Salon des Artistes Français* (genre scenes and history painting). Then in Madrid, Berlin and London. His major Symbolist works date from 1898–1900.

BURNE-JONES Sir Edward Coley
(1833–1898) English painter born in Birmingham. Read theology at Exeter College with William Morris. Together they discovered the work of Rossetti, whose pupil Burne-Jones then became. Four trips to Italy (1859–1873) allowed him to study the Renaissance painters (Mantegna, Botticelli, Michelangelo) who were his models. He quickly became one of the leading figures in the latter period of the Pre-Raphaelite movement.

CADORIN Guido
(1892–1976) Eleventh son of one of the oldest artistic families in Venice. Studied with the painter Césare Laurenti. Invited by Marinetti to join the Futurists but refused. 1915 exhibited at Roman Secession. After 1915, his work ceases to be relevant to Symbolism.

CARRA Carlo
(1891–1966) Piedmontese. 1895 apprentice decorator. 1904, at the Accademia Brera, he practiced Expressionism with fantastical subjects using a technique close to Divisionism. Met Boccioni and in 1910 signed the first Futurist Manifesto. Travelled to Paris and discovered Cubism; thereafter attempted a synthesis between Cubism and Futurism till 1916, when he met de Chirico and Savinio in Ferrara and

C

Eugène CARRIERE

Walter CRANE

Paul DELVAUX

Jean DELVILLE

Giorgio de CHIRICO

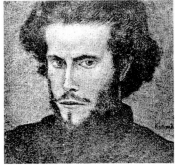

William DEGOUVE DE NUNCQUES

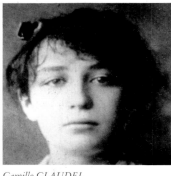

Camille CLAUDEL

took up *Pittura metafisica*. His work in this movement makes him one of the major figures of the *Novecento*.

CARRIERE Eugène
(1849–1906) A lithographer's assistant in Strasbourg, he studied at the Paris Beaux-Arts with Cabanel. In 1877, he visited London where he discovered the work of Turner and met Whistler. With Puvis de Chavannes, one of the founders of the Société Nationale, where he exhibited regularly. Close to the founders of Symbolism, who were all friends of his, he specialised in the suggestion of emotion, obtained by realistic portrayal of faces and gestures in a hazy grey or blackish wash which is his trademark.

CHIRICO Giorgio de
(1888–1978) Italian painter born in Volo, Greece. Attracted by classical myth from childhood, influenced by philosophers such as Nietzsche and Schopenhauer, in art he admired only Arnold Böcklin and Max Klinger. Moved to Paris in 1911, where he began his reflections on what he termed "metaphysical paint-

ing". Noticed by Apollinaire, he was "appropriated" by the Surrealists 1923–1924. But de Chirico had by now returned to Böcklin and proclaimed himself the heir of Raphael and the Venetian masters. The ambitions of his early years remain essential: the aspiration to make painting a divinatory activity triggering a series of signals and oracles.

ČIURLIONIS Mikolajus
(1875–1911) Lithuanian. Studied in his home town, Druzkinikai till 1901; lived in Warsaw for the next six years. Interested in Lithuanian mythology and the ideas of Nietzsche and Steiner. Of musical inspiration, his work is sometimes abstract.

CLAUDEL Camille
(1856–1920) Brilliant sculptress, collaborator, mistress and rival of Rodin, sister of the poet Paul Claudel. Spent the last thirty years of her life in a mental institution with persecution mania. Her tragic story has been filmed with Isabelle Adjani in the role of Camille.

COLE Thomas
(1801–1848). Precursor of Symbolism in the United States. Born in England, went with his parents to settle in America at eighteen. He devoted himself exclusively to painting from 1825. 1829–1832 he travelled to England, France and Italy. Returning to the US, he settled in Catskill, New York. From this period date his sequences *The Course of Empire* and *The Voyage of Life*. 1841–1842 second voyage to Europe, where he admired the work of Claude Lorrain and above all of Turner. His work then became more Romantic. With Cole's *œuvre*, landscape becomes established as a genre in American painting.

CRANE Walter
(1845–1915) English painter. First studied under his father the miniaturist Thomas Crane and the engraver W.J. Linton. Among the most influential illustrators of his period. His painting deals mainly with literary and mythological themes. Later he put his art at the service of Socialist ideas, which he shared with William Morris.

DAVIES Arthur Bowen
(1862–1928) American painter. Studied at Utica (with Dwight Williams), New York and Chicago. In 1908, he organised an exhibition by a group of artists afterwards dubbed The Eight, who rebelled against the National Academy of Design and broke with traditional painting. As President of the Society of Independent Artists, he was one of the organisers of the 1913 Armory Show which brought modern art before the American public. His painting is characterised by Böcklinesque symbolic landscapes and influenced above all by the Pre-Raphaelites whose work he admired during a trip to Europe. His colleagues in The Eight later accused him of having introduced modernism and "thrown away the key" – of not having given them any further orientation other than rejecting the past.

DEGOUVE DE NUNCQUES William
(1867–1935) Scion of an old French family which settled in Belgium in 1870, he was encouraged to dream by his cultured and eccentric father. 1883 he shared a studio with Jan Toorop who influenced him. Friend of Henry de Groux who orientated him toward Symbolism. Close to Belgian literary circles, he married the sister of the poet Emile Verhaeren. Supported in Paris by Rodin, Puvis de Chavannes and Maurice Denis. His painting remains Symbolist till the turn of the century. It consists mainly of mysterious landscapes of a studied naivety.

DELVAUX Paul
(1897–1994) Born in the province of Liège, he studied architecture at the Académie des Beaux-Arts at Brussels. First influenced by the Expressionism of Permeke, in 1934 he discovered de Chirico and Magritte and for a brief period became a distant cousin of Surrealism. But Delvaux's universe of

D

E

eroticism and apparent naivety, peopled with female nudes apparently sleepwalking through buildings as in dreams, makes him a quintessential Symbolist.

DELVILLE Jean
(1867–1953) Belgian writer and painter, Delville was an initiate of the occult. His work *Dialogue among Ourselves. Cabbalistic, Occult and Idealist Arguments* (1895) is an account of ideas standard in those movements. 1892 became, with Emile Fabry and Xavier Mellery, one of the founders of the *Cercle pour l'Art*. Influenced by Péladan, he also founded the Salon d'Art Idéaliste. Delville exhibited at the Rose+Croix Salons of 1892 and 1895. Now somewhat forgotten, his work has recently been revived; it reveals the idealist and esoteric currents so typical of an epoch in which secretive obsessions were constantly at work. His canvases exhibit a poetry in which sexual and spiritual anxieties mingle insidiously in a climate of fascination and strangeness.

DENIS Maurice
(1870–1943) This most gifted and multitalented French Symbolist renewed religious art and was a decorator and illustrator as well as an excellent art critic. In 1888 he entered the Académie Julian, where he met Bonnard, Ranson and Sérusier. His murals adorn many public buildings (the Théâtre des Champs-Elysées, the Petit Palais, the Sénat) and churches in Paris. Illustrator, theatre-designer (for Lugné-Poë), lithographer and painter. 1895 he travelled across Northern Italy by bicycle with Sérusier. 1919 he founded the Ateliers de l'Art Sacré.

DENISSOV Vassili
(1862–1920) Russian painter, like the other Russian Symbolists an admirer of Vrubel. In 1910 he painted a posthumous tribute, *The Fallen Demon, on the death of Mikhail Vrubel*, which is his major claim to fame.

DUCHAMP Marcel
(1887–1968) Scion of an artistic family, he was the brother of Jacques Villon and of the sculptor Raymond Duchamp-Villon. Created uproar

from his beginnings as Symbolist and Futurist. The culminating scandal was the exhibition of "readymades" and the urinary baptised "Fontaine" of 1917. Thereafter he devoted himself to professional chess. A major artist who inaugurated whole areas of modern art. His most spectacular compositions, *The Large Glass* (1915–1923) and *Given*, which was posthumously revealed at the Museum of Art of Philadelphia (an installation with a nude woman lying on her back holding an Auer gaslight in a landscape with a waterfall, all visible only through two holes pierced in an old wooden door), are in Dadaistic spirit with Symbolist overtones.

EGEDIUS Halfdan
(1877–1899) Norwegian. He began his art studies at eight, in Oslo and Copenhagen. Spent the last two years of his short life illustrating the Nordic royal sagas.

ENCKELL Magnus
(1870–1925) Norwegian. In Paris, influenced intellectually by Edouard Schuré and Péladan, artistically by Puvis de Chavannes, Carrière and Manet. Deciding that in Paris mysticism was finished, he left for Italy. 1894, *en route* for the South, he encountered the art of Böcklin. Broke with Symbolism before the turn of the century.

ENSOR James
(1860–1949) Belgian painter. Born in Ostende where his parents had a souvenir shop, Ensor attended the Brussels Beaux-Arts from 1877–

1880. A founder member of the group XX, from which he was nearly expelled because of the originality of his art, he began to be respected towards the turn of the century. The theme of masks is central to the work of Ensor. It produces strangely compelling works of peerless originality, charged with meanings psychological, intellectual and pictural, passing indirect judgement on the nature of mankind and his deepest convictions. A precursor of Expressionism, he influenced Emil Nolde (who adopted his theme of the mask) and (by his engravings) Paul Klee. His fantastical universe foreshadows Surrealism.

ERNST Max
(1891–1976) Born near Cologne, naturalised French in 1958, Ernst showed a passionate interest in occultism, psychiatry and the history of art while still young. He later said: "The geographical, political and climatic conditions of Cologne no doubt favour the creation of fertile conflicts in the mind of a sensitive child. Many different avenues of European sensibility are found there: the influence of Mediterranean and Western rationalism, the Oriental inclination toward the occult, Nordic myths, the Prussian categorical imperative, the ideals of the French Revolution…" From the Blaue Reiter to Dada, "degenerate art" and Surrealism, Ernst created an *œuvre* which he aspired to carry "beyond painting" and which sought to achieve the pictorial "equivalence" of poetic effect dear to the heart of the Symbolists.

Halfdan EGEDIUS

James ENSOR

Maurice DENIS

Marcel DUCHAMP

Magnus ENCKELL

Max ERNST

FABRY Emile

(1865–1966) Belgian painter of tortured allegories. In 1892, he founded, with Delville and Mellery, the *Cercle pour l'Art*. He exhibited at the Rose+Croix Salons in 1893 and 1895. In 1900, he became a Professor at the Brussels Académie. He received many commissions for frescos for public and private buildings (Théâtre de la Monnaie, town halls of Saint-Gilles, Woluwe-Saint-Pierre, Laeken, etc.).

FANTIN-LATOUR Henri

(1836–1904) French painter and friend of the Impressionists. A painter of still-lifes in the tradition of Chardin and of portraits of austere realism, he was only marginally a member of the Symbolist movement, in particular in the works in which he was inspired by Wagnerian opera.

FEURE Georges de

(1868–1928) Of Dutch origin, one of the most elegant Symbolists and one of the founders of Art Nouveau. His works tends to the ornamental. 1894 de Feure worked with Jules Chéret and exhibited water-colours at the Rose+Croix Salons. His innovative style of depiction of fashionable women brought him success. Frequenting the world of music, he was highly reputed for his poster designs.

FILIGER Charles

(1865–1928) French, the most mystical of the Pont-Aven painters. He studied with Colarossi in Paris. In 1889, he settled in Pouldu. Met Gauguin and Sérusier. For ten years, Comte Antoine de la Rochefoucauld paid him an annual pension of 1,200 francs. Alfred Jarry entrusted him with the illustration of the Symbolist magazine *l'Ymagier*. He exhibited at Rose+Croix Salon in 1892. After 1903 his works became geometric and he pursued research into colour.

FILONOV Pavel Nicolaievich

(1883–1941). Born in St Petersburg, son of a washer-woman and a hansom cab driver, Filonov was an admirer of Vrubel. Motivated in early youth to create a new and "proletarian" art, over the course of his life he worked out a highly individual approach to art which singles him out from all other tendencies. The exhibition which was to be devoted to him at the Russian Museum in Leningrad in 1929 was cancelled on the grounds of his bourgeois individualism. He died of exposure in the streets of Leningrad during the siege of the town. The retrospective which had been refused him during his lifetime was bestowed sixty years later. It revealed a complex and varied *œuvre*.

FREDERIC Léon

(1865–1940) Belgian painter, reached Symbolism through an overexacting realism. Torn between Symbolism and naturalism, Frédéric exhibited at the Brussels Salon in 1878, then with the Essor circle. In 1898 his works were exhibited at the Salon d'Art Idéaliste. He also painted vast socio-political canvases.

FUSELI Henry (born Johann Heinrich FÜSSLI)

(1741–1825) Born in Zurich, he spent most of his life in England. Read theology intending to become a priest, but the discovery of Italy, where he spent eight years absorbing the atmosphere of the recently uncovered ruins and the works of Michelangelo, drove him to paint themes which can be described as Romantic, centred around the imaginary, the Gothic and the horrible. He found in the works of Shakespeare, Milton and Wieland a dream-like universe which suited him. The cold, neo-classical purity to which he aspired does not mask the presence of the uneasy sexuality of the 1800s. He is most at home with the macabre, the realms of the unconscious and Romantic eccentricity, making him one of the great precursors of Symbolism and even of Surrealism.

GALLEN KALLELA Axel

(1865–1931) Finnish. At first a Nordic realist, Gallén Kallela adopted the Symbolist manner after a visit from the writer Adolph Paul, who was a *habitué* of the "Zum schwarzen Ferkel" cabaret in Berlin which Munch frequented. From 1895 he was influenced by the Jugendstil. He illustrated scenes from the *Kalevala*.

GAUDI Y CORNET Antoni

(1852–1926) Catalan architect. Son of a boiler-maker, he enrolled in the Barcelona school of architecture at just sixteen. The influence of Art Nouveau allowed him to escape a tradition which was excessively constricting. He built several large blocks in Barcelona. His unfinished masterpiece is the Sagrada Familia Cathedral, begun in 1883. For Dalí, Gaudí was a Catalan genius, who found inspiration in the eroded shapes of the rocks of Ampurdan. Dalí added:

Henri FANTIN-LATOUR

Georges de FEURE

Pavel FILONOV

Charles FILIGER

Henry FUSELI

Axel GALLEN KALLELA

Antoni GAUDI

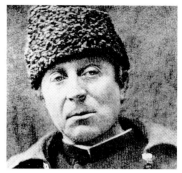

Paul GAUGUIN

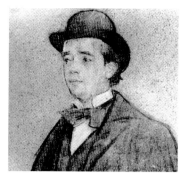

Adria GUAL-QUERALT

Ferdinand HODLER

Louis Welden HAWKINS

Ludwig von HOFMANN

Richard HOLST

H

"The absurd gate of the Sagrada Familia, which seems to open onto a void, in fact opens onto a splendid phantasmagoric universe in which desires have been given solid form."

GAUGUIN Paul

(1848–1903) Born in Paris but brought up in Peru. With Cézanne, Seurat and van Gogh, belonged to the generation that came after Impressionism. He adopted an original style of painting, Synthetism, which allowed him to take up the ambitions of Symbolism with his own revolutionary approach. 1888 was the decisive year: in Pont-Aven, the very young Emile Bernard, with Louis Anquetin, invented *Cloisonnisme*, a technique consisting of a firm outline filled in with flat areas of colour as in *images d'Epinal* or Japanese ukiyo-e prints. "Bernard invented a style," wrote one critic, "but it was Gauguin who breathed life into it." Gauguin thus emerges as one of the great pioneers of the "simplifications" of modern art, a precursor of Expressionism, abstraction, Synthetic Cubism and even of de Chirico. In Gauguin's view, painting had play a part in "changing life"; he changed his own by departing for Tahiti. This earned him the sympathy of poets such as Mallarmé and Breton, but the hatred of the self-righteous who could not forgive his combining a scandalous life-style with a Symbolist style of painting.

GREINER Otto

(1869–1916) German, born in Leipzig. In 1891, he travelled to Florence and Rome, where he remained till 1898. Met Max Klinger who exercised a decisive influence on his work. His cycle *Woman* is dedicated to Klinger. The Leipzig Museum possesses a complete collection of his works.

GROUX Henry de

(1867–1930) Belgian painter who made his career in France. His violent work was much appreciated by the literary Symbolists. A student of Portaels at the Brussels Academy, de Groux exhibited with the Essor circle in 1886. Elected a member of the XX in 1887, he was expelled in 1890 for having insulted van Gogh, Signac, and Toulouse-Lautrec. A friend of Degouve de Nuncques with whom he shared studios in Brussels and Paris. Settled in Paris in 1892, but his awkward character

closed off many social avenues. He was appreciated by Jan Toorop, Léon Bloy and Emile Zola.

GUAL-QUERALT Adria

(1872–1944) Studied with Pedro Borell in Barcelona, then worked in his father's studio till 1901. His work in the theatre (he was a director and drama teacher) made him one of the major figures in the Catalan modern movement. Subsequently he continued to produce a substantial corpus of drawings and paintings.

HAWKINS Louis Welden

(1849–1910) Born in Germany of English parents, he took French nationality in 1895. Studied in Paris, at the Académie Julian. 1881–1891 he exhibited at the Salon des Artistes Français; from 1894 with the Société Nationale, the Rose+Croix Salons and the Libre Esthetique in Brussels. In touch with the Symbolist writers, with Stéphane Mallarmé, Jean Lorrain, Robert de Montesquiou, etc. Akin to the Pre-Raphaelites in his dense, highly detailed style combined with strange or exotic subject matter.

HODLER Ferdinand

(1853–1918) Swiss. 1871–1878 he studied in Geneva with Barthélémy Menn, a pupil of Ingres and friend of Corot. He travelled in Switzerland and Spain and discovered the works of Dürer, Holbein and Raphael. Began his Symbolist period with *Night*, which won him international repute. Hodler exhibited at the Salon des Artistes Français, the Rose+Croix and the Vienna, Munich and Berlin *Sezession*. The coherence of his compositions was based on repeated lines, volumes and colours, a method he termed "parallelism".

HOFMANN Ludwig von

(1861–1945) German. Studied under the direction of his uncle Heinrich von Hofmann then with Ferdinand Keller in Karlsruhe. In 1889 he attended the Académie Julian in Paris and discovered the work of Puvis de Chavannes and Albert Besnard. He met Max Klinger in Berlin in 1890. 1891–1894 in Rome. 1903–1908 he taught at the Weimar School of Fine Arts. In 1906 he settled in Dresden. In his landscapes, he combined turn-of-the-century style with Symbolist subjects; these later faded out as his style became increasingly ornamental.

HOLST Richard Nicolaus Roland

(1868–1938) Dutch. Attended the Amsterdam School of Fine Arts, and subsequently went through an Impressionist phase. His Symbolist phase began around 1891. From 1900, he turned toward a more monumental style.

HUNT William Holman

(1827–1910) English. Expected to enter business, but enrolled at the Royal Academy at seventeen and

William HUNT

Fernand KHNOPFF

Gustav KLIMT

Max KLINGER

Wassily KANDINSKY

Ferdinand KELLER

there met John Everett Millais, who was then sixteen. In 1848, he met Rossetti as a result of the latter's enthusiasm for one of his paintings. Shortly afterwards, the three formed the Pre-Raphaelite Brotherhood. Hunt subsequently devoted himself to religious subjects, staying in Palestine in 1854. In 1905, he published *The Pre-Raphaelites and the Pre-Raphaelite Brotherhood*, which is today the main source of information on the movement.

JOSEPHSON Ernst
(1851–1906) Swedish. Trained in various European capitals. Then settled in Brittany where he practised spiritualism, communicating with the spirit of the Swedish mystic Swedenborg. He was subject to hallucinations, to which he gave expression in his highly original *œuvre*.

KANDINSKY Wassily
(1866–1944) Of Russian origin, he took German citizenship in 1928, then French citizenship in 1939. 1899 graduated in law from the University of Moscow. 1904 studied with Ashbe and and von Stuck in

Munich. 1903–1907 travelled in Northern Africa, Italy and France. 1907–1914 lived in Berlin and Munich. Taught at the Free National Workshops of Art in Moscow and in 1920 at the University of Moscow. Left for Germany in 1922. In 1933, he settled in France. His first period can be described as Symbolist. A mystic who followed orthodox rites and kept icons with him as he moved around Europe, Kandinsky had a taste for the occult which was not without influence on his colour Symbolism. He carried Russia with him in his heart, and his early work is inspired by the legends and tales of Russian folklore. "My predilection for what is *hidden*, for the *mysterious*, saved me from the unhappy influence of popular art," he wrote. His famous "abstract" watercolour of 1910, hung upside-down, inaugurated the move toward abstraction. Till the end of his life he continued to stretch the boundaries of painting, bringing to it freedoms then unknown. He opened the way to the painting of the future by following his own "internal necessity".

KELLER Ferdinand
(1842–1922) Germany history painter. From age sixteen to twenty, he lived in Brazil. In Karlsruhe, studied under Schirmer and Canon. 1866, travelled in France and Switzerland. 1867–1869 lived in Rome, where he met Feuerbach. 1870 began teaching in the Karlsruhe Academy, of which he became director. In 1900 he discovered the work of Böcklin and became a devoted admirer, developing a new interest in idealist landscape. Keller is most important as a history painter. His highly decorative and brightly coloured paintings won him the reputation of the "Makart of Baden", after the Austrian history painter Makart (1840–1884), who worked in Vienna.

KHNOPFF Fernand
(1858–1921) The greatest Belgian Symbolist and the only one to achieve an international reputation. Spent his childhood in Bruges, where his father was a magistrate. Abandoned his law studies to enrol at the Académie des Beaux-Arts. He was influenced by Xavier Mellery. In Paris in 1877, he discovered Delacroix, Gustave Moreau, Rossetti and Burne-Jones. One of the founders of the group XX. Supported by Verhaeren

and Péladan. He exhibited at the first Rose+Croix Salon. Linked to the Belgian Symbolist poets, he adopted their thematic melancholy. He was a dandy and a society portraitist. His preferred model was his sister, with whom he was in love; her features appear in the two kinds of women central to his work, the sphinx-woman and the angel-woman. These appear surrounded by emblems, sometimes as immaterial creatures floating in the world of memory. They exemplify the withdrawal into oneself and the indulgence in dream that characterise Belgian Symbolism.

KLIMT Gustav
(1862–1918) Austrian, son of a Viennese jeweller. From age fourteen to twenty he studied at the School of Plastic Art in Vienna. From the age of eighteen, he, his brother Ernst and Franz Matsch undertook commissions for decorative works. In 1897 he became the first President of the Vienna *Sezession*. Influenced first by Makart, he turned away from him after a trip to Vienna where he discovered Byzantine mosaics. In 1912, he withdrew from the *Sezession* and became President of the Austrian National Union of Artists. In 1917, he was granted an honorary professorship at the Viennese Academy. From his early works, Klimt caused uproar. His works were frequently taken down; the Nazis burnt some of them. His technique is fairly classical, but his subjects were scandalous; naked young girls mingle with skeletons, sexuality expressed in all its forms, from the couple to the pregnant woman, from lesbianism to masturbation. Ornament is all-pervasive in his work; from this background the bodies struggle to the surface. He was witness to the decadence of an entire society and the fantastic world that his paintings occupy testify to this by their collocation of sex and death, while the audacity and freedom of his graphic style foreshadow modern art.

KLINGER Julius
(1876–1920) Austrian. Painter, engraver and graphic artist linked to the Vienna *Sezession*. He took part in the illustration of the magazine *Ver Sacrum* and designed typographical sets.

KLINGER Max
(1857–1920) German. 1874 entered the studio of Gussow at the Karlsruhe Academy of Fine Arts; when Gussow

L

left for Berlin, he followed. His principal inspiration was the engravings of Rembrandt, Menzel and Goya. From 1878 on, began various sequences of engravings such as the *Paraphrase on the Discovery of a Glove* (1880–1881). In 1879 and 1880, he spent time in Brussels and Munich, 1883–1886 in Paris. 1888–1890 he was in Italy, where he met Böcklin. 1893 settled in Leipzig. From 1897, he devoted most of his time to sculpture. Influenced by music; Beethoven and Brahms influenced his sequences of engravings. His monument to Beethoven, a synthesis of the major principles of *Art Nouveau* and a reaction to Phidias' *Zeus*, was the sensation of the 1904 Vienna *Sezession*. Klinger's *Beethoven*, heroically nude, fist clenched, his gaze transfixing the horizon, is a martyr who will redeem humanity, and perfectly embodies the Secessionists' aspirations.

KUBIN Alfred
(1877–1959) Austrian. An apprentice photographer at Klagenfurt. During a state of depression in 1896–1897, he attempted suicide on the tomb of his mother. 1897 attended Schmidt-Rottluff's course at the Academy of Fine Arts. In 1901 he discovered the engravings of Klinger and, with them, his own vocation. In 1905 he visited Odilon Redon in Paris. In 1906 he acquired Zwickeldt Castle, to which he retired. In 1908, after the death of his father, he wrote a novel of the fantastic, *The Other Side*. Illustrated the works of Nerval, Poe, Strindberg, and Wilde. He was a friend of Klee and Franz Marc and member of the New Assocation of Young Artists and of the Blauer Reiter. With his traumatic youth, Kubin plunged deep into the unconscious in order to transcend everyday reality. His delirious graphic production mixes the most diverse influences, which he expanded to express his infinite internal universe.

KUPKA Frantisek
(1871–1957) Painter of Czechoslovakian origin. 1886–1889 studied at the Prague Academy of Fine Arts. In 1891 he settled in Vienna where he discovered the German poets and philosophers. In 1895 moved to Paris. In 1910, at the same time as Kandinsky, turned to abstraction. Like many Symbolists, Kupka was initially interested in occultism and was a medium in spiritualist experiments. When Apollinaire, in an article on Orphism, suggested that Kupka's painting was the plastic equivalent of music, Kupka rejected the analogy. In the *New York Times* of 1913, he stated "Man exteriorises his thoughts in words… Why should he not be able to do the same in painting and sculpture, independent of the forms and colours that surround him?" Like Kandinsky, Kupka began as a Symbolist before becoming one of the great pioneers of abstract art.

LACOMBE Georges
(1868–1916) French landscape painter. Much influenced by Gauguin, he became a member of the Nabis. Born to wealthy parents who moved in artistic circles, Lacombe was given his first lessons in painting by his mother. 1892 met Sérusier. Gauguin's influence is particularly clear in his wooden sculptures. These treat symbolic (sometimes esoteric) subjects illustrating the cycle of life and death.

LE SIDANER Henri
(1862–1939) Born in Mauritius. In 1872 his family moved to Dunkirk. In 1880 studied under Cabanel at the Ecole des Beaux-Arts. 1882–1887 lived at Etaples in the Pas-de-Calais, then 1898–1899 in Bruges. Returned to France and settled in Versailles. An intimiste and landscape artist influenced by Impressionism, his art remains very intellectual, with significant literary influence. It was said

of him at the time that he was "the Maeterlinck of painting".

LEVY-DHURMER Lucien (born Lévy)
(1865–1953) One of the best and strangest French Symbolists. Master of pastels, painter of fantastical scenes, portraits and beautiful Mediterranean landscapes. From 1879, attended drawing and sculpture classes at his local school in Paris. In 1886, he met Raphael Collin, who advised him. 1887–1895 lived at Golfe Juan, working as a decorator of porcelain figurines and objets d'art. Discovered classical art on a trip to Italy. Returning to Paris in 1869, he exhibited under a pseudonym, adding the last two syllables of his mother's maiden name (Goldhurmer) to his own, probably to avoid confusion with another artist called Lévy. His characteristic style, a hazy academicism, was appreciated in equal measure by the public and by other artists. While maintaining an academic approach to detail, he assimilated the lessons of Impressionism, creating works whose astonishingly successful colouristic harmony invariably relates to the idea or vision he sought to evoke. After 1901, he gave up his Symbolist themes to some extent, the exception being his idealised female nudes which illustrate the music of Beethoven, Fauré and Debussy.

LJUBA (born Alekse Ljubomir Popovic)
(b. 1934) Serbian. Lives and works in Paris. 1953 studied at the Belgrade Academy of Fine Arts. In 1960 took part in group exhibitions in Europe.

Georges LACOMBE

Lucien LEVY-DHURMER

Alfred KUBIN

Frantisek KUPKA

Henri LE SIDANER

Popovic LJUBA

Settled in Paris in 1963: "appropriated" by the Surrealists. His large, vaporous, bizarre compositions, typically one or two nude figures surrounded by a chaos of baroque forms, are known internationally from New York to Tokyo. Ljuba is less Surrealist than Symbolist; his canvases are pervaded with a sense of cosmic mystery, in which all kinds of dream-like, esoteric, organic, and mineral metaphors are set in a climate of theatrical fantasy.

MACKINTOSH Charles Rennie

(1868–1928) Glaswegian architect. Mackintosh created a decorative style combining geometric elements with the sinuous lines typical of so many designers at the turn of the century. His works were praised in Vienna and Turin, and his reputation as an architect was international. He combined his Symbolist ideas with a classical architectural training, and his works created such a vogue that the term "Mackintoshism" was invented to define his influence.

Charles Rennie MACKINTOSH

Aristide MAILLOL

MAILLOL Aristide

(1861–1944) French sculptor of Catalan origin. A disciple of Rodin. Rejected by the Beaux-Arts in 1881, he was accepted by Cabanel and met Gauguin, whose influence was to prove decisive. In 1893, befriended the Nabis and was influenced by Maurice Denis and Puvis de Chavannes. He was first and foremost a painter and only turned toward the sculpture which assured his reputation when a serious eye-infection forced him to give up painting.

MALCZEWSKI Jacek

(1858–1929) 1873–1876 a pupil of Matejko at the Cracow Fine Arts Academy from 1858 to 1929. Then spent time in Munich and Paris. His early works are sombre and Romantic. In 1890, his palette brightened. His work concerns primarily the tragic situation of Poland and autobiographical themes, to which must be added Symbolist themes relating to the fate of the artist. He painted many self-portraits in which he is dressed in different guises or in dialogue with Death who is represented as a beautiful woman. The desire for his country's independence was strong in him, and in his *Polish Hamlet*, whose hands are bound, he painted a quintessential symbol of Poland.

MALEVICH Kasimir

(1878–1935) Russian painter born in Kiev. He studied art in his native town under Borissov-Mussatov, a Symbolist painter who had himself been a student of Gustave Moreau in Paris. Went to Moscow where he frequented avant-garde circles, espe-

Kasimir MALEVICH

cially Larionov and Goncharova. Under their influence he developed rapidly, and in 1915, at the famous "0.10" shown in St Petersburg, he showed his famous *Black Square on a White Ground*, the emblematic work of Suprematism. Like Kandinsky and Mondrian, Malevich started from Impressionism and Symbolism and, within a few years, had explored and resolved the fundamental contradictions of painting, carrying them to an exemplary degree of simplicity and austerity.

MAREES Hans von

(1837–1887) German. Trained first in Munich, then Berlin. Travelled in Italy, Spain, Holland, and France, where he took up Pointillism. His meeting with Böcklin was to prove fundamental and had a decisive influence on his artistic development and his desire to renew the style he had evolved in Italy. The central theme of his work is harmony between man and nature, as seen in his paintings of antiquity, such as *Arcadia* and *The Golden Age*.

MARTINI Alberto

(1876–1954) Italian engraver. In Munich in 1898, he had some contact with Jugendstil. Was interested in 16th century German drawings, in particular in Dürer and Cranach. In 1895 he began to engrave and illustrate, in particular the works of Poe, Dante, Boccaccio, Verlaine, Rimbaud, and Mallarmé. In Paris from 1928 to 1931. He refused an invitation to join the Surrealists. In 1934, returned to Milan and stayed there till his death. His works make him the greatest Italian illustrator. Like Moreau and Redon, he inclined toward the fantastical in his art. He had always painted, but turned increasingly toward painting later in his career. A late representative of Symbolism and decadent art, Martini uses dream-like elements and psychological insights which were more important to him than Surrealist poetics, from which he always kept his distance.

MASEK Karel

(1865–1927) Czechoslovakian painter and architect. He studied in Prague, Munich, and Paris, where he

Jacek MALCZEWSKI

Hans von MAREES

Alberto MARTINI

Jan MATEJKO

M

Henri MATISSE

Charles MAURIN

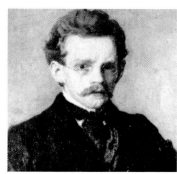

Józef MEHOFFER

Xavier MELLERY

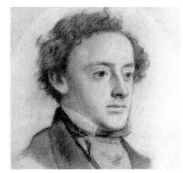

John Everett MILLAIS

George MINNE

took up Pointillisme. From 1894, exhibited in Munich and Dresden. In 1898, he was appointed professor at the Prague School of Decorative Arts. His decorative work survives in many Prague buildings.

MATEJKO Jan

(1836–1893) Polish painter. An academic artist, Matejko mainly painted large history paintings. His work played an important role in forging a heroic vision of the history of Poland at a time of insurrection and repression. A professor at the Cracow Academy, he numbered amongst his students Symbolist artists such as Malczewski, Wyspiavski, Pruszkowski and Mehoffer.

MATISSE Henri

(1869–1954) Born in Northern France, Matisse is, with Picasso, one of the great geniuses of modern art. A notary's clerk, he came relatively late to his artistic vocation. He was a student of Bouguereau and then Gustave Moreau; the latter predicted that he would "simplify painting". At this point Matisse was ignorant of Impressionism and of the innovations of Gauguin and Seurat. What he discovered, thanks to Moreau, was the magic of colours and the aesthetic power of the arabesque, which were to become the two obsessions of his life and which he was at last able to combine in the famous gouache "cut-outs" of *Jazz*. With these, he could "carve directly in colour" like a sculptor. The road that led Matisse to the "scandalous" colours of Fauvisme led through the Symbolism of his teacher Moreau. It also passed through the work of Puvis de Chavannes, in particular his *Young Girls at the Seaside*, which Matisse admired at the Salon of the Société Nationale in 1895. Thus the three feminine nudes of Matisse's *Luxury* can be interpreted as one body seen in three different poses or in more symbolic terms as representing three states of being: passive, active, and contemplative. In ascribing to mural painting a decorative function of stark clarity, Puvis de Chavannes had, in Matisse's view, given that art a new point of departure. This is precisely the function that Matisse sought, when, animated by his own desire for the monumental, he brought majestically forth from the sea like a new Venus the pale yellow giantess of *Luxury*. One feels

that the two other smaller creatures, the one pink, the other green, are only there to render homage to this goddess by kneeling at her feet and offering her flowers.

MAURIN Charles

(1856–1914) French. A friend of Félix Vallotton and contributor to the *Revue Blanche*. 1882–1890 exhibited at the Salon des Artistes Français and three times at the Rose+Croix Salon. An eclectic artist, he was not indifferent to the social turmoil of his time. He practised a variety of techniques and even designed patterns for cloth. He moved from a solid, classical style in nudes and portraits to a *Synthetist* style; he also attempted correspondences between music and colours.

MAXENCE Edgar

(1871–1954) French painter, pupil of Gustave Moreau. Exhibited with the Rose+Croix and vulgarised Symbolist themes at the official Salon by exhibiting idealist landscapes usually with medieval contexts. Up to 1900, his works involved experiments with his medium, so that his paintings resemble half-sculpted, half-painted icons. Subsequently, his Symbolism became more decorative and superficial.

MEHOFFER Józef

(1869–1946) Polish. Student of Matejko's in 1887 at the Cracow Fine Arts Academy; in 1890 attended the Vienna Fine Arts, and in 1891–1896 attended the Academy Colarossi and the Paris Beaux-Arts. Wyspiavski, who studied with him, influenced him in his decorative work. He illustrated magazines such as *Zycie* and *Chimera* and won a reputation as a designer of stained-glass. The great work of his life was the preparation of the cartoons for the stained-glass windows of the Cathedral of St Nicolas in Fribourg, Switzerland.

MELLERY Xavier

(1845–1921) Belgian painter. Winner of the Prix de Rome in 1870, he discovered Carpaccio in Venice and classical sculpture and the Sistine Chapel in Rome. On his return to Belgium, he received a commission to illustrate a work by Charles de Coster and for this purpose went to the island of Marken in Holland, where popular traditions were still vigorous. The result was an almost

expressionist phase. From 1885, he began to produce decorative and allegorical work in the spirit of Puvis de Chavannes. Mellery was a member of the group of XX and exhibited at the Rose+Croix Salon. Mellery's dream was to decorate the Belgian capital with immense frescos painted on its public monuments. The project was never realised, but some preliminary studies, in gouache on gold or silver background, have survived. In his disappointment, he continued with his more *intimiste* work, full of mystery and poetry. Some of these form part of sequences called *The Life of Things* or *The Soul of Things.* A precursor of Symbolism, he was the teacher and initiator of Khnopff.

MILLAIS John Everett

(1829–1896) English painter. A precocious talent, he enrolled at the Royal Academy at the age of eleven. There he befriended Hunt and Rossetti and together they formed the Pre-Raphaelite Brotherhood. From his twenty-eighth year, he began to take up fashionable subjects (society portraits and history painting) which won him lasting success. But ten years later he confided to Hunt that "my maturity has not fulfilled the hopes and ambitions of my youth". He was knighted in 1885 and elected President of the Royal Academy in 1896. Millais' social position and substantial income made him the most overtly successful of the Pre-Raphaelite painters.

MINNE George

(1866–1941) Belgian sculptor and graphic artist. His sensibility absorbed the latent tendencies and obsessions of his time and made a style of them. His anxious and even mystical character is expressed in the new

forms of whch his *Fountain of the Kneeling Youths* is a symbol. Attended the Ghent Academy 1882–1884. From 1889, worked alone, inspired by the example of Rodin. A friend of the Symbolist painters Grégoire Le Roy, Van Lerberghe, Maeterlinck and Verhaeren. He was invited to exhibit with the XX group in 1890 and became a member of the group in 1891. He exhibited at the Rose+Croix Salons. Moved to Laethem in 1899. He was a professor at the Ghent Academy from 1912 to 1914 and from 1918 to 1919.

MONDRIAN Piet (born Pieter Cornelis Mondriaan)

(1872–1944) Dutch painter. The first child of a strictly Calvinist family. Influenced by Toorop, he began to paint esoteric works in 1909. Only after moving to Paris did he begin to develop the austere and radical abstraction for which he is principally known. A theosophist, in 1900 he composed Symbolist works of esoteric import. Two things contributed to the acceleration of his development: his work on motifs and his discovery of the Fauves through Van Dongen and Sluyters, who proclaimed to him the merit of the raw colours of Gauguin and Matisse. Mondrian then radically overhauled his palette and brushstroke; study of colour remained for some time one of his main preoccupations. But the pervasive blue) and the verticality of these human trunks solidly based in firm horizontals suggest the new direction that was coming.

MONTALD Constant

(1862–1944) Belgian landscape artist and designer. The Ghent Academy awarded him a travel grant in 1884 and he stayed in Paris, where he at-

Piet MONDRIAN

Alphonse MUCHA

Gustave MOREAU

Edvard MUNCH

William MORRIS

tended the Beaux-Arts. Won the Prix de Rome in 1886, and spent three years in Italy and Egypt. After his return to Belgium and up till 1932, taught at the Brussels Beaux-Arts. He was a friend of Stefan Zweig and Emile Verhaeren.

MOREAU Gustave
(1826–1898) French. Without doubt one of the greatest Symbolist artists. Entered the studio of François Picot at the Paris Beaux-Arts in 1846. A friend of Théodore Chassériau, whom he frequented from 1850 until the latter's death in 1856. From 1857 to 1859 he travelled in Italy. Won considerable reputation at the 1864 Salon with his *Oedipus and Sphinx*. His unfavourable critical reception in 1869 meant that he returned to the Salon only in 1876 with his *Salome Dancing Before Herod*, which was admired by many critics, notably Huysmans. In 1884 succeeded Elie Delaunay as a teacher at the Beaux-Arts. Matisse, Marquet, Camoin and Rouault were among his students, and their works show his influence. The heir of Romanticism and an admirer of the Italian masters of the Quattrocento,

Gustave Moreau is the embodiment of Symbolism. He defined his art as a "passionate silence" and transcribed in it obsessions and oneiric themes which made of him one of the great masters of sexual Symbolism. He seized upon the personage of Salome and made of her one of the main themes of his work, if not indeed the most important. In his many variations on this theme, he portrayed Woman as both a baleful seductress and a perverse innocent.

MORRIS William
(1834–1896) English Pre-Raphaelite. He read theology with Burne-Jones at Exeter College. Together they discovered the work of Rossetti and, with it, their artistic vocation. A painter, writer and socialist, Morris was also a great designer and decorator. The company that he founded produced furniture, stained-glass, objects, textiles and wallpaper.

MOSSA Gustave Adolphe
(1883–1971) Born in Nice. A late Symbolist, himself the son of a painter, Mossa admired Moreau. His work takes up the Symbolist themes with detachment and humour. He treated most of the Symbolist subjects, in particular that of Woman, who appears in his work as perverse by nature.

MUCHA Alphonse Maria
(1860–1939) Czech painter, poster artist and designer, and the embodiment of turn-of-the-century art. A wealthy patron enabled him to study at the Munich Academy, then, in 1887, at the Académie Julian. He was an illustrator for several magazines and newspapers. In 1894, his first poster for Sarah Bernhardt won him considerable renown. In 1904 he

travelled to the United States. In 1911 returned to Prague to devote himself to an œuvre celebrating the epic of Slav history. Mucha's fame was owed to his very personal style of drawing, which was both elegant and supple, giving a slender, sophisticated vision of Woman. His taste for curved and intertwined forms combined with a wild proliferation of plant life was expressed in some of the most celebrated posters of his time.

MUNCH Edvard
(1863–1944) Norwegian. Undoubtedly the greatest artist of Northern Europe. Stayed in Paris in 1885 and 1889. First exhibited in Oslo in 1892. An exhibition in Berlin that same year caused uproar. In Berlin, he met Strindberg and Przybyszewski. He made numerous trips to Germany, France and Italy. In 1896, in Paris, he met Gauguin, van Gogh and Mallarmé. He suffered acute depression in 1908. After 1909, lived mainly in Norway. As the public is averse to any form of tragic obsession, his artistic vision has sometimes been condemned or misunderstood. Like van Gogh, Munch belongs to the class of those afflicted by profound anxiety and a sense of revolt, whose creative activity and violent inspiration are indissociable from a life marked by dramatic events. Considered one of the precursors of Expressionism, Munch occupies in the Nordic countries a role as important as that of Cézanne for the Latin countries.

NESTOR (born Néstor de la Torre)
(1887–1938) Born in Las Palmas in the Canaries. Studied in Madrid with a grant from the Las Palmas municipality. 1904–1907 several trips to Belgium, France and England, where he saw the work of the Pre-Raphaelites and Whistler. In 1914, he exhibited at the Grafton Gallery in London; in 1930 he had a one-man show at the Galérie Charpentier in Paris. He is relatively unknown, but was particularly admired by Dalí, who borrowed from him in the composition of his homage to Meissonier, *Tuna Fishing*.

OSBERT Alphonse
(1857–1939) French Symbolist. A student of Lehmann, Cormon and Bonnat at the Paris Beaux-Arts, his first love was Spanish art and the works of José Ribera. Subsequent encounters with Puvis de Chavannes, Séon and Seurat led him to brighten his palette. At this time he also adopted the themes characteristic of Symbolism and became a specialist in the subject of lyre-bearing classical Muses contemplating landscapes bathed in the setting sun. He exhibited at the Rose+Croix Salons.

PELIZZA DA VOLPEDO Giuseppe
(1869–1907). Italian. Studied at the Accademia Brera in Milan. Began working in the style of the Macchiaioli before turning to Divisionism in

N

O

P

1894. Began working on Symbolist subjects in 1895. His theoretical research had considerable influence in Italy. He was interested in socialist ideas and read Marx and Engels. He painted a series of pictures whose main theme is the sun and which express the ideal signification of light; this form of the representation of emotion ultimately became a process of abstraction. His later works are close to those of Balla and Boccioni.

PETROV-VODKIN Kosma
(1878–1939) Russian. After studying art in Moscow, he spent time in Monaco and Paris. Travelled to Italy, Greece, France and Africa. He taught art in St Petersburg, and was a teacher at the School of Fine Arts in St Petersburg from 1918 to 1932. He was influenced by Puvis de Chavannes, Maurice Denis and Ferdinand Hodler. His works express the eternal ideas of beauty, love and happiness.

PICABIA Francis
(1879–1953) Born in Paris. With Duchamp, one of the most revolutionary artists of the 20th century. Picabia began with Impressionist and Symbolist works, passing through Fauvism and Cubism before reaching Dada. This is a relatively conformist career. Yet Apollinaire wrote: "Mad, fiery works which tell of astounding conflicts between the substance of the painting and the imagination." Whereas Duchamp appropriated industrial machinery with little or no modification, Picabia emphasised his own intervention by humorous or poetic inscriptions of a very "Symbolist" kind.

PICASSO Pablo Ruiz
(1881–1973) Born in Malaga, the most admired and frequently criticised amongst the giants of 20th century art, and the most famous Spanish Parisian. A Symbolist during his "Red" and "Blue" phases, he made no secret of his sympathy for the people and for the melodramatic atmosphere of scenes in the lives of the underprivileged. Picasso expressed this by means not of anecdote but of gesture and stance. Deeply and lastingly affected by Symbolism, Picasso for a while idealised not only his subjects but also the line and very

muted colours with which he portrayed them. Human distress wears the timeless appearance of ordeals inflicted by destiny on humanity – or else these people are merely metaphors for Picasso's own state of mind. This quintessentially Symbolist attitude is a far cry from the Expressionism with which the artist's first two periods have on occasion been associated. The Expressionism emerged in the abrupt flare-up of colour in the works that followed these two periods. These violent colours foreshadowed the Fauvism and Expressionism of Die Brücke, but Picasso did not long persist with them.

PODKOWINSKI Wladyslaw
(1866–1895) Polish. In 1880 entered the Warsaw School of Graphic Art where he was taught by Wojciech Gerson. In 1885 published his first drawings in the Warsaw newspapers. In 1886 he studied at the St Petersburg Academy. Travelled to Paris in 1889. Influenced by Monet, he painted in Impressionist style on his return to Poland. In 1892, entered a Symbolist phase.

PREISLER Jan
(1872–1918). Czech. 1887–1895 studied at the Prague Technical School. In 1902, he travelled in Italy, in 1906 in France and Belgium and Holland. He exhibited in 1906 in Venice, and in 1911 in Rome. Became a professor at the Prague Academy. Preisler's Symbolism takes the form of thematic presentations in which the artist sets forth his ideas and intentions. This normally consists of the tangible representation of a spiritual

state. The kinship with Munch, whom Preisler greatly admired, thus becomes apparent.

PREVIATI Gaetano
(1852–1920). Italian. Studied at the Ferrara School of Art. His 1891 *Maternity* set off a lively polemic. Exhibited at the Rose+Croix Salon in 1892, at the Berlin *Sezession* in 1902, and won a Gold Medal at the Munich Quadriennale in 1905. Organised the *Dream Room* at the Venice Biennale in 1907. This was devoted to a kind of sentimental and allegorical Symbolism which Balla admired. The signatories of the Futurist manifestoes hailed Previati as the champion of anti-naturalism and the avant-garde.

PRUSZKOWSKI Witold
(1846–1896) Polish painter. Studied in Paris, Munich and at the Cracow Academy of Fine Arts with Jan Matejko. His Symbolist work is inspired above all by the legend and the poetry of Julius Slowacki.

Kosma PETROV-VODKIN

Alphonse OSBERT

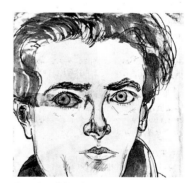

Francis PICABIA

NESTOR

Giuseppe PELIZZA DA VOLPEDO

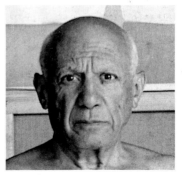

Pablo PICASSO

PUVIS DE CHAVANNES Pierre

(1824–1898) The greatest French decorative painter. His international influence was even greater than that of Moreau. He had to abandon his studies at the Polytechnique because of illness and travelled in Italy during his convalescence, where he discovered the frescos of the Quattrocento and decided to become a painter. Ary Scheffer, Couture, Delacroix (for exactly four days!) and above all Théodore Chassériau were his teachers at the Beaux-Arts. In 1850, exhibited a *pietà* at the Salon. In 1861 his career as a painter of murals for public buildings began with the Musée d'Amiens. He decorated many buildings, including the Panthéon, the Hôtels de Ville of Paris and Poitiers, the Sorbonne, various French museums, and the Boston Public Library. A very French mind – to the extent that his work attracted that other very French painter, Matisse – he brought to his art a sense of grandeur and an organisational logic that were precisely the gifts required for vast mural decorations. His decorative compositions attempt to reach monumentality not through depth but through superficiality, linearity of construction, the "majesty" of the organisation and also by a certain philosophical pretention. The nobility of the man is clear; the influence of his work quite outstripped its intrinsic qualities, but he was, whether we like it or not, one of the masters of the Symbolist age, an age which made of Beauty and the Pure Idea a veritable religion.

RANSON Paul

(1862–1909) French painter. One of the founders of the Nabis. Had a lifelong interest in the occult and in liturgical art. Studied at the Ecoles des Arts Décoratifs of Limoges and Paris, then, in 1888 at the Académie Julian in Paris. There he met Sérusier and his Nabi friends. His town house on the Boulevard du Montparnasse (dubbed "the Temple") became their meeting place. In 1908, he founded the Académie Ranson, run by his wife after his death; his friends Bonnard, Denis, Maillol, Sérusier, Vallotton and Van Rysselberghe all taught there.

REDON Odilon

(1840–1916) The greatest of the French Symbolists. He was a pupil of Stanislas Gorin at Bordeaux, of Gerôme at the Paris Beaux-Arts, and finally of Rodolphe Bresdin. In 1870 he settled in Paris. Worked at first with charcoal. In 1879, published a first series of lithographs *In Dream*. Others were to follow. In 1884, he took part in the Salon des Indépendants of which he was one of the founders, and in the Salon of the XX in Brussels (in 1886, 1887 and 1890). A friend of Mallarmé, Francis Jammes, Jean Moréas, and Paul Valéry. He took up pastels and colour in the 1890s. His finest creations are those in which his supple draughtsmanship and rare, phosphorescent colours evoke a mythical universe. It is no coincidence that these evocative images, whose sumptuous line encloses dream-like colours, attracted the praise of the Symbolist writers, from Stéphane Mallarmé to J.-K. Huysmans. He was admired by painters as various as Gauguin, Emile Bernard, Matisse and the Nabis, who dragged him out of his retirement. Painting was, for Redon, a way of escaping his own psychological problems, problems as "literary" as those of Gustave Moreau, whom he knew and admired.

REPIN Ilya Efimovich

(1844–1930) Russian painter. An important member of the Wanderers, Repin practised a kind of melodramatic realism before joining the *Mir Itkustva* (World of Art) circle. He subsequently produced one or two works in Symbolist vein but the primary identity of these works remains their Russianness.

RODIN Auguste

(1840–1917) The great French sculptor was also the most admired of all the Symbolists. He was three times rejected by the Paris Beaux-Arts; his *Man with Broken Nose* was rejected by the 1864 Salon, and between 1871 and 1877 Rodin was forced to make his living in Brussels. His return to Paris was an event. Rodin is distinctive among Symbolists for the vigour of his treatment, particular in the *Balzac* and the *Gates of Hell*. Other works of smoother, softer outline, such as *Thought* and *The Kiss* are more representative of contemporary taste. But it is the famous *Gates of Hell*, a crucible teeming with creatures inspired by Dante's *Inferno*, Ovid's *Metamorphoses* and Baudelaire's *Les Fleurs du Mal* – creatures whose very existence is owed to the "will to power" and power of invention so dear to the heart of Nietzsche – that make Rodin the perfect Symbolist. Rodin is a Michelangelo who has tasted of Wagner... In this infinitely rich *œuvre*, a Promethean humanism resonates with Freud's discovery of the unconscious and of repression. Rodin himself stated: "Men are led by symbols, and symbols do not lie."

ROMANI Romolo

(1884–1916) Italian. Romani, influenced by Odilon Redon, took Symbolism in a direction that prefigured Surrealism and abstract painting. He signed the Futurist manifesto in 1910. In 1912, mental illness put an end to his career.

ROPS Félicien

(1833–1898) A Baudelairian graphic artist much admired by Péladan; a Belgian who lived most of his life in

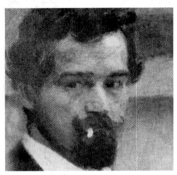

Jan PREISLER

Gaetano PREVIATI

Pierre PUVIS DE CHAVANNES

Paul RANSON

Odilon REDON

R

Auguste RODIN

Dante Gabriel ROSSETTI

Georges ROUAULT

Félicien ROPS

Bruno SCHULZ

Paris. He attended the Namur Académie, then went on to Brussels while attending the workshop of Saint-Luc. In 1856, founded the satirical weekly *Uylenspiegel*. In 1868 became Vice-President of the Société Libre des Beaux-Arts de Brussels. In 1870, he founded the Society of Etchers. He settled in Paris in 1874. He was welcomed by Puvis de Chavannes and Gustave Moreau. He engraved and illustrated (Baudelaire, Barbey d'Aurevilly), and had close links with Péladan, who admired him, though Rops seems not to have taken Péladan too seriously. He was a lover of the fantastic and the supernatural, and his themes are therefore frequently Symbolist in kind. The devil, skeletons, the prostitute, and death are the Baudelairian acccessories of his art. In fact, despite Péladan's appeals, Rops was not very interested in the Rose+Croix artists, and much more so in the mores of his time, in the singularities of the modern mind as it appeared in the spectacle of Parisian life. His libertine life and scandalous and erotic subjects made him infamous in his own lifetime.

ROSSETTI Dante Gabriel

(1828–1882) English, son of an Italian political refugee, he enrolled at the Royal Academy in 1847. There he made friends with Millais and Hunt and together they founded the Pre-Raphaelite Brotherhood. In 1850, Rossetti met a saleswoman called Elizabeth Siddal who was to become the model of Pre-Raphaelite women. She became his mistress, and they were married in 1860. Two years later she committed suicide. Rossetti went into a decline, but continued to write and painted some of his most important works. The author of poems derivative of the 13th century troubadours and Browning, he placed his poems solemnly in his wife's coffin. A highly symbolic gesture. But seven years later he had his wife exhumed in order to retrieve and publish the poems... Chesterton's verdict is almost certainly too severe: "Rossetti was a man remarkable in everything, but who did not succeed in any art; if he had succeeded, we should probably never have heard of him. He owes his success to his half-successes."

ROUAULT Georges

(1871–1958) French painter and engraver. An apprentice with a painter

and glass-maker, he was admitted to the evening drawing courses of the Ecole des Arts Décoratifs in 1885. He was a disciple of Gustave Moreau: his colleagues were Matisse, Manguin, Marquet, and Evenepoel. Moreau's influence on his gifted pupils was a lasting one. Rouault himself said: "Gustave Moreau taught us to discipline our will without any preconceived ideas... He taught us to respect a certain inner vision." In 1903, Rouault became the director of the Musée Gustave Moreau. He frequented J.-K. Huysmans and made friends with Léon Bloy. He shared with the latter an "infinite compassion" for those who suffer in the midst of a society which corrupts the honest. This is the quest that led Rouault to portray in harshly contrasting colours and brutal black strokes a gallery of characters with three main types: prostitutes, judges and clowns. They were, in Bloy's words, "horrific and vengeful caricatures". This was the road that brought Moreau's student from Symbolism to Expressionism, something relatively unusual in French painting.

RYDER Albert Pinkham

(1847–1917) Self-taught American artist. Rejected by the National Academy of Design at twenty, he trained with a minor artist, William Edgar Marshall, and was then admitted. Travelled in Europe in 1877, 1882, 1887, and 1896. A visionary painter, he chose subjects from Shakespeare, Byron, Poe and Wagner. He painted some 170 pictures, many of small dimensions, and is considered one of the pioneering figures in American art.

SAMIRAILO Victor

(1868–1939) Russian painter and illustrator. Influenced by Vrubel as most of the French Symbolist painters were, he too illustrated the works of Lermontov.

SCHULZ Bruno

(1892–1942) Polish writer, designer, painter and engraver. Studied architecture in Lvov and at the Vienna Academy of Fine Arts. After 1924, worked as an art teacher in Drohobycz, his native town. In 1934, he published *The Street of Crocodiles*. He was admired and supported by Witkacy (Witkiewicz) and by other major writers. Witkacy paid for him

to spend a fortnight in Paris. Schulz was killed in 1942, shot down in the street by a Gestapo officer. His premature death prevented his full development after very promising beginnings. The scabrous theme of his *Book of Idolatry*, man sexually dominated by woman, inevitably shocked provincial philistines – for them it was an offense against morality and a provocation. Schulz's plates would not have been out of place in Sacher-Masoch's *Venus in Furs*, the work which defined masochism; Schulz's taste must have inclined in this direction. It is a tragedy that this descendant of Goya and Rops was prevented from carrying any further his study of the vast, existential drama in which Woman is a source of light, pain and desire, and of the Word according to Schulz.

SCHWABE Carlos

(1866–1929) Born in Germany, brought up in Switzerland. In 1890, visited Paris. He exhibited at the Salon National and at the Rose+Croix, whose poster he designed in 1892. An illustrator and designer of wall-paper, he was influenced by the Pre-Raphaelites in his painting. From his early years drawing stylised flowers, he retained a particular aptitude at presenting flora in line with a complex Symbolism illustrating the great themes of the life of the soul. His drawings, which have great purity and extraordinary detail, have been compared to those of Dürer, Mantegna and Botticelli.

SEGANTINI Giovanni

(1858–1899) Italian painter, born at Arco, near Trento. Abandoned by his father in the streets of Milan at the age of eight, he was sent to refor-

S

Carlos SCHWABE

Paul SERUSIER

Léon SPILLIAERT

Giovanni SEGANTINI

Hugo SIMBERG

Alexandre SEON

matory school. The director of the establishment had him enrolled at the Accademia Brera. 1886–1894 worked in *Pointilliste* style. At this point he discovered literature and began to read the Symbolists. He read philosophers and poets and knew Liebermann, Klimt and Cassirer. In 1898, he took part in the Vienna *Sezession*. He was preparing a large triptych for the 1900 Exhibition in Paris when he died. Segantini had discovered the form of Divisionism used by Seurat and applied it to landscapes to which his essentially lyrical nature inclined. His Neo-Impressionism was therefore more spontaneous than learned. But his palette, which had been very sombre in his early works, brightened to great effect, eventually attaining the luminous intensity of almost mystic kind which constitutes the particular charm of his work.

SEON Alexandre
(1855–1917) French illustrator and decorator and one of the major disciples of Puvis de Chavannes. After studying at the Beaux-Arts of Lyon and Paris (where he studied with

Lehmann), Séon in 1891 became Puvis de Chavannes' student and then his collaborator. With Péladan and Antoine de la Rochefoucauld, he was one of the founders of the Rose+Croix Salon, where he often exhibited to considerable critical praise from the Symbolist critics.

SEROV Valentin Alexandrovich
(1865–1911) Russian painter. Between two periods of study with Ilya Repin, he travelled in France, studying at Monaco and Paris. He was a renowned portraitist (his subjects included Rimsky-Korsakov, Czar Nicholas II and Maxim Gorky). He was a member of *Mir Iskustva*. As part of the circle of the wealthy patron Savva Mamontov, he collaborated in the production of performances at Mamontov's private opera; he also worked with Diaghilev. He developed a new conception of landscape painting based on his knowledge of French painting.

SERUSIER Paul
(1864–1927) French disciple of Gauguin and the Nabis. The theorist of mystical Symbolism. His meeting with Gauguin at Pont-Aven in 1888 and one little painting that he completed in Gauguin's company were decisive in the development of his art and that of his friends, with whom he founded the group called the Nabis. History has been unjust to Sérusier. Loyal to the Nabis when they were criticised, he could not, without contradiction, renew his own style, and avoided all such temptations. He died twenty-five years after Gauguin. But the fact remains that this eloquent man was admired and loved by Bonnard, Vuillard and Roussel, and that he painted, on the lid of a cigar box, the little painting

dubbed *The Talisman*. This was the founding work of a new aesthetic. It was the poet Henri Cazalis who gave to the group who espoused this aesthetic the name "Nabis", from the Hebrew for "prophets".

SIMBERG Hugo
(1873–1917) Finnish painter. A student of Gallén Kallela from 1895–1897, he discovered Symbolist painting through his teacher. Admired Burne-Jones and Böcklin and worked to some extent under their influence. The fantastical world of Simberg shows the imprint of an original form of pantheism inspired by the untamed natural world that surrounded him. The colours of his little water-colours, which obtained considerable popularity, are closely related to those of ancient Finnish folk tapestries.

SOMOV Konstantin
(1869–1939) Russian artist. He studied under various teachers in Russia, went to France and enrolled at the Académie Colarossi in 1897 for one year. He was a member of *Mir Iskustva*.

SPILLIAERT Léon
(1881–1946) Flemish Symbolist who moved toward a form of Expressionism and whose style sometimes recalls de Chirico. The son of an Ostend perfumer, his talent for drawing emerged in childhood and was constantly exercised. In 1902 he met Verhaeren with whom he struck up a lasting friendship. In Paris, he discovered the work of Gauguin, van Gogh and Picasso. He settled in Brussels in 1935. He was a member of various artistic circles: the Independents, the Sillon, the Contemporary Art group and the Compagnons de l'Art. His very personal technique combined water-colour, gouache, pastel and sometimes crayon on cardboard or paper. He brings together a naive sincerity, sometimes containing a degree of eroticism, a very pure line in arabesque, and decorative surfaces akin to those of the Nabis.

STUCK Franz von
(1863–1928) German painter, sculptor, engraver and architect. From 1878 to 1885 he studied at the School of Plastic Arts in Munich, then at the Munich Academy. He at first earned his living by illustrating various magazines. In 1892 was one of the

founders of the Munich *Sezession*. His Symbolist period is of this decade. In 1895 he began teaching at the Munich Academy, where his pupils included Kandinsky, Klee and Albers, whose subsequent careers enhanced von Stuck's fame. Designed and built the Villa Stuck. Von Stuck has suffered from unfair comparison with Böcklin and been described as superficial in his Symbolist vein. In fact, his many nudes, with their torrid sensuality and a linear style combining decorative and erotic elements, are direct precursors of Jugendstil.

THORN PRIKKER Johan

(1868–1932) Dutch painter and engraver. With Toorop, one of finest Dutch representatives of Symbolism. He studied at the Hague Academy from 1883–1887, going on to paint in Impressionist style. He discovered Gauguin, Maurice Denis, and Toorop, and moved toward Symbolism after 1892; in 1895 he dropped this style. In 1904 he became a teacher at the School of Applied Art in Krefeld. His compositions combine floral motifs and abstract arabesques but do not always escape affectation and mawkishness.

TOOROP Jan

(1858–1928) Dutch painter, born in Java. Studied art in Delft and Amsterdam. A grant allowed him to study in Brussels, where he came into contact with the XX group, and became a member in 1885. He befriended Khnopff, Ensor and de Groux. In 1886, he met Whistler in London. He discovered the Pre-Raphaelites and William Morris' views on art and socialism. In 1890 he developed his own version of Symbolism using elements of a Javanese aesthetic. Met Péladan in 1892. In 1905 converted to Catholicism. His themes thereafter became religious and even mystic. His style simplified and he adopted a technique close to *Pointillisme*, which he put at the service of a fragmentation of the surface of the painting at poles from the measured unity to which Seurat aspired. These fragmentary surfaces relate Toorop to Expressionism.

VALLOTTON Félix

(1865–1925) French painter and engraver of Swiss origin, born in Lausanne. He came to Paris in 1882 to study drawing, and settled there definitively taking French citizenship. At the Académie Julian he made friends with Bonnard, Sérusier, Roussel, Vuillard and Ranson. He learnt xylography, and became known for this speciality. The Nabis were the principal influence on his work at this stage. In 1893, he sent *Bathing on a Summer Evening* to the Salon des Indépendants. The critics were mightily displeased by this mixture of irony and unashamed nudity, in which the many female bodies were scattered across the canvas like notes on a score. His unflattering nudes are remarkable above all for their "Japanese" organisation within the composition. His black humour, sense of the ridiculous and his eroticism provoked considerable hostility. In 1910, the Zurich authorities banned young women from entering his exhibition. He withdrew to the Midi and then to Normandy, where he painted superb landscapes in which a graceful luminosity softens the rigorous simplifications of form.

VEDDER Elihu

(1836–1923) American painter and illustrator. He received his first training from the genre painter T.H. Matteson. 1856–1860 travelled in Europe. He spent seven months in Paris, where he studied with Picot. Then he studied drawing and anatomy with Rafaello Bonaiuti in Florence. 1861–1865 he was in New York, and 1866 and 1869 he again travelled in Europe. He maintained relations with the Pre-Raphaelites, but his drawings have a power of evocation which is reminiscent of Redon. As a decorator, he created the allegorical paintings which are to be seen in the hallway of the Reading Room of the Library of Congress in Washington.

VRUBEL Mikhail

(1856–1910) The pioneer of new art in Russia. After studying art and law at St Petersburg, from 1884–1889 he worked on the restoration of the 12th century frescos in the Church of Saint Cyril in Kiev. He also executed original frescos there. Then he moved to Moscow, where he designed sets for Savva Mamontov and decorative pannels for his house. His best known works are the series illustrating Lermontov's poem The Demon. Vrubel, still little known in the West, is a major Russian artist who influenced an entire generation of painters, including Kandinsky and Malevich, through his symbology and his figures from folk-tales; these express both anguish and the premonition of total disaster. His declared aspiration was to "elevate the soul by grandiose images beyond all everyday pettiness". His exaltation unfortunately ended in madness in 1902. But he continued to work in moments of lucidity, creating visionary works in which the spirit of his times is reflected.

WATTS George Frederick

(1817–1904) English painter and sculptor. Enrolled at the Royal Academy in 1835. In 1843 won first prize in a competition to decorate Westminster Hall. That same year he left for Italy where he remained till 1847. Watts practised a "continental" imprecision of treatment compared to his English contemporaries, and

Jan TOOROP

Franz von STUCK

Félix VALLOTTON

Johan THORN PRIKKER

Mikhail VRUBEL

enjoyed a considerable reputation in France. He was close to the Pre-Raphaelites nevertheless, and, like them, much influenced by Italian art. His works are allegorical, moralising, mystical and symbolic, and they epitomise Victorian taste.

WHISTLER James McNeill

(1834–1903) American painter and engraver. His father was the engineer

George WATTS

James WHISTLER

Jens WILLUMSEN

responsible for building the railway between Moscow and St Petersburg; Whistler started his artistic education at the Imperial Academy of St Petersburg. When his family returned to America, he decided to continue his studies in Paris. There he studied with Fantin-Latour and Legros in the studio of Gleyre at the Beaux-Arts. Together they founded the Société des Trois. Whistler is close to Symbolism in his contempt for "realism". In 1859, he moved to London, where he made his career, though he often returned to Paris. There he befriended Baudelaire and the Impressionists. His *Young Girl in White* was greeted by the critics as an allegory. But it was in fact a manifesto in favour of a lighter style of painting and simplified colours; colour acquired an almost abstract quality. The famous critic John Ruskin, who fervently defended the Pre-Raphaelites, accused Whistler of "flinging a pot of paint in the public's face"; the same expression was later used of Matisse in the Salon des Fauves. Whistler's *Ten O'Clock Lecture* was translated by Mallarmé; in it, Whistler humorously develops his theory of an art based on neither narrative nor moral values. In his view, just as "music is the poetry of the ear, so painting is that of the eye". And this cultivated dandy never ceased to include in his "art for art's sake" references derived from Symbolism.

WIERTZ Antoine

(1806–1865) Belgian painter, born in Dinant. A precocious draughtsman, he was an admirer of Géricault. He was the son of a Dinan tailor who forced him to learn music, drawing and grammar from early youth. In 1820, studied at the Antwerp Academy. He spent 1829–1832 in France, won the Prix de Rome in 1832, and stayed in Italy from 1834 to 1836 at the Académie de France in Rome, where, under the direction of Horace Vernet, he copied the great Italian masters. In 1838, exhibited his *Patrocles* in Paris. The unfavourable critical reaction determined him not to seek French citizenship. In 1850, the Belgian government financed the construction of a studio modelled on one of the Greek temples of Paestum. His style shows

the inspiration of Rubens along with reminiscences of medieval painters, but expresses humanitarian and even revolutionary overtones. This is combined with wild invention and a frequently erotic Symbolism. His masterpiece is *The Beautiful Rosine*, in which a beautiful woman is placed before a skeleton. The work is halfway between traditional *vanitas* and Baudelairian meditation.

WILLUMSEN Jens Ferdinand

(1863–1958) Danish painter and sculptor, born in Copenhagen. Studied architecture and paintings. In Paris 1888–1889 and 1890–1894, met the Pont-Aven painters and the Symbolists. In 1889 travelled in Spain and encountered the work of El Greco and Goya. In 1890 discovered Redon's work through the intermediary of Theo van Gogh. On his return to Denmark, he painted landscapes characterised by intense colours, inundated in violent light, with tragic sentiments sometimes expressed in painfully expressionist style.

WITKIEWICZ Stanislaw Ignacy ("Witkacy")

(1885–1939) Polish painter and author, son of the painter, writer and critic Stanislaw Witkiewicz, he was initiated into art by his parents and their very prominent friends. In 1905, he studied with Jan Stanislawski and Józef Mehoffer at the Cracow Academy. In 1914, he travelled to Australia with the ethnologist Bronislaw Malinowski. When war broke out, he returned to Poland and enlisted in the Russian army. He witnessed the Revolution in St Petersburg. In 1924, he declared that art was dead. In 1925, he created the "S.I. Witkiewicz Portrait Company", of which he was, of course, the sole representative. Painter, author of plays and novels, art theorist, he was a provocateur of the first order. He committed suicide on 17 September 1939 on learning that the Red Army had invaded Poland. His delirious and aggressive works, with their wild arabesques free of all functional constraint and their strident colours, foreshadow the gestural painting of the CoBrA group.

Stanislaw WITKIEWICZ

Witold WOJTKIEWICZ

Stanislaw WYSPIANSKI

WOJTKIEWICZ Witold
(1879–1909) Polish painter. One of the founders of the "Green Balloon" cabaret in the "Jama Michalika" *pâtisserie* in Cracow; the *pâtisserie* still exists. He exhibited his drawings there. His work made such an impact on André Gide and Maurice Denis that they organised an exhibition for him in Paris. He died two years later at thirty. His art generally combines the lyrical and the grotesque. His form of Symbolism was close to Expressionism and a precursor of Surrealism.

WYSPIANSKI Stanislaw
(1869–1907) Polish poet, painter, dramatist and stage-director, the son of a well-known sculptor. In 1887 he studied with Matejko at the Cracow Academy; he simultaneously studied art history at the Jagellonian University. 1890–1894 stayed in Paris. Occasional attendance at the Académie Colarossi. Met Gauguin in 1893. Returned to Poland in 1894 and made a revolution in decorative art, introducing the ornamental Secessionist forms with his ally Mehoffer. In 1896, he illustrated Homer's *Iliad*. In 1898, became the editor of the magazine *Zycie* ("Life"). In 1904, became a teacher at the Cracow Academy. He was one of the pioneers of Art Nouveau in Poland and a leader of the Young Poland movement.

ZECCHIN Vittorio
(1878–1947) Italian painter. Studied at the Venice Academy. 1909–1912 painted works inspired by the Munich and Vienna *Sezession*. In 1920, exhibited mosaics in Milan; in 1925, took part in the International Exhibition of Decorative and Industrial Art in Paris. He exhibited at the Cracow Biennale in 1926, 1928 and 1934. His works immediately call to mind his predecessor Klimt and Klimt's inspiration, the mosaics of Ravenna.

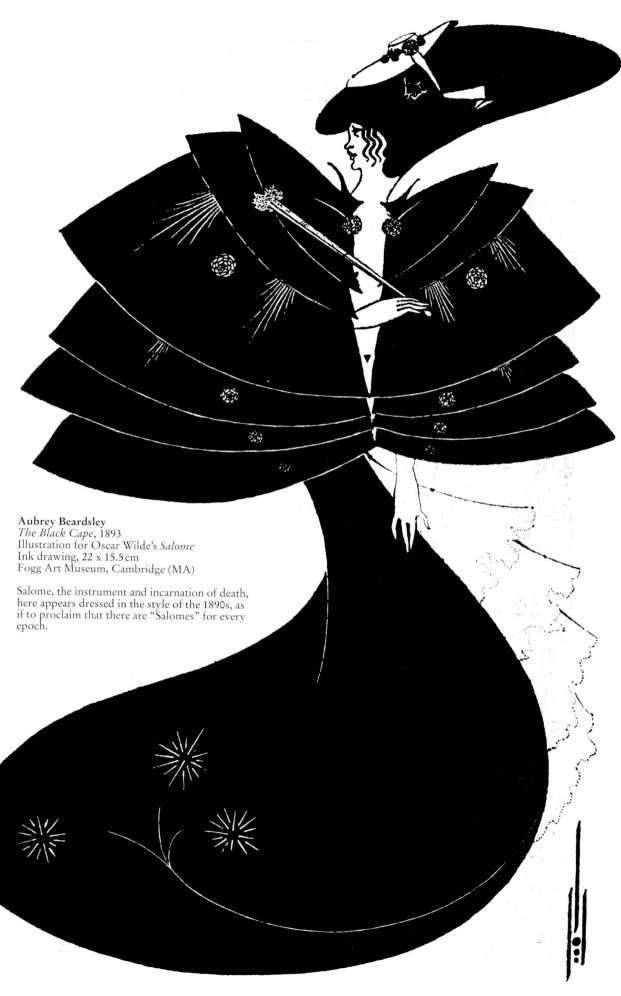

Aubrey Beardsley
The Black Cape, 1893
Illustration for Oscar Wilde's *Salome*
Ink drawing, 22 x 15.5 cm
Fogg Art Museum, Cambridge (MA)

Salome, the instrument and incarnation of death, here appears dressed in the style of the 1890s, as if to proclaim that there are "Salomes" for every epoch.

Selected Bibliography

Art Nouveau in Munich, The Philadelphia Museum of Art and Prestel, Munich, 1988.

Renato Barilli. *Il Symbolismo nella Pittura francese dell'Ottocento*. Fabri, Milan, 1967.

Georges Bernier. *La Revue Blanche*. Hazan, Paris, 1991.

Hélène A. Borisova and Gregory Sternive. *Art Nouveau Russe*. Editions du Regard, Paris, 1987.

Jean-Paul Bouillon. *Journal de l'Art Nouveau, 1870–1914*. Skira, Geneva 1985.

Pierre Brunel, Jean Cassou, Francis Claudon, Georges Pillement, Lionel Richard. *Encyclopédie du Symbolisme*. Somogy, Paris, 1979.

Jean Cassou, Emile Langui, Nikolaus Pevsner. *Les Sources du XXᵉ siècle*. Editions des deux Mondes, Paris, 1961.

Jean Cassou. *Encyclopédie du Symbolisme*. Somogy, Paris, 1979.

Françoise-Thérèse Charpentier, Christian Delize, etc. *Art Nouveau. L'Ecole de Nancy*. Denoël et Serpenoise, Paris, 1987.

Charles Chassé. *Le Mouvement symboliste dans l'art du XIXᵉ siècle*. Floury, Paris, 1947.

Robert L. Delevoy. *Journal du Symbolisme*. Skira, Geneva, 1977.

Bernard Delvaille. *La Poésie symboliste* [Anthology]. Seghers, Paris, 1971.

Carlos Schwabe
Illustration for Emile Zola's "The Dream", 1892

V. Fatejew. *Phantastische Werke Russischer Künstler*. Aurora, Saint Petersburg, 1989.

Michael Gibson. *The Symbolists*. Abrams, New York, 1988.

T. Hilton. *The Pre-Raphaelites*. Thames and Hudson, London, 1970.

Hans H. Hofstätter. *Jugendstil Druckkunst*. Holle-Verlag, Baden-Baden, 1968.

Werner Hoffmann. *Zauber der Medusa. Europäische Manierismen*. Edited by the Wiener Festwochen, Vienna, 1987.

Diane Chalmers Johnson. *American Art Nouveau*. Abrams, New York, 1979.

Philippe Jullian. *Esthètes et Magiciens*. Librairie académique Perrin, Paris, 1969.

Philippe Jullian. *Les Symbolistes*. Ides et Calendes, Neuchâtel, 1973.

Francine-Claire Legrand. *Le Symbolisme en Belgique*. Laconti, Brussels, 1971.

Gérard-Georges Lemaire. *Les Préraphaélites entre l'Enfer et le Ciel* [Anthology]. Bourgeois, Paris, 1989.

Edward Lucie-Smith. *Symbolist Art*. Thames and Hudson, London, 1972.

Lumières du Nord. La Peinture scandinave, 1885–1905. Petit Palais, Paris, 1987.

Jeremy Maas. *Victorian Painters*. Barrie & Jenkins, London, 1969.

Stephan Tschudi Madsen. *L'Art Nouveau*. Hachette, Paris, 1967.

Jan Marsh. *Preraphaelite Women*. Weidenfeld and Nicolson, London, 1987.

Lara-Vinca Masini. *Art Nouveau*. Thames and Hudson, London, 1984.

Pierre-Louis Mathieu. *La génération symboliste*. Skira, Geneva, 1990.

Alain Mercier. *Les Sources ésotériques et occultes de la poésie symboliste, 1870–1914*. Nizet, Paris.
Vol. I. Le Symbolisme français, 1969.
Vol. II. Le Symbolisme européen, 1974.

Guy Michaud. *Message poétique du Symbolisme*. Nizet, Paris, 1947.

El Modernisme, Barcelona, 1990–1991.

Gabriel Mourey. *Dante Gabriel Rossetti et les Préraphaélites anglais*. Laurens, Paris, year not given.

A. Olszewski. *An Outline History of Polish 20th Century Art and Architecture*. Interpress, Warsaw, 1989.

Michael Pabst. *L'Art graphique à Vienne autour de 1900*. Mercure de France, Paris, 1985.

Jeannine Paque. *Le Symbolisme belge*. Labor, Brussels, 1989.

José Pierre. *Le Symbolisme*. Hazan, Paris, 1976.

José Pierre. *L'Univers symboliste. Fin de siècle et décadence*. Somogy, Paris, 1991.

Jean Pierrot. *L'Imaginaire décadent, 1880–1900*. Publications de l'Université de Rouen/P.U.F., Paris, 1977.

Mario Praz. *La Chair, la Mort et le Diable. Le Romantisme noir*. Denoël, Paris, 1977.

Noël Richard. *Le Mouvement décadent*. Nizet, Paris, 1968.

Il Sacro e il Profano nell'arte dei Simbolisti. Galleria Civica d'Arte Moderna, Turin, 1969.

Simbolismo en Europa. Néstor en las Hespérides. Centro Atlantico de Arte Moderno, Las Palmas de Gran Canaria, 1990–1991.

Symboles et Réalités. La Peinture allemande, 1848–1905. Petit Palais, Paris, 1984–1985.

Le Symbolisme en Europe. Grand Palais, Paris, 1976.

Vienne 1880–1938: L'Apocalypse joyeuse. Musée national d'Art moderne, Centre Georges Pompidou, Paris, 1986.

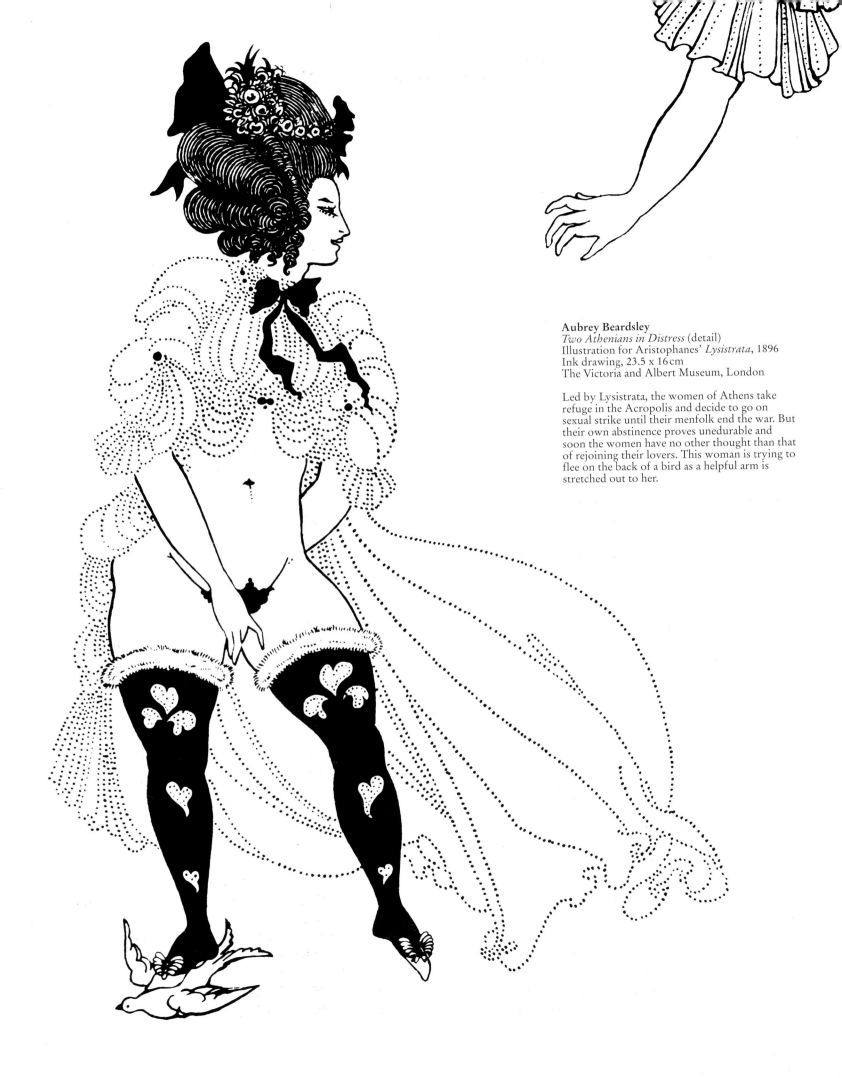

Aubrey Beardsley
Two Athenians in Distress (detail)
Illustration for Aristophanes' *Lysistrata*, 1896
Ink drawing, 23.5 x 16 cm
The Victoria and Albert Museum, London

Led by Lysistrata, the women of Athens take
refuge in the Acropolis and decide to go on
sexual strike until their menfolk end the war. But
their own abstinence proves unedurable and
soon the women have no other thought than that
of rejoining their lovers. This woman is trying to
flee on the back of a bird as a helpful arm is
stretched out to her.

Table of illustrations

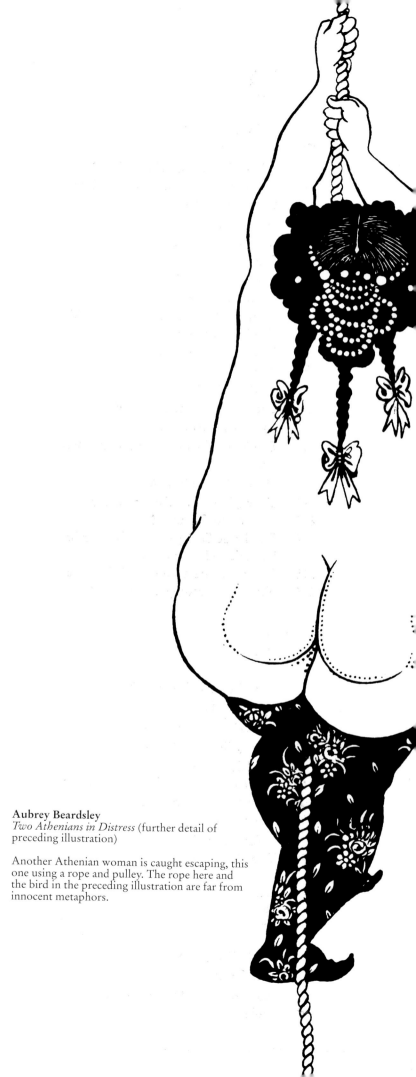

Aubrey Beardsley
Two Athenians in Distress (further detail of preceding illustration)

Another Athenian woman is caught escaping, this one using a rope and pulley. The rope here and the bird in the preceding illustration are far from innocent metaphors.

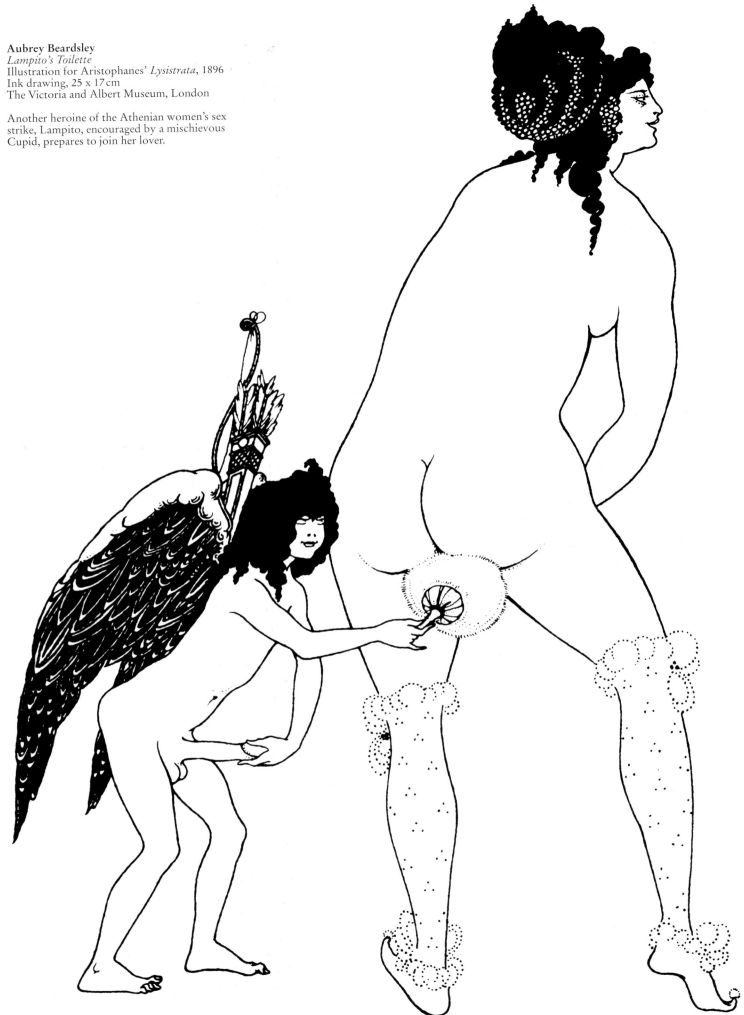

Aubrey Beardsley
Lampito's Toilette
Illustration for Aristophanes' *Lysistrata*, 1896
Ink drawing, 25 x 17 cm
The Victoria and Albert Museum, London

Another heroine of the Athenian women's sex
strike, Lampito, encouraged by a mischievous
Cupid, prepares to join her lover.

T

V

W

Z

Acknowledgements

The reproductions come from the author's archive, except for the illustrations on the following pages:
(abbr.: r = right; l = left; t = top; b = bottom)

Archiv für Kunst und Geschichte, Berlin: 158 t, 166, 168, 169 t, 180
Arthothek, Peissenberg: 8 t, 25, 68–69, 119 b, 127, 136
Bibliothèque Royale Albert Ier, Cabinet des Estampes, Brussels: 98 l, 104 t
Billedgallerie, Rasmus Meyers Samling und Stenersens Samling, Bergen: 144
Birmingham City Museums and Art Gallery, Birmingham: 74 bl
Board of Trustees of the National Museums and Galleries on Merseyside, Lady Lever Art Gallery, Liverpool: 73 t, 199 t
The Bridgeman Art Library, London/F. Labisse Collection, Neuilly: 87
The Bridgeman Art Library, London: 77, 107
The Central Art Archives, Helsinki: 148, 149, 150 t, 151 t
Christie's Colour Library, London: 13, 167 rb
Clemens-Sels-Museum, Neuss: 50
Collection Arturo Schwarz, Milan: 212
Collection of the J. Paul Getty Museum, Malibu: 102–103
Collection State Museum Kröller-Müller, Otterlo: 2, 93, 94, 99, 115 tr, 115 b
The Detroit Institute of Art, Gift of Mr. Bert L. Smokler and Mr. and Mrs. Lawrence A. Fleischman, Detroit: 23 b
Foto Saporetti, Milan: 218 b, 219
Fundación Colección Thyssen-Bornemisza, Madrid: 7
Galerie Michael Pabst, Munich / © Photo: Verlag Silke Schreiber: 129
Glasgow School of Art, Glasgow: 80 r
Hamburger Kunsthalle, Hamburg / © Photo: Elke Walford: 131–133
J. F. Willumsens Museum, Frederikssund / © Photo: Claus Orsted: 153 t
Koninklijk Museum voor Schone Kunsten, Antwerp: 15 t
Kunsthaus Zürich, Prêt de Gottfried-Keller-Stiftung, Zurich: 46–47
Kunstmuseum Bern, Berne: 11 b, 120 t
M. K. Čiurlionis State Museum of Art, Kaunas: 194, 195
Manchester City Art Galleries, Manchester: 72
Munch-Museet, Oslo: 145, 146 t, 146 b, 147 t, 147 b
Musée d'Art et d'Histoire, Geneva / © Photo: M. Aeschimann, Geneva: 142
Musée d'Art Moderne, Petit Palais, Geneva: 44 t
Musée de l'Avallonais, Avallon / © Photo: Studio G. Deroude: 49
Musée des Arts Décoratifs, Paris / © Photo: L. Sully-Jaulmes, Paris: 9
Musée des Beaux-Arts de Clermont-Ferrand / © Photo: Jean-Pierre Verniette, Clermont-Ferrand: 35 r

Musée des Beaux-Arts, Lyon / © Photo: René Basset, Caluire: 52
Musée des Beaux-Arts, Quimper / © Photo: Imago: 45
Musée National d'Art Moderne, Centre Georges Pompidou, Paris: 156 h
Musées Royaux des Beaux-Arts de Belgique, Brussels: 28, 86, 90, 95, 103, 106 l, 112, 113
Museu Nacional d'Art de Catalunya, Calveras/Sagristá, Barcelona: 206 b
Museum Boymans van Beuningen, Rotterdam: 109 tr, 109 br, 114
Museum of Fine Arts, Gand: 104 b
Museum voor Schone Kunsten, Ostend: 110 r
Muzeum Narodowe Wroclaw, Wroclaw: 172 b
Muzeum Narodowe, Warsaw: 168, 170 tl, 170 tr, 171 t, 173 t, 173 bl, 174 t, 174 b, 175 b
Narodowe Muzeum Poznan / © Photo: Jerzy Nowakowski, Poznan: 166, 167 t, 168, 169 b
Nasjonalgalleriet, Oslo / © Photo: J. Lathion, Nasjonalgalleriet, Oslo: 150 b, 152 t
National Gallery of Art, Ailsa Mellon Bruce Fund, Washington: 83
National Gallery of Art, Andrew W. Mellon Collection, Washington: 82
National Gallery, Prague: 157 t, 159, 167 tr
National Museum of American Art, Washington DC, Art Resource NY: 85
Nationalmuseum, Stockholm: 151 b
Öffentliche Kunstsammlung Basel, Kunstmuseum, Basle / © Photo: Martin Bühler: 14, 17, 118
Photothèque des Musées de la Ville de Paris, Paris: 39, 47 tl, 53 l
Propriété Province de Namur, Musée Félicien Rops / © Photo: Luc Schrobiltgen, Brussels: 98 r
R. M. N., Paris: 8 b, 19, 20, 30, 32, 36, 37, 43, 44 b, 51, 54 b, 55, 57, 61, 64 r, 110 l, 137, 143 r, 160
SCALA Istituto Fotografico Editoriale S.p.A., Antella: 198, 202 b, 205 t
Southampton City Art Gallery, Civic Centre, Southampton: 65 l
Staatliche Kunsthalle Karlsruhe, Karlsruhe: 16
Tate Gallery, London: 26, 70 t, 74 t, 79
Tompkins Collection, Courtesy of Museum of Fine Arts, Boston: 40–41
Virginia Museum of Fine Arts, The Adolph D. and Wilkins C. William Fund, Richmond / © Photo: Ann Hutchison: 81 l
Reproduced by permission of the Warden and Fellows of Keble College, Oxford: 74 br
Reproduced by permission of the Trustees of The Watts Gallery, Compton, Surrey: 78 l
Photo x – All rights reserved

Kasimir Malevich
Two Dryads, c. 1908
Vignette in ink, 19.7 x 13.5 cm
Former A. Leporskaya collection